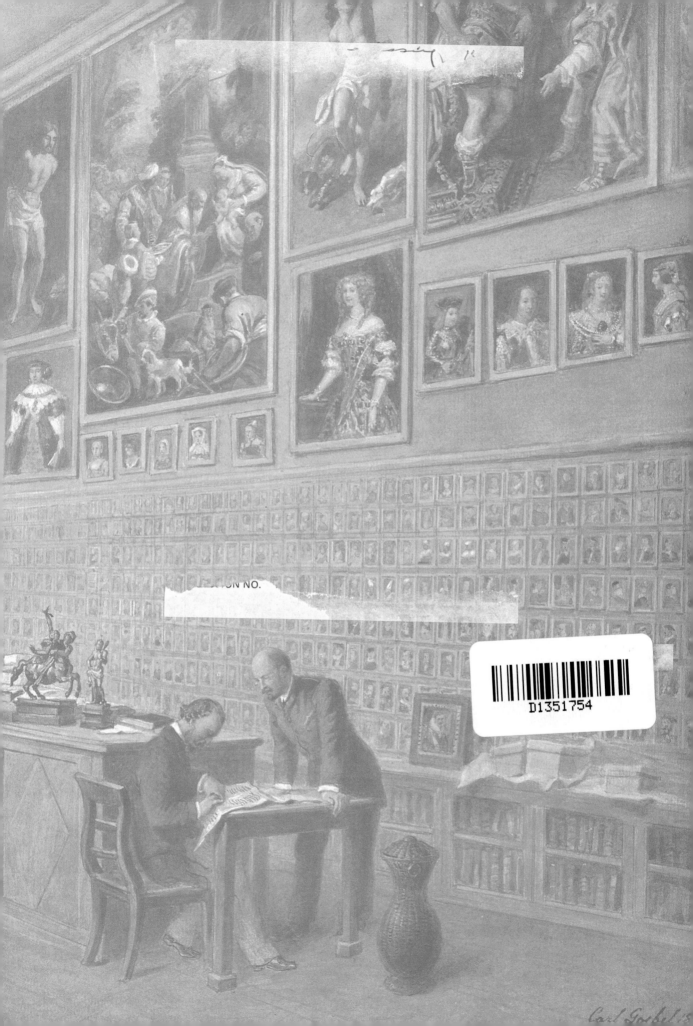

Carl Gorbel

The Kunsthistorische Museum Vienna

The Treasury and the Collection of
sculpture and decorative arts

The Paintings Collection

Manfred Leithe-Jasper

Director of the Treasury
and the Collection of sculpture and decorative arts

Rudolf Distelberger

Curator
Collection of sculpture and decorative arts

Wolfgang Prohaska

Curator
Paintings Collection

Vienna

The Kunsthistorische Museum

Scala / Philip Wilson

© 1984 Philip Wilson Publishers Ltd and
Summerfield Press Ltd

First published in 1984 by Philip Wilson
Publishers Ltd and Summerfield Press Ltd
Russell Chambers, Covent Garden, London WC2E 8AA

Translated from the German by Elsie Callander and Ilse Seldon
Photography: Fotostudio Otto, Vienna
Design: Alan Bartram
Series Editor: Kathy Elgin
Produced by Scala Istituto Fotografico Editoriale, Firenze
Phototypeset by Tradespools Ltd, Frome, Somerset
Printed in Italy

ISBN 0 85667 207 6

FRONT COVER: *Portrait of a Man with a Book* by Vincenzo di Biagio, called Catena
BACK COVER: *Saliera* (salt-cellar) by Benvenuto Cellini
ENDPAPERS: *Paintings and the 'Ambras' portrait collection in the
Lower Belvedere Palace, Vienna* by Carl Goebel

Contents

The Treasury

The Collection
of sculpture and
decorative arts

The Treasury
Manfred Leithe-Jasper

Introduction

The title 'Art Historical Museum' embraces both the collections from many spheres and periods of European art and culture and the Museum building itself, which can claim to be an edifice of the highest architectural interest.

Since the beginning of the nineteenth century, plans had been made in Vienna to transfer the collections of the Imperial Court, which had previously been inadequately housed in various sections of the Imperial Palace and the Castle Belvedere, to a central site in the city for exhibition as a self-contained unit. The erection of two museum buildings of identical external form opposite each other, to house the Natural History Museum and the Art Historical Museum, finally brought about the geographical separation of the natural history objects from the artifacts of the Imperial collections. Although Karl Haase had won an architectural competition for the building, it was Gottfried von Semper, who, by decisively changing the latter's plans, really gave the buildings their solemn, monumental character. The sumptuous interior, however, is the work of Karl Hasenauer, whose talents lay unmistakably in decorative art. The most outstanding artists of Austria took part in the work, such as the painters Munkácsy, Makart, and Klimt, and the sculptors Tilgner and Weyr. The precious materials used in the decoration contributed further to the achievement of a desired brilliance and to the creation of an appropriate framework for the priceless works of art, which were to find a permanent home here after centuries of Imperial patronage. As a result of connecting the Museums, to the west, and the Court mews lying to the east with the Castle, which was also enlarged at this time, to the Court churches and the Court library, as well as the Court theatres situated a short distance away behind the Court Gardens, an 'Imperial forum' was created. This 'forum' continued the old tradition of the universality of the Imperial Court embracing all spheres of life, and indeed was able for the first time to show this in monumental fashion.

The actual building of the Museum was begun in 1871; and on 17 October 1891 it was inaugurated by the Emperor Franz Josef. The Egyptian and Far Eastern Collection, the Antiquities Room, and the Collection of sculpture and decorative arts are now housed on the upper ground floor. The main exhibits of the Paintings Gallery are displayed on the first floor, while the secondary Collection takes up the second floor of the south wing, and the Coin Room the north wing. For reasons of space, the Collection of weapons, consisting of the combined stocks of the Imperial armoury and the Court hunting store, had already been moved over before the Second World War to the new wing of the Hofburg, the Imperial Palace, to which the Collection of old musical instruments, and recently also the stock of the old antique collection from Ephesus, was transferred. The Treasury remained in the old Hofburg. In the mews section, where the

Emperor Karl VI had already once installed the Paintings Gallery in 1728, pictures and sculpture of the nineteenth and twentieth centuries were exhibited in a display in what was called the 'New Gallery' in 1967. These had come from the stocks of the Paintings Gallery and the Collection of sculpture and decorative arts. Also in the Hofburg is the costume section, a fine collection of former Court clothes and uniforms. The Wagenburg, a Collection of historical carriages and harnesses mainly from the Court—formerly housed in the Court mews— has been exhibited since 1921 in the Winter Riding School of the Castle of Schönbrunn. Finally, the Art Historical Museum has had an annexe for the last few years in the Castle of Ambras near Innsbruck, which consists of a *Kunst-* and *Wunderkammer* (art and treasure chamber), an armoury, and the temporary exhibition of historical portraits of Austria.

A brief glance at the history of the collections of the Art Historical Museum shows that their character largely bears the mark of the personalities of individual collectors. Although the Museum was only inaugurated towards the end of the last century, the tradition of Hapsburg collecting goes back to the Middle Ages, at least as far as Emperor Ferdinand in 1564, and is to be found continuously recorded in inventories of various collecting fields. It was only in the following generations, however, that famous collectors exerted an influence which really bore the stamp of the Hapsburg collections. The most noteworthy of these figures is Archduke Ferdinand II, who had already, as Governor of Bohemia and especially as Regent of Tirol and the Austrian forelands, developed extensive and mainly historical collecting and installed his famous *Kunst- und Wunderkammer* in the Castle of Ambras. His 'Heroes' Armoury', for which he published the first printed collection catalogue (which, however, did not appear until six years after his death in 1601) forms the basis of the present collection of weapons, the richest and most varied armoury in the West. The Art Room at Ambras constitutes, along with the stocks taken over from the Treasury, the basis of the Collection of sculpture and decorative arts.

Ferdinand's nephew, the Emperor Rudolf II (reigned 1576–1612) ranks as one of the greatest patrons and collectors known in Europe. Not only did he establish one of the most important collections of all time in his residence in Prague, but he also inherited the Ambras Collection from the heir of Archduke Ferdinand II for the House of Hapsburg, thus securing its continuity. He was one of the most committed collectors of the paintings of Albrecht Dürer, Pieter Bruegel the Elder, and Correggio, which are still the glory of the Paintings Gallery today. To the same extent as he collected older works of art did he overwhelm the artists of his time with commissions. The style of objects from the highly productive Court workshops in the spheres of stone-carving and goldsmith's art is still essentially to be found in the collections of the Treasury and

sculpture and decorative arts. The greater part of this unique collection had in fact reached Vienna before Sweden invaded Prague at the end of the 30 Years War, plundering whatever treasures remained there.

Apart from Rudolf II, the Paintings Gallery has another Hapsburg founder: Archduke Leopold Wilhelm, the younger brother of the Emperor Ferdinand III, who was Governor General in the Hapsburg Netherlands from 1646 to 1656. The important acquisitions that he had managed to make there brought the Gallery its unique richness of seventeenth-century Flemish and Italian paintings, and especially of sixteenth-century Venetian paintings.

With his passion for collecting, Archduke Leopold William was, however, something of an outsider from his family in his century, since they had turned increasingly to the representative arts, music and the theatre, and had been seized with a veritable passion for building in the late seventeenth and early eighteenth centuries. Along with a heightened need for prestige, this must also have been the real motivation of Emperor Karl VI in the 1820s for the first very comprehensive decorative exhibition in the Paintings Gallery in the Castle mews. Then his daughter, the Empress Maria Theresa (reigned 1740–80), had the Treasury re-arranged in 1750. She was also responsible for the acquisition of great altar works by Rubens, Van Dyck, and Caravaggio in the Netherlands. Her son, Emperor Josef II (reigned 1780–90), ordered the transfer of the Paintings Gallery from the mews to the Upper Belvedere Castle, where for the first time it was arranged systematically from an art history standpoint, and found a place in keeping with its importance. Joseph II was an enlightened monarch and decreed that it should be open to the public.

The reign of Emperor Franz II (1792–1835), the last Emperor of the Holy Roman Empire, coincided with the classical period; not surprisingly, it was the Antiquities Room that benefited from considerable additions. It also coincided, however, with one of the most troubled political phases of European history, the time of the French Revolution. The Ambras Collection had been brought to Vienna for security reasons and was exhibited in the Lower Belvedere; at the same time the treasure of the Order of the Golden Fleece from Brussels and the Imperial jewels from Aachen and Nürnberg had also found refuge in Vienna from the army of Napoleon.

During the reign of Emperor Franz Josef (1848–1916) there was in Vienna—unlike London, Paris, Berlin, and New York—no large-scale collecting activity. It was rather the re-arrangement and re-organization of the Hapsburg artistic estate that was the outstanding event in the history of collecting, an event which had its temporary zenith in the combining of nearly all the holdings in the splendid and purpose-built Art Historical Museum.

At the end of the First World War and after the ensuing disintegration of the Austro-Hungarian monarchy, the republic of Austria took over the artistic estate of Hapsburg-Lorraine. This heritage had first to be defended against unjustified claims by the States succeeding the Austro-Hungarian Empire, a defence which was not always, but mainly, successful. As a result of the breakup of the Court, the Art Historical Museum once more received significant additions. The Treasury and tapestry collection were now incorporated and put under the direction of the Collection of sculpture and decorative arts. At this point the costumes and carriages sections were also added, and finally the art collection of the Austrian Este line, most of which stemmed from the collection of the Marquis Tommaso degli Obbizzi in the castle of 'Il Catajo' near Padua, which was divided between the Antiquities Room, the Collection of sculpture and decorative arts, and the new Collection of musical instruments which was then founded. In 1932 the Museum was endowed with yet another important bequest: it is to this legacy from the Viennese industrialist Gustav von Benda that the Collection of sculpture and decorative arts is indebted for the very precious works of the Florentine Renaissance.

The Second World War did not spare the Art Historical Museum, which suffered severe bomb damage. The contents of the collections had fortunately for the most part been evacuated and were brought back with very few losses after the War. Purchases and occasional bequests are still added to the collections even today, but large-scale acquisition is no longer financially possible. However, the tremendous historical head-start that had been achieved in earlier centuries more than makes up for this. Thus the Art Historical Museum, in spite of its chequered history, which at the same time bears witness to a rare continuity, remains one of the leading museums of the world.

View of the sculpture collection before the
foundation of the Kunsthistorische Museum.

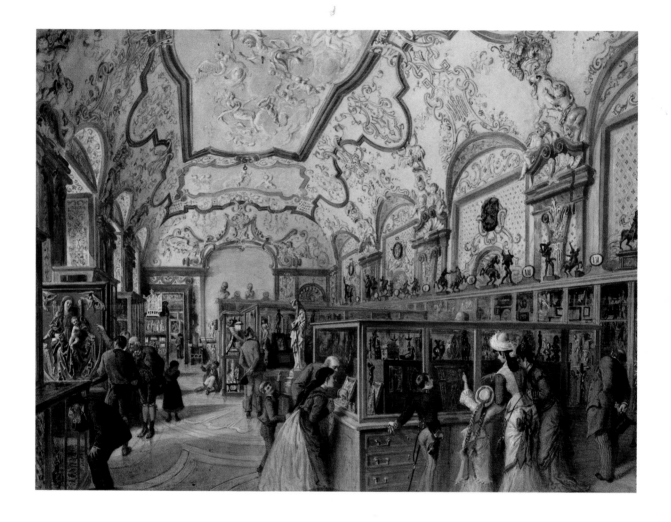

The secular Treasury

Although it is true that the objects in the secular Treasury came from the medieval treasure of the Hapsburgs, the history of this collection did not by any means proceed in a straight line but often by very tortuous and not always reconstructable paths. This was the result of frequent divisions of inheritances in the various lines, especially in the Middle Ages and the Renaissance. Since, however, the oldest line of the house of Hapsburg at the time always possessed the central Austrian States and later also Hungary and Bohemia, this treasure was gradually concentrated in the capital, Vienna, the Imperial residence. So it has always been possible to prove the existence in Vienna, in unbroken tradition from the time of Emperor Ferdinand I (born in 1564), of a Treasury, which since the seventeenth and eighteenth centuries, when considerable holdings from the Prague art room of Emperor Rudolf II and from the Graz art room of the younger Styrian line were added, increasingly developed into an art collection. Under the Empress Maria Theresa, this Treasury was re-established in 1750 in the place where it is still to be found today and in the display cases which have still for the most part been retained. After the death of her husband, Emperor Franz Stefan of Lorraine, in 1765, she also arranged for the private diamonds to be placed in the Treasury, which by the standards of the time were immensely precious. Finally, the treasure of the Order of the Golden Fleece from Brussels and the Imperial jewels from Nürnberg and Aachen were rescued from the conquering armies of Napoleon and the French Revolution and brought to Vienna between 1794 and 1797. They were deposited in the Treasury at the behest of Franz II, the last Roman Emperor, in 1800, and thus the collection attained its largest dimensions and greatest splendour. On the occasion of the proclamation of Austria as an Empire in 1804, the Imperial Dynastic Crown of the Hapsburgs became the official crown of the new Empire, and the private family Treasury became a collection of the highest political importance. Consequently, when a radical re-arrangement of, and new inventory for the Hapsburg art possessions took place between 1871 and 1891, Franz Josef ordered that the Treasury holdings should be split: the Royal insignia and family souvenirs and jewels remained in the Treasury, whilst all other objects were joined together with the other family collections and taken to the newly erected Art Historical Museum to be exhibited. At the time of the breakup of the monarchy at the end of the First World War, the family jewellery, which ranked as private possessions, and the diamond treasure of the Imperial family were taken with them into exile, but the Treasury was joined to the Art Historical Museum as a separate collection under the same administration as the sculpture and decorative arts. In 1938 Hitler had the Imperial jewels transferred to Nürnberg. After that the Treasury was closed and re-established and re-opened only in 1954, when the Imperial jewels had been restored to Austria.

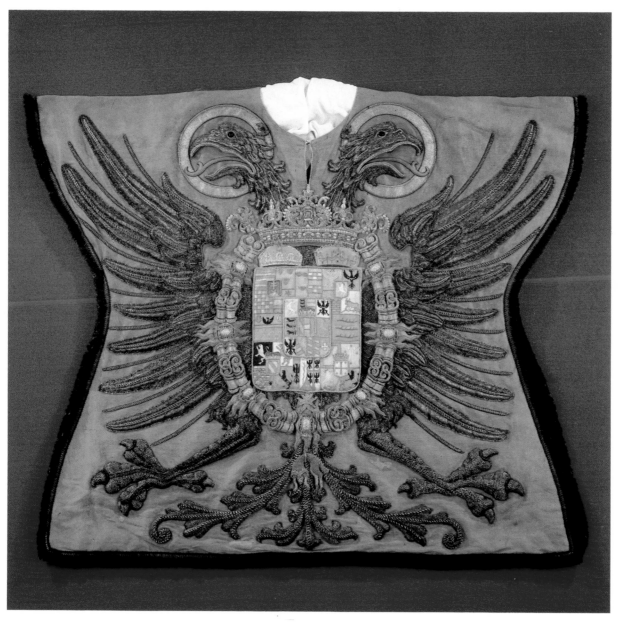

TABARD OF THE HERALD OF THE ROMAN EMPEROR
**Matthias Helm and Christoff Rauch,
Prague (?), 1613**
Gold cloth, black silk, and coloured
embroidery
The coat of arms of Emperor Matthias on the
breast plate was replaced by that of Emperor
Leopold II in 1790, at the time of the latter's
coronation. (XIVS/100)

The insignia of the Austrian hereditary homage

The departure point and basis of the abundant power of the House of Austria were the Duchy and later the Archduchy of Austria with which the Roman King Rudolf of Hapsburg invested his two sons, Albrecht and Rudolf, after the victorious battle against King Ottokar of Bohemia in 1278. Here, as in the other 'hereditary lands' belonging to the Hapsburg sphere of power, the enthroning of the monarch was not accomplished by his coronation as in Hungary and Bohemia, which were later also Hapsburg kingdoms, but through the ceremony of hereditary homage, by which the estates that were represented in the State Parliaments swore allegiance to the ruler, while the latter swore to respect their rights. Nevertheless, royal insignia were used even in this ceremony: the Austrian Archduke's hat, which is kept in the monastery of Klosterneuburg in accordance with the foundation privilege of 1616, and was at the disposal of the ruler for the ceremony of homage, an orb and a sceptre. The estates were represented by 'hereditary offices' going back to the old Court offices, which had their own insignia and were handed down from generation to generation in the noblest families.

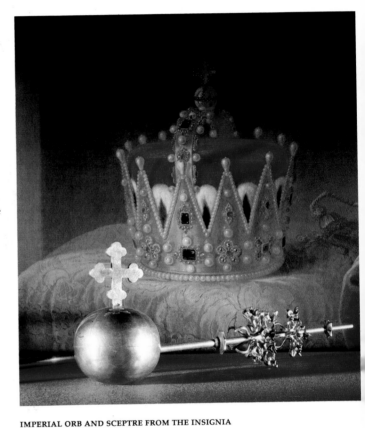

IMPERIAL ORB AND SCEPTRE FROM THE INSIGNIA OF THE AUSTRIAN HEREDITARY HOMAGE
Bohemian (?) orb second half of 15th century, sceptre mid-14th century
Silver-gilt; *H* 16 cm *L* 80 cm respectively
Having originally formed part of the Bohemian coronation regalia, the orb and sceptre were incorporated into the Austrian hereditary insignia by Emperor Matthias. The background shows a Baroque copy of the Austrian Archduke's coronet. (XIV/43/44)

▷
FEUDAL SWORD (SWORD OF INVESTITURE)
Hans Sumersperger, 1496
Blued steel, inlaid in gold, brass, silver and mother-of-pearl; *L* 139 cm
This ceremonial sword came from the private Coronation robes of the Emperor Maximilian I, and bears the coats of arms of his territorial possessions. (XIV/4)

HOUND'S COLLAR, FALCONRY BAG, FALCON LURE,
AND FALCON HOODS
The insignia of the Grand Master of the
Imperial Hunt and the Grand Master of
Imperial Falconry
Vienna, 1835
Green velvet, embroidered in gold; silver gilt;
red leather (XIV/36–40)

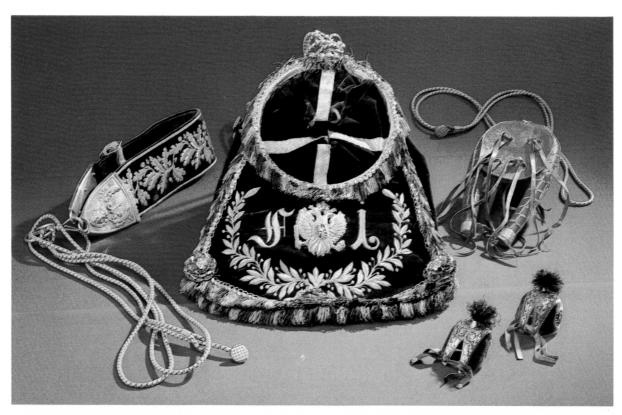

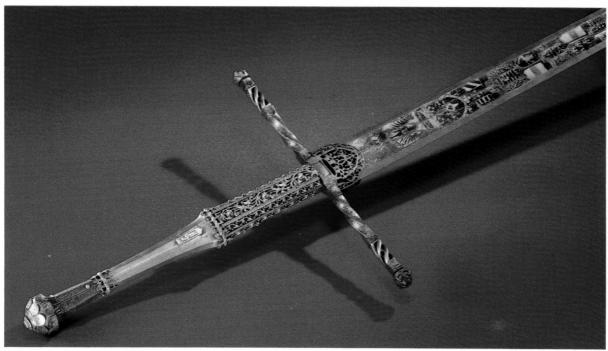

The insignia and jewels of the Holy Roman Empire

The insignia and jewels of the Holy Roman Empire can perhaps be described as some of the most venerable and splendid monuments of Western history, for they are the symbol of an idea of rulership which began with the coronation of Charlemagne on Christmas Eve 800 and lasted till the year 1806, when the Emperor Franz II dissolved this Empire under the pressure of the superior power of Napoleon. For medieval man at least, the Imperium Romanum lived on in the Holy Roman Empire under the rule of Christ, which explains the coexistence of secular and spiritual or theological representation in the insignia and the multiplicity of important religious relics among the jewels. The relics ranked as a divine pledge of lawful rule on earth which started with Christ by virtue of his sacrifice on the Cross, and whose representative the Emperor now was. This was particularly true of the great Cross particle and of the Holy Lance, into which, in keeping with tradition, a nail from Christ's Cross had even been worked, and which in all probability Pope Hadrian, in a reference to Constantine the Great, had presented to Charlemagne. As a result, this token of power became a link between the Imperium Romanum of Constantine and the later Holy Roman Empire of Charlemagne. The consequence of this and the ensuing coronation was that Charlemagne was accorded great respect as the first Western Emperor, and that three jewels, which according to legend came from his grave, were regarded as 'relics of Charlemagne' and their presence at coronations showed a wish to establish a direct visible and legal link between the first Western Emperor and the one who was about to be crowned. The new Emperor took the coronation oath on the Imperial book of Gospels, a Carolingian royal manuscript; the *Stephansbursa* (bursa of St Stephen), a reliquary of the ninth century, no doubt originating from Rheims, in which earth soaked in the blood of the first martyr St Stephen was preserved, was worked into the seat of the throne; and the Emperor was girded during the coronation with the 'sabre of Charlemagne', a ninth-century East-European work.

The main item of the insignia, however, was the Crown. It was probably made for Emperor Otto II, possibly in the Benedictine Abbey of Reichenau which was in the forefront of artistic achievements in the second half of the tenth-century. Here again a complicated theological sequence symbolizes the transcendental character of world dominion as it was understood in the Middle Ages. The ground-plan of the heavenly Jerusalem was conceived as octagonal, and thus the Crown was cast in similar form, the twelve great precious stones of the frontal band symbolizing the twelve apostles, in juxtaposition to whom in the Old Testament stand the twelve tribes of Israel, while the iconography of the four enamel bands refers to the coronation liturgy. In the Ottonian period close contacts existed with the East Roman-Byzantine Empire, so the arch may go back to the plumed arch of the Roman Imperial helmet. Out of these formal interlacings emerged the unique, recognizable form of the Crown, which is clearly distinguished from all other Western crowns.

Also unique is the set of coronation robes belonging to the Imperial jewels. Apart from the *Adlerdalmatik* (eagle dalmatic) and the *Stola* (stole), all the pieces come from the coronation vestments for the most part made by Arabian artists in the twelfth and thirteenth centuries for the Norman kings of Sicily. They eventually reached Friedrich II by way of inheritance and through him were added to the Imperial treasure.

With the exception of the three 'Aachen pieces', which were preserved in the Aachen Cathedral treasury, the insignia and jewels of the Holy Roman Empire were primarily at the immediate disposal of the Emperors and were kept by them in fortified castles. This old tradition was not broken until 1424, when Emperor Sigismund placed the treasure under the protection of the free city of Nürnberg, in order to preserve it from the attacks of the Hussites.

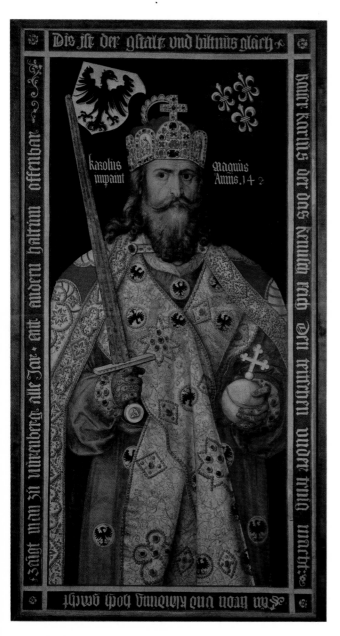
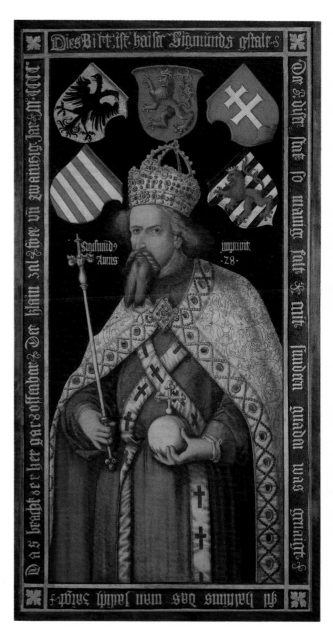

EMPEROR CHARLEMAGNE AND EMPEROR
SIGISMUND
**After Albrecht Dürer's idealized portraits,
Nuŕnberg *c* 1600**
Oil on canvas
Charlemagne is considered the founder of the
Holy Roman Empire. In 1424 Sigismund
transferred the custody of the Imperial insignia
to the Free Imperial City of Nürnberg, in
whose hands it remained until 1796. (GG 2770/
2771)

▽

IMPERIAL ORB
West German (Cologne?), last quarter of 12th century
Gold, gold filigree, precious stones, and pearls; *H* 21 cm
The first evidence available of an orb being used in a coronation ceremony dates from 1191, when Pope Coelestin III, in accordance with the wishes of Emperor Heinrich VI, handed the latter the Imperial orb in addition to the other insignia. (XIII/2)

▷

SCEPTRE AND ASPERGILLUM (SPRINKLER)
German, sceptre second third of 14th century, aspergillum *c* 1300
Sceptre: parcel-gilt silver; *L* 61.5 cm
Aspergillum: silver; *L* 58.5 cm
Sceptre and aspergillum, a liturgical accessory, are the insignia of the secular, but originally also the sacred, office of the Emperor. (XII/3 and XIII/4)

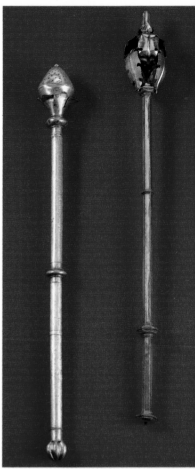

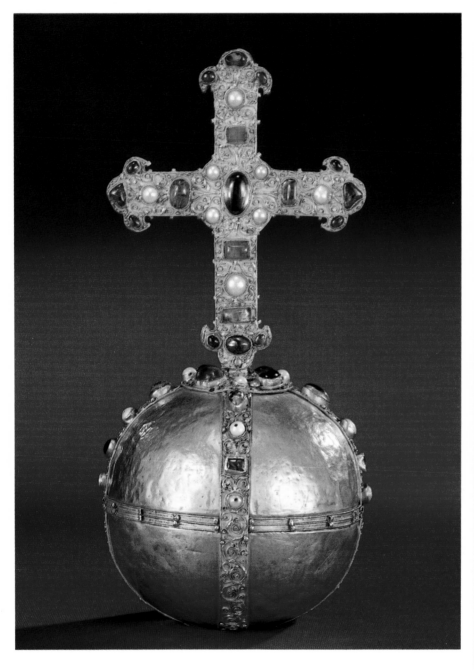

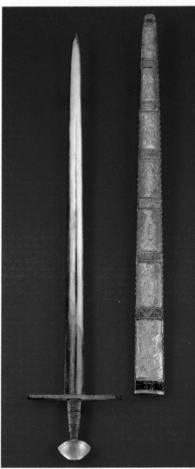

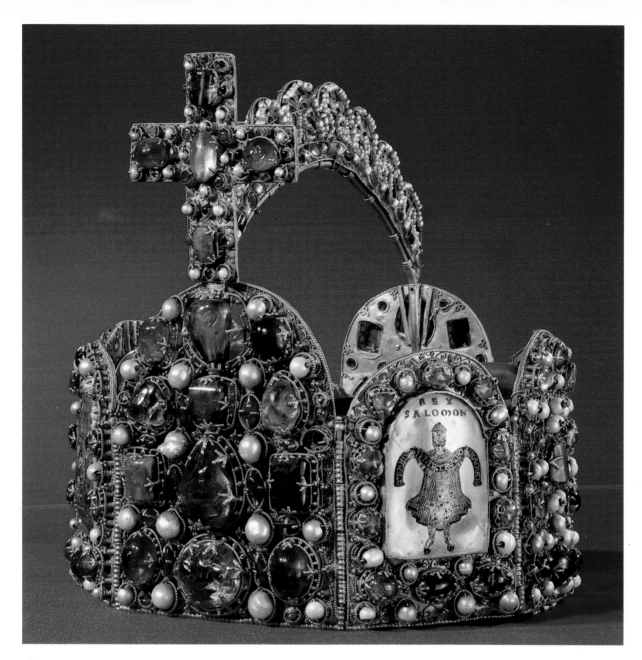

◁

IMPERIAL SWORD

The scabbard German, first half of 11th century; the sword between 1198 and 1218, later restored

Sword: blade steel, pommel and cross-bar silver-gilt, hilt bound with silver wire
Scabbard: olive wood, gold, enamel, garnets, and formerly pearls; *L* 110 cm
The pommel bears the Imperial Eagle and the coat of arms of King Otto IV (of Brunswick, reigned 1198–1218). It has the inscription BENEDICTVS DO(MINV)S DE(V)S.QVI.DOCET MANVS. The cross-bar has the inscription +CRISTVS:VINCIT: CRISTVS REINAT and CRISTVS VINCIT:CRISTVS REIGNAT:CRIST(VS) INPERAT. In the coronation procession the sword bearer carried the sword, point upwards, in front of the Emperor. (XIII/17)

△

IMPERIAL CROWN

West German (Reichenau?), second half of 10th century with later additions

Gold, gold filigree, various precious stones, pearls, and enamel; *H* approx 25.5 cm
It is now thought that the crown was made for Emperor Otto II in the years 978/980. The cross as we see it today dates from the time of Heinrich II (d 1024), the arch from that of the latter's successor, Konrad II (d 1039). (XIII/1)

THE IMPERIAL BOOK OF GOSPELS: THE GOSPEL OF ST JOHN

Manuscript: Aachen, end of 8th century
Purple-dyed parchment, gold, silver, and watercolour; 32.4 × 24.9 cm
Cover: Hans von Reutlingen, Aachen, *c* 1500
Silver, silver-gilt, precious stones, and red velvet; 34.5 × 26.1 cm
At the coronation, the future ruler took the oath of allegiance on this Gospel, raising his fingers and touching the first page of the Gospel of St John. (18)

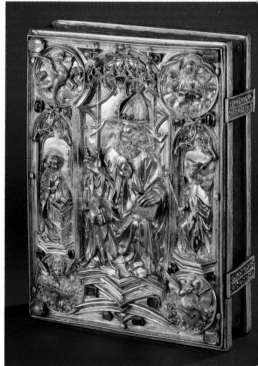

THE 'SABRE OF CHARLEMAGNE'

Eastern Europe, end of 9th or beginning of 10th century

Sabre: blade steel with gilded copper inlay; wood, fish-skin, gold, silver-gilt, and precious stones; *L* 90.5 cm

Scabbard: wood, leather, gold; *L* 86.5 cm

It was earlier thought that the sabre was a present to Charlemagne from Harun al Raschid or part of the Emperor's booty from the Avarsi campaign. It was with this sabre that the monarch was girded at the coronation. (XIII/5)

THE BURSA OF ST STEPHEN

Aachen, beginning of 9th century with 15th-century additions

Gold on a wooden core, precious stones and pearls, the reverse silver-gilt; *H* 32 cm

This reliquary is said to have contained earth saturated with the blood of St Stephen, the first martyr. (XIII /26)

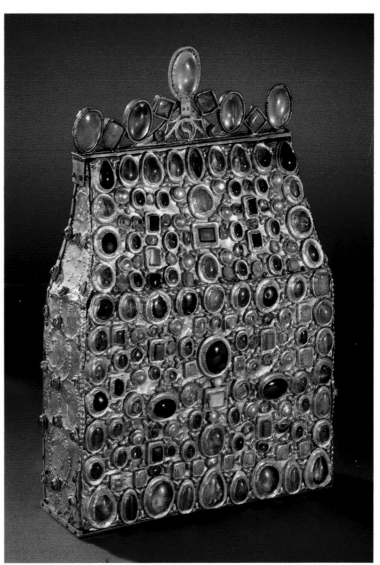

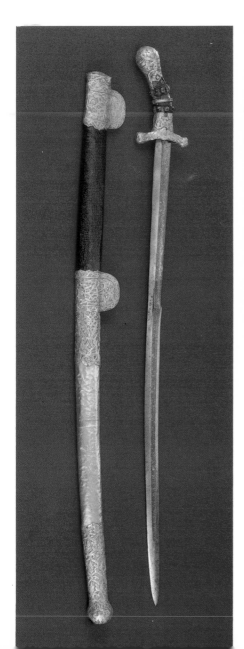

West German, *c* 1024, the base 1352

Oak, gold, precious stones, pearls, and niello
Base: silver-gilt and enamel; *H* overall 94.3 cm
It was in the Imperial cross that the Imperial
relics were originally kept; the Holy lance in
the transverse arm, the particle of the Holy
Cross in the shaft (XIII/21)

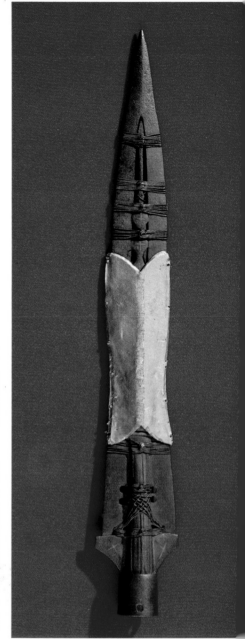

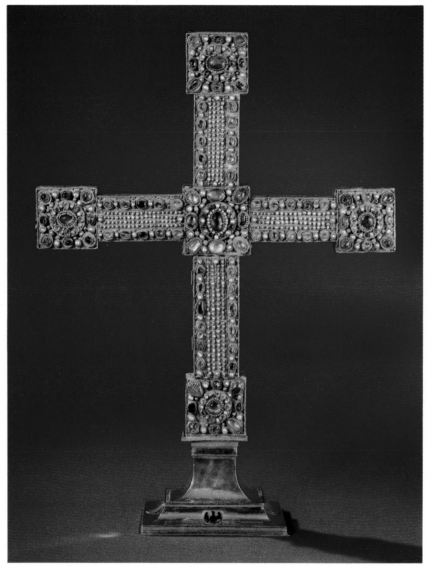

▷

RELIQUARY WITH THE CROSS PARTICLE
Setting German, 14th century
Wood: Pinus nigra Arnold or Pinus sillvestris L;
gold; *H* 31 cm
The Cross particle was originally kept in the
Imperial Cross and was probably given its gold
setting in the form of a processional cross in
the reign of the Emperor Karl IV. The leather
case was made in Nürnberg in 1517. (XIII/20)

HOLY LANCE
Langobardian-Carolingian, 8th century
Steel, iron, brass, gold, silver, and leather;
L 51 cm
A pointed oval opening was chiselled out of
the blade of the lance, into which a carefully-
forged ornamental iron pin was fitted, which
was thought to be a nail from the Cross of
Christ. The blade of the lance was broken
before the year 1000, and Heinrich IV
ordered a silver band to be made to mend it; in
the reign of Karl IV it was given a gold sleeve.
It is thought that the lance was originally in the
possession of Charlemagne, then of Rudolf of
Burgundy. Between 926 and 935 it came into
the possession of Heinrich I and through him
it became part of the Imperial treasure. At that
time it was held to be the lance of St Mauritius,
but later on it was revered as the lance with
which Longinus opened the side of Christ. The
victory of Otto I over the Hungarians in the
Battle of Lechfeld (the plateau between the
rivers Lech and Wertach) in 955 was
attributed to its miraculous powers. (XIII/19)

▷
RELIQUARY CONTAINING A FRAGMENT OF THE ROBE
OF ST JOHN THE EVANGELIST AND RELIQUARY
CONTAINING THE LINKS OF THE CHAIN
Avignon or Prague, between 1368 and 1378
Gold and niello; 24.8 × 15 × 1.3 cm,
12.5 × 4.7 × 2.8 cm respectively
The links of the chain are said to be pieces of
the iron chains with which the Apostles John,
Peter, and Paul were bound in prison. Pope
Urban V presented the Emperor Karl IV with
these relics in 1368.

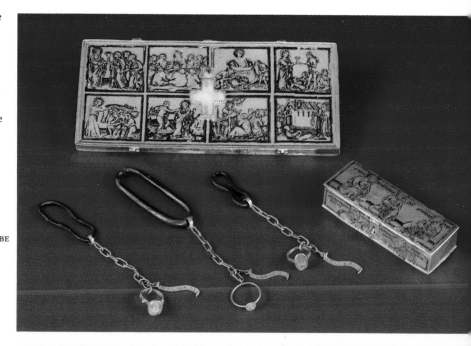

RELIQUARY CONTAINING A FRAGMENT FROM CHRIST'S CRIB
Venice, c 1340–50 or Prague, c 1368–78
Gold, precious stones, and pearls; 49 × 41 × 2.1 cm
Pope Urban V presented the Emperor Karl IV with this relic in
1368. The goldsmith's work is reminiscent of that of Paolo
d'Oro in Venice. (XIII/24)

CORONATION ROBE
Palermo, Royal workshop, 1133/4
Red silk, embroidered in gold; gold filigree,
enamel, precious stones, and pearls; *W* 342 cm
The Cufic inscription in Arabic round the hem
states that the robe was made in 1133/4 by
Arab artists for King Roger II of Sicily. It came
into the possession of the Emperor Friedrich II
with the Sicilian inheritance. It is thought that
he incorporated the robe into the Imperial
treasure after his coronation in Rome in 1220.
(XIII/14)

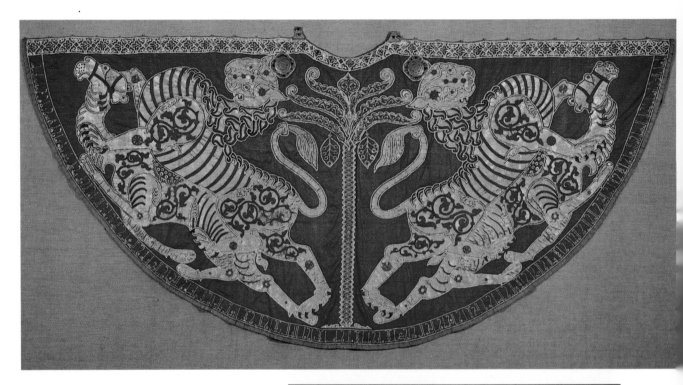

TWO RELIQUARIES CONTAINING FRAGMENTS OF THE
TABLECLOTH USED BY CHRIST AND OF CHRIST'S
APRON
Hans Krug the Younger; Nürnberg 1518
Silver gilt, precious stones and pearls;
H 55.5 cm (*right*), *H* 55 cm (*left*) (XIIIS/22 and 23)

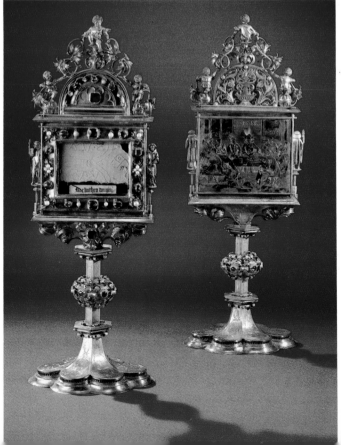

DALMATIC

Palermo, Royal workshop, between 1130 and 1154

Purple silk with trimmings in red silk, embroidered in gold; gold filigree, enamel, and pearls; H overall 141 cm (XIII/6)

GLOVES

Sicily, beginning of 13th century

Red silk, embroidered in gold; rubies, sapphires, pearls; enamelled gold; L 15.5 cm and 17 cm respectively

The gloves were presumably made for the Emperor Friedrich II before 1220, the year of his coronation, in the Royal workshop in Sicily. (XIII/11)

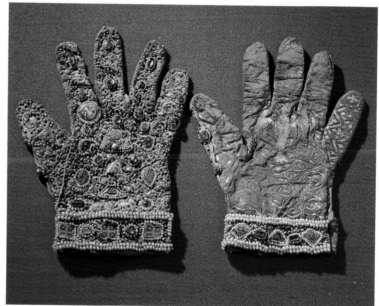

SHOES

Sicily, beginning of 13th century, altered in Nürnberg between 1612 and 1619

Calf with red silk and gold edging; precious stones and pearls; L 25.5 cm and 26 cm each

Like the gloves, these shoes were presumably made before 1220 for the Emperor Friedrich II. (XIII/13)

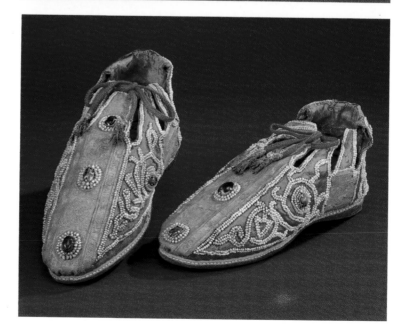

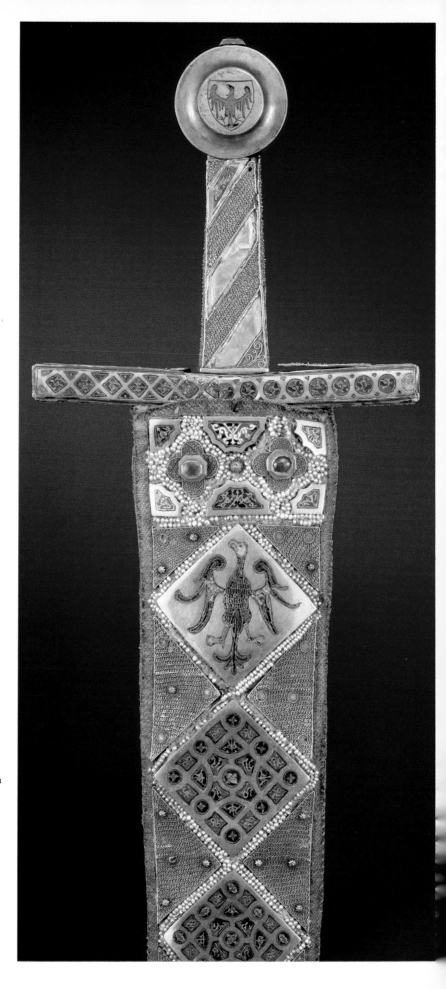

CEREMONIAL SWORD

Sicily, before 1220

The blade is made of steel; the hilt and cross-bar of wood with gold plaques faced with filigree and cloisonné enamel. The pommel, an addition dating from the time of Karl IV, is made of silver-gilt with the Imperial coat of arms, showing the Eagle, and the Bohemian coat of arms showing the Lion. *L* 108 cm

The wooden sheath is lined with parchment covered with linen; it has gold panels with enamel and gold filigree and is studded with precious stones and pearls.

From a set made before 1220 for the Emperor Friedrich II. This sword was later used when the Nürnberg envoy was knighted after the coronation. (XIII/16)

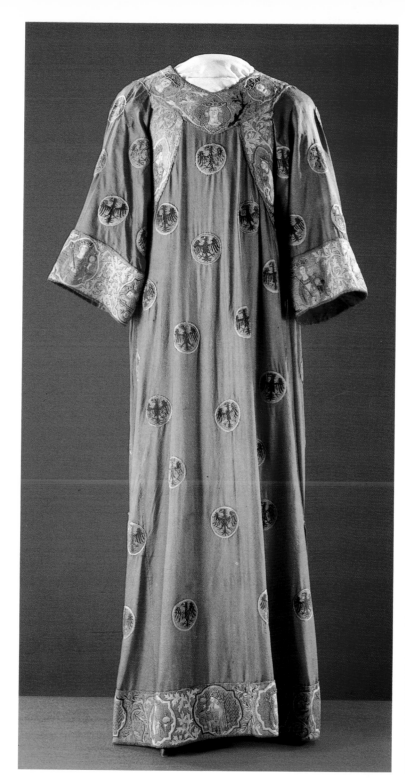

THE EAGLE DALMATIC
South German, first half of 14th century
Chinese purple damask, *c* 1300; gold and silk
embroidery
This dalmatic occasionally replaced the smaller
Tunicella. (XIII/15)

CASE FOR THE IMPERIAL CROWN
Prague, after 1350
Leather with rich partly-coloured tooling; iron
mounts; *H* 23 cm
Presumably made to the orders of the Emperor
Karl IV, as indicated by the coats of arms with
the Imperial Eagle and the Bohemian Lion.
(XIII/30)

The Austrian Empire

When Napoleon declared himself Emperor of the French, and in view of the increasingly obvious signs of the breaking up of the Holy Roman Empire as a consequence of Buonaparte's victory, Emperor Franz II proclaimed the hereditary Empire of Austria on 11 August 1804. This new Empire included all the territorial possessions of the Hapsburgs at the time, namely the hereditary Austrian territories plus the kingdoms of Hungary and Bohemia. After Napoleon's downfall, when a new European order was being determined at the Congress of Vienna, the Italian provinces which fell to Austria were united to form the Lombardo-Venetian kingdom, which was integrated into the new Imperial State. It was only at the time of the Austro-Hungarian agreement of 1867 that there ensued a division of the territories of the Hungarian St Stephen's Crown, the symbol of the State, from those of the Empire. This was when the Imperial and Royal double monarchy of Austro-Hungary emerged under the personal union of the Hapsburgs, the two halves united in the person of one sovereign.

The crown of Emperor Rudolf II, the so-called Imperial Dynastic Crown, became the official insignia of the new Imperial State in 1804 and remained after the introduction of the double monarchy as the insignia of the Austrian half of the Empire. St Stephen's Crown, which had been kept in Budapest, meanwhile became the official insignia of the kingdom of Hungary. The new Imperial State also took over the Hapsburg Orders of Merit, some of which had been found by the Empress Maria Theresa. They remained in existence until the end of the monarchy in 1918.

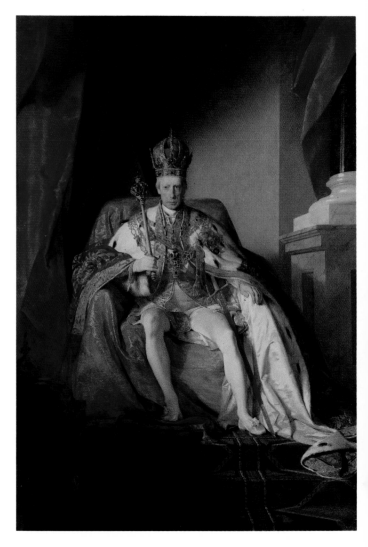

EMPEROR FRANZ I OF AUSTRIA IN THE AUSTRIAN
IMPERIAL ROBES
Friedrich von Amerling, Vienna, 1832
Oil on canvas, 260 × 164 cm
Franz I is depicted in the robes of the Austrian Emperor. He wears the crown of Rudolf II of the House of Austria, which in 1804 became the official crown (insignia) of the Austrian Empire, as well as the ribbons of the four orders of the House of Austria: the Golden Fleece, the Order of St Stephen, the Leopold Order, and the Order of the Iron Crown, whose Grandmaster was the Emperor.
(GG 8618)

MANTLE OF THE AUSTRIAN IMPERIAL ROBES
Vienna, 1830; after a design by the Director of Scenery and Costumes of the Imperial Theatres, Philipp von Stubenrauch
Red velvet, gold embroidery, and ermine
(XIV/117)

THE CORONATION ROBES OF THE LOMBARDO-VENETIAN KINGDOM
Vienna, 1838; after a design by Philipp von Stubenrauch
Blue velvet, gold embroidery, ermine, white moiré silk, and lace; silver gilt
The robes were made for the coronation of Ferdinand I as King of Lombardo-Venetia, held in Milan in 1838. (XIV/118–120)

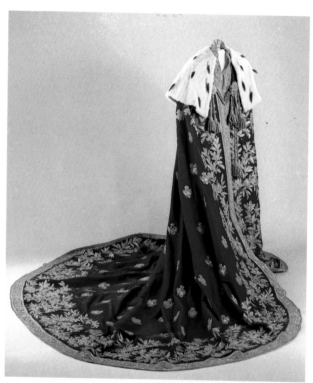

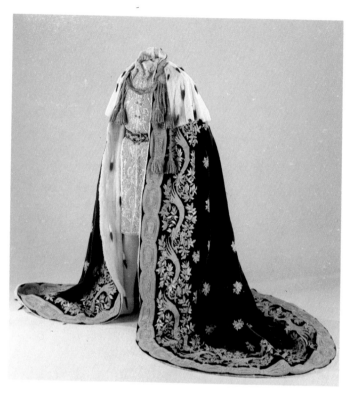

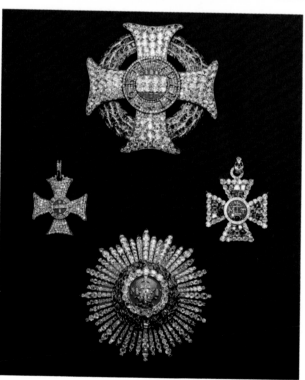

GRAND CROSS AND CROSS OF THE MILITARY ORDER OF MARIA THERESA AND THE STAR AND CROSS OF THE ORDER OF ST STEPHEN
Gold, silver, enamel, diamonds, emeralds, and rubies
To celebrate the Austrian victory over the Prussians near Kolin on 18 June 1757, the Empress Maria Theresa founded a military order of merit, which bore her name. On the occasion of the election of her son Joseph II as King of Rome in 1764 she founded the Order of St Stephen, which was the highest civil order of merit in the monarchy. (XIa 16, 17, 20 and 21)

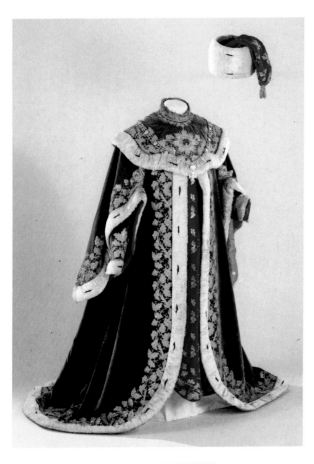

ROBES OF A KNIGHT OF THE HUNGARIAN ORDER
OF ST STEPHEN
Vienna, _c_ 1764
Green and red velvet and imitation ermine,
with gold embroidery (III/StO-217)

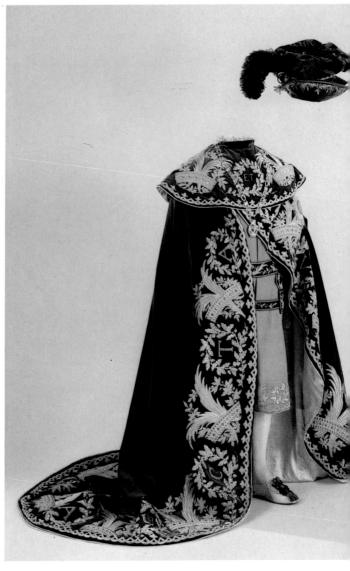

ROBES OF A KNIGHT OF THE AUSTRIAN ORDER OF
THE IRON CROWN
**Vienna, 1815; after a design by Philipp von
Stubenrauch**
Violet and orange velvet with silver
embroidery and white silk
The order was created by Napoleon and re-
founded by Austria on the occasion of the
establishment of the Lombardo-Venetian
kingdom in 1815. The emblem of the order is
the Iron Crown of Lombardy. (EK-2)

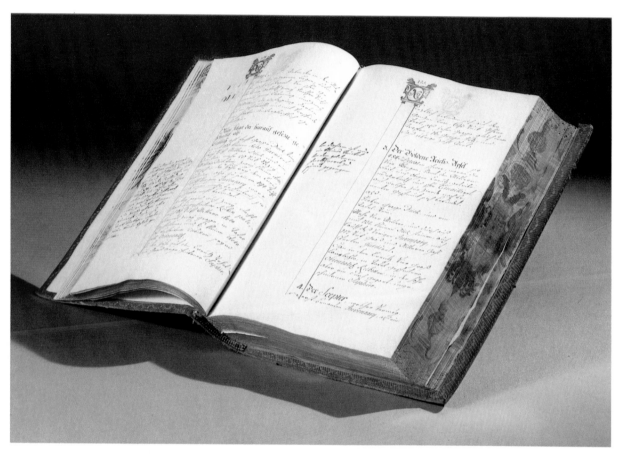

The dynastic treasure of Hapsburg-Lorraine is the family treasure of the House of Austria and hence constitutes the real nucleus of the secular Treasury. It was part of the entail of primogeniture of the Imperial Art Collections, which started with Ferdinand I. To the Hapsburg-Lorraine treasure belong the Imperial crown insignia which were formerly private and which became the official Austrian insignia in 1804, also a large holding of jewels, as well as the agate bowl and the so-called *Ainkhürn* (unicorn), the two inalienable heirlooms of the House, and also the baptismal objects and Christening robes and numerous keepsakes recalling individual members of the Archduchy. The latter include particularly those pieces connected with Napoleon I, Emperor of the French, and his second consort Louise, Archduchess and Imperial Princess of Austria and her son Napoleon Franz Karl, King of Rome and later Duke of Reichsstadt. Finally, they include those objects which stem from the possessions of the luckless Emperor Maximilian of Mexico, the younger brother of Emperor Franz Josef. This treasure was originally considerably bigger, because after 1871 all the art collections were joined together and exhibited in the Art Historical Museum, and only those objects which could provide a record of the power and greatness of the Imperial House by reason of their symbolic, historical, or material value were left in the Treasury.

THE TREASURY INVENTORY OF 1750
The inventory was established by the Empress Maria Theresa after the reorganization of the collections.

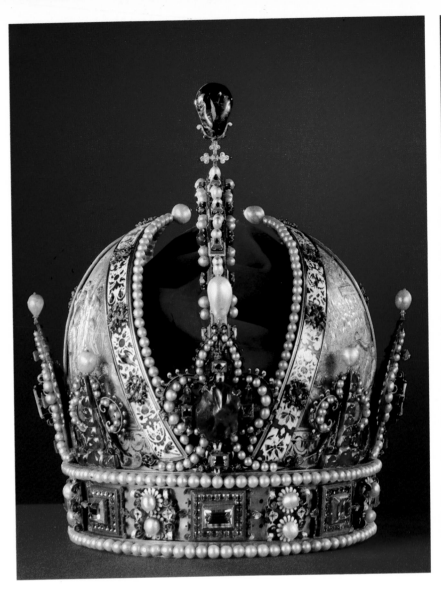

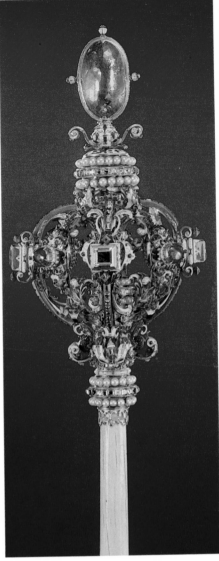

△

CROWN OF THE EMPEROR RUDOLF II

Prague, Imperial Court Workshop, 1602

Gold, enamel, table-cut diamonds, rubies, a single sapphire, and pearls; *H* 28.6 cm
This crown, one of the major works of the European goldsmith's art, was originally the private crown of the Emperor of the House of Hapsburg and became part of the official insignia of the Austrian Hereditary Empire in 1804. In it were combined the lily-circlet of the Medieval Royal crown with the arch of the Imperial crown and the bishop's mitre, the badge of sacred dignity. The Emperor was the only layman who had been granted the right to wear the mitre. (XIa 1)

AUSTRIAN SCEPTRE

Andreas Osenbruck; Prague, 1612–15

'Unicorn's horn' (in fact narwhal horn); gold, enamel, table-cut diamonds, rubies, a single sapphire, and pearls; *L* 75.5 cm
This sceptre, ordered by the Emperor Matthias replaced—together with the orb—the older Rudolfian insignia. These became part of the Bohemian Royal insignia, and the former Bohemian sceptre and orb became the Austrian Archducal insignia. (XIa 2)

▷

CROWN OF STEPHAN BOCSKAY AND CASE

Turkish, beginning of 17th century, cloth Persian, *c* 1600

Gold with niello, rubies, emeralds, turquoises, and pearls; *H* 23.5 cm
The crown had been sent to the Transylvanian usurper Stephan Bocskay by Sultan Ahmed I in 1605 as a token of Turkish recognition. However, the former had to hand it over to Archduke Matthias as a token of submission as early as 1606. (XIV/25 and 184)

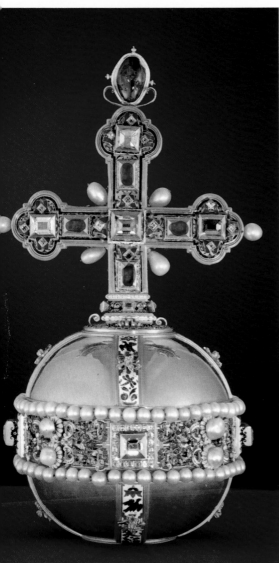

◁

AUSTRIAN ORB

Prague, Imperial Court workshop, after 1612(?)

Gold, enamel, table-cut diamonds, rubies, a single sapphire, and pearls; *H* 27.4 cm
The orb seems to have been made at a time between the crown and the sceptre. It has as yet not been possible to interpret the symbolic significance of the three strikingly large sapphires surmounting each of the three insignia. (xia 3)

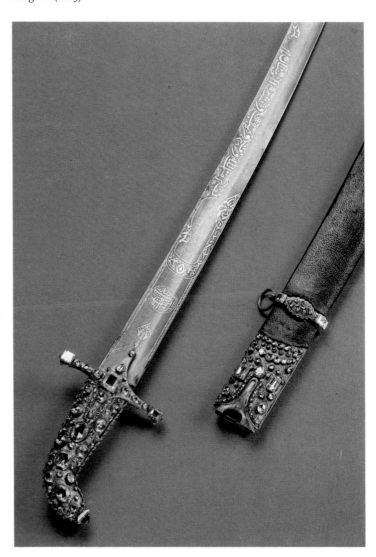

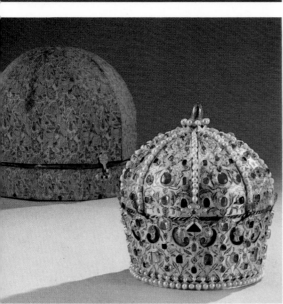

△

SABRE

Turkish, second half of 17th century, Austrian additions *c* 1712

Damascened steel; gold, silver, table and lozenge-cut diamonds; leather; *L* 91.5 cm
The inscription on the blade reads (in translation), IN THE NAME OF GOD, THE GENTLE ALL-MERCIFUL—HELP FROM GOD, VICTORY AND GLAD TIDINGS TO THE FAITHFUL. The silver ornaments and diamond decoration were added on the occasion of the coronation of the Emperor Karl VI as King of Hungary in 1712. (xia/50)

JEWEL CASKET OF EMPRESS MARIE LOUISE
Martin Guillaume Biennais, Paris, *c* **1810**
Silver-gilt, green velvet; 45.7 × 32.2 × 29.5 cm
According to tradition, Napoleon's wedding
present was handed to the Empress in this
case. The small table is after a design by the
Viennese architect Theophil Hansen between
1856 and 1880. (XIV/153)

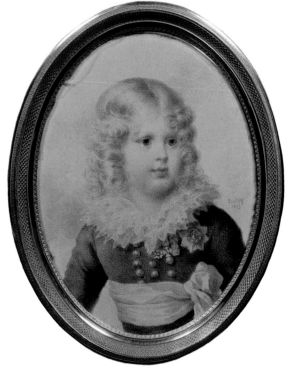

NAPOLEON FRANZ KARL, KING OF ROME, LATER
DUKE OF REICHSTADT
Jean-Baptiste Isabey, 1815
Watercolour; 15 × 11 cm
The picture was probably painted during
Isabey's stay in Vienna during the Congress of
Vienna. (XIV/150)

TRIPOD WITH BASIN

Luigi and Francesco Manfredini, Milan, 1811
Silver-gilt; lapis lazuli mounted on a brass core;
H 81.5 cm
This tripod, a copy of an antique bronze tripod
in the Museo Nazionale in Naples, was a
present from the city of Milan to the Empress
Marie Louise on the birth of her son. (xiv/152)

CRADLE OF THE KING OF ROME

**Jean-Baptiste Claude Odiot and Pierre
Philippe Thomire, Paris, 1811, after designs
by Pierre Paul Prud'hon**
Silver-gilt; mother-of-pearl, velvet, silk, and
tulle
The cradle was a present from the city of Paris
to Napoleon and his second wife, the Empress
Marie Louise, on the occasion of the birth of
their son Napoleon Franz Karl. (xiv/28)

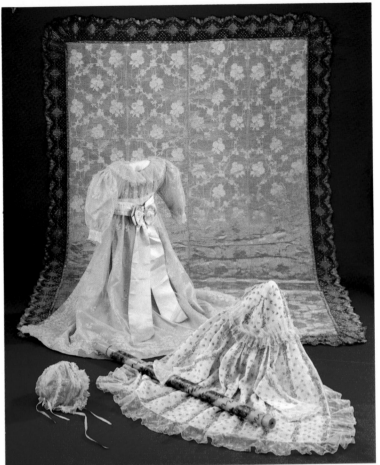

▷ VARIOUS CHRISTENING ROBES

Vienna, 1762 and 1830 respectively
Silver moiré with gold lace; cambric with gold embroidery; pink silk, tulle, and lace
The little pink Christening robe was worn by the babe who was later to become the Emperor Franz Josef (*b* 1830), and by his siblings. (XIV/10, 11 and A 208)

▽ SMALL EWER

Prague, Imperial Court Workshop, beginning of 17th century
Gold, partly enamelled, and rubies; *H* 15.5 cm
This smaller ewer was used for Christenings instead of the ewer from the Baptismal set, which was too heavy. (XIV/7)

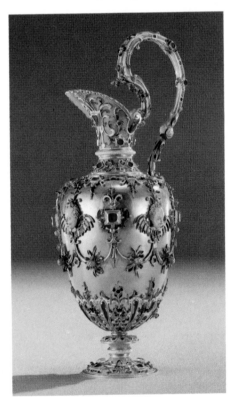

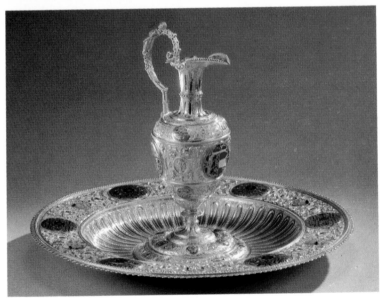

BAPTISMAL EWER AND BASIN

North Italian(?), 1571
Gold, partly decorated in enamel. *H* of ewer 34.5 cm; *Diam* of basin 61.5 cm
This set was a wedding present from the Carinthian *Stände* (the different Estates) to the Archduke Karl of Inner Austria and his wife the Duchess Maria of Bavaria. It was used for Christening ceremonies at Court as early as the seventeenth century. (XIV/5 and 6)

AQUAMARINE
Setting *c* 1600
Oriental aquamarine of 492 carats; gold
The aquamarine is mentioned 1607–11 in the
Kunstkammer of Emperor Rudolf II. (PI 1911)

VESSEL CUT FROM A SINGLE EMERALD
Dionysio Miseroni, Prague, 1641
Columbian emerald of 2680 carats from the
mines at Muzo; enamelled gold
This is the largest cut emerald in the world.
(PI 2048)

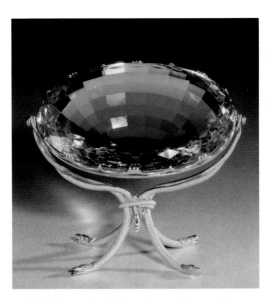

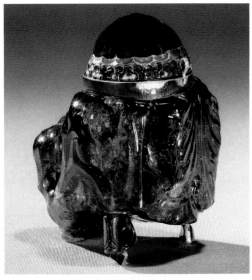

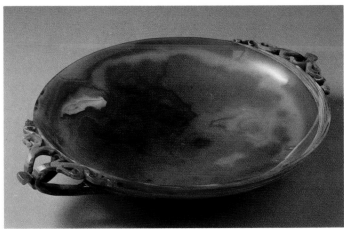

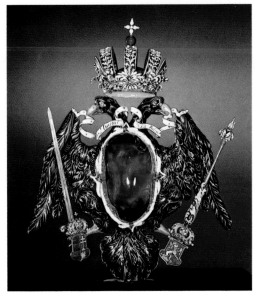

AGATE BOWL
Flabius Aristo, Trier, 4th century A.D.
Agate; *W* 75 cm
This bowl, the largest of its kind, was believed
to be the Holy Grail. Because of a faulty
transcription, it was thought that the name of
Christ could be read in it. It was therefore held
to be so precious that in the Inheritance
Agreement of 1564 the bowl, together with
the *Ainkhürn* was declared 'the inalienable
heirloom of the House of Austria'. (XIV/1)

HYACINTH (JACINTH) 'LA BELLA'
1687, set in an Imperial Double Eagle
Hyacinth (jacinth) of 416 carats; gold; silver-
gilt, and enamel (XIa/51)

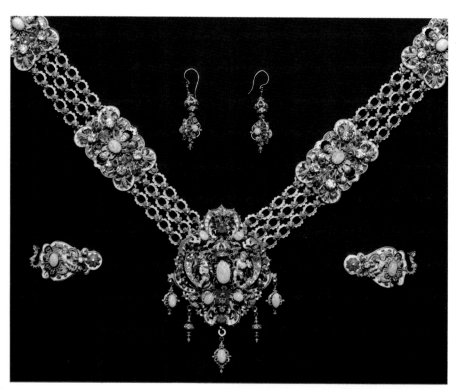

△
HUNGARIAN OPAL JEWELLERY
Egger Bros, Budapest, 1881
Gold, enamel; Hungarian opals, rubies, and
diamonds
Present from the City of Budapest to Princess
Stephanie of Belgium on her marriage to
Crown Prince Rudolf in 1881. (x1b/41)

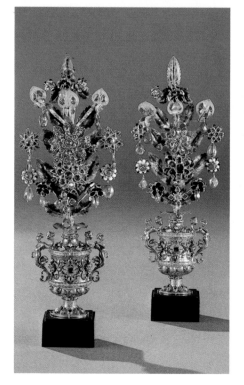

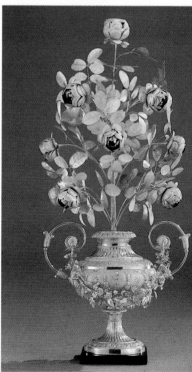

▷
TWO FLOWER VASES
Augsburg, end of 17th century
Silver-gilt, enamel, and precious stones;
H 24.3 and 25.1 cm respectively (P1 1080
and 1081)

FOUR PIECES OF JEWELLERY BELONGING TO THE
EMPRESS ELISABETH
Vienna(?), before 1896
Gold, silver, diamonds, and pearls
The pieces were the personal jewellery worn
by the Empress, who was murdered in Geneva
in 1896. (xiv/193, 194, 195, 196)

With the marriage of the Duchess Maria of Burgundy to
Archduke Maximilian of Austria in 1477, the House of Haps-
burg acquired one of the richest complexes of states in Europe.
Maria's father, Charles the Bold, the last Duke of Burgundy
from the House of Valois, had been killed in the Battle of Nancy
in 1477. The lands ruled by him were partly under the French
Crown and partly belonged to the Holy Roman Empire. France
immediately collected her fiefs, but the Imperial fiefs reverted
to the Empire, passing by way of inheritance to the House of
Hapsburg. This enormous increase in power—after all the
Netherlands, which were economically and culturally compar-
able, were part of this inheritance—ensured the further politi-
cal rise of the dynasty, which was to be followed in the next
generation by the hereditary acquisitions of Spain and subse-
quently of Hungary and Bohemia. In addition to the great
territorial increase, Maximilian and his son Philip I (the
Handsome) inherited a rich estate of jewels and works of art,
although they were mere remnants of the fabulous Burgundian
treasure, which for the most part had fallen into the hands of
the victorious Swiss on the death of Charles the Bold. Although
Maximilian had to pawn numerous objects from his holding to
alleviate his chronic lack of money, the remains of the collection
still preserved in the Treasury today give a good idea of the
former untold riches of the Dukes of Burgundy.

The Hapsburgs also inherited the Order of the Golden Fleece
at this time. It had been founded by Philip the Good of
Burgundy in 1430 on the occasion of his marriage to Isabella of
Portugal, his third wife. He had a political as well as an ethical
aim. Through the conferring of orders, the powerful elements
in the country, who constituted centrifugal forces which were
becoming increasingly dangerous, were bound more closely to
the person of the State Prince. Moreover, the knights of the
order were to defend the Christian faith, for the Turks at this
time were already beginning to threaten the Christian West,
which was the reason for Philip the Good's serious interest in
Crusades. This is clearly conveyed in the emblem of the order,
the Golden Fleece, which was adopted both from the ancient
legend of Jason and the Old Testament story of the prophet
Gideon.

The Master of the Order was the Duke, and with the
accession of Burgundy to Hapsburg, the reigning head of the
House of Austria. The number of knights was at first restricted
to 31 but was raised to 51 by the Emperor Karl v with the
consent of the Pope in 1516, and later to 60 and 70. This
demonstrates the steady growth of the Hapsburg Empire.

GOLDEN ROSE
Giuseppe Spagna, Rome, 1819
Gold; *H* 60 cm
Pope Pius vi sent this rose, consecrated by
him on the Sunday before Lent, to the
Empress Carolina Augusta in 1819. (xiv/19)

EMPEROR MAXIMILIAN I (1459–1519)
Bernhard Strigel, *c* 1500
Oil on panel; 60.5 × 41 cm (GG 922)

MARIA OF BURGUNDY (1458–82)
Nicolas Reiser(?), Schwaz, *c* 1500
Oil on panel; 79 × 46 cm
Maria, the daughter of Duke Charles the Bold
of Burgundy, was the first wife of the Emperor
Maximilian I. As heiress of Burgundy, she
brought the House of Austria the
Netherlandish provinces. (GG 4402)

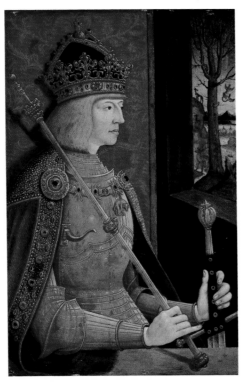

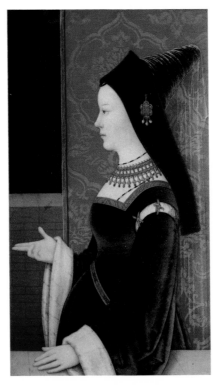

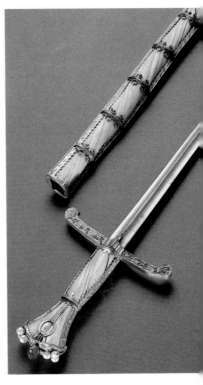

RING
Burgundian(?), second half of 15th century
Gold, set with diamonds
The diamonds form the letter 'M'.
Traditionally thought to be the engagement
ring of the Duchess Maria of Burgundy.
(P1 131)

BROOCH
Netherlands, *c* 1450
Gold, partly enamelled, precious stones, and
pearls; *Diam* approx 5 cm
The brooch depicts a betrothed couple or pair
of lovers in a garden. (P1 130)

◁

THE *AINKHÜRN* SWORD
Burgundian, second half of 15th century
Steel blade; Narwhal tusk; gold, enamel, silver
gilt, a single ruby, and pearls; 106 cm
The sword was a possession of Charles the
Bold of Burgundy and came as part of his
daughter Maria's inheritance to the Emperor
Maximilian I. (XIV/3)

GNADENSTUHL (THRONE OF GRACE)
Burgundian-Netherlandish, 1453–67
Ivory; 14.6 × 11.1 cm
According to the emblems, the relief was a
possession of Duke Philip the Good of
Burgundy. (PI 10078)

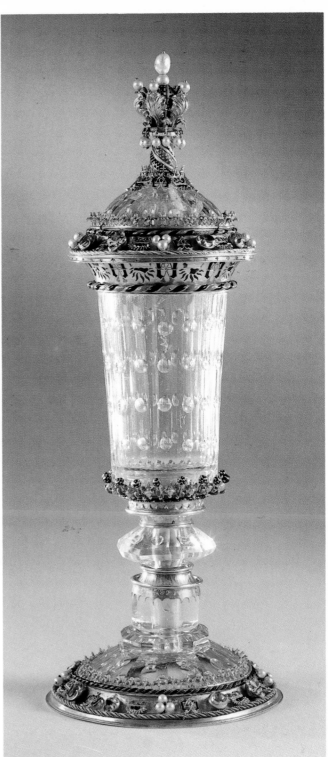

COURT GOBLET OF DUKE PHILIP THE GOOD OF
BURGUNDY
Burgundian, *c* 1453–67
Rock-crystal; gold, partly enamelled;
diamonds, rubies, and pearls; *H* 46 cm
The 'Court goblet' is one of the most precious
remaining pieces of the treasure of the Dukes
of Burgundy. (PI 27)

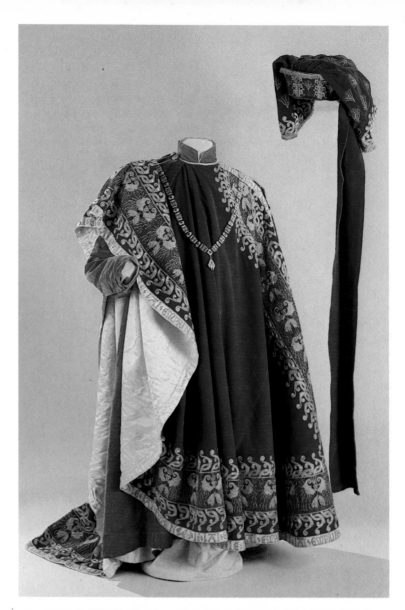

ROBES OF A KNIGHT OF THE ORDER OF THE
GOLDEN FLEECE
Vienna, second half of 18th century
Red velvet, white satin, gold embroidery
(III/TO-41)

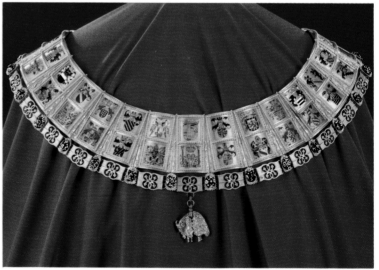

POTENCE (ARMORIAL CHAIN) OF THE HERALD OF
THE ORDER OF THE GOLDEN FLEECE
Netherlands, after 1517
Gold, partly enamelled; *Circ* outside 143 cm,
inside 98.8 cm
The potence consists of a collar of 26 plaques;
into each of these are inserted two tiny shields
with the coat of arms of a Knight of the Order.
From the shields hangs a chain consisting of
links in the form of firestones and flints, from
which hangs a pendant Golden Fleece as the
emblem of the Order. (Dep Prot 4)

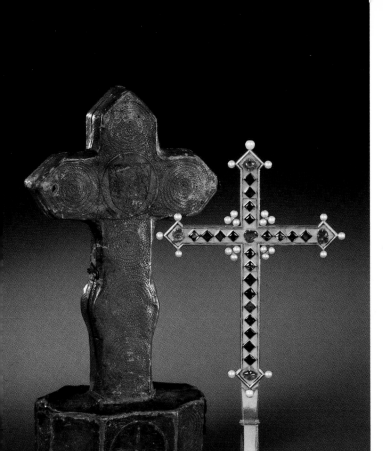

◁

THE SWEARING-IN CROSS OF THE ORDER OF THE
GOLDEN FLEECE AND ITS CASE
**French, *c* 1400; the base of a later date
(between 1453 and 1467)**
Gold, rubies, sapphires, and pearls; *H* 36 cm
The cross originally belonged to Duke Jean of
Berry, and Philip the Good of Burgundy later
had the base altered. Newly appointed
Knights of the Order or its officials take the
oath before this cross even today.
(Dept Prot 1)

**The Regalia of the Order of the Golden
Fleece**
(see also p. 36)

ANTEPENDIUM
**Burgundian-Netherlandish, second quarter of
15th century**
Coloured silk embroidery over gold and silver
thread; velvet, silk; pearls and pastes
330 × 120 cm (PI 18)

The ecclesiastical Treasury

◁

PLUVIAL (Cope of Christ)
Burgundian-Netherlandish, second quarter of 15th century
Coloured silk embroidery over gold and silver threads; velvet, silk, and pearls; 164 × 330 cm
(P1 19)

◁

PLUVIAL (Cope of Mary; detail)
Burgundian-Netherlandish, second quarter of 15th century
Coloured silk embroidery over gold and silver thread; velvet, silk, and pearls; 164 × 330 cm
The master who designed the pluvials is as yet unidentified. Stylistically he is close to Rogier van der Weyden. (P1 21)

◁ ◁

CLASP FOR PLUVIAL
Burgundian-Netherlandish, *c* 1500 with later additions
Silver, parcel-gilt and enamelled; *H* 19 cm
The coat of arms is that of Philip the Handsome, son of Emperor Maximilian I and Maria of Burgundy. (Dep Prot 31)

The religious Treasury contains mainly liturgical accessories: paraments and relics which were in use in the various Court churches and chapels in Vienna, Schönbrunn, Laxenburg, and Baden and to some extent still are. The main holdings to be mentioned here are those of the Hofburg chapel in Vienna; this is because Emperor Joseph II, on his accession to power in 1780, had placed the religious Treasury under the administration of the Court Chaplain, and had thus created a climate for the merging of holdings of the most varied provenance. As the Hofburg Chaplain had episcopal rank and as the most important Church ceremonies took place in the Hofburg chapel, the decoration of this church was extremely rich. Its stock of paraments, stemming mainly from the Baroque period, merits special attention.

Apart from these, it is the numerous relics in their extremely sumptuous cases that attract the attention of the visitor. They derive mainly from the early seventeenth century, the time of the Counter Reformation. These reliquaries were for the most part made in the Imperial Court Workshop founded by Emperor Rudolf II or in south German workshops. They are a testimony to the great piety of the Hapsburgs and also to the ostentatious splendour expressed in their religious monuments; but they testify also to the Wittelsbachs, who were related to the Hapsburgs by marriage, and who were bearers and champions of Catholicism within the Holy Roman Empire, which was gaining strength. Parts of this stock of relics, which had originally served the private worship of its owners, had later found their way into the treasure of the *Kapuzinerkirche* (Capuchin church) in Vienna, which had been the burial church of the Hapsburgs since 1619. They were transferred back into the care of the ecclesiastical Treasury.

Here we are dealing largely with objects which served at one and the same time both as vehicles of worship and as a pledge of a better after-life. The keys to the Hapsburg coffins, kept safe in the ecclesiastical Treasury, also represent a link with the other world, since they are a symbol of the end of earthly existence and the beginning of the hoped for eternal life. Thus the ecclesiastical Treasury is an outstanding monument to the deep religious feeling of the Austrian nation.

▷

THREE CHASUBLES
Austrian, 17th–18th century
Brocade or gold embroidery on silk (A 610, 115
and 22)

CHASUBLE WITH CHRIST ON THE TREE CROSS
Bohemian or Austrian, _c_ 1500
Relief embroidery on red velvet, with later
additions. (A 11)

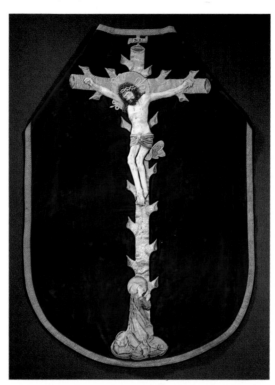

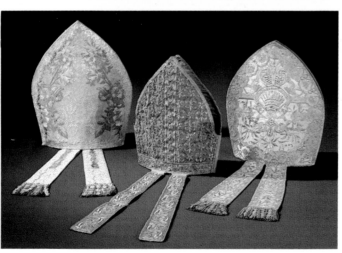

△

THREE MITRES
German and Austrian, 16th–18th century
Silk brocade with silk; gold and silver
embroidery
As the Court chaplain was always of Bishop's
rank, he had the right to wear a mitre. (A 28,
Kap 4 and A2)

CRUCIFIXION GROUP

South German, early 17th century; figure of Christ after Giambologna

Bronze, light brown patina;
Crucifix *H* 101.5 cm (E 34)

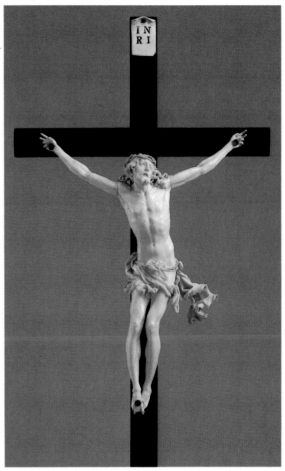

CRUCIFIX

Austrian, *c* 1710–20
Ivory on black polished wood; almandine;
H overall 87.5 cm (46)

◁

MEISSEN ALTAR SET

Johann Joachim Kaendler, *c* 1737–41
Porcelain
This set was a present from Augustus III of Saxony to his mother-in-law, the Dowager Empress Amalia. (P1 7078–7111)

TWO CHALICES

Right: **South German, 1438**
Silver, parcel-gilt, *H* 19 cm
On the base are the letters AEIOV (the mark
identifying it as belonging to the Emperor
Friedrich III) and the year 1438.
Left: **South-east German, *c* 1500**
Silver, parcel-gilt; *H* 23.3 cm (B1 and B10)

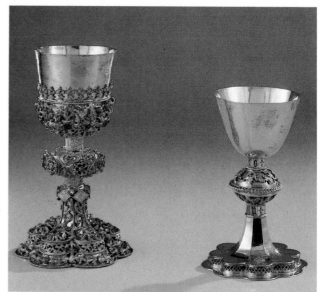

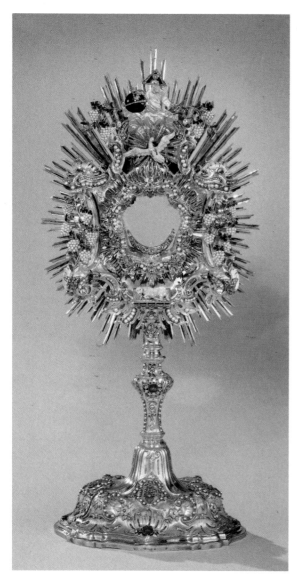

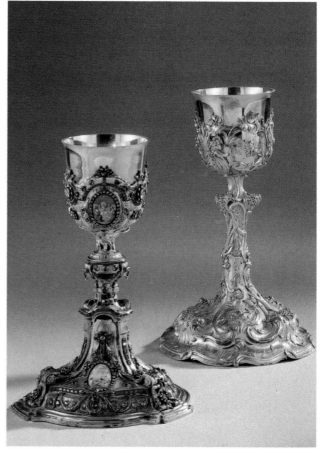

MONSTRANCE
Vienna, 1760
Silver-gilt, and enamel; diamonds, emeralds,
sapphires, jacinths, and pearls; *H* 71.5 cm
(B 30)

TWO CHALICES
Right: **J. Hueber, Vienna, 1767**
Silver-gilt; *H* 30 cm
Left: **Josef Moser, Vienna, 1775**
Silver-gilt and enamel; diamonds, rubies,
emeralds, amethysts, and garnets; *H* 27.2 cm
(B4 and B8)

PENDANT OF CHARLEMAGNE

German, 14th century(?), possibly a re-fashioned Carolingian reliquary

Gold on a wooden core, semi-precious stones, and a single onyx cameo dating from the 1st–2nd century; *H* 14.5 cm

The relic is said to have been worn as a talisman by Charlemagne. (D 128)

RELIQUARY MONSTRANCE

Venetian, 14th century with 16th century German additions

Silver and silver gilt; precious and semi-precious stones, rock-crystal, corals, and pearls; miniatures on vellum; *H* 68.5 cm
(Kap 56)

MARSUPIUM (POUCH) OF KING STEPHAN OF HUNGARY

Slavonic, 12th–13th century

Silk with silk and gold embroidery; partly painted; silver-gilt; garnets and pearls; *H* 18 cm

Tradition has it that this was a small pouch used by King Stephan as a portable reliquary. (Kap 186)

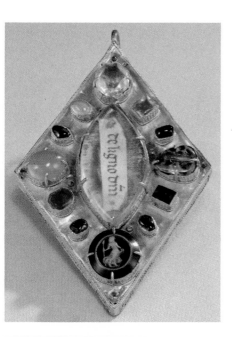

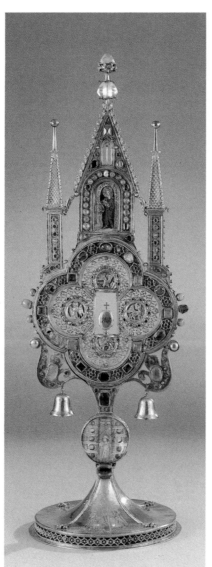

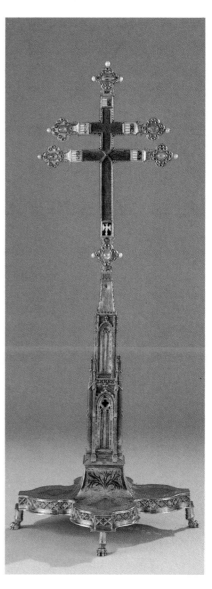

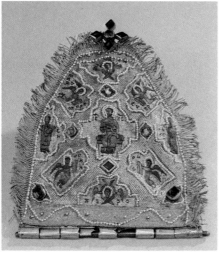

RELIQUARY CROSS OF KING LUDWIG THE GREAT OF HUNGARY

Hungarian(?) between 1370 and 1382

Gold, silver-gilt, and enamel; rubies, sapphires, emeralds, pearls, and glass; *H* overall 67.2 cm (D 251, 252)

TWO RELIQUARIES WITH THE WAX BUSTS OF
ST VALERIANUS AND ST TIBURTIUS
**After designs by Hans Krumper, Munich,
beginning of 17th century**
Ebony; wax; cloth; gold enamel, gilt bronze;
H 36 m (D 70 and 71)

OSTENSORY CONTAINING VARIOUS RELICS
OF CHRIST
South German, beginning of 17th century
Ebony; gold and enamel; rock-crystal,
diamonds, rubies, and pearls; H 48.5 cm
(D 23)

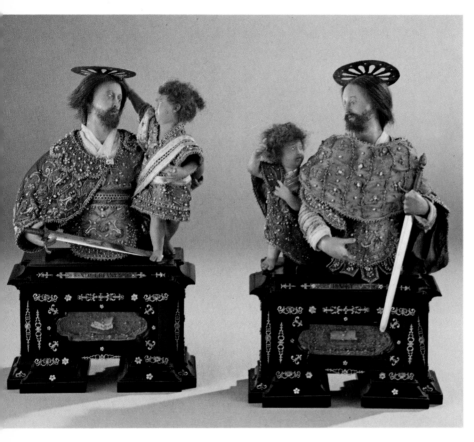

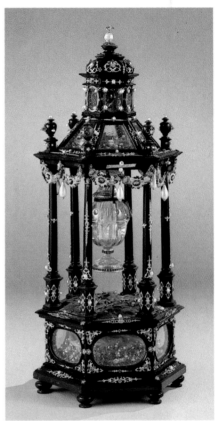

PRAYER-BOOK OF EMPEROR FERDINAND II
South German, 1590
Gold covers, enamelled; 6 × 4.8 cm;
pages vellum, gilt-edged; 5.6 × 4.4 cm
Ferdinand was given this prayerbook by his
parents in 1590 on leaving for Ingolstadt
University. (D 27)

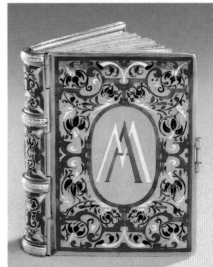

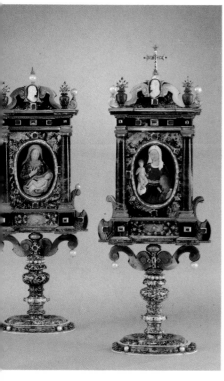

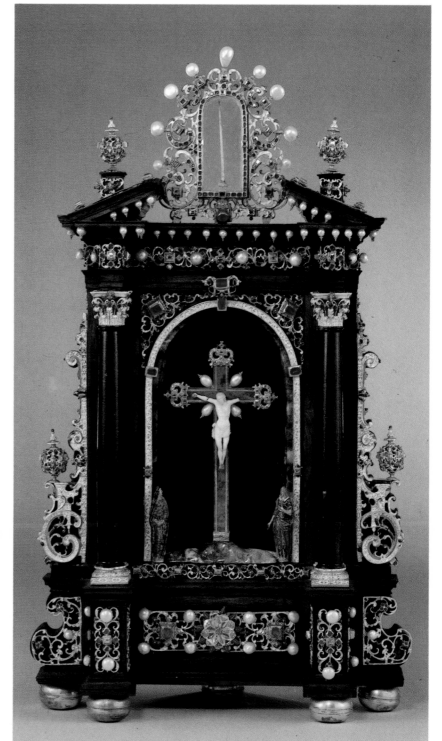

TWO SMALL HOUSE ALTARS
Ottavio Miseroni, who worked at the Imperial Court Workshop in Prague after 1588
Jasper, agate, lapis lazuli, diamonds, rubies, and pearls; gold, enamel, silver-gilt; *H* 30.5 and 33 cm
One of the *commessi* in the medallions depicts Mary with the Child, the other St Anne. (Kap 219 and 220)

SMALL HOUSE ALTAR WITH CRUCIFIXION GROUP
Prague, Imperial Court Workshop, early 17th century
Ebony; jasper, jasper agate, agate, gold, enamel, table-cut diamond, rubies, and pearls; *H* 44.2 cm
In the pediment is a thorn from the Crown of Christ. These small house altars with relics, which are precious both artistically and in their materials, are characteristic of the Prague Court Workshops, founded before the reign of the Emperor Rudolf II. (Kap 221)

OSTENSORY CONTAINING A THORN FROM THE
CROWN OF CHRIST AND RELICS OF VARIOUS SAINTS
South German, Augsburg(?), 1592
Ebony; rock-crystal; gold and enamel;
diamonds, rubies, emeralds, and pearls;
H 50.4 cm
The ostensory is surmounted by an allegorical
figure of Faith. It is decorated with what is
presumed to be an unknown lady's jewellery.
(D 21)

OSTENSORY CONTAINING RELICS OF VARIOUS
SAINTS
Matthäus Wallbaum, Augsburg, 1588
Ebony, silver, parcel-gilt; H 49.8 cm (D 89)

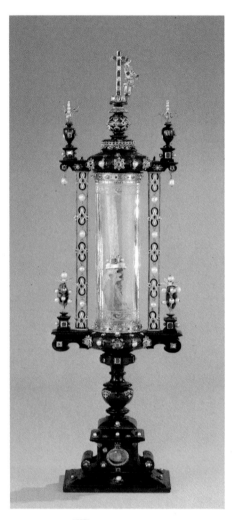

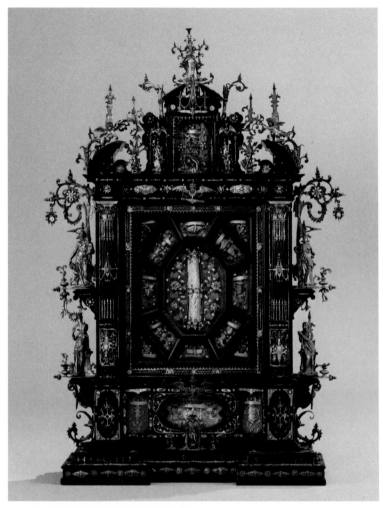

▷
TWO SMALL HOUSE ALTARS AND AN OSTENSORY
**Matthäus Wallbaum and workshop,
Augsburg, 1588**
Ebony; silver, parcel-gilt; miniatures;
H 40.7, 36.4 and 46.8 cm (D 179, 173, 90)

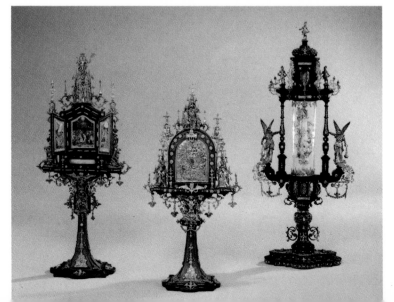

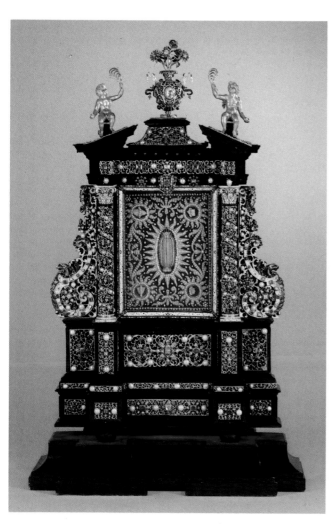

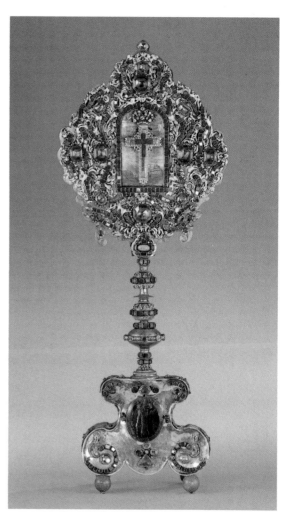

SMALL HOUSE ALTAR WITH A THORN FROM THE
CROWN OF CHRIST
South German, mid 17th century
Ebony; gold, enamel, silver, parcel-gilt and
enamel; gilt-bronze; chrysolite, almandine,
rock crystal, garnets, and pearls; *H* 70 cm
(D 59)

RELIQUARY CONTAINING A FRAGMENT OF THE
HOLY CROSS
Vienna(?), 1668
Gold, silver-gilt and enamel; diamonds,
chrysoprases, garnets, amethysts, agate,
carnelians, and rock-crystal; *H* 53.5 cm
This particle of the Cross, which belonged to
the Dowager Empress Eleonora Gonzaga,
miraculously survived the Hofburg (Imperial
Palace) fire in 1669. This prompted the
foundation of the 'Sternkreuz Orden' (Order
of the Starry Cross), the highest Ladies' order
of the House of Austria. (D 25)

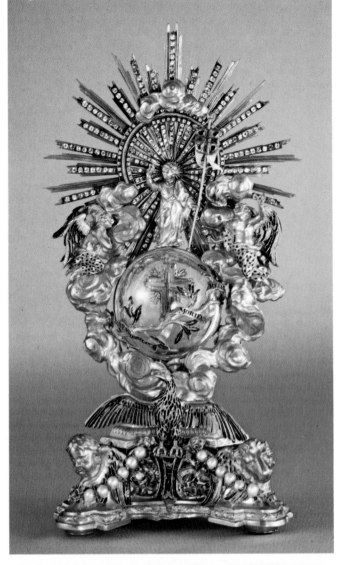

PACIFICALE (RELIQUARY)
Johann Baptist Känischbauer von Hohenried, Vienna, 1726
Gold and enamel, silver; diamonds, rubies, rock-crystal, pearls, and glass; *H* 25.3 cm
It is possible that the design of this *pacificale*, glorifying the Cross, is based on a drawing by Johann Bernhard Fischer von Erlach.

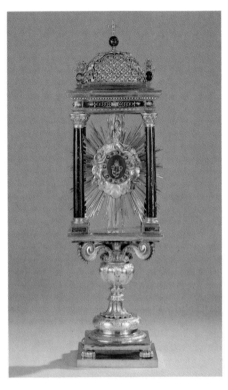

△
OSTENSORY CONTAINING A TOOTH OF ST PETER
Rome, probably 1853
Parcel-gilt silver; bronze; lapis lazuli, diamonds, rubies, emeralds, sapphires, topazes, aquamarines, amethysts, and jacinths; *H* 78.5 cm
The ostensory was a present from Pope Pius IX to the Emperor Franz Josef I on his lucky escape from an attempt on his life. (D 45)

▷
OSTENSORY WITH A NAIL FROM THE CROSS OF CHRIST
Vienna(?), mid 17th century
Gold and enamel; silver-gilt; emeralds, sapphires, topazes, amethysts, aquamarine, jacinth, turquoises, and garnets; *H* 79.6 cm
(D 62)

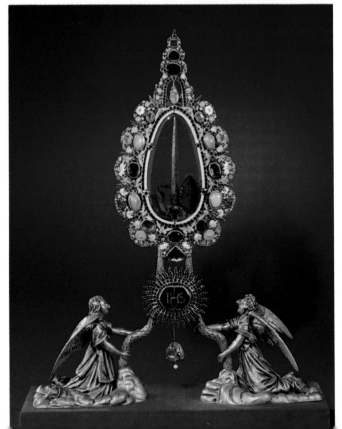

SUDARIUM OF ST VERONICA
Italian, *c* 1617 and Austrian, *c* 1800
Linen; ebony; parcel-gilt silver; gilt copper;
mother-of-pearl; onyx cameos; ivory;
58.5 × 48.4 cm
The Sudarium came from Rome. The Princess
Savelli presented it to Karl VI in 1720. Since
there are several relics of this kind, their
existence is thought to be attributable to the
folding, and consequent falling apart, of the
cloth into several parts. (D 108)

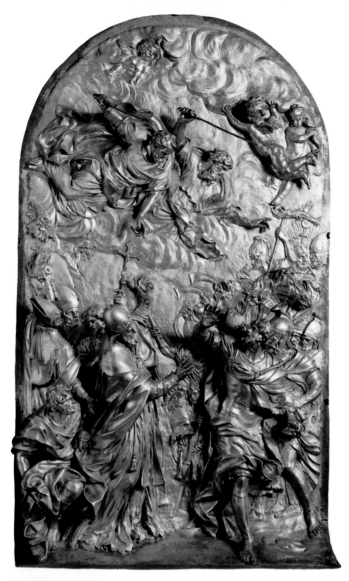

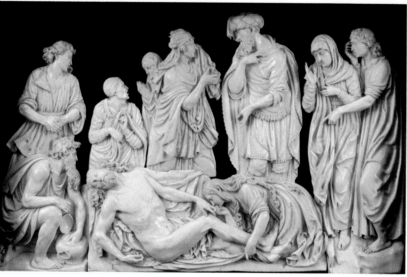

△
MEETING BETWEEN POPE LEO THE GREAT AND
ATTILA, KING OF THE HUNS
Alessandro Algardi, Rome, *c* 1650
Gilt-bronze; *H* 98 cm
Cast of the model made for the massive marble
relief in St Peter's, Rome. (D 164)

THE LAMENTATION OF CHRIST
**Leonhard Kern, Schwäbisch Hall, first half of
17th century**
Ivory relief in a contemporary brown wooden
casket under glass. 24.5 × 40.2 cm (D 198)

CABINET HOLDING THE KEYS TO THE COFFINS OF
THE HAPSBURGS
**Alexander Albert, Court cabinet maker,
Vienna, 1895**
The drawers in the middle section are reserved
for the keys to the coffins of the Emperors and
their closest families, while the keys to the
coffins of all other Archdukes of the House of
Austria are kept in the side sections.
Altogether the keys to 139 coffins are kept in
the cabinet, the oldest of these dating back to
the seventeenth century. (XVI A 24)

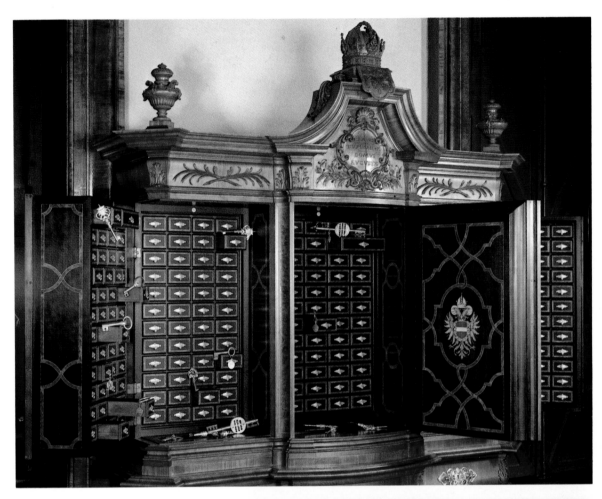

▷

ALLEGORY ON THE DEATH OF THE EMPEROR
FERDINAND (11 March 1657)
Daniel Neuberger, 1657
Wax; glittering coloured quartz sand; in an
ebony casket under glass; 36.5 × 46.5 cm
(Kap 244)

The Collection of sculpture and decorative arts
Rudolf Distelberger

Introduction

The title 'Collection of sculpture and decorative arts' has only existed since 1919, when it succeeded the even more unhappy 'Collection of industrial arts'. Both descriptions rely upon a narrow definition of the concept of 'decorative arts' (*Kunstgewerbe*), which originated in the nineteenth century and is still in use today. *Kunstgewerbe* here describes a genre of objects which were not fashioned for their own sake, but were aesthetically created as utility objects.

The name of the Collection is thus misleading, inasmuch as it does not contain a significant amount of the usual large sculpture, and as the modern definition of *Kunstgewerbe* does not adequately define those objects which have been preserved in it. The explanation of this confusion is to be found in the particular kind of objects which were collected in the sixteenth and seventeenth centuries, and the point of view from which these objects were expected to be seen. The Collection contains, with the exception of objects from the Middle Ages and a few isolated historical souvenir pieces, hardly any objects which entered the Museum because they had fallen out of use. In most cases, they had, in fact, been made specially for the Collection, that is to say for the various Hapsburg *Kunstkammer* (art rooms) which were its forerunners; or had alternatively been made for general acceptance in a princely art room. Whole artistic genres here included, such as small bronzes, statuettes, and turners' work in ivory, or gem-carving, owe their existence and flourishing development to the high standards demanded by the princes for their *Kunstkammer*.

In the sixteenth century, the *Kunstkammer*, whose collecting history goes back as far as the fourteenth century, had developed into an encyclopedic collection embracing specimens from the various fields of nature (*Naturalia*), of art and craft (*Artefacta*), and of science (*Scientifica*). The various fields might overlap in a single object, when, for example, a rare natural product was sumptuously mounted and artistically fashioned. However, the interest of a princely collector in a natural object was not determined by scientific criteria in the modern sense; on the contrary, such an object was acquired on account of its rarity value or its exceptional and exotic quality, or because magic powers of healing and miracle-working were ascribed to it. In the case of an artifact, artistic quality, the ingenuity or virtuosity of the work, its antiquity, its costliness, or even dynastic or historical factors were significant to its collectability.

The phenomenon of the *Kunstkammer* should be seen in the context of the élitist social position of a prince and his consequent claim to universal dominion over the whole of creation. His efforts culminated in the production of a microcosm which became a mirror or model of the universe and allowed him personally to appear in an ideologically heightened light. Like God above the universe, so stood the prince, who derived his claims to power from the grace of God, above his world, which he appropriated in the objects of the *Kunstkammer*. In accordance with his rank in society, he tried to assemble around him the noblest, rarest, or most remarkable products of nature and also the most admirable and precious creations of human artistic ability. In addition, the exotic objects illustrated the global scope of his will and influence. The pretensions of the Emperor rose even higher than those of other princes, which accounts for the extremely high quality of the items in the Vienna Collection. The Emperor Rudolf II even had the Augsburg clockmaker and contractor Georg Roll incarcerated because he believed that he had furnished him with a celestial globe inferior to that supplied to his brother, the Archduke Ernst.

The usability or usefulness of the objects was generally of no importance, except in the case of the *Scientifica*—watches, clock-work figurines, and instruments—in which the manifold workings and functions of their mechanisms were, of course, the real object of admiration. What emerged from the *Kunstkammer* were rather the first non-utilitarian works of art, that is to say those that were completely devoid of any non-aesthetic significance. Even objects which had the appearance of being able to fulfil a useful purpose were not utility objects. Christoph Jamnitzer's ewer and dish (p 108) might be quoted as examples, for they are absolutely unusable, and the lid of the ewer cannot be opened. We are presented here with merely the representation of a ewer and dish, not by means of brush or pen but in gilded silver. Similarly, the vessels made of precious stones, ostrich eggs, exotic nuts, rhinoceros horn, or the delicate ivory goblets turned on the lathe, are mere representations of vessels for the *Kunstkammer*, which, apart from their rare natural materials, were particularly valued for the masterly conquest of the technical difficulties in the working of the particular substance. The famous *saliera* (salt-cellar) of Cellini is primarily a work of art, then a splendid table decoration, and only finally a usable salt-cellar. The utilitarian purpose is secondary to the artistic one, and only determines the form as a representational theme. The so-called *Kunstkammer* pieces thus do not fall under the modern headings of 'decorative' or 'applied' arts but are non-utilitarian display objects of the highest artistic and material standard. They form an artistic genre which embraces all decorative art techniques, and whose themes are drawn both from figure motives and also frequently from the world of objects actually used by a prince. Questions as to their function are pointless if they are directed to their practical application and not to their significance in the prince's conception of the world and of himself.

The Collection of sculpture and decorative arts contains a combination of treasures from several Hapsburg *Kunstkammer*. Among these collections two are worthy of special mention, since the nucleus of the present Collection is derived from

them. The first is the *Kunstkammer* and Treasury of Archduke Ferdinand II (1529–95), which is also known by the title of the Ambras Collection, since it was first exhibited in Ambras Castle near Innsbruck. It also supplied the majority of the pieces still preserved from the older collections of Emperor Friedrich III (1415–93), Maximilian I (1459–1519), and Ferdinand I (1503–64). Secondly, the *Kunstkammer* of Emperor Rudolf II (1552–1612), which had been compiled in Prague and to which had been transferred Rudolf's share of the inheritance from the collection of his father, Maximilian II (1527–76), is significant. Although many of Rudolf's treasures were permanently lost to the hereditary collection after the plundering of the Prague Castle by General Königsmark in the last days of the Thirty Years' War, he was nevertheless enriched by those objects which Emperor Matthias and Ferdinand II had previously brought to Vienna. They included the most outstanding works of goldsmiths' and gem-carvers' art of the time around 1600, as well as some masterly bronzes.

In the seventeenth century objects were added from the art collections of Archduke Leopold Wilhelm (1614–62), the younger son of Emperor Ferdinand II, who was the Governor of the Netherlands. Although he is doubtless mainly renowned as one of the fathers of the Paintings Gallery, he had also bought, along with the great painting collections from Italy, excellent Renaissance bronzes and also collected small sculpture in stone and wood.

The Vienna Treasury was in fact originally the oldest Hapsburg *Kunstkammer*. Apart from the transfer of the treasures from Prague, it was continuously enriched during the reigns of the Emperors Ferdinand II (1619–1637), Ferdinand III (1637–57), and Leopold I (1658–1705). The popularity of ivory statuettes and reliefs in the seventeenth century pushed the small bronzes into the background. Alongside works in semi-precious stones which continued to be very popular at the Viennese Court, turned pieces in ivory, carvings in rhinoceros horn, and miniature wax models were coming into fashion.

In the eighteenth century there was no longer any *Kunstkammer* collecting activity worth mentioning. The name 'treasury' remained, and it was re-organized under Maria Theresa. The remains of the *Graz Kunstkammer*, founded by Archduke Karl II (1540–90) on the nucleus of his father Maximilian II's estate, was incorporated into it.

The main addition in the nineteenth century was the transfer of the Ambras Collection to Vienna in 1806. It was established in 1814 in the former Garden Palace of Prince Eugene of Savoy, the Lower Belvedere. The combination of these objects with the pieces of the Vienna Treasury only took place in 1890/1 in the course of the re-organization of all the Hapsburg artistic possessions when they were removed to the newly erected Art Historical Museum. Between 1870 and 1880 a series of objects had already been transferred from the Collection of antiquities and from the Emperor's Castle of Laxenburg.

The twentieth century has recently but unexpectedly considerably enlarged the Collection. The first addition was the so-called 'Este Collection', which had been in the possession of the Obizzi family. The family's main collector was the Marquis Tomaso degli Obizzi, who died in 1805, although the Collection's origins go back to the seventeenth century. By way of inheritance it had found its way into the hands of the Austrian line of Este, and the successor to the throne, Archduke Franz Ferdinand, whose assassination was the catalyst of the First World War, had it brought to Vienna. At first it was displayed as a unit on its own and only in 1935 was it divided up among the collections of the Art Historical Museum. It contains among other works Italian sculpture of the Middle Ages and the Renaissance as well as bronzes and plaques.

The Museum's tapestry collection came originally from the Imperial Estate, and in 1921 was placed under the administration of the Collection. Owing to the fact that the tapestries were and are hung for only short periods of time, they have retained their splendid colours, and it is probably true to say that they constitute the best preserved collection of this kind in the world.

The twentieth century has also seen a number of valuable bequests. Gustav von Benda left his precious collection to the Museum in 1932. It contains many and varied important pieces, but what was of greatest value for the Collection of sculpture and decorative arts were the works of the early Florentine Renaissance. Clarisse de Rothschild dedicated a set of clocks and scientific instruments to the Collection in 1949 in memory of Dr Alphonse de Rothschild. Smaller additions resulted from exchanges with other public museums in Vienna, but at the same time they occasioned considerable losses. There were a few successful isolated purchases of significance.

The wide ramifications of the genealogy of the Collection of sculpture and decorative arts can also be seen in the indications of provenance in the inscriptions of the exhibits, where the inventories in which the pieces were first mentioned are often

quoted. The objects are not always identifiable in the oldest possible inventory, with the result that only a general indication of origin is possible, as for example 'from the Treasury' or 'from the Ambras Collection'. A part of this time-consuming task of establishing the sequence of the inventories in respect of all the pieces has not yet been completed. The inventories of the Vienna Treasury have been lost and may well have been destroyed at the time of its re-arrangement in 1750. Since nearly all the important inventories are published and since constant reference is made to them, it is appropriate to quote them here with their place of origin, in chronological order:

Inventory of the estate of Archduke Ferdinand of Tirol in Ruhelust, Innsbruck, and Ambras, dating from 30 May 1596 (abbreviated to: Inventory of the Ambras Collection of 1596); in *Year book of the art history collections of A. H. Kaiserhaus* (the Supreme Imperial House), Vol VII/2, 1888, PP CCXXVI-CCCXII and Vol X, 1889, pp I-X (Library).

The *Kunstkammer* inventory of Emperor Rudolf II, 1607–11; in *Year book of the art history collections in Vienna*, Vol 72, 1976.

Inventory of Emperor Matthias's estate (after 5 May 1619); in *Year book of the art history collections of the A. H. Kaiserhaus*, Vol XX/2, 1899, PP XLIX-CXXII (also contains Emperor Rudolf II's art possessions, which do not appear in the inventory of 1607–11).

Inventory of Archduke Leopold Wilhelm's art collections; dating from 14 July 1659; in *Yearbook of the art history collections of the A. H. Kaiserhaus*, Vol I/2, 1883, pp LXXIX-CLXXVII.

Inventory of the Imperial secular Treasury in Vienna, 1750; in *Yearbook of the art history collections of the A. H. Kaiserhaus*, Vol X/2, 1889, pp CCLII-CCCXXIV.

Ernst Ritter von Birk, inventory of all the Dutch tapestries and Gobelins to be found in the possession of the A. H. Kaiserhaus; in *Yearbook of the art history collections of the A. H. Kaiserhaus*, Vol I/1, 1883, pp 213–248, Vol II/1, 1884, pp 167–216.

The Este Art Collection, as relevant to the Collection of sculpture and decorative arts is published: Leo Planiscig, *The Este Art Collection*, Vol I, *Skulpturen und Plastiken des Mittelalters und der Renaissance* (Medieval and Renaissance Sculpture) Vienna, 1919.

The Middle Ages

The art of the Middle Ages served almost exclusively religious and sacred purposes. The more extensively religious demands determined life and thought, the more strictly and solemnly were they set to work in art. The connection with antiquity was preserved for understandable reasons, for indeed both Emperor and Church in Byzantium felt themselves to be the direct successors of the old Empire with Constantinople, the 'new Rome' as its centre, while in ancient Rome the Church re-interpreted the old idea of Rome's supremacy in a Christian context and never gave up its claim to leadership. The old Imperial notions were revived in the secular power of Charlemagne. The great importance of the rôle played by ancient tradition can be seen in three ivory reliefs from the ninth and tenth centuries from both West and East (p 53). The role played in worship by the aquamanile, of which the Museum possesses one of the finest known specimens, is expressed in the symbolic figure of the griffin. It is a symbol of Christ, who purifies the soul just as the vessel purifies the hands with water. A masterpiece of late Romanesque goldsmiths' art is the Wilten chalice (p 55), whose iconographic sequence traces the history of human salvation from the Creation to the Redemption. The Bishop of Pecs presented it to the Council of Trent in 1562 as a proof that in former times Communion was administered to the faithful in two forms.

Worldly ends were served by the remarkable *Püsterich* (fire-blower) (p 54). The object was filled with water and placed in the embers of a fire, whereupon it emitted steam from small holes in the nose and mouth and thus fanned the flames. Among the most important Medieval objects in the Vienna Collection is the large group of masterpieces of gem-carving. The great rock-crystal ewer (p 56), for example, with its many facets and double handle has no match anywhere in the world. The provenance and dating of these marvellous pieces, as well as their original use, have not yet been clarified, but they could be connected with the revival of the ancient art of gem-carving at the time of the conquest of Constantinople in 1204, when not only ancient cameos but probably also lapidaries had been brought to the west. The slightly smaller, extremely finely-cut ewer (p 56) with its elegantly curved outline, in the clearest crystal, can only be a product of French Court art of the fourteenth century. The accentuation of the Imperial idea and the deliberate propagandist identification of himself with Augustus by the Hohenstaufen Friederich II (reigned 1212–50) accounts for the imitation of Antiquity in gem-carving at his Court in Southern Italy, several outstanding examples of which are in the collection (p 57). No princely collection could now be without the precious stones that were worked into vessels or gems.

Around 1400 the soft, curvilinear forms of the International Gothic style were widespread throughout Europe. One of the most significant creations of German sculpture at this time is the courtly, refined 'Krumau Madonna' (p 59), whose soft, flowing cascades of folds form under her knees into a supporting triangle. This style is also exemplified in the Venetian bust (p 59) with its portrait-like features, and the greater part of the Vienna pattern book (*Musterbuch*) (p 60). The two Ambras sets of playing cards (pp 60, 61), however—the Court hunt set with wonderful natural scenes—already belong to the middle of the last phase of the late Gothic period, which leads up to works such as the Thalheim Madonna (p 63) and the standing Madonna of Tilman Riemenschneider (p 64), which represent an ideal type of middle-class woman.

The high secular Court culture and art of the late Middle Ages are represented, along with the Ambras playing cards, by the richly ornamented Venetian games board and the French ivory casket of the fourteenth century (both p 58). Jewel-boxes from the Embriachi workshop (p 58), several of which are in the Collection, and the artistically carved Troubadour's box in wood with the *Wildleute* (personifications of natural forces) (p 63) are also representative. The Adder's Tongue Credence (p 61), which probably came from the Emperor Maximilian I bequest, is an extremely rare piece, as only two other such pieces have been preserved. Early display pieces, which might have been in the possession of Emperor Friederich III, are the Burgundian State goblet (p 61) and a goblet with cover in rock crystal (p 62), both of which bear Friederich's mark, as well as the double goblets of rock crystal or veined wood (pp 62, 64), which may rank as early *Kunstkammer* pieces.

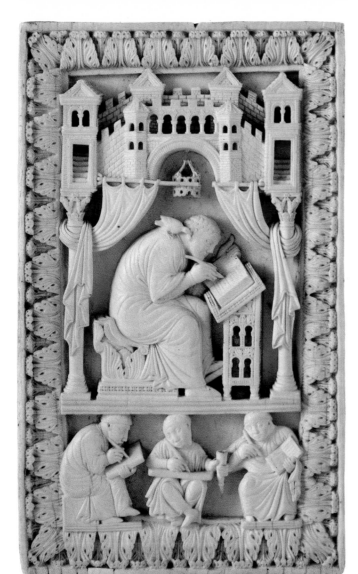

ST GREGORY WITH THE SCRIBES
Carolingian, Franco-Saxon school, late 9th century
Ivory; 20.5 × 12.5 cm
Originally the centre section of the cover of a sacramentary. Acquired in 1928 from the Heiligenkreuz Monastery; 1647, in the collection of Archduke Leopold Wilhelm. (8399)

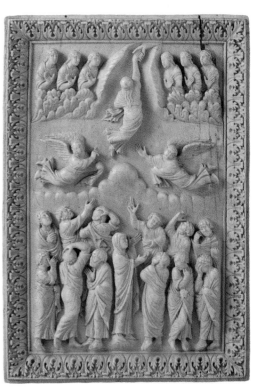

△
ASCENSION OF CHRIST
Metz, *c* 980
Ivory; 20.6 × 14.4 cm
Formerly the centre section of a book cover. Acquired in 1915 from a private owner. (7284)

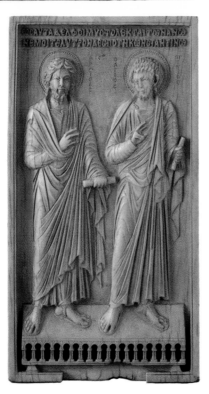

◁
SS PETER AND ANDREW
Constantinople, middle of 10th century (before 959)
Ivory; 24.6 × 13.5 cm
Greek inscription: 'Brothers in the flesh, prophets of the divine mystery, obtain for the ruler Constantine forgiveness of his sins.'
Reference to Constantine VII *Porphyrogenetos* (912–959)
From the Antiquities Room (in the collection of Gabriel Riccardi, Florence during the 18th century). (8136)

PÜSTERICH (FIRE-BLOWER, AEOLOPILE)
North Italian(?), 12th century
Bronze cast; *H* 23.5 cm
From the Antiquities Room. (5702)

AQUAMANILE (WATER JUG) IN THE FORM OF A
GRIFFIN
Lotharingian, 2nd half of 12th century
Gilt bronze, part-silvered, niello; *H* 17 cm
Served for liturgical hand-washing.
From the Antiquities Room. (83)

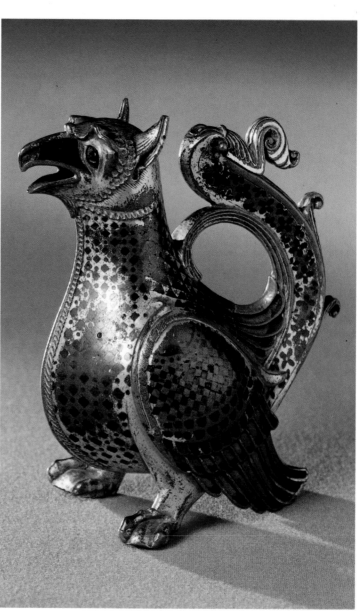

CAMEO: JOHN THE BAPTIST
Constantinople, 11th–12th century
Heliotrope; gold mounts; *Diam* 4.6 cm
Listed in the Treasury inventory of 1750.
(IXa 20)

▷
COMMUNION CHALICE FROM ST PETER'S ABBEY
SALZBURG
Salzburg, *c* 1160–80
Silver-gilt, the knop beryl, jewelled mount;
H 23 cm
On the base and bowl are twelve figures
of the Old Testament (identification still
incomplete).
Acquired 1952 from the collection of Oskar
Bondy, Vienna. (9983)

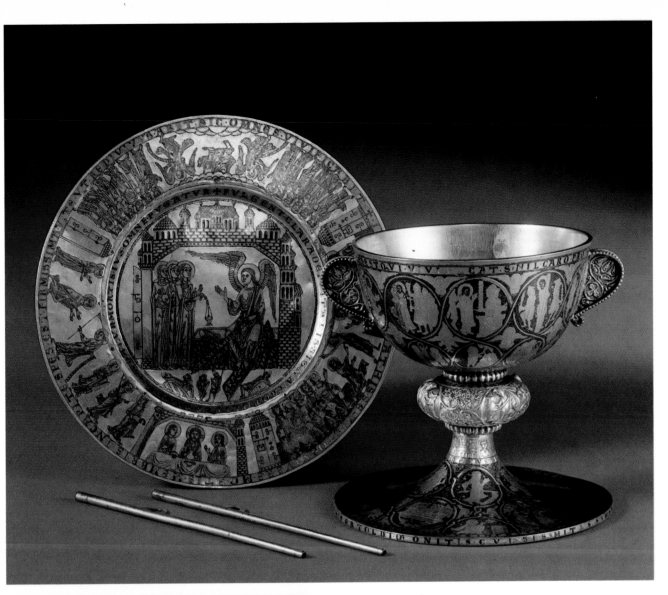

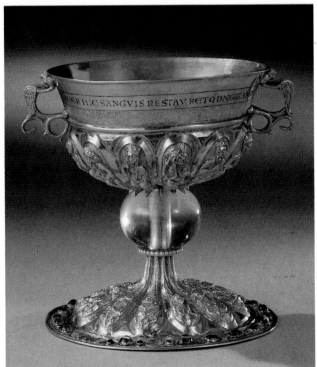

THE WILTEN CHALICE WITH PATEN AND *FISTULAE*
(Eucharistic reeds)
Lower Saxon, *c* 1180
Silver, parcel-gilt, niello; *H* 16.7 cm,
Diam of paten 23.5 cm, *fistulae L* 19.6 cm each
On the chalice and paten are pictures from the
Scriptures: on the base scenes from the Old
Testament, on the bowl from the New
Testament. The paten shows the Death and
Resurrection of Christ and the associated
events. Count Berthold III of Andechs
(1148–88), who is mentioned in the
inscription, was instrumental in bringing the
chalice to the Abbey of Wilten. Acquired in
1938 from Wilten Abbey, Innsbruck. (8924)

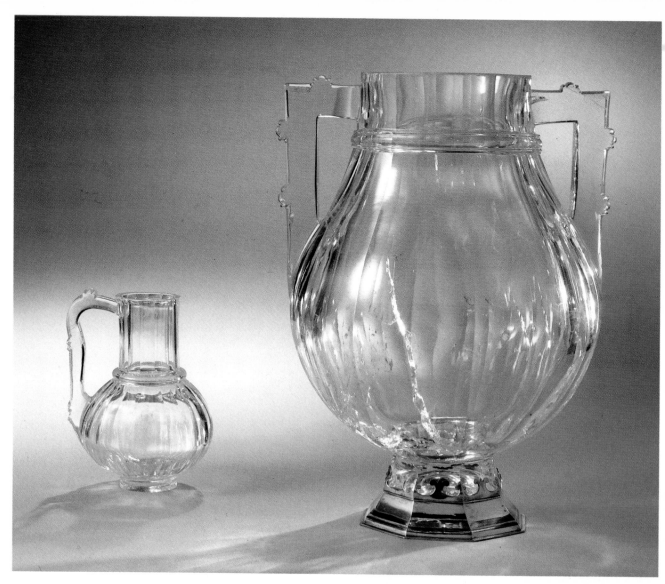

ROCK-CRYSTAL EWERS
**Origin uncertain (South Italy?, Venice?),
13th century**
H 41.3 cm and 19 cm
The two-handled bowl is the largest rock-
crystal vessel surviving from the Middle Ages.
Its former use is uncertain.
Listed in the Treasury inventory of 1750.
(2316, 1513)

▷
ROCK-CRYSTAL EWER
Paris(?), 14th century?
H 26.1 cm
From the Treasury. (2272)

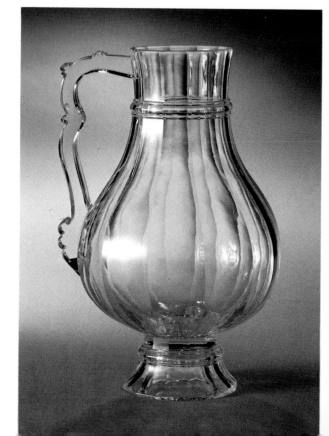

AGATE BOWL
Prague(?) 2nd half of 14th century
Mount silver gilt; *H* 18.6 cm, *Diam* 27.2 cm
Probably a product of the Prague Court
workshop of Emperor Karl IV. From the
Ambras Collection. (6699)

CAMEO: POSEIDON AS PATRON OF THE ISTHMIAN GAMES
Italian, Hohenstaufen, 1st half of 13th century
Onyx; gold mount early 19th-century; *H* 7 cm, *W* 8.8 cm
Listed in the Estate inventory of Emperor Matthias of 1619. (ixa62)

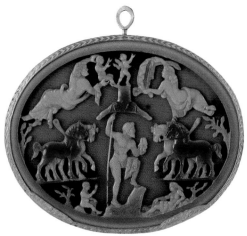

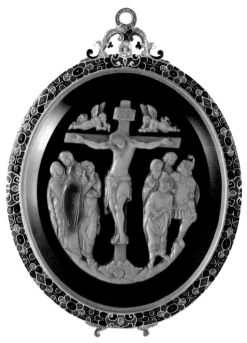

△

CAMEO: THE CRUCIFIXION OF CHRIST
Italian, 2nd half of 13th century
Onyx; mount French, 2nd half of 16th century; gold and enamel; *H* 9.2 cm, *W* 6.7 cm
Listed in the Treasury inventory of 1750. (ixa4)

◁

AMETHYST BOWL
Venice, late 14th/early 5th century
Mount silver-gilt; *H* 16.3 cm, *L* 23.8 cm
Listed in Treasury inventory of 1750. (86)

GAMES BOARD

Venice, early 14th century
Inlaid wood, miniatures, and painted clay
reliefs under rock-crystal, jasper, chalcedony,
bone; 38 × 38 cm
The pictures show motifs from chivalry
without thematic coherence. Listed in the
Ambras Collection inventory of 1596. (168)

OCTAGONAL JEWEL CASKET

**Workshop of Baldassare degli Embriachi,
Venice, late 14th/early 15th century**
Wood with *intarsia* (Italian marquetry), bone;
H 43 cm
Mythological scenes are depicted on the sides.
From the Este Collection. (8020)

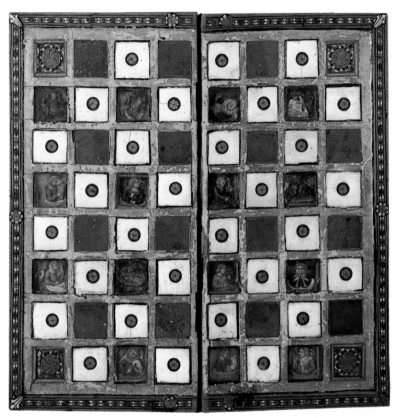

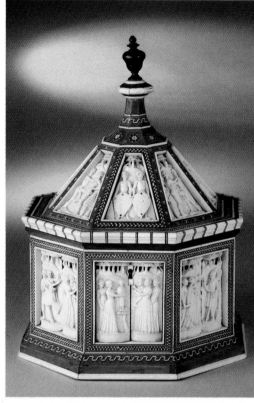

▷

CASKET

French, 2nd half of 14th century
Ivory; *L* 21 cm, *W* 10.2 cm, *H* 7 cm
Depicts scenes from the story of the Châtelaine
de Vergi, a popular troubadour song.
From the Ambras Collection. (115)

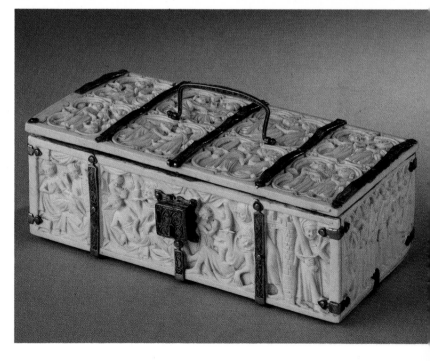

◁ KRUMAU MADONNA
Prague, c 1400
Sandstone; *H* 112 cm
Example of the so-called 'Fair Madonnas'; one
of the main works of the *Weich* style.
Taken over from the Austrian State Gallery
1922. (Dep Prot 1)

▽
BUST RELIQUARY (CASSIAN?)
Southern Tirol(?), late 14th century
Gilt copper; *H* 45 cm, *W* 38 cm
The relic was kept in the head under the mitre.
Comes from Dreikirchen, Southern Tirol;
acquired 1932 from the Auspitz Collection.
(8867)

▽ ▽
BUST OF A PROPHET
**Circle of Pier Paolo and Jacopo dalle
Masegne, Venice, c 1400**
Yellowish marble; *H* 41 cm
Along with six other busts, the prophet
formerly adorned the walls of the sarcophagus
on the tomb of Margherita Gonzaga in
Mantua.
From the Este Collection. (7432)

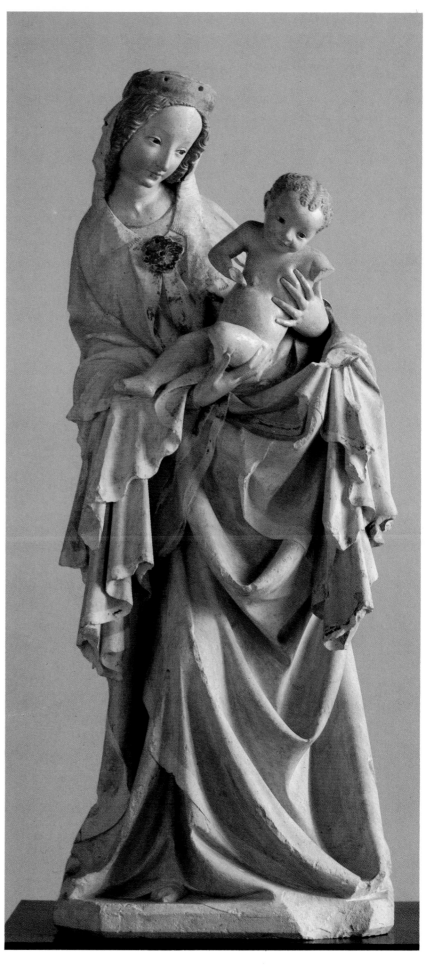

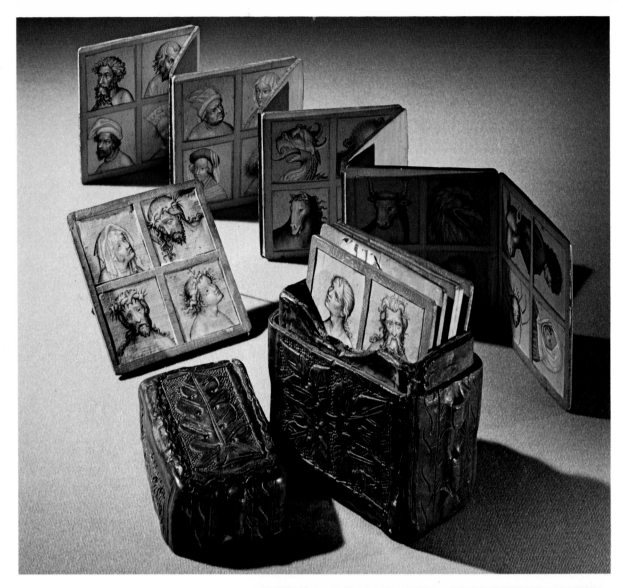

△

THE VIENNA 'MUSTERBUCH' (PATTERN BOOK)
Vienna or Prague, early 15th century
Fifty-six drawings tinted in white and red on
paper in groups of four on small maple panels;
each 9.5 × 9 cm; leather case.
A travelling painter's collection of motifs.
(5003, 5004)

▷

THE 'AMBRAS COURT HUNT PLAYING CARDS'
Upper Rhenish (Circle of Konrad Witz),
c 1440/50
54 playing cards (formerly 56); layers of
paper stuck together, line drawing,
watercolours; each approx 15.6 × 9.5 cm
The four suits are herons, hounds, falcons,
and falcon-lures.
Listed in the inventory of the Ambras
Collection of 1596. (5018–5071)

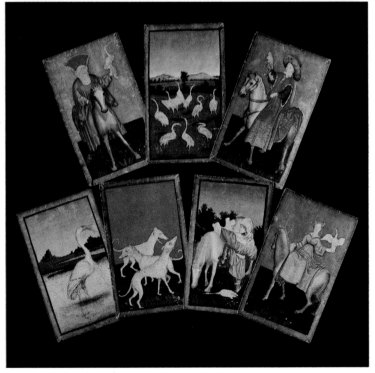

SO-CALLED 'ADDERS' TONGUES CREDENCE'

German, middle of 15th century

Silver-gilt; fossilized sharks' teeth, a single citrine; H 27 cm

The adders' tongues were supposed to give a warning of poisons in food and drink, and to neutralize poisons. From the Ambras Collection. (89)

STATE GOBLET OF EMPEROR FRIEDRICH III

Burgundian, third quarter of 15th century

Silver, parcel-gilt, enamel, rock-crystal; H 43 cm

Probably a present from Duke Charles the Bold of Burgundy to the Emperor. Listed in the inventory of the Ambras Collection of 1596. (65)

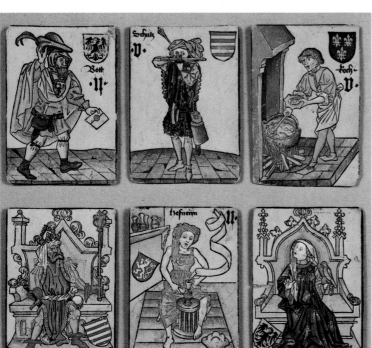

◁

THE 'HOFÄMTERSPIEL' (THE COURT PLAYING CARDS)

South German, upper Rhenish(?), c 1450

Forty-eight playing cards surviving; layers of paper, woodcut and line drawing, water-colours, gold and silver leaf; each approx 14 × 10 cm

Representations of occupations and classes with King and Queen at the top. The suits are the Imperial coats of arms, and those of Bohemia, Hungary, and France. Listed in the inventory of the Ambras Collection of 1596. (5077–5124)

TWO GOBLETS WITH COVERS
Venetian or Burgundian, *c* 1440/50
Silver, parcel-gilt, enamelled; *H* 29 and
28.5 cm
The knob on the cover of both has been
replaced.
From the Ambras Collections. (85, 88)

DOUBLE ROCK-CRYSTAL GOBLET
Mount Nürnberg, 2nd half of 15th century
Silver-gilt; *H* 24.5 cm
Taken over from Laxenburg in 1872. (82)

ROCK-CRYSTAL GOBLET AND COVER
**Base mount South German(?), 1449; mount of
cover and rim Graz(?), 1564**
Silver-gilt; *H* 25.7 cm
On the base is the personal mark of Emperor
Friedrich III, AEIOV, and date. Presented by
Archduke Karl II of Inner Austria to his Court
steward Caspar Freiherr zu Herberstein in
1564. (6896)

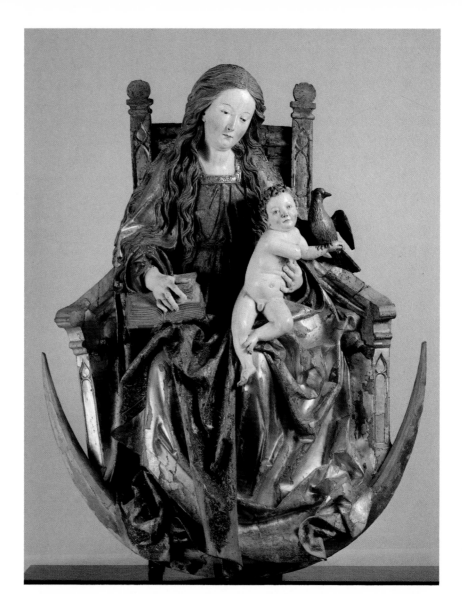

ENTHRONED MADONNA WITH CHILD ON THE
CRESCENT MOON
**Master of the Thalheim altar, Swabian
(Ulm?),** *c* **1510**
Polychromed wood; *H* 112 cm
Acquired in 1862 from the Gasser Collection.
(30)

TROUBADOUR'S BOX
Upper or Middle Rhenish, *c* **1460/70**
Boxwood; *L* 31 cm, *W* 16 cm, *H* 12 cm
On the lid and sides are scenes from the life of
the *Wildleute* (wild men), personifications of
natural forces.
From the Antiquities Room. (118)

TWO DOUBLE BOWLS
South German, late 15th century
Veined wood, the mount silver-gilt;
left H 18 cm, *right H* 15 cm
The very hard dense-veined wood is the result
of fusions of various deciduous trees and
rootstocks.
From the Ambras Collection and the Gustav
Benda bequest 1932. (73 and 9054)

THE VIRGIN MARY WITH CHILD
**Tilman Riemenschneider (b. Osterode in the
Harz c 1460, d. Würzburg 1531), Würzburg,
c 1505/10**
Polychromed wood; *H* 145 cm
Taken over from the Austrian Museum for
Applied Arts 1935 (previously came from the
Gasser Collection in 1869). (8899)

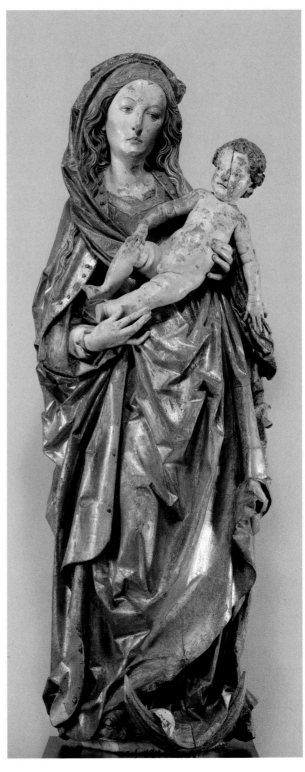

DRINKING HORN WITH GRIFFIN SUPPORT
Low German, 2nd half of 15th century
Horn; mount silver-gilt; base gilt bronze;
H 26 cm, *L* 24.5 cm
From Castle Laxenburg. (80)

Early and High Renaissance

As a result of the study of Antiquity and Nature, the Renaissance, with its newly acquired self-awareness, focused all its efforts and interest on Man as an individual. Thus a new demand emerged in the arts for the representation of individual facial features and the corporeality of the human physique.

The discovery of the uniqueness of the individual is expressed above all in the new genre of the portrait. The form of the bust of King Alfonso I of Aragon (p 67), with the head seeming to emerge from an empty suit of armour, was unusual for the middle of the fifteenth century and is derived from Roman Imperial likenesses. This form is also to be found on Pisanello's Alfonso medallions, by means of which the King's bust can be definitely identified. Whereas this unknown sculptor extols the princely man of power, Francesco Laurana in his portrait of a Princess of Aragon (p 70) concentrates on an almost abstract, firm, yet extremely sensitive line, in order to bring out the majestic aloofness of his tender model. Doubt has rightly been cast on the former identification of the subject as Isabella of Aragon, the great granddaughter of Alfonso I.

The 'Polyhymnia' by Tagliacarne (p 69) is, on the other hand, an idealized head, fashioned on antique lines with large surfaces, whose smooth face makes a happy contrast to the rough, unfinished, yet picturesque garland of flowers. The use of hard porphyry, the Imperial stone of Antiquity, is designed to present the great and revered past ages even more vividly. A new theme of the Renaissance which goes back to Hellenic times is that of the child, the *putto*. Desiderio da Settignano's 'Laughing Boy' and the *putto* with fig and grapes by an anonymous Florentine artist (both p 67), are truly pictures drawn from life.

Alongside the profane themes, which played an increasingly important rôle, religious assignments naturally continued to exist. Because of a new self-awareness, however, the Holy figures and Biblical scenes were brought out of their sacred remoteness and placed firmly on earth. Antonio Rossellino's 'Madonna' is a tender mother with her child (p 68); and in the Entombment of Christ (p 69), the people depicted appear to feel the real grief and deep mourning of close friends and relatives, even when they express these in antique gestures.

Another new creation of the Renaissance was the bronze statuette as an independent work of art, made for collectors and connoisseurs. Like gem-carving, this artistic genre grew out of the humanists' interest in antiquities. In this sphere the Vienna Collection has a great artistic unity and in size and importance can scarcely be surpassed by any other collection. One of the most significant works of the early Renaissance is Bertoldo's 'Bellerophon' (p 68), whose severe profile gives the impression that it was modelled on an ancient sarcophagus relief. Bertoldo was the custodian of the Medici collection of antiquities and had an important mediating rôle as the disciple of Donatello and the teacher of Michelangelo.

The collection has whole sets of works of the north Italian masters of this time. In the forefront of these is Antico, whose real name was Pier Jacopo Alari Buonacolsi and who deliberately adopted this demonstrative pseudonym. His bronzes are in many cases variations after antique sculptures. The life-size busts of Bacchus and Ariadne (p 71) represent the peak of his production in the antique style. It is interesting to compare the classical beauty of their heads and their absorbed remoteness with Tullio Lombardi's *Paar alla antica* (couple in antique style) (p 70), who appear astonishingly life-like as they turn towards each other. With various evocations of Rome, such as the figure of *Venus felix* after a statue in the Vatican or the 'Hercules and Antaeus' also after a former Vatican antiquity (both p 71), Antico created a copy of the splendour of Ancient Rome for the art room of the Marchioness Isabella d'Este (1474–1539) in Mantua. Moderno, whose true identity is unknown, no doubt chose his pseudonym in contrast to Antico. He incorporated antique motives into his modern compositions, as is shown in his two silver reliefs from the period of his work at the Papal Mint in Rome (p 73). Andrea Riccio was at first influenced by the art of Donatello. The graphic realism of his early period, as seen in the 'Woodcutter resting' (p 72), is toned down when he borrows from Hellenic sculpture, as seen in the 'Boy with Goose' (p 73), and is then expressed only in the extremely careful chasing of the surface.

The German Renaissance is also represented in the Collection of sculpture and decorative arts with outstanding works. The bourgeois Imperial cities of Nürnberg and Augsburg were centres of artistic development in the time of Albrecht Dürer (1471–1528) and Emperor Maximilian I (reigned 1493–1519). Outstanding ability in an exact observation and description of nature was clearly moving in the direction of the aspirations to classical form of the Italian Renaissance.

The old theme of *Vanitas*, the allegory of the transience of all earthly things, was expressed by Gregor Erhart around 1500 by means of naked human figures (p 75), which are nevertheless rooted in the Late Gothic style which was drawing to a close. On the other hand, this fine, close-up group already has the intimate quality of a *Kunstkammer* piece, geared to the connoisseur and amateur as collector. With wise perceptiveness, Albert Ilg selected it out of the scores of treasures with which he was surrounded in the newly installed Museum for the place at the top of the inventory of 1893, a judgement which is still valid today. At the time no one could escape the influence of Dürer's intense creative power. Even the goldsmiths' art in Nürnberg was influenced by the master, who had first learned this craft from his father and by whom a series of designs for goblets has been preserved. One of the goblets in the large group of Nürnberg works in the Collection is traditionally named after Dürer (p 75), because the rounded contours which emerge organically, leading to a flexibly bulb-

ous domed outline, are so close to his sketches that the design must rank as his invention. In Maximilian's goblet (p 75), the outline has hardened and the contours, which have developed into naturalistic pear shapes, are merely superimposed on the form. A leading goldsmith at this time in Nürnberg was Ludwig Krug, who was also active as a sculptor, painter, and copper engraver. His goblets (p 76), in which the Renaissance tendency to accentuate the horizontal is more strongly marked, also hark back to Dürer's inspiration. Peter Flötner, who had been working in Nürnberg since 1522, occupied an outstanding position in the statuary art of the city. The 'Adam' (p. 78) is the only wooden figure which has so far been authenticated as his work, and it may have served as a model for a bronze cast.

In Augsburg, Hans Daucher was one of the sculptors in whose work the ideas of the Renaissance took on plastic form. He was a pupil of Gregor Erhart, but the art of Albrecht Dürer and the Italian rules of form exerted a greater influence over him. A woodcut by the Nürnberg master is the basis of the Annunciation (p 77). Recent research shows Daucher's work to be considerably more extensive: 'Cupids playing' (p 77) and portraits on box lids, one of which is reproduced here (p 78), have recently been attributed to him. An Augsburg master must also have made the stone medallion with the likeness of Elisabeth von Hessen (p 78), which is one of the Collection's latest acquisitions. Conrat Meit and Christoph Weiditz come to grips with the representation of nudes in their Adam and Eve statuettes (pp 78, 79). Meit, a native of Worms, who was at first also under the influence of Dürer's art, went to Mecheln in 1512 in the service of Margaret of Austria, the Regent of the Netherlands, and settled in Antwerp in 1534. Weiditz, who had been resident in Augsburg since 1526, travelled to Spain and the Netherlands in the service of Charles v and must also have known Italy. The two precious figures belong to his most mannered style in his late phase. Out of these artistic interweavings from all parts of Europe a new style was born, examples of which will be introduced in the following section.

One of the highlights of the South German 'Little Masters' art' of the Renaissance is the backgammon board which Hans Kels the Elder made for Emperor Ferdinand I in 1537 (p 79). The outer side is adorned with equestrian portraits of Charles v and Ferdinand I, surrounded by likenesses of their forebears and kinsmen and also by coats of arms from the Hapsburg demesne. In the corners on Ferdinand's side are the Assyrian Ninus, the Persian Cyrus, Alexander, and Romulus, representing the four great world monarchies; on Charles v's side are the Romans, Caesar, Augustus, Trajan, and Constantine. The sequence, which also includes mythological scenes and Old Testament heroes and kings on the thirty-two playing pieces which go with the board, was no doubt worked out by a learned humanist. The extremely fine ornamentation rules out any possibility of practical use and makes the board a virtuoso *Kunstkammer* piece.

▷

LAUGHING BOY
Desiderio da Settignano (b. and d. in Florei
c **1430–64), Florence,** *c* **1455**
Marble; *H* 33 cm
Gustav Benda bequest 1932. (9104).

ALFONSO I OF ARAGON, KING OF NAPLES
Naples, middle of 15th century
Marble; H 96 cm
Acquired 1834 from private owner. (5441).

Florence, late 15th century
Painted terracotta; H 65 cm
Gustav Benda bequest 1932. (9111)

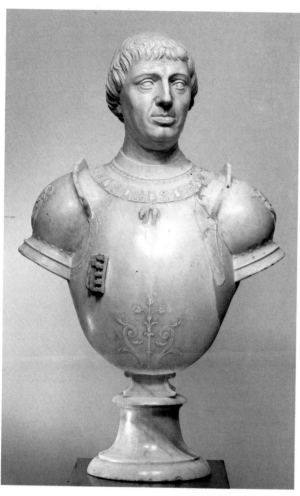

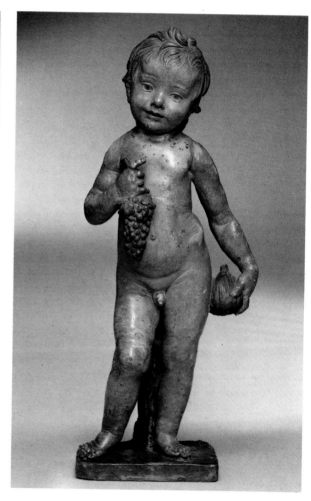

BELLEROPHON TAMING PEGASUS
Bertoldo di Giovanni (b. *c* 1420, d. 1491
Poggio a Caiano near Florence), Florence,
c **1480/84**
Bronze, signed; *H* 32.5 cm
Cast by Adriano Fiorentino (*c* 1440/50–99),
who worked with Bertoldo from 1480 until
1484.
From the Antiquities Room (1781 in the
collection De France). (5596)

▷
MADONNA WITH CHILD
Antonio Rossellino (b. and d. Florence
1427–79), Florence, *c* **1465/70**
Marble; 69.5 × 52 cm
Taken to Ambras by Claudia de Medici in
1626. (5455)

ENTOMBMENT OF CHRIST
North Italy (Padua or Mantua), *c* **1480**
Bronze, parcel-gilt; 24.3 × 44.5 cm
The relief is closely reminiscent of the art of
Andrea Mantegna. Listed in the inventory of
the art collection of Archduke Leopold
Wilhelm of 1659. (6059).

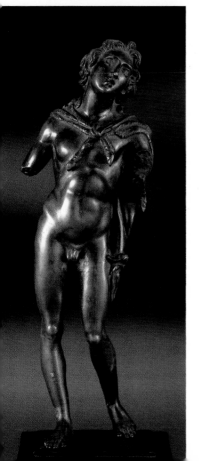

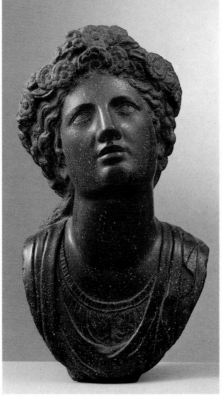

◁
POLYHYMNIA
**Pier Maria Serbaldi della Pescia, called
Tagliacarne (b. 1454/5, worked in Florence
and Rome, Master of the Papal Mint 1515),
Florence,** *c* **1500**
Porphyry; *H* 42.5 cm
From the Antiquities Room. (3529)

◁ ◁
APOLLO(?)
Florence, late 15th/early 16th century
Bronze; *H* 25.5 cm
From the Ambras Collection. (5593)

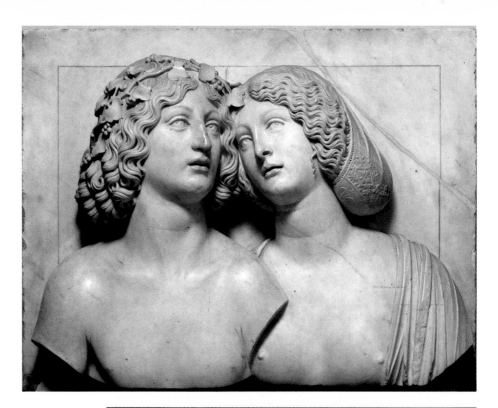

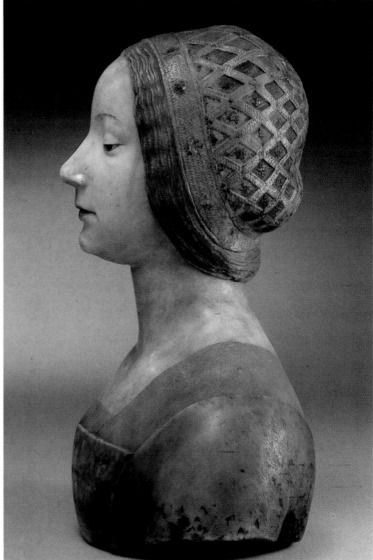

△

YOUNG COUPLE AS BACCHUS AND ARIADNE
Tullio Lombardi (b. and d. Venice *c* 1455–1532), Venice *c* 1505
Marble; 55 × 71 cm
From the Este Collection. (7471)

▷

PORTRAIT OF A PRINCESS FROM THE HOUSE OF
ARAGON
Francesco Laurana (b. Vrana near Zara *c* 1430, d. France 1502), Naples, between 1483 and 1498
Polychromed marble; *H* 44 cm
The bust was produced during Laurana's third stay in Naples. From the Treasury. (3405)

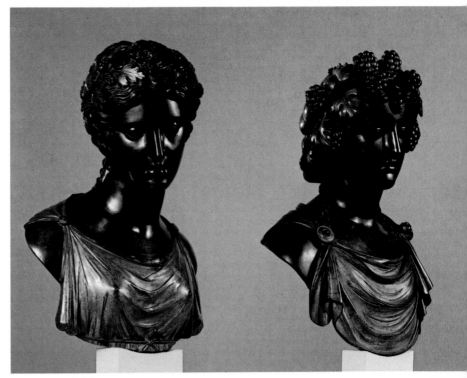

BACCHUS AND ARIADNE
Pier Jacopo Alari Buonacolsi, called Antico
(b. Mantua(?) c 1460, d. Gazzuoli near
Mantua 1528), Mantua, early 16th century
Bronze; H 59 and 50 cm
Listed as Bacchus in the inventory of
Archduke Leopold Wilhelm's collection of
1659. From the Antiquities Room.
(5987 and 5991)

▷

VENUS FELIX
Pier Jacopo Alari Buonacolsi, called Antico
(b. Mantua c 1460, d. Gazzuoli near Mantua
1528), Mantua, early 16th century
Bronze, hair and robe fire-gilt; H with pedestal
32 cm
Ten ancient coins are set into the base. The
statuette is a variation after an antique marble
Venus in the Vatican.
From the Antiquities Room. (5726)

▷ ▷

HERCULES AND ANTAEUS
Pier Jacopo Alari Buonacolsi, called Antico
(b. Mantua(?) c 1460, d. Gazzuoli near
Mantua 1528), Mantua, early 16th century
Bronze; 43.5 cm
After an antique model. According to the
inscription, the sculpture formerly belonged to
Marchioness Isabella d'Este (1474–1539),
Mantua, authenticated.
Listed in the inventory of the art collection of
Archduke Leopold Wilhelm of 1659. (5767)

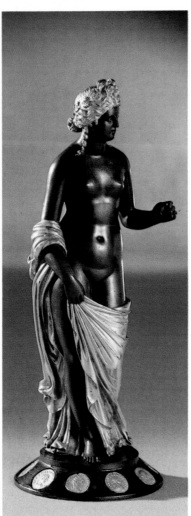

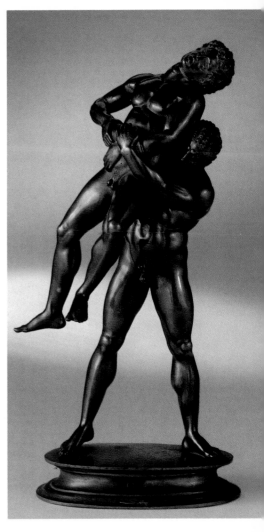

VENUS
Tullio Lombardi (b. and d. Venice *c* 1455–1532), Venice, early 16th century
Bronze; *H* 23 cm
The statuette was conceived as a torso inspired by antique sculpture.
From the Ambras Collection. (5600)

WALKING YOUTH
North Italy(?), early 16th century
Bronze; *H* 71.5 cm
Originally in the Caerino dei Cesari of the Palazzo Ducale in Mantua.
From the collection of Archduke Leopold Wilhelm. (6023)

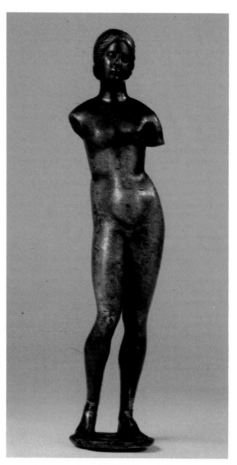

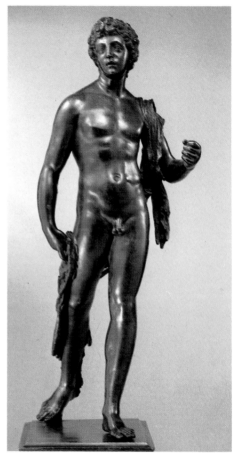

◁
WOODCUTTER RESTING
Andrea Riccio (b. Trient between 1460 and 1465, d. Padua 1532), Padua, *c* 1500
Mounted on polychromed terracotta; *H* 37 cm
The realistically formed figure sits in the attitude of a Christ in repose. Donated in 1920 by Prince Johannes II of Liechtenstein. (7345)

▷
BOY WITH GOOSE
Andrea Riccio (b. Trient between 1460 and 1465, d. Padua 1532), Padua, *c* 1515
Bronze; *H* 19.6 cm
After a Hellenistic model.
From the Antiquities Room. (5518)

FLAGELLATION OF CHRIST
Moderno (pseudonym of a goldsmith working in North Italy and Rome in late 15th/early 16th century), Rome, *c* 1538/9
Silver, parcel-gilt; 13.9 × 10.3 cm
The figure of Christ is inspired by the Laokoon discovered in 1506. Taken over from Castle Laxenburg. (1105)

SACRA CONVERSATIONE (MADONNA WITH SAINTS)
Moderno (pseudonym of a goldsmith working in North Italy and Rome in the late 15th/early 16th century), Rome *c* 1538/9
Silver, parcel-gilt; 13.9 × 10.2 cm
Companion-piece to the 'Scourging of Christ', with several features inspired by the antique. Taken over in 1872 from Castle Laxenburg. (1107)

◁

SATYR
Andrea Riccio (b. Trient between 1460 and 1465, d. Padua 1532), Padua, early 16th century
Bronze; *H* 21.7 cm
From the Antiquities Room. (5539)

BAPTISM OF CHRIST

Netherlandish (Brussels?), early 16th century
Tapestry of wool, silk, gold, and silver thread;
200 × 175 cm
Composition of the main group after Rogier
van der Weyden's *Johannesaltar* (altar of St
John) in Berlin.
Old Imperial property. (xxx/2)

TRIONFI OF PETRARCH

**Two tapestries from a series of six, French,
early 16th century**
Wool and silk
Triumph of Death over Chastity, section: Pandora;
4.14 × 5.42 m
Old Imperial property.
*Triumph of Fame over Death, section; Emperor
Charlemagne;* 4.20 × 5.64 m
Old Imperial property.(CII/3 and II/4)

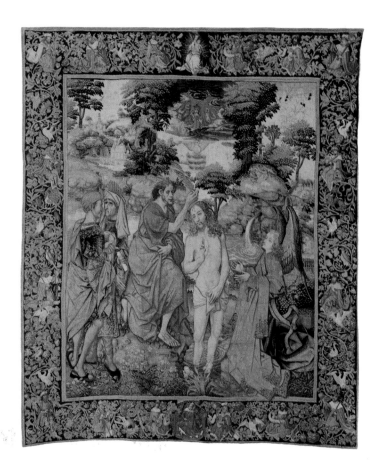

▷

ALLEGORY OF VANITY

Gregor Erhart (b. Ulm c 1465, d. Augsburg 1540), Augsburg, c 1500

Limewood with old polychrome; H 46 cm
A youth, a maiden, and an old woman, in whom the signs of physical degeneration are all too obvious, are a parable for the transience of earthly things. Acquired in 1861 from the Monastery of St Florian. (1)

▷ ▷

GOBLET WITH COVER (SO-CALLED 'DÜRER GOBLET')

Nürnberg, c 1500

Silver-gilt; H 47.8 cm
Probably based on sketches by Albrecht Dürer. Listed in the inventory of the Ambras Collection of 1596. (109)

▷

FALCONER

Anton Pilgram (b. Brünn(?) c 1450/60, d. Vienna(?) c 1515), c 1500

Pearwood; hood, eyes, and base stained; H 31.3 cm
From the Ambras Collection. (3968)

▷ ▷

GOBLET WITH COVER (SO-CALLED 'MAXIMILIAN GOBLET)

Nürnberg c 1510

Silver-gilt; enamelled Imperial coat of arms on inside of cover; H 56 cm
The goblet is supposed by old tradition to have come from Emperor Maximilian's Estate. Listed in the inventory of the Ambras Collection of 1596. (110)

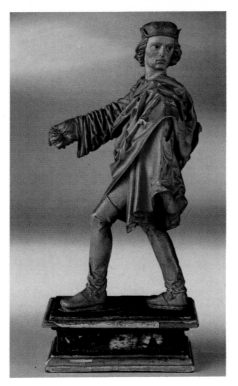

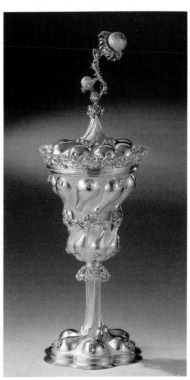

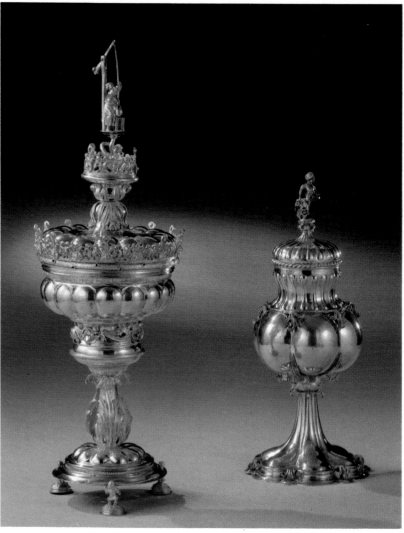

▷

TWO GOBLETS WITH COVERS

Ludwig Krug (worked in Nürnberg from 1514, d. there 1532), Nürnberg, *c* 1520/30

Silver-gilt; *H* 44 cm and 32 cm

Listed in the inventory of the Ambras Collection of 1596. (898, 879)

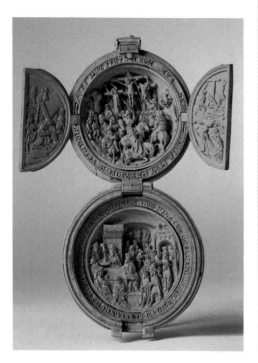

△

PRAYER NUT

Low German, early 16th century

Boxwood; *Diam* 6.2 cm

Miniature carving, showing the crucifixion (*above*); Christ before Pilate and Flagellation (*below*).

From the Treasury. (4206)

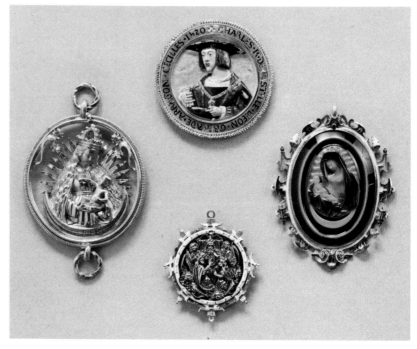

EMPEROR MAXIMILIAN I AS ST GEORGE
Hans Daucher (b. Ulm *c* 1486, d. Stuttgart 1538), Augsburg, *c* 1520/5
Solnhofen limestone; 23 × 15.5 cm
With initials, inscription: IM[PERATOR] CAES[AR] MAXIMILIANUS AUGUSTU(S)
Gustav Benda bequest, 1932. (7236)

THE ANNUNCIATION
Hans Daucher (b. Ulm *c* 1486, d. Stuttgart 1538), *c* 1510
Solnhofen limestone; 18 × 15 cm, with initials
Acquired on the art-market. (4422)

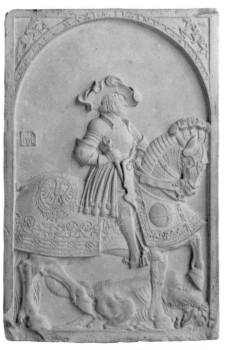 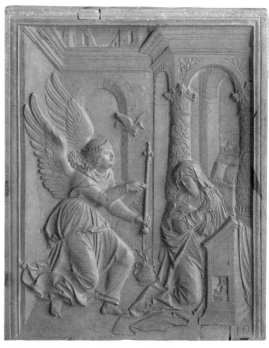

◁

JEWELLERY

Above centre: Hat-buckle (medallion), depicting Emperor Charles v
Spanish or French, 1520
Gold, enamel; *Diam* 5.72 cm
Inscription: CHARLES R(OI) DE CASTILLE LEON GRENADE ARAGON CECILLES 1520

Below centre: Pendant, 'Coronation of Mary'
German, late 15th century, mount *c* 1600
Silver, parcel-gilt and enamel, in gold and enamel frame; *Diam* 4.6 cm
Both pieces from the Treasury. (1610 and 132)

Left: Pendant, 'Mary and Child on the crescent moon'
South German, *c* 1510
Silver, parcel-gilt; *Diam* including rings 9 cm
Gustav Benda bequest 1932.

Right: Pendant, Mary and Child
Netherlandish, 1st half 15th century
Onyx; mount gold and enamel, 2nd half of 16th century; *H* 7.5 cm, *W* 6 cm
Listed in Treasury inventory of 1750.
(9024 and XII 10)

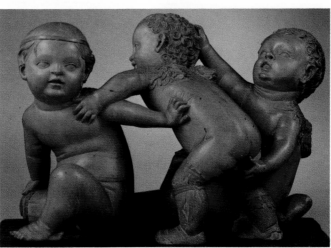

CUPIDS PLAYING
Hans Daucher (b. Ulm *c* 1486, d. Stuttgart, 1538), Augsburg, *c* 1520
Pearwood; *H* 42 cm, *W* 76 cm
The Cupids symbolize human passions.
Taken over from the Court Library, 1908.
(8920)

ADAM AND EVE
Conrat Meit (b. Worms *c* 1475/80, d. Antwerp 1550/1), *c* 1520/5
Boxwood; *H* 25.5 and 24 cm
Taken over from the Austrian Museum of Applied Arts. (9888 and 9889)

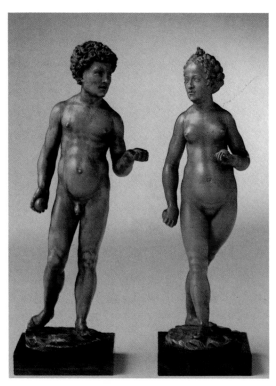

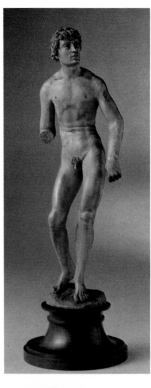

ADAM
Peter Flötner (b. Switzerland(?) *c* 1485, d. Nürnberg 1546), Nürnberg, *c* 1525
Boxwood; *H* 34.5 cm with monogram
Acquired from the collection of Victor von Miller, Vienna, 1872. (3896)

◁
BOX, BUST PORTRAIT OF ELECTOR FRIEDRICH DER *WEISE* (THE WISE) OF SAXONY
Hans Daucher, (b. Ulm *c* 1486, d. Stuttgart 1538), Augsburg, 1525
Walnut; portrait pearwood; *Diam* 22 cm
Inscription, HERZOG FRIDRICH CURFURST IN SASEN 1525. The portrait is after a Dürer engraving of 1524.
From the collection of Archduke Leopold Wilhelm. (3878)

ELISABETH VON HESSEN
Augsburg master(?), dated 1519
Solnhofen stone; *Diam* 16.8 cm
Inscription, ELISABET LANTG [ÄFIN] Z [U] HESSEN. Elisabeth married Duke Johann of Saxony in 1519, hence the monogram I and E and love knots.
Acquired on the art-market in 1979. (10129)

▷
EMPEROR CHARLES V
South German, *c* 1530/5
Alabaster with traces of polychrome; beads; *H* 14.2 cm, *W* 12.9 cm
Originally probably on a polychrome stone base.
Acquired 1808 from the De France Collection. (XIIa82)

ADAM AND EVE
Christoph Weiditz (b. Strassburg or Freiburg
c 1500, d. Augsburg 1559), Augsburg c 1540/50
Pearwood; *H* 32 cm and 31.2 cm
From the Ambras Collection. (3965 and 3967)

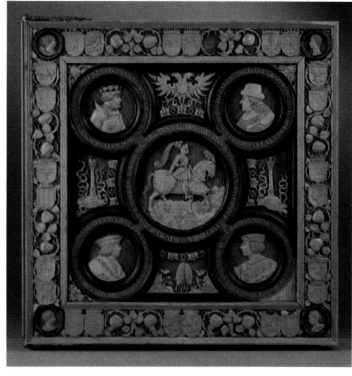

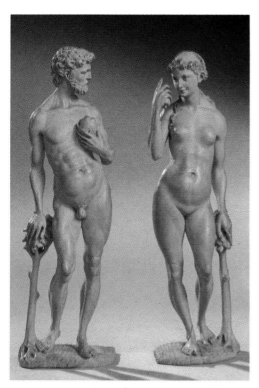

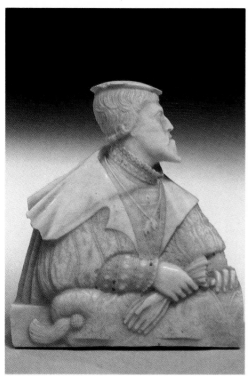

BACKGAMMON BOARD, OUTER SIDE
Hans Kels the Elder (b. c 1480, d.
Kaufbeuren 1559/60), signed and dated 1537
Oak, walnut, boxwood, Hungarian veined
ashwood; 56.1 × 56.1 cm
In the centre is an equestrian portrait of
Charles v, surrounded by portrait medallions
of his forebears Albrecht II, Friedrich III,
Maximilian I, and Philip the Handsome. With
the board are 32 draughtsmen with
predominately mythological scenes.
Listed in the Treasury inventory of 1750. (3419)

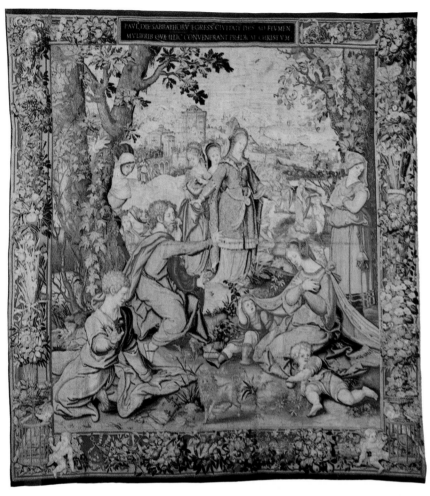

SCENES FROM THE LIFE OF ST PAUL
Brussels, _c_ 1540
Tapestry of wool, silk, gold and silver thread;
417 × 383 cm
Inscription in the upper border in translation:
'Paul is leaving the city of Philippi on the
Sabbath, going in the direction of the river and
is preaching Christianity there to the
assembled women'.
From the Estate of Emperor Franz I (died
1765). (III/1)

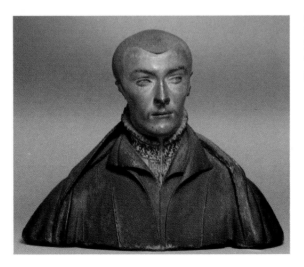

BUST OF A YOUNG MAN
Upper Rhenish(?), _c_ 1540/5
Polychromed terracotta, mounted; _H_ 48 cm
Taken over from the Austrian National Library
in 1936. (8919)

Late Renaissance

The late Renaissance art of the period between approximately 1530 and 1600 forms the heart of the Collection of sculpture and decorative arts. Bronzes, goldsmiths' works, and gem-carvings of the highest quality are present in such abundance that the selection of certain pieces rather than others of equal merit could appear invidious. This wealth is accounted for by the history of the Collection and by the general development of the *Kunstkammer* into a vehicle of princely prestige and display of power during this period.

The most famous piece in the collection is Benvenuto Celllini's golden *saliera* (salt-cellar) (p 83). The artist was proud of his cosmographic invention, which he describes in his autobiography (and which is quoted beside the illustration). His description is supplemented in the sequence on the base of the piece, on which the four wind gods, day and night, morning and evening, are recumbent; day and evening are almost identical copies of the same figures on Michelangelo's Medici tombs. Between them lie representations of human activities. Cellini's figures call for a comparison with a roughly contemporary tapestry (p 84), which reproduces the decoration of Francesco Primaticcio in the great gallery of the Royal Palace of Fontainebleau, together with the roof beams and corbel mouldings. The salt-cellar was part of the truly royal gift which Charles ix of France sent to Archduke Ferdinand ii in 1570 when the latter represented the King in Speyer at his marriage with Archduchess Elisabeth. Part of the present, which was obviously intended to honour Ferdinand as a collector, were also the Burgundian Court goblet (p 33), the golden Michael goblet, and an onyx ewer (p 82).

Among the portraits, the majestic, carefully-worked bust of Charles v by Leone Leoni (p 85) is the most important work. Emperor Rudolf ii had his bust made after this model by Adriaen de Vries (p 105). The unusual lifelike portrait of Philip ii by Pompeo Leoni (p 86) was originally placed in a suit of armour designed to give as much verisimilitude as possible. A quite different sort of likeness can be observed in the highly spiritual bronze head of Cardinal Carlo Borromeo (p 85), with its vibrant surface. A stylistic forerunner to this is to be found in the graphic formation of the face in the portrait of a lady by Alessandro Vittoria (p 87).

The collection of bronze statuettes contains a series of the most significant masterpieces of the time. The figure of the youthful Hercules by a Florentine master (p 84) could have been made as an illustration of the theoretical dispute among artists on the question of whether painting or sculpture should be considered the superior art. Cellini decided in favour of sculpture, because in the case of a figure it could deal with many aspects of equal value in the round, whereas painting had to be satisfied with only one. The inclination of the head, the turn of the body, and the poise of the arm in the Hercules challenge the beholder to turn the figure or to walk round it in order to comprehend it fully. Giambologna, the leading master of the second half of the century in Florence, perfects this artistic principle in his *Figura serpentinata*. His main works are the 'Astronomy', the two-figure 'Rape of the Sabines', and the famous 'Flying Mercury' (all p 88), in which weightlessness in sculpture is the primary intention. Sansovino's 'Jupiter' (p 84), Vittoria's 'Winter', (p 87), and Cattaneo's *Luna* (p 87) represent the figure art of Venice of the same period.

Vienna has the most extensive collection of vessel gem-carving in the world. The precious ewers, bowls, or goblets in rock-crystal, lapis lazuli, or prase (quartz) (pp 89–90) were among the *Kunstkammer* pieces most in demand. It must be remembered that in them the aesthetic value of the noble minerals combined with a virtuoso command of the brittle material to yield the most exquisite artistic creations. Milan developed into the uncontested centre of the gem-carvers' art and also of cameos (p 92), which served the whole of Europe. Over a long period the Miseroni (pp 89, 94) and Saracchi (pp 89, 91) families constituted the leading workshops. Artists from Milan also worked in the Florentine workshops founded by Francesco i. Masterpieces of this Court studio are the Lapis-lazuli pail (p 90) and the famous Florentine portable altar (p 94), both of which were mounted by the goldsmith Jaques Bylivelt. The frame of the portable altar is completely independent of the Biblical theme of the *commesso* picture and could just as easily surround a depiction of 'Diana Bathing'. A *commesso* is a type of marquetry picture, composed of precious stones in the manner of *intarsia*.

The increasing need of the Courts for prestige also explains the uncommonly sumptuous tapestries which are richly interwoven with gold and silver thread (pp 80, 84, 91, 93–6). In this field Brussels held absolute pride of place.

'MICHAEL' GOBLET
Paris or Antwerp, *c* 1530/40
Gold; diamonds, emeralds, rubies, pearls;
H 51.7 cm
A present from King Charles IX of France to
Archduke Ferdinand II in 1570. Listed in the
inventory of the Ambras Collection of 1596.
(1120)

ONYX EWER
Paris, *c* 1560/70
Mount gold enamelled; diamonds, emeralds,
rubies; *H* 27.1 cm
A present from King Charles IX of France to
Archduke Ferdinand II in 1570.
Listed in the inventory of the Ambras
Collection of 1596. (1096)

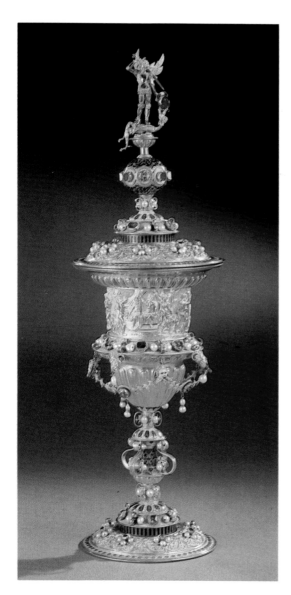

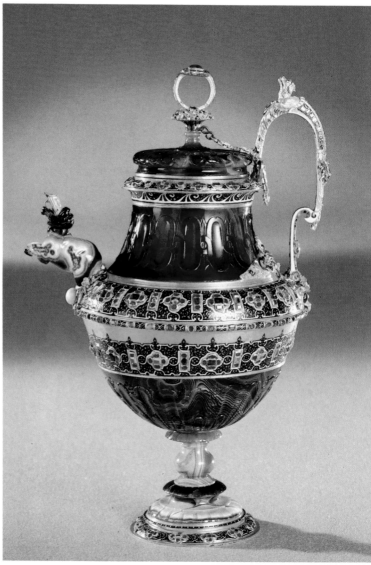

SALIERA (SALT-CELLAR)
**Benvenuto Cellini (b. and d. Florence
1500–72), 1540–3.**
Gold, part enamelled; ivory base; *H* 26 cm,
L 33.5 cm
Made for King François I of France. The little
ship served as a salt-cellar. The sea-god
Neptune, who is dispensing the salt, sits
opposite Tellus, the goddess of the Earth, with
spices.

A present from King Charles IX of France to
Archduke Ferdinand II (of Tirol) in 1570.
Listed in the inventory of the Ambras
Collection of 1596. (881)

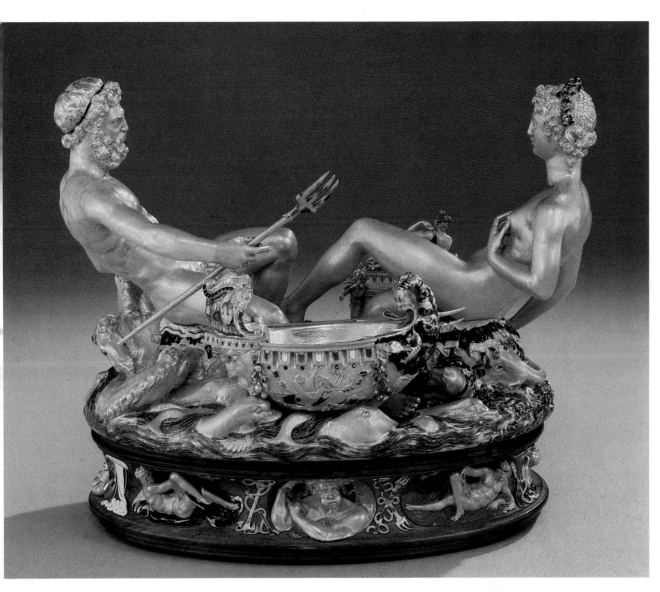

EXTRACT FROM *THE LIFE OF BENVENUTO CELLINI: A FLORENTINE
ARTIST*, WRITTEN BY HIMSELF, TRANSLATED INTO ENGLISH BY
ANNE MACDONELL (DENT, 1926)

*At once he [François I] began to speak to me, saying, that since he had
such a beautiful basin and jug from my hand, he wished for a fine salt-
cellar to keep them company. So he asked me to make him a design for
one, and without delay. I answered, 'Your Majesty will see such a
design sooner than you expect; for while I was making the basin, I
thought a salt-cellar should be made to go with it; so the thing is ready,
and, if it please you, I can show it to you now.' . . . Off I went, and
speedily returned; for I had but to cross the Seine. I brought back with*

*me a wax model, which I had already made at the request of the
Cardinal of Ferrara in Rome. When I uncovered it, his Majesty
exclaimed in his astonishment, 'This is a hundred times more divine
than I could ever have imagined. The man is a wonder! He should
never lay down his tools.' Then turning to me with a most joyful face,
he said that the model pleased him very much, and that he would like
me to carry it out in gold. The Cardinal of Ferrara, who was present,
gave me a look as if to say he recognised the design as the one I had
made for him in Rome. So I reminded him of what I had said before –
that I should make it for him who was destined to possess it. . . . Next
morning I set to work on the fine salt-cellar, and threw the greatest
energy into this and my other works.*

Jacopo Sansovino (b. Florence 1486, d. Venice 1570), Venice, 2nd third of 16th century
Bronze, black lacquer; *H* 43 cm
Illustrated in the pictorial inventory *Prodromus* of 1735. (5655)

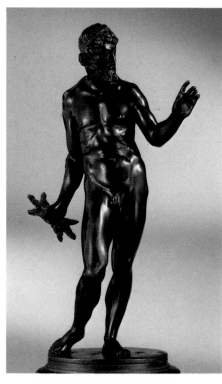

▷

YOUNG HERCULES
Florence *c* 1550
Bronze, black lacquer; *H* 38.8 cm
The unknown artist strove to make the figure attractive from several angles.
From the Ambras Collection. (5658)

▽

MYTHOLOGICAL-ALLEGORICAL SCENES: DANAE
Fontainebleau, 1541–50
Tapestry of wool, silk, gold and silver thread; 332 × 625 cm
From a series of six pieces, reproducing the decoration of the great gallery of Fontainebleau.
Mentioned in Vienna in 1690. (CV/1)

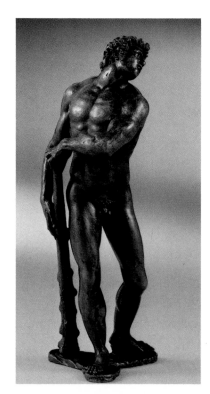

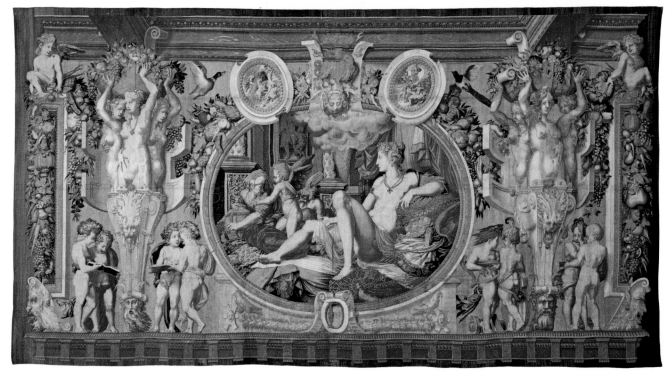

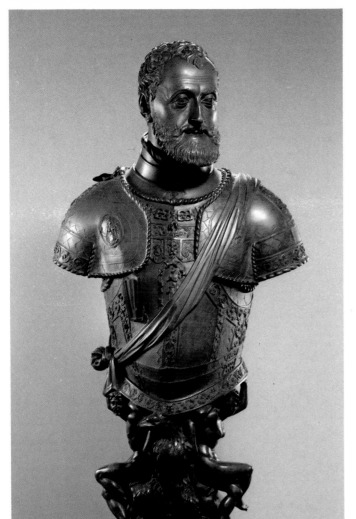

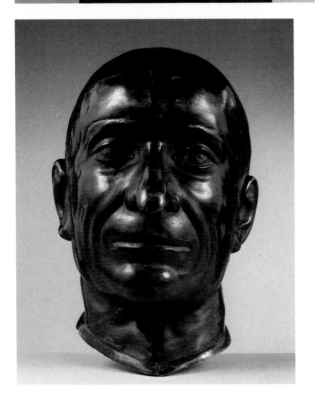

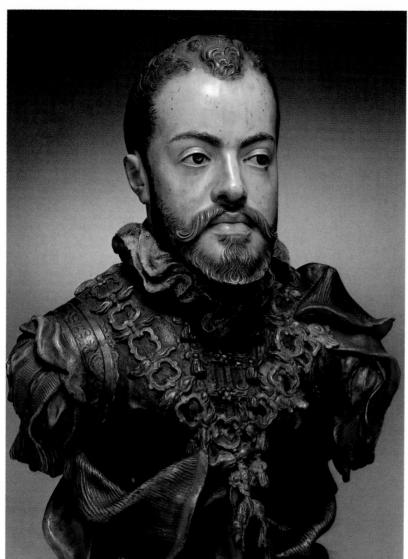

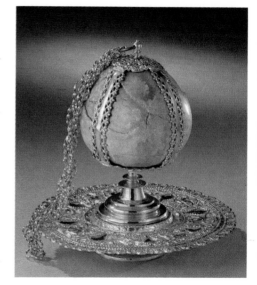

BEZOAR

Spanish, 1st half of 16th century
Mount gold; emeralds, rubies; *H* 20.5 cm
The high-grade gold and the emeralds are of
American origin.
Listed in the Treasury inventory of 1750.
(981)

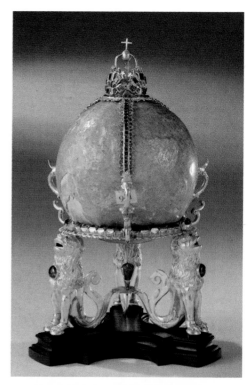

△
PORTRAIT-HEAD OF KING PHILIP II OF SPAIN
**Pompeo Leoni (b. *c* 1533, d. Madrid 1608),
Madrid, *c* 1556**
Painted silver; placed on the polychromed clay
bust of Balthasar Moll in 1753; *H* with bust
62 cm
The head was originally mounted on a dummy
displaying a ceremonial armour.
From the Treasury. (3412)

▷
BEZOAR AND DISH
Spanish, 1st half of 16th century
Mount and dish gold; *H* 21 cm, *Diam* 25.5 cm
The bezoar (from Persian *bâd-sahr*, 'counter-
poison') is formed in the stomach or bowels of
certain ruminants and was considered to be an
effective remedy and antitoxin.
Listed in the Treasury inventory of 1750.
(994 AND 993)

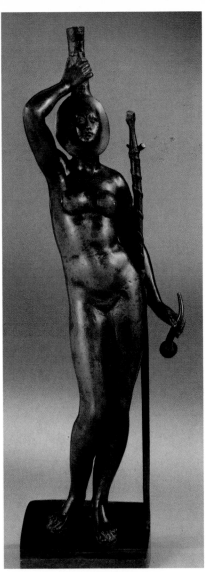

LUNA

Danese Cattaneo(?) (b. Colomata near Carrara 1509, d. Padua 1573), Venice, c 1540/50

Bronze, natural brown patina; H 50 cm
Illustrated in the pictorial inventory *Prodromus* of 1735. (5511)

◁

ALLEGORY OF WINTER

Alessandro Vittoria (b. Trient 1525, d. Venice 1608), Venice c 1580

Bronze, natural dark-brown patina; H 33 cm
From the Antiquities Room. (5664)

PORTRAIT OF A LADY OF THE HOUSE OF ZORZI

Alessandro Vittoria (b. Trient 1525, d. Venice 1608), Venice c 1570/80

Terracotta; H 83 cm
Taken over in 1942 from the Austrian
Museum of Applied Arts. (9905)

TWO-FIGURE RAPE GROUP
Giambologna (b. Douai 1529, d. Florence 1608), Florence, *c* 1579
Bronze, natural light-brown patina, dark brown lacquer; *H* 98.2 cm
Listed in inventory of Emperor Rudolf II's *Kunstkammer* of 1607/11. (6029)

ALLEGORY OF ASTRONOMY OR VENUS URANIA
Giambologna (b. Douai 1529, d. Florence 1608), Florence *c* 1573
Bronze, fire-gilt; *H* 38.8 cm
Listed in Treasury inventory of 1750. (5893)

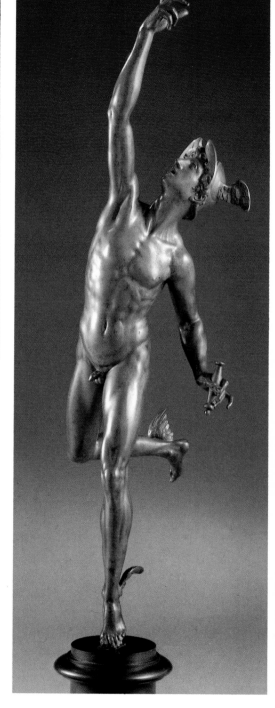

FLYING MERCURY
Giambologna (b. Douai 1529, d. Florence 1608), Florence *c* 1565
Bronze, natural light patina; *H* 62.7 cm
The representation of weightlessness combined with a striving for viewability from all angles was new in sculpture.
Listed in the inventory of Emperor Rudolf II's *Kunstkammer* of 1607/11. (5898)

SHELL BOWL ON LONG STEM
Gasparo Miseroni (b. Milan 1518, d. *c* 1572),
Milan, *c* 1560/70
Rock-crystal; mount enamelled gold;
H 23.5 cm, *L* 30.2 cm
A serpent is winding itself round the shells in
this playfully virtuoso mastery of the hard,
brittle material.
Listed in the inventory of the Ambras
Collection of 1596. (2268)

ROCK-CRYSTAL EWER
Italy, 2nd half of 16th century
H 32.9 cm
In the Renaissance, the ancient art of gem-
carving was resumed on a grand scale. The
rare and precious natural materials served to
enhance the princes' prestige.
From the Treasury. (2224)

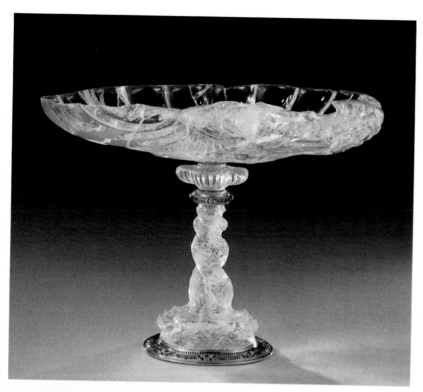

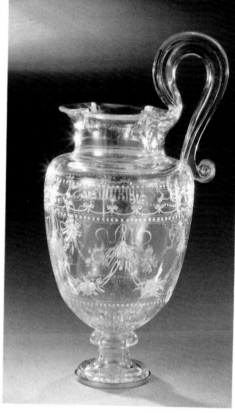

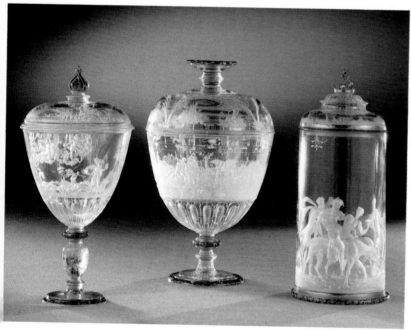

◁

THREE VESSELS IN ROCK-CRYSTAL
Goblet with cover, depicting the Proserpine myth
Annibale Fontana (b. and d. Milan 1504–87),
Milan, *c* 1570
H 23.8 cm
Double goblet with scenes from Ovid's
Metamorphoses
Milan, *c* 1570
H 25.9 cm
Tankard with lid depicting Bacchanalian procession
Saracchi workshop, Milan, *c* 1585
H 25.1 cm
All mounts enamelled gold.
Listed in the inventory of the Ambras
Collection of 1596, or from the Treasury.
(2360, 1415 and 2344)

LAPIS LAZULI PAIL

Gian Stefano Caroni (d. Florence 1611), Florence, 1575/6

Mount and handle enamelled gold, by Jaques Bylivelt (b. Delft 1550, d. Florence 1603), Florence, 1576–81

H 36 cm

A present from the Grand Duke Ferdinando II to Emperor Ferdinand II in 1628. (1655)

LAPIS LAZULI DRAGON BOWL

Milan, c 1580

Mount enamelled gold; emeralds, rubies, pearls; H 17 cm, L 18.9 cm

Listed in the inventory of Rudolf II's *Kunstkammer* of 1607/11. (1851)

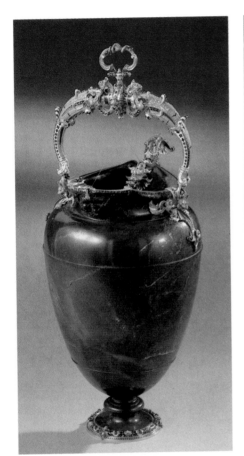

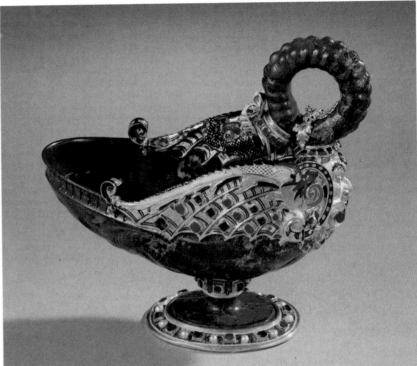

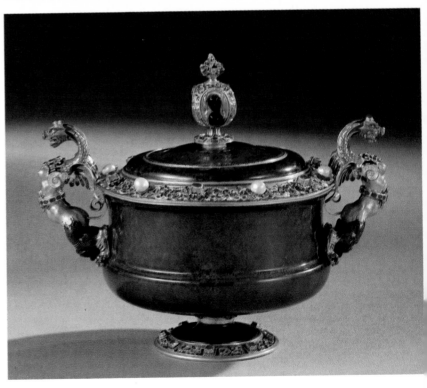

PRASE BOWL WITH COVER

Milan, c 1580

Mount enamelled gold; onyx cameos, rubies, pearls; H 19.3 cm

Listed in the inventory of Emperor Rudolf II's *Kunstkammer* of 1607/11. (2014)

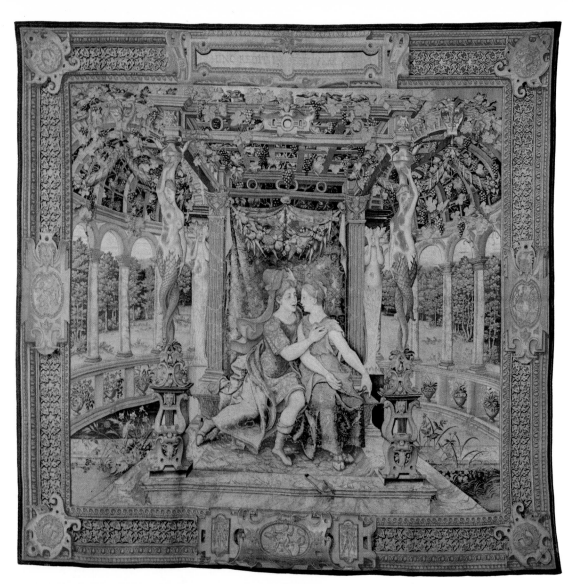

△

THE UNION OF VERTUMNUS AND POMONA
Brussels, mid 16th century
Tapestry made of wool, silk, gold, and silver
thread; 425 × 445 cm
Part of a series of nine tapestries. Based on
Ovid's *Metamorphoses* XIV 623–771. (xx/9)

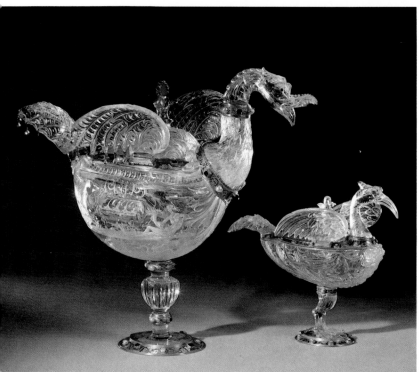

◁

TWO ROCK-CRYSTAL BIRDS (CENTREPIECES)
Saracchi Workshop, Milan, *c* 1580/90
Setting: enamelled gold, emeralds, cameos,
and pearls; *H* 40.9 cm and 23.1 cm
These pieces were described as *Reiger* (herons)
in the old inventories. Originally they had real
aigrettes on their heads. Listed in the
inventory of the Ambras Collection in 1596.
(2401, 2238)

CAMEOS

Above centre: Aurora
Jacopo da Trezzo (b. Milan, 1514, d. Madrid, 1589), Madrid(?) late 16th century
Agate; setting: Prague, beginning of 17th century; enamelled gold; 5.4 × 5.7 cm (XII/134)

Above left: Sacrificial death of Marcus Curtius
Francesco Tortorino (worked in second half of 16th century) Milan, late 16th century, signed
Chalcedony; setting: Milan, end of 16th century; enamelled gold, rubies, diamonds, and a single pearl; 4.7 × 4.8 cm (XII/113)

Above right: Juno, Venus, Pallas Athene
Milan, second half of 16th century
Chalcedony; setting: Milan, end of 16th century; enamelled gold, diamonds, and rubies; 4.2 × 4.8 cm (XII/152)

Middle: Leda and the Swan
Italy, late 16th century
Commesso of chalcedony and enamelled gold; diamonds, and rubies; 7.3 × 7.8 cm (XII/123)

Below left: The Emperor Karl V
Southern Netherlands; second half of 16th century
Onyx; setting: Southern Netherlands, end of 16th century enamelled gold and rubies; 5.4 × 4.7 cm (XII/71)

Below right: The Archduchess Johanna, Princess of Portugal (1537–73)
Jacopo da Trezzo (b. Milan 1514, d. Madrid 1589), Madrid, late 16th century
Chalcedony; setting: South German(?), dated 1566; 6.5 × 5.3 cm (XII/70)

Below centre: Diana as a Moor
Milan, second half of 16th century
Jasper, a single pearl, gold, diamonds; setting: Milan(?), early 17th century, enamelled gold, diamonds; 6.1 × 5 cm (XII/120)
All listed in the 1619 Estate inventory of the Emperor Matthias.

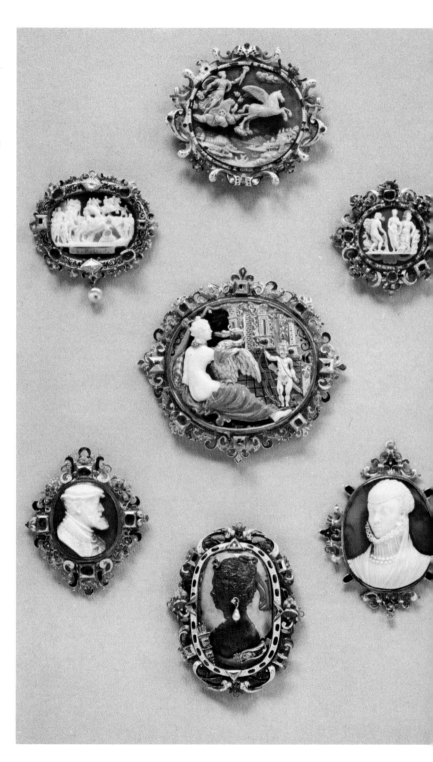

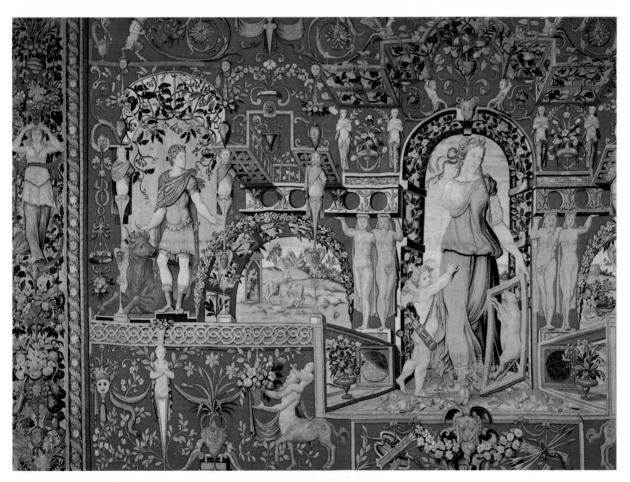

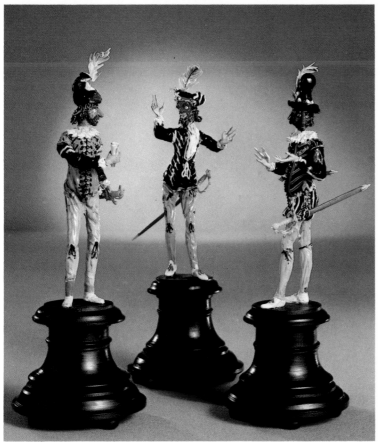

△

THE TWELVE MONTHS, APRIL (SECTION)
Brussels, later than mid 16th century
Tapestry of wool, silk, gold and silver thread;
420 × 610 cm
April is ruled by Venus, in the sign of Taurus.
Through the arch is a vista of scenes from
country life.
From the old Imperial collection. (XI/4)

◁

THREE FIGURES FROM THE *COMMEDIA DELL'ARTE*
Venice (Murano) *c* 1600
Stained glass; *H* 21.4 cm, 19.6 cm, and
20.4 cm
The figurines do not conform to the
contemporary style of figures; with all the
eloquence of their gestures they present the
type of the *Capitano* (the military man). Apart
from two such figurines in Copenhagen, no
others have survived.
From the Treasury. (2705, 2711, and 2714)

SMALL HOUSE ALTAR, 'CHRIST AND THE
SAMARITAN WOMAN AT THE WELL OF JACOB'
**Frame of rock crystal by Gian Ambrogio
Caroni (d. Florence 1611); decorations in
enamelled gold by Jacques Bylivelt (b. Delft
1550, d. Florence 1603), completed in 1591;
side niches by Bernardino Gaffuri
(d. Florence 1606), while picture and figures
(*Commessi in pietre dure*) are by Cristofano
Gaffuri (d. Florence 1626), both completed in
1600**
A single large emerald forms the well
H 37.8 cm, W 23.5 cm
A gift to the Emperor Karl VI (1711–40). (1542)

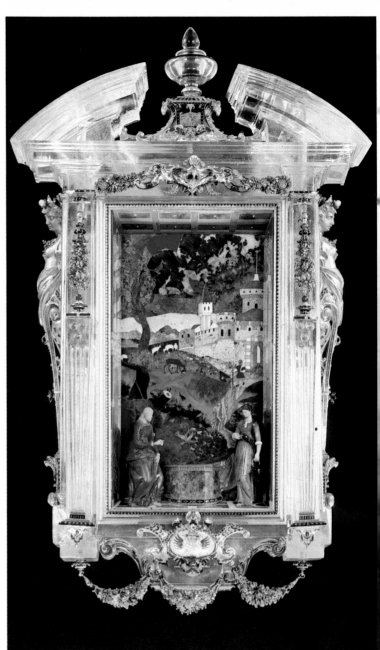

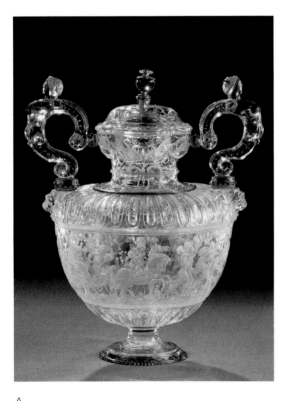

△
ROCK-CRYSTAL VASE WITH COVER
**Miseroni workshop(?), Milan, late 16th
century**
Setting enamelled gold; H 28.9 cm
On the bowl is the triumph of Bacchus, after
an engraving by Etienne Delaune.
From the Treasury. (2353)

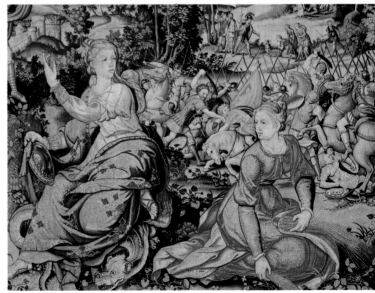

◁

THE SEVEN VIRTUES, WISDOM (SECTION)
Woven by François Geubels, Brussels, late 16th century
Tapestry of wool, silk, gold and silver thread; 342 × 530 cm
Next to the figure of Wisdom is Ruth, gleaning corn.
From the old Imperial collection. (XVII/4)

△

SCENES FROM THE STORY OF MOSES: MOSES AND ISRAEL PRAISING THE LORD (SECTION)
Woven by Jan van Tiegen, Brussels, mid-16th century
Tapestry of wool, silk, gold and silver thread; 420 × 563 cm
From the old Imperial collection. (I /4)

SCENES FROM THE BOOK OF JOSHUA: JOSHUA
BEING INVITED TO ENTER THE PROMISED LAND
(SECTION)
**Brussels, *c* 1540/50, after designs by Pieter
Coecke van Aelst**
Tapestry of wool, silk, gold and silver thread;
453 × 600 cm
From a series of eight.
From the old Imperial collection. (XIX/1)

INKSTAND
**Wenzel Jamnitzer (b. Vienna 1508,
d. Nürnberg 1585), Nürnberg, late 16th
century**
Silver; *H* 6 cm, *L* 22.7 cm, *W* 10.2 cm
The animals on the sides and lid are casts from
nature.
Listed in the 1596 inventory of the Ambras
Collection. (1155–64)

The *Kunstkammer* of Archduke Ferdinand II and Emperor Rudolf II

In the second half of the sixteenth century and around 1600 respectively, two main sources of the Collection of sculpture and decorative arts became evident: the *Kunstkammer* of Archduke Ferdinand II of Tirol and of Emperor Rudolf II. Objects of this provenance have already been mentioned several times, but here the two collectors and their work are described so that many objects from their collections may be understood.

Archduke Ferdinand II (p 99), born in 1529 the second son of King Ferdinand I, was Governor of Bohemia from 1547 to 1563 in Prague and thereafter until his death in 1595 State Prince of Tirol and the forelands. He began collecting on a large scale in Bohemia, his special interest being armour. On the one hand, coats of mail represented for him the historical personality of their one-time owners, and on the other, he valued them as pieces which reminded him of the events at which they had been worn. They constituted an imaginary collection of heroes, which he later called his 'honourable company'. While he was in Tirol, the Archduke was gradually able to arrange his collections, which he was trying from 1570 onwards to replenish, in Ambras Castle near Innsbruck in an orderly exhibition. The Ambras Collection of portraits became famous, and indeed at the time of Ferdinand's death it included more than a thousand likenesses of Church dignitaries, members of the Hapsburg family, rulers, celebrities, saints, miracle-workers, and fools from all parts of the world. His focus on Man from a historical and genealogical point of view as the bearer of history, and with special reference to his own great House, is thus an essential feature of Ferdinand's collection. In the *Kunstkammer* a series of ancient objects was included which had belonged to his great forebears.

The *Kunstkammer*, containing eighteen large cases reaching to the ceiling, which stood back to back in the middle of the room, was installed in a long gallery. On the walls hung pictures, and from the ceiling stuffed animals and bones. Inside, the cases were painted in different colours and their contents were arranged according to material: gold and rock-crystal perhaps in the blue case, silver in the green one. This was the first display of a collection geared to the viewer.

Corresponding to the modern concept of the encyclopaedia, the scope of the *Kunstkammer* embraced natural history specimens and artifacts divided up with as much differentiation as possible and with a balanced proportion between various spheres of collecting. Any special emphasis of the collection should be sought in the fields which are not found elsewhere, or only rarely, namely those which demonstrate Ferdinand's personal preference. These are works in coral, glass products, and elaborate turned pieces, which are partly still in Ambras, and *Handsteine* (hand-stones). When these things were acquired, or produced in the Innsbruck Court Workshops, it was not artistic criteria that were foremost, but rather rarity value,

inventive fancy, and the ingenuity and virtuosity of the works.

Hand-stones are display objects (the size of a hand) of particularly beautiful or high grade lumps of ore or miniature mountains made up of many different samples of rock from a mine, which were artistically sculpted, sometimes with mining and sometimes with Biblical scenes. The majority of all extant hand-stones come from the Ambras Collection and are to be found in Vienna. Among the objects which belong to nature as well as art are the ostrich-egg goblet (p 99), which is built up so elaborately with corals that it could hardly be held in the hand for an actual drink, and the shell lavabo (p 102). On Wenzel Jamnitzer's inkstand (p 96), the natural history specimens are cast in silver. The little box shaped like a miniature temple (p 101), in which Ferdinand kept some of his coins, is a work of art in itself.

Emperor Rudolf II (1552–1612), Ferdinand's nephew, was the most important and the most passionate collector of the House of Austria (p 105). He spent his most decisive formative years, that is to say from eleven to nineteen, in Spain at the Court of his uncle, King Philip II. In the midst of the rich art collections, the splendour, and the ceremonial of this Court, he not only formed his taste in artistic matters, but also developed an awareness of his outstanding personal significance as a future ruler. When he became Emperor at the age of twenty-four on the death of his father, Maximilian II, in 1576, consciousness of his rank and high standards of quality were so strongly combined in his collecting activity that the priceless treasures he brought together in his Prague residence—pictures, antiques, show weapons, and the *Kunstkammer*—should all be understood as an expression of a highly sophisticated Imperial idea. His agents travelled all over Europe, acquiring works of art for him. Rudolf tried, however, to make his collections particularly exclusive by setting up extensive Court workshops. International painters, sculptors, goldsmiths, gem-carvers, graphic artists, clockmakers, and others were summoned to Prague to work, as far as possible, exclusively for the Emperor. Rudolf's cultivated artistic taste had such a strong influence on these Court artists that it is possible to speak of a Rudolfian style in art around 1600.

Very few people were favoured with permission to view the fabulous collections. The Emperor, who was introvert by nature, was obviously becoming a prey to melancholy and suffered increasingly frequent deep depressions. As he also had recourse to all kinds of alchemistic, astrological, and magic practices, which at the time were regarded as an extension of knowledge by other means, and also seldom showed himself in public, he and his treasures were shrouded in legend even during his lifetime. While the Ambras Collection has survived the centuries relatively well, unfavourable events have resulted in Rudolf's collection coming down to us in a very incomplete state.

Sculpture at the time was under the influence of Giambologna, whose works Rudolf avidly collected (p 88). Adriaen de Vries, the most important disciple of Giambologna, was taken by Rudolf into his service. The Emperor commissioned him to sculpt his bronze bust after the Charles v portrait by Leoni (pp 105, 85) in order to measure himself directly against this great model. Along with de Vries, Hubert Gerhard was the leading sculptor in Germany. The bronze group 'Mars, Venus, and Cupid' (p 107) is a reduction of the larger than life-size group in the Castle of Kirchheim near Augsburg which he made for Hans Fugger. Johann Gregor van der Schardt (p 106) was also under the spell of Giambologna. The ivory engraver Nikolaus Pfaff, who made an exquisite little Venus (p 107), is mentioned only in the inventory of Rudolf's *Kunstkammer*.

In the field of goldsmiths' art, the Collection is indebted to the Emperor for works, again of the highest quality. The Augsburg and Nürnberg masters who were occasionally summoned to Prague adapted themselves totally to the Imperial style. Rudolf's influence is most apparent in the complicated sequence of Christoph Jamnitzer's magnificent pieces (p 108), which in addition to the *trionfi* after Petrarch also include the ages of the world, the continents, and other allegorical figures and mythological scenes. The basin of the Augsburg artist Christoph Lencker (p 109) also follows the Prague Court art in the style of its figures. The natural history specimens evidently have a special part to play. The extremely sumptuous mount of the narwhal goblet (p 109) can only be accounted for by the unusual powers which were ascribed to the narwhal tusk. Bezoars, stomach stones from various ruminants, were valued by the Emperor on account of their alleged healing powers and

their protective action against poison (pp 86, 110). The rhinoceros horn goblet, with the tusks of a wild boar worked into the cover (p 110), was supposed to increase physical powers. The Seychelles nut, on the other hand, was an exceptional rarity, and this rarity underlay the lavish artistry of Anton Schweinberger's workmanship (p 110). Rudolf II was particularly fond of precious stones, believing in the age-old powers of healing and miracle-working that were attributed to them. With the appointment of the Milan gem-carver, Ottavio Miseroni, he founded the famous Prague gem-carving studio, in which not only vessels (p 111) but also cameos (p 115) were produced. The brothers Giovanni and Cosimo Castrucci also spent long years in Prague making a valuable series of *commessi* in *pietre dure* (p 105) for the Emperor, many of which are still preserved in Vienna.

Rudolf II was also strongly attracted to the reproduction of time by mechanical means. Through the elaborate clocks, with their manifold indexes and dials, and with astrolabes and calendars, he drew the powers of the heavens into his world and felt akin to them. Great attention was thus concentrated on the artistic fashioning of clocks (pp 112, 113). Significant technical and scientific innovations were also carried out successfully by the inventor of the rolling ball clock, Christoph Margraf (p 112) and the famous mathematician and designer Jost Bürgi (p 113), whom Johannes Kepler called a second Archimedes. The sixteenth-century conception of art with its high regard for the artificial, accounts for the mechanical, clockwork products (pp 102, 114), which gave the impression of being able to invest the inanimate with life.

▷

WAX PORTRAIT OF ARCHDUKE FERDINAND II (1529–95)
Francesco Segala (working mainly in Padua and Venice, second half 16th century), Innsbruck *c* 1575
Coloured wax studded with small gems and pearls; signed; 22.3 × 19.9 cm
Archduke Ferdinand, Governor of Bohemia from 1547–63, sovereign of the Tirol from 1563–95, established a famous *Kunstkammer* in Ambras Castle near Innsbruck.
Listed in the 1596 inventory of the Ambras Collection. (3085)

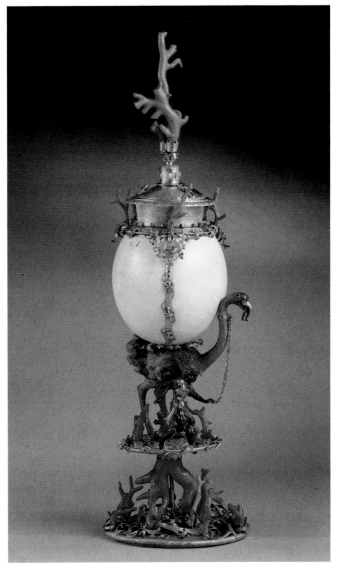

▽

GOBLET WITH COVER
Antonio Montano (worked in Hall, the Tirol, 1572–90), Hall, after 1582
Yellowish glass; *H* 34.1 cm
On the cup (*Kuppa*) are the coats of arms of Archduke Ferdinand II and his second Duchess Anna Katarina of Mantua.
From the Ambras Collection. (3363)

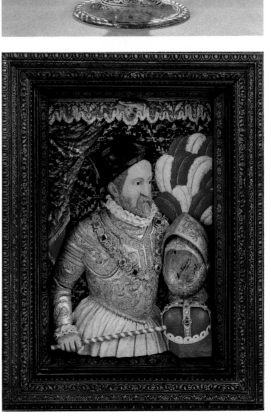

△

OSTRICH-EGG GOBLET
Clement Kicklinger (master 1561, d. Augsburg 1617), Augsburg *c* 1570/5
Ostrich egg, corals; silver-gilt or painted; *H* 56.8 cm
Behind the arrangement of the natural specimens one can sense the belief in their special magical powers.
From the Ambras Collection. (897)

△
LEDA AND THE SWAN
Francesco Segala (mainly working in Padua and Venice, second half of 16th century), Innsbruck, c 1575
Coloured wax; painted background;
14.8 × 13.8 cm
Listed in the 1596 inventory of the Ambras
Collection. (3067)

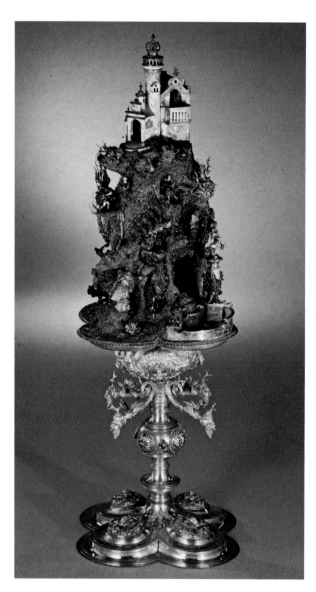

HAND-STONE IN THE FORM OF A TABLE FOUNTAIN
Bohemia(?), late 16th century
Various stone samples, enamel figurines,
silver painted, especially gilt; H 60.5 cm
King David looking down from the balcony of
his palace at Bathsheba in the bath. Miners
working on the slopes.
Listed in the 1596 inventory of the Ambras
Collection. (4161)

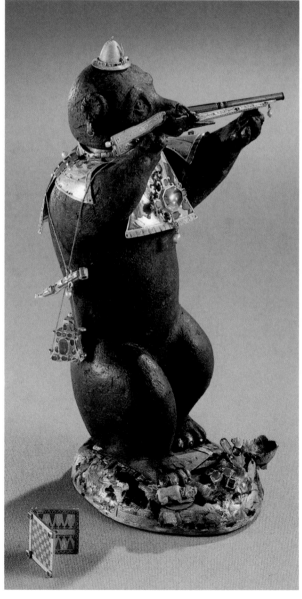

AND-STONE

ohemia (Joachimsthal?), mid 16th century

tone samples, silver filigree, the figures made
f silver-glance, the buildings painted in silver;
tand silver-gilt, inlay of gold glass; *H* 27.8 cm
cenes: The Resurrection, the three women at
he tomb of Christ, the Disciples in Emmaus
reverse side).
isted in the 1596 inventory of the Ambras
Collection. (4147)

COIN BOX OF ARCHDUKE FERDINAND II

Augsburg, second half of 16th century

Ebony, gilt bronze figurines, precious stones,
pearls; *H* 86 cm
On top is a circular temple, dedicated to the
Muses. Inside are six sections with sixty-six
slots for coins.
Listed in the 1596 inventory of the Ambras
Collection. (3390)

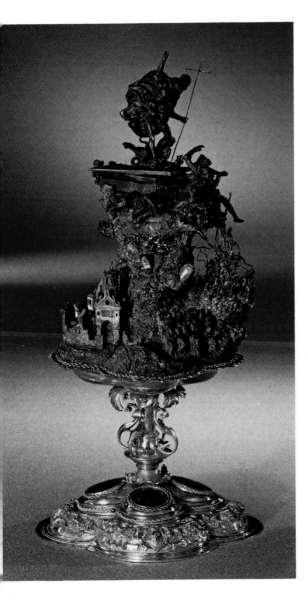

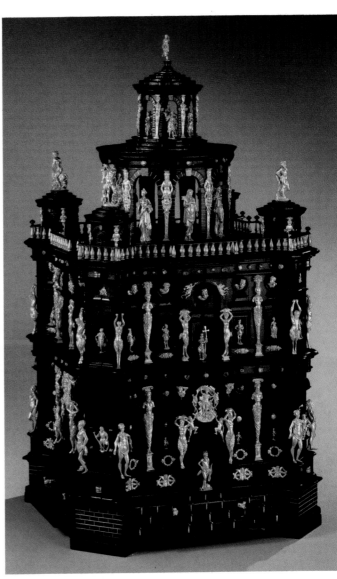

◁

THE BEAR AS HUNTER

Gregor Bair (b. Meran, master 1573,
d. Augsburg 1604), Augsburg, *c* 1580/90
Bear silver, covered with musquash; base
enamelled silver, gold, precious stones, pearls;
H 21.3 cm
Allegory of a topsy-turvy world.
Listed in the 1596 inventory of the Ambras
Collection. (1094)

▷

HUMOROUS BOTTLE
Christoph Gantner (d. Innsbruck 1605),
Innsbruck c 1580/90
Tin-glazed earthenware; H 26.6 cm
The head of the figure can be removed. The
glutton cannot reach the near-by delicacies as
his arms have to support the richly laid table—
a punishment for his gluttony.
Listed in the 1621 inventory of the Ambras
Collection. (3155)

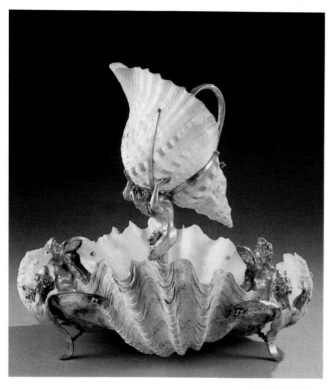

△

SHELL LAVABO: EWER AND BASIN
Elias Gross (master c 1566, d. 1572 in
Augsburg), Augsburg, c 1570
Tricnada shells, triton shell, silver-gilt; H of
ewer 32 cm, W of basin 39.5 cm
From the Ambras Collection. (4128 and 4129)

▷

GIRL PLAYING A CITTERN: MECHANICAL DOLL
Spain(?), second half of 16th century
Iron works; player's body painted wood;
garments linen and silk brocade; H 44 cm
The doll moves with mincing steps, turns its
head and strikes the strings of the instrument.
Such human figures were greatly admired, as
they gave the illusion of the inanimate brought
to life.
Koloman von Wischnitz-Naszod Bequest,
1934. (10,000)

TABLE CLOCK

Jeremias Metzker (worked in Augsburg between 1555 and 1599), Augsburg 1564, signed and dated

Gilt bronze; iron works; *H* 29.7 cm
Face with hour-dial numbered I–XII and 1–24, sections for length of day and night or sunrise and sunset respectively, calendar dial (*left*), position of the sun in the zodiac (*right*), small dial indicating the Sundays, dial to regulate the striking mechanism (*above right*); on the narrow sides control dials; on the second face a mechanical Astrolabe, weekday indicator.
From the Treasury. (852)

ARMILLARY SPHERE

Pierre de Fobis (worked in Lyons between 1507 and *c* 1575), Lyons, mid-16th century, signed

Gilt brass, iron, glass; *H* 53 cm
The armillary sphere served to show the different celestial movements and is thus a precursor of the orreries.
Presented in 1949 by Claire de Rothschild in memory of Dr Alphonse de Rothschild. (9843)

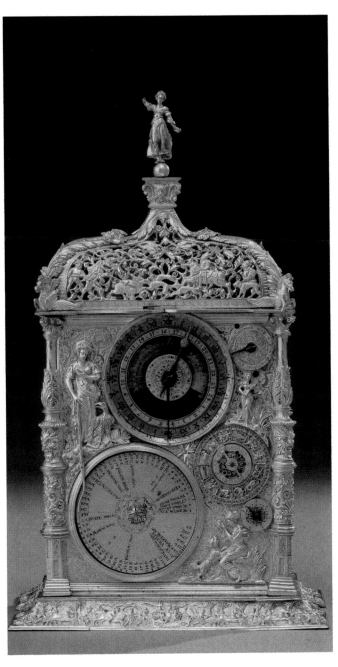

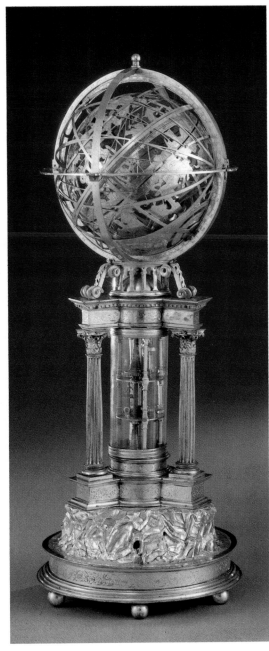

Above: Cross pendant
South German, early 17th century
Enamelled gold; 13 diamonds, 6 rubies,
2 pendant pearls; *H* 6.1 cm
Gustav Benda bequest, 1932. (9022)

Centre left: Medallion: St John the Evangelist
Milan, late 16th century
Enamelled gold; *H* 5.6 cm
Listed in the 1619 Estate inventory of the
Emperor Matthias. (1608)

Centre: Pendant: Moses smiting the rock
Augsburg, *c* 1600
Enamelled gold; 11 diamonds, 4 rubies,
3 pendant pearls; *H* 7.3 cm
From the Treasury. (1616)

Centre right: Medallion: Judith with the head of
Holofernes
Milan, late 16th century
Enamelled gold; *H* 4.8 cm
The setting is missing.
Listed in the 1619 Estate inventory of the
Emperor Matthias. (1586)

Below: Pendant, huge pearl in the form of a
cluster of grapes
South German, early 17th century
Setting: enamelled gold, rubies; *L* 5.3 cm
Listed in the 1750 Treasury inventory. (2127)

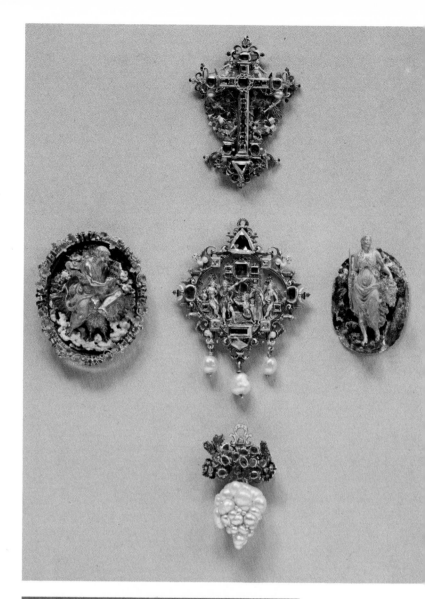

MINIATURE ALTAR: ADORATION OF THE MAGI
**Court Workshop, Munich or Augsburg,
c 1600**
Ebony; enamelled gold; pearls, diamonds,
emeralds, rubies, sapphires; 17.5 × 11.9 cm
Present from the Empress Eleonora Magdalena
Theresia to the Emperor Leopold I (reigned
1658–1705, married Eleonora 1676) on the
occasion of his name-day. (3218)

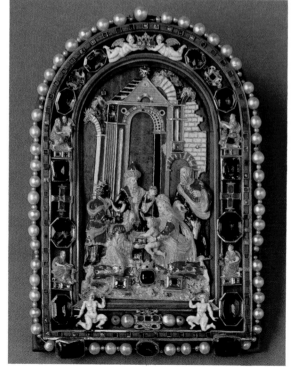

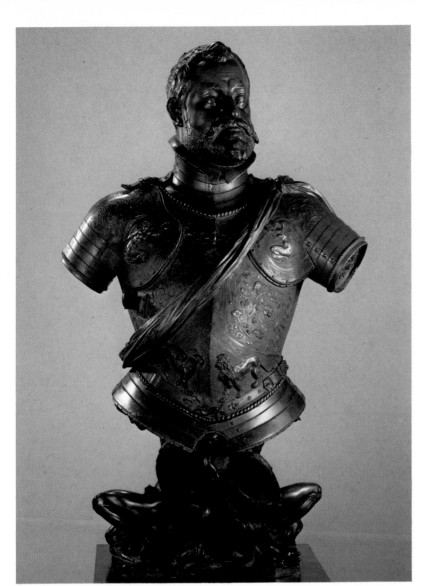

BUST OF THE EMPEROR RUDOLF II
**Adriaen de Vries (b. The Hague c 1545,
d. Prague 1626), Prague, 1603, signed and
dated**
Bronze, light brown lacquer; *H* 112 cm
Conceived as a companion piece to the bust of
Emperor Karl v by Leone Leoni.
Listed in the inventory of the *Kunstkammer* of
Emperor Rudolf II, carried off to Sweden in
1648, brought back in 1806. (5506)

▽

VIEW OF THE HRADSCHIN IN PRAGUE
**Castrucci Court Workshop, Prague (Giovanni
and Cosimo Castrucci, worked in Florence
and Prague), early 17th century**
Commesso in *pietre dure*; 23.5 × 11.4 cm
After a woodcut by Johann Willenberger.
From the Treasury. (3060)

MERCURY

Johann Gregor von der Schardt (b. Nimeguen
c 1530, worked mainly in Nürnberg),
Nürnberg, late 16th century
Bronze, brown lacquer; *H* 53 cm
From the Treasury. (5900)

ALLEGORY OF SPRING

Wenzel Jamnitzer (b. Vienna 1508,
d. Nürnberg 1585), and Johann Gregor von
der Schardt, Nürnberg *c* 1580
Gilt cast brass; *H* 71.2 cm
The figures of the four seasons were the
bearers of a precious silver fountain.
Listed in the 1607/11 inventory of the
Kunstkammer of the Emperor Rudolf II. (1118)

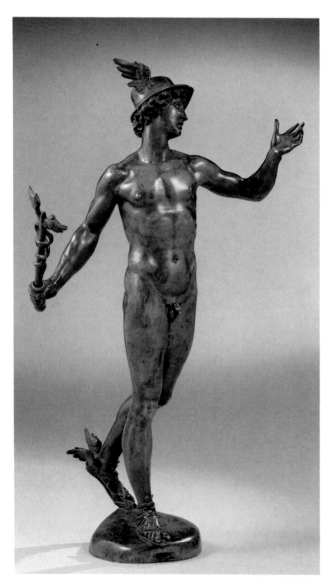

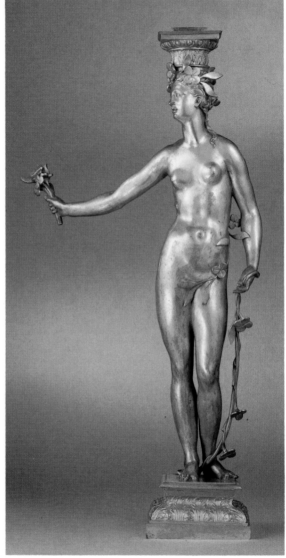

VENUS AND CUPID
Nikolaus Pfaff, Prague, *c* **1600**
Ivory; *H* without base 13.5 cm
No biographical details are known for Pfaff.
Listed in the 1607/11 inventory of the
Kunstkammer of the Emperor Rudolf II as a
work by N. Pfaff. (4658)

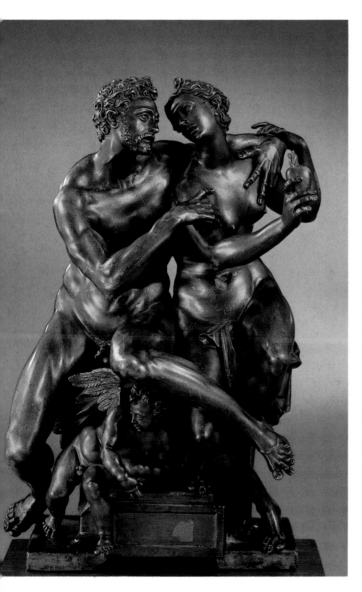

MARS, VENUS, AND CUPID
Hubert Gerhard (b. Amsterdam(?) *c* **1550,**
d. Munich 1622/3), late 16th century
Bronze, reddish-brown lacquer; *H* 41.4 cm
The intricate intertwining of the figures
identifies them as works of the school of
Giambologna.
From the Treasury. (5848)

▷

ORNAMENTAL EWER
**Christoph Jamnitzer (b. and d. Nürnberg
1562–1618), Nürnberg between 1603 and 1607**
Silver-gilt, enamel; *H* 43.5 cm
The panels of the ewer are chased with five
trionfi after Petrarch: the Triumph of Chastity
over Love; of Death over Chastity; of Fame
over Death; of Time over Fame; of Eternity
over Time.
From the Treasury. (1128)

▷ ▷

EWER
**Nikolaus Schmidt (b. Greifswald, master
1582, d. Nürnberg 1609), Nürnberg, *c* 1600**
Silver-gilt, mother of pearl, garnets; *H* 54 cm
It is known that a basin belongs to this ewer,
which can be identified in the 1607/11
inventory of the *Kunstkammer* of the Emperor
Rudolf II.
From the Treasury. (1124)

ORNAMENTAL DISH DEPICTING THE STORY OF EUROPA
Christoph Lencker (b. Ludwigsorget c 1556, d. Augsburg 1613), Augsburg, late 16th century
Silver-gilt, enamel; L 69 cm, W 58.5 cm
Listed in the 1607/11 inventory of the
Kunstkammer of the Emperor Rudolf II. (1110)

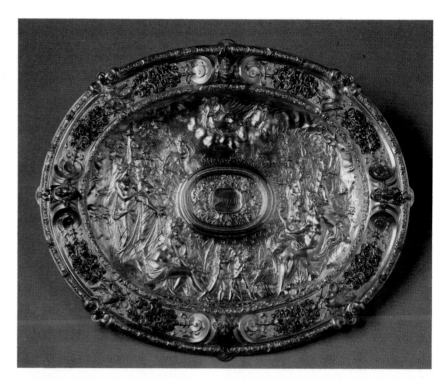

◁
ORNAMENTAL DISH DEPICTING CUPID'S
TRIUMPHAL PROCESSION
Christoph Jamnitzer (b. and d. Nürnberg 1563–1618), Nürnberg between 1603 and 1607, signed
Silver-gilt, enamel; L 64.7 cm, W 53 cm
Together with the ewer (1128), the basin forms a set which is considered the most important work of the master.
Listed in the 1607/11 inventory of the
Kunstkammer of the Emperor Rudolf II. (1104)

▷
GOBLET WITH COVER, MADE OF NARWHAL
TUSK IVORY
Prague Court Workshop, early 17th century
Mount: enamelled gold, diamonds, rubies; the cover is crowned with two cameos of agate;
H 22.2 cm
The tusk of the Narwhal was supposed to be the horn of the legendary Unicorn. It is for this reason that extraordinary magical powers are ascribed to it.
Listed in the 1619 Estate inventory of the
Emperor Matthias. (1113)

▷▷
JASPER JUG
Miseroni Workshop, Milan, late 16th century
Gold mounts by Paulus van Vianen
(b. Utrecht after 1570, d. Prague 1613),
Prague 1608, signed and dated
H 35.9 cm
Listed in the 1607/11 inventory of the
Kunstkammer of the Emperor Rudolf II. (1866)

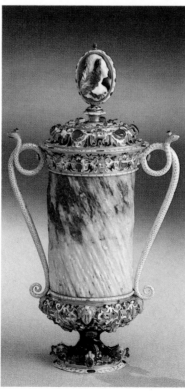

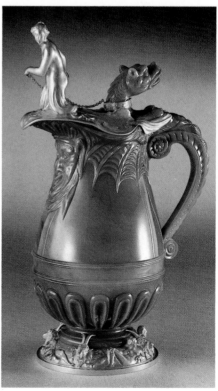

GOBLET WITH COVER
By Nürnberg or Augsburg masters (working) in Prague, 1611

Rhinoceros horn, tusk of a young boar, silver-gilt; *H* 49.7 cm

These natural specimens, which were ranked as trophies, were valued as much for their rarity as the magical powers ascribed to them. Listed in the 1607/11 inventory of the *Kunstkammer* of the Emperor Rudolf II. (3709)

BOWL WITH COVER MADE FROM A HOLLOWED-OUT BEZOAR
Prague, Imperial Court Workshop, early 17th century

Mount: enamelled gold; *H* 14.3 cm

Rudolf II valued the magical powers of bezoars particularly highly. He used them among other remedies against melancholy. From the Treasury. (3259)

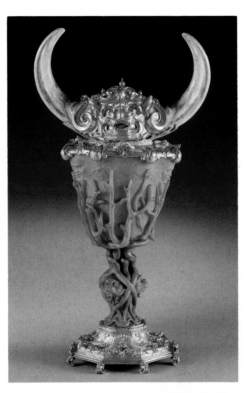

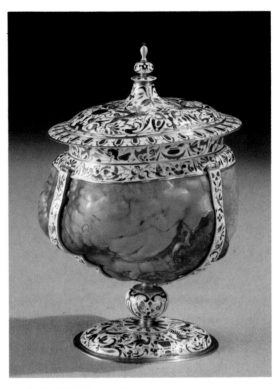

EWER MADE OF HALF A SEYCHELLES NUT
Anton Schweinberger (Augsburg master, Court Goldsmith of Emperor Rudolf II, worked in Prague 1587–1603, d. *c* 1603), Prague *c* 1600, signed

Carved Seychelles nut, silver-gilt; *H* 38.5 cm

In 16th-century Europe the nut *Lodoicea Maledivia* was considered a great rarity and a wonder of the first rank.

Listed in the 1607/11 inventory of the *Kunstkammer* of the Emperor Rudolf II. (6872)

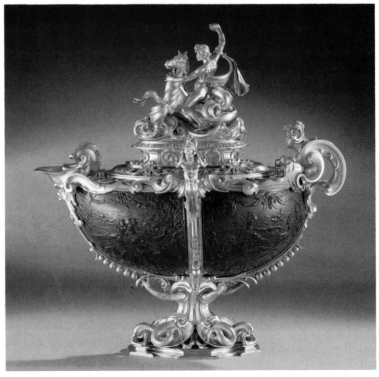

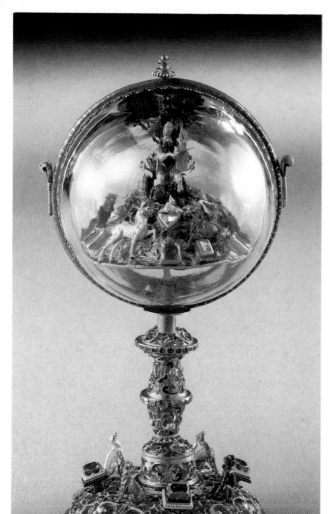

◁

ORPHEUS GLOBE
South German, second half of 16th century
Rock-crystal, enamelled gold, diamonds,
rubies; *H* 16.7 cm
From the Treasury. (1097)

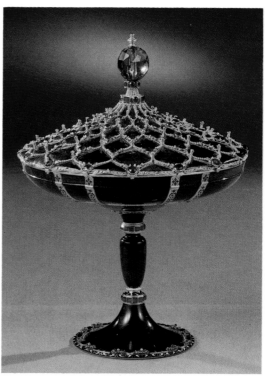

△

PRASE BOWL WITH COVER ON A TALL PEDESTAL
Prague, Imperial Court Workshop, *c* 1600
Mount: enamelled gold, garnets, citrine
(yellow quartz); *Diam* 18.4 cm, *H* 23.8 cm
Listed in the 1607/11 inventory of the
Kunstkammer of the Emperor Rudolf IIs. (1918)

◁

MOSS-AGATE BOWL
**Ottavio Miseroni (Gem-carver from Milan,
d. Prague 1624), Prague, early 17th century**
Mount: enamelled gold; *H* 17.7 cm
With the summoning of Ottavio Miseroni to
Prague in 1588, Rudolf II founded a famous
studio for gem-carving, which existed until
1684.
Listed in the 1607/11 inventory of the
Kunstkammer of the Emperor Rudolf II. (1987)

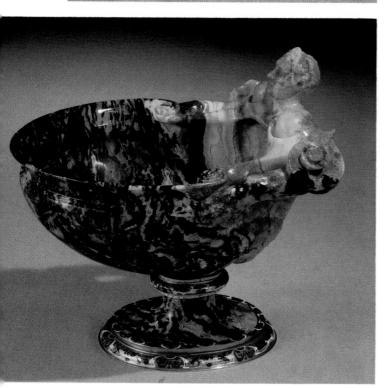

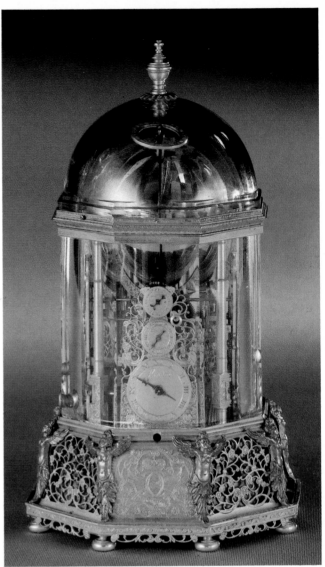

CELESTIAL GLOBE
**Georg Roll (b. Liegnitz 1546, d. Augsburg
1592) and Johann Reinhold (b. Liegnitz(?)
c 1550, d. Augsburg 1590), Augsburg 1583/4,
signed and dated**
Bronze, gilt brass, partly painted, silver, wood;
iron works; H 54 cm
Listed in the 1607/11 inventory of the
Kunstkammer of the Emperor Rudolf II. (854)

ROLLING BALL CLOCK
**Christof Margraf (worked in Prague between
1587 and 1620/4), Prague, 1596, signed and
dated**
Wood, gilt copper, glass, silver ore, painted in
body colours; iron works; H when open
40.3 cm, W 28 cm, D 23 cm
From the Treasury. (845)

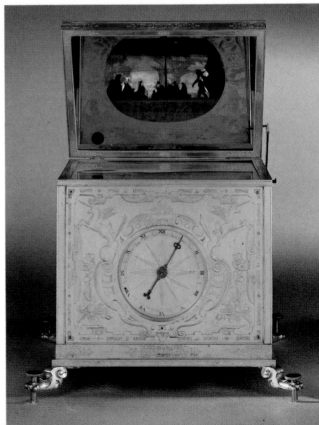

TABLE CLOCK

Jost Bürgi (b. Lichtensteig, Canton of St Gallen, Switzerland 1552, d. Kassel 1632), Prague, between 1622 and 1627, signed

Gilt brass, silver, rock-crystal; brass works; H 18.6 cm

The hour, minute, and second dials lie one on top of the other. This is one of the main works of the great mathematician and technologist, demonstrating several technical innovations. Listed in the 1750 inventory of the Treasury. (1116)

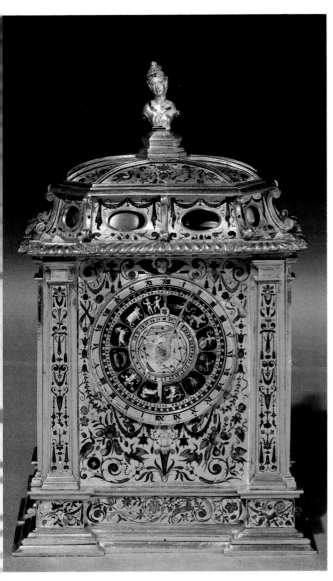

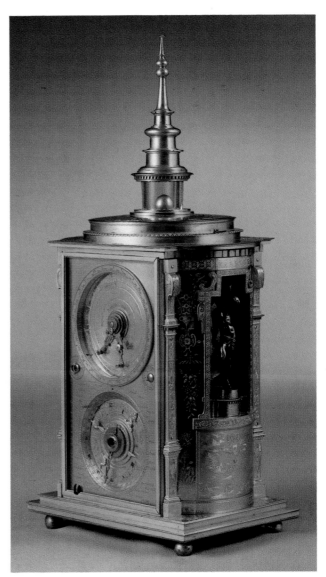

TABLE CLOCK

Case by Cornelius Gross (Master before 1534, d. Augsburg 1575), deep cut enamel by David Altenstetter (master 1573, d. Augsburg 1617), Augsburg c 1570/5

Silver, enamel; iron works and brass; H 21.8 cm

Listed in the 1607/11 inventory of the *Kunstkammer* of the Emperor Rudolf II. (1121)

PLANETARIUM CLOCK

Jost Bürgi (b. Lichtensteig, Canton of St Gallen, Switzerland, 1552, d. Kassel 1632), Prague c 1604

Bronze, gilt brass, painting on parchment, glass, rock-crystal; brass and iron works; H 39.3 cm

First known example with a heliocentric orrery.

From the Treasury. (846)

MUSICAL BOX IN THE FORM OF A SHIP

Hans Schlottheim (b. Naumburg/Saale
c 1545, d. Augsburg 1625), Augsburg 1585,
dated

Silver-gilt, figurines and sails painted; iron
works: H 67 cm, L 66 cm (874)

CLOCK WITH FIGURES REPRESENTING DIANA ON A
CENTAUR

Augsburg, c 1600/10; goldsmith work by
Melchior Mair (b. c 1565, master c 1598, d.
Augsburg 1613)

Silver, parcel-gilt, deep-cut enamel, precious
stones, wood; H 39.5 cm
The mechanical works are in the base, and the
works of the clock in the body of the Centaur.
Listed in the 1619 Estate inventory of the
Emperor Matthias. (1166)

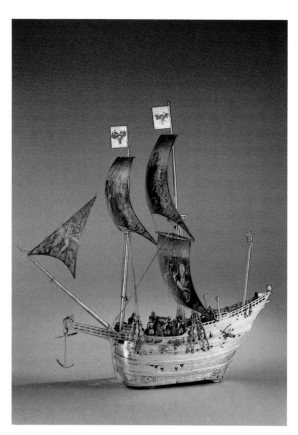

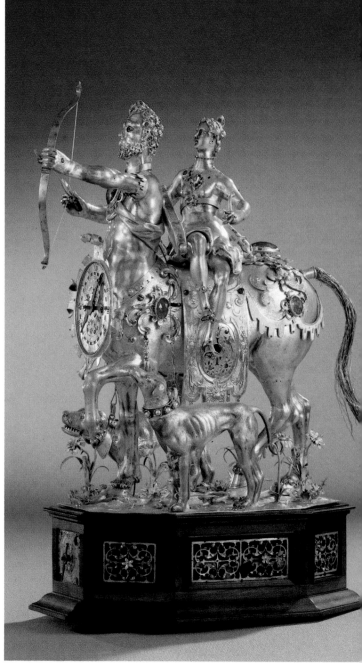

MUSICAL BOX IN THE FORM OF A SHIP

Hans Schlottheim (b. Naumburg/Saale
c 1545, d. Augsburg 1625), Augsburg 1585,
dated

CLOCK WITH FIGURES REPRESENTING DIANA ON A
CENTAUR

Augsburg, c 1600/10; goldsmith work by
Melchior Mair (b. c 1565, master c 1598, d.
Augsburg 1613)

Above left: Rudolf II
Ottavio Miseroni (d. Prague 1624), Prague c 1590, signed
Chalcedony, silver filigree; Setting: enamelled gold, Prague, c 1610/20); H 5.6 cm, W 4.1 cm
Listed in the 1750 inventory of the Treasury. (XII/58)

Above right: Ceres
Ottavio Miseroni, Prague, c 1600
Relief *commesso* on a chalcedony ground; Setting: enamelled gold; Prague, early 17th century; H 8.2 cm, W 6.6 cm
Listed in the 1619 Estate inventory of the Emperor Matthias. (XII/29)

Centre: Half-figure of a girl
Ottavio Miseroni, Prague c 1600
Relief *commesso* on a chalcedony ground; Setting: gold, single pearl; H 8.5 cm, W 5.3 cm
Listed in the 1750 Treasury inventory.(XII/140)

Below left: Latona transforming the Lycian peasants into frogs
Alessandro Masnago, Milan, late 16th century
Jasper; Setting: enamelled gold; Milan, end of 16th century; H 6 cm, W 7.3 cm
Listed in the 1750 inventory of the Treasury. (XII/136)

Below right: The Entombment of Christ
Alessandro Masnago, Milan, late 16th century
Agate; Setting: silver-gilt; H 5.6 cm, W 7.3 cm
Listed in the 1619 Estate inventory of the Emperor Matthias. (XII/822)

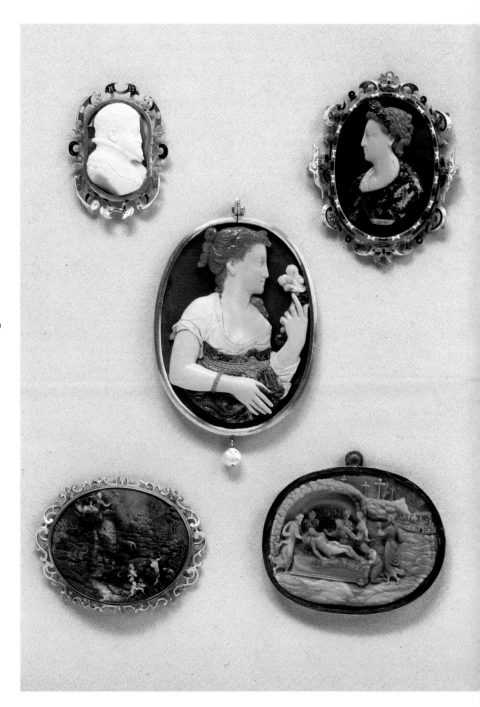

Baroque

In the Baroque period there was a shift of emphasis in collecting, before interest turned away from the *Kunstkammer* in the eighteenth century. Ousted by the sensuous charm of ivory, which now fascinated the collector, the bronze statuette lost some of its importance. Goldsmiths' art and the production of clocks and mechanical instruments had also passed their peak in Rudolf's time.

An extremely interesting and unique artist, whose identity is still unknown, is the so-called *Furienmeister*, Master of the Furies (p 117), whose works have been variously dated from the middle of the seventeenth until the second half of the eighteenth century. The language he speaks is, nevertheless, incomparably more vigorous than that used in the eighteenth century. The vibrant, sensuous surface of the similarly elongated and mannered figures of Poseidon and Amphitrite from around 1700 (p 118), which are ascribed to the Venetian Antonio Leoni, are just as far removed from him in style as Jacob Auer's gently animated modelling in the virtuoso piece 'Apollo and Daphne' (p 125). The *Furienmeister* is probably a South German artist of the early seventeenth century, who had in his field of vision both the achievements of Giambologna and also the nervous Chiliasm of German art around 1500, which he elaborated into a very personal style of gripping and expressive power. The early Baroque figures of Leonhard Kern (p 118) make an emotionless and earthbound impression compared with them, while Adam Lenckhardt's realistically solid group (p 118) reflects the coarse, boisterous manners of the time of the Thirty Years' War. A great master of ivory sculpture was Ignaz Elhafen, who knew how to draw the most delicated, sensuous charms out of the warm, dense material. He was particularly fond of using mythological scenes to represent beautiful bodies (p 122), which he distributed in a pleasing manner across a single plane of the foreground. In sharp contrast is another large-scale sculptor, Johann Ignaz Bendl, whose graphic reliefs feature a dynamic group in the foreground, from which the eye is progressively drawn to the depths by images in a succession of planes. The Vienna collection has a twelve-piece series of these (p 122). The three great equestrian statues of Matthias Steinl, of which Emperor Joseph I is reproduced here (p 125), occupy a special position. In this technical work of art, made up of sections, a meticulous realism in detail is combined with the huge animated conception of the young future Emperor as the conqueror of the snake-headed spirit of evil. Another work attributed to Steinl is the towering, many-faceted 'Allegory of Water and Air' (p 125), which clearly competes with Giambologna's 'Rape' group and which in so doing admirably demonstrates technical composition by following the curved shape of the tusk.

In the seventeenth century many princes followed the fashion of producing complicated turned pieces in ivory. Nürnberg had acquired a special reputation in this field. The leading master was Lorenz Zick, who instructed the Emperor Ferdinand III in this technique in Vienna, and whose father, Peter Zick, was the master of Emperor Rudolf II. The trick with the 'Counterfeit globe' (p 117) consisted in turning the globe out of a single piece of ivory and through small openings in the globe, two medallions for miniatures. Zick had great skill in constantly inventing new technical surprises, which had many imitators. Along with the ivories, vessels of precious stones formed the biggest addition to the Vienna Treasury in the seventeenth century. Dionysio Miseroni, the son of Ottavio, worked almost exclusively for the Emperor in Prague. He developed heavy, angular shapes for vessels, whose decoration ranges from severe surface ribbing to Italianate tendril patterns (p 119). Along with these, pieces from Milan found their way—mostly as presents—to the Court at Vienna (pp 119, 120).

The few Baroque works of goldsmiths' art in the Collection are not really *Kunstkammer* pieces, but decorative works that had fallen out of use and had been handed over to the Treasury by the Court. The heavy gold breakfast service belonging to Maria Theresa and made by Anton Matthias Domanek (p 127), which along with the matching toilet-set of her husband, Franz Stephan of Lorraine, consists of some seventy pieces, is one of the main works of the Vienna goldsmiths' art of the eighteenth century.

Portrait sculptures found their way into the Collection more or less by chance (pp 124, 125, 127). Giulia Albani (p 125) was the aunt of Pope Clement XI, and had brought him up after the early death of his mother. He had a memorial erected on her tomb in San Domenico in Pesaro, which occasioned Rusconi's sculpture, showing her in eternal devotion.

ONE OF THE FURIES

South German, early 17th century

Ivory; H 37.4 cm

A group of expressively shaped ivory figures attributed to an anonymous master. These statuettes earned him the title *Furienmeister* (the master who created the Furies). Transferred 1846 from the Natural Philosophy Room. (3727)

ONE OF THE HESPERIDES FEEDING THE DRAGON LADON WITH GOLDEN APPLES

Furienmeister, **South German, early 17th century**

Ivory; H 30.4 cm

Transferred 1846 from the Natural Philosophy Room. (4559)

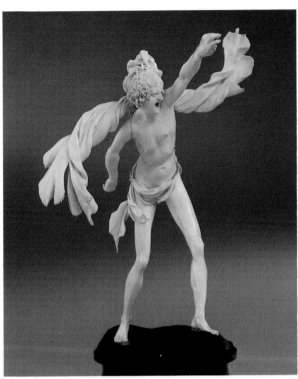

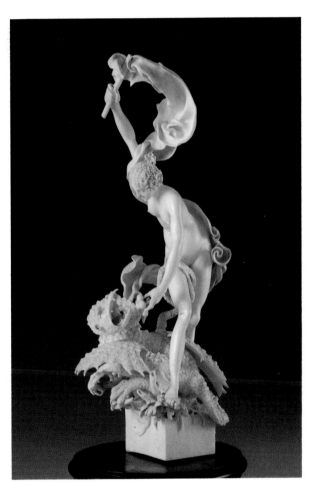

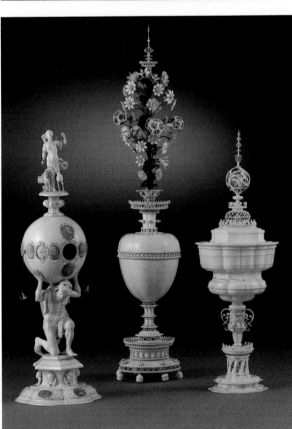

◁

TURNED IVORY PIECES

Left: the so-called *Konterfetten* globe (globe with miniatures)

Lorenz Zick (b. and d. Nürnberg 1594–1666) Nürnberg, between 1637 and 1657

H 37.5 cm

On the globe are shell cameos depicting the Hapsburg Emperors from Emperor Rudolf II to Emperor Ferdinand III.

Centre: Goblet with cover crowned with flowers.

South German, early 17th century

H 54 cm

Right: Goblet with cover

Georg Burrer (worked in Stuttgart, early 17th century), Stuttgart, 1616, signed and dated

H 37.4 cm

All three pieces from the Treasury. (4503, 4777 and 4681)

POSEIDON AND AMPHITRITE
Italian, c 1700, in the style of Antonio Leoni
Ivory; *H each* 29 cm
Bought in 1931 on the art-market. (8798 and 8799)

SATYR WITH THE NYMPH CORISCA
Adam Lenckhardt (b. Würzberg 1610, d. Vienna 1661), Vienna, 1639, signed and dated
Ivory: *H* without base 22.7 cm
From the Treasury. (4564)

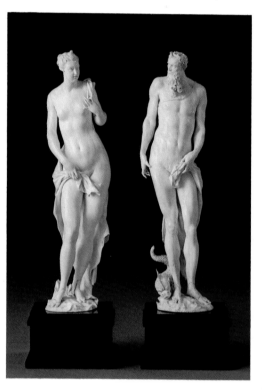

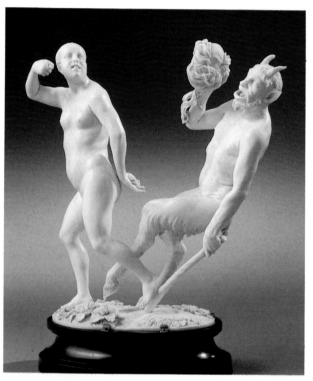

▷
ABRAHAM AND KING DAVID
Leonhard Kern (b. Forchtenberg, Württemberg 1585, d. Schwäbisch Hall 1662), Schwäbisch Hall, c 1620 and c 1625 respectively
Ivory; *H* 30 cm and 27.4 cm
From the Treasury. (4571 and 4573)

ORNAMENTAL ROCK-CRYSTAL VASE
Milan, first half of 17th century
Base silver-gilt, tendril in relief of enamelled
gold; H 54.4 cm
Hunting scenes are engraved on the bowl of
the vase.
From the Treasury. (1549)

CITRINE FLOWER VASE
**Dionysio Miseroni (b. and d. Prague
c 1607–61), Prague, 1647/8**
H without flowers 26 cm
The flowers are made of coloured agates and
jaspers, of chalcedony and rock-crystal; stand
enamelled gold.
·Transferred to the Vienna Treasury in 1648.
(1330)

THREE ORNAMENTAL VESSELS
**Dionysio Miseroni (b. and d. Prague
c 1607–61)**
Hexagonal goblet with cover
Prague 1648/9
Smoked quartz; base silver-gilt; basse-taille
enamel; H 29 cm
Large faceted vase with cover, with tendril intaglio
Prague, 1653–5
Rock-crystal; mount silver-gilt, enamel;
H 47.2 cm
Bowl of light smoked quartz
Prague, 1650
L 18.5 cm
All three pieces were transferred direct to the
Vienna Treasury. (2246, 1339 and 1367)

BRATINA: RUSSIAN BROTHERHOOD CUP
Moscow, c 1630/40
Gold, part-enamelled; rubies, sapphires,
emeralds, pearls; *H* 27 cm
On the cover the white Polish Eagle is depicted
with the letters wr on the breast. Russian
inscription. Present from Archduke Michael
Feodorovish of Moscow to King Wladislaus iv
of Poland in 1637.
Listed in the 1750 inventory of the Treasury.
(1114)

**CENTREPIECE IN THE SHAPE OF A DRAGON WITH A
LION'S HEAD**
Milan, c 1650
Rock-crystal; base silver-gilt, tendril in relief
enamelled gold; *H* 48.2 cm. *L* 56.4 cm
Listed in the Vienna Treasury in 1659. (2331)

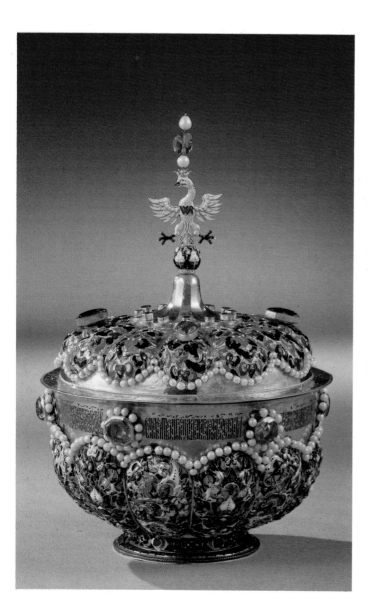

▷
THE SERMON OF JOHN THE BAPTIST
**Georg Schweigger (b. and d. Nürnberg
1613–90), Nürnberg, 1645, signed and dated**
Kehlheim stone; 20 × 14 cm
To the left of the soldier with the plumed
helmet is Albrecht Dürer.
From the Ambras Collection. (4376)

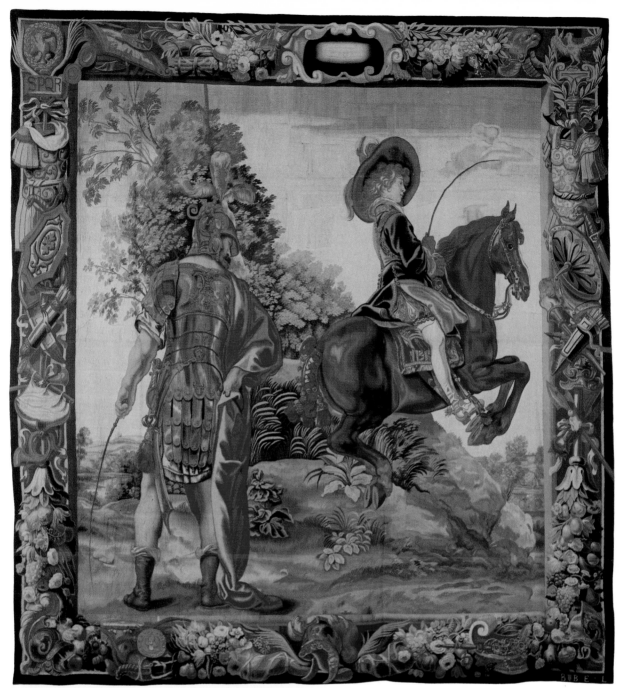

△

KING LOUIS XIII OF FRANCE'S RIDING LESSON:
BALLOTADE POSITION
**Brussels, *c* 1660, studio of Everard Leyniers
(1597–1670), with initials**
Wool and silk tapestry, some gold and silver
thread; 410 × 382 cm
From a series of eight.
Purchased on the occasion of the Emperor
Leopold I's wedding in 1666. (XL/7)

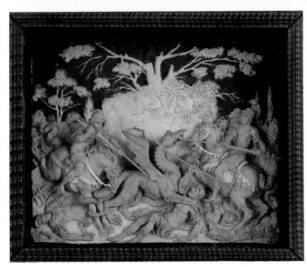

◁

FIGHT WITH THE DRAGON
**Daniel Neuberger (b. Augsburg *c* 1625,
d. Regensburg 1680), Vienna, between 1651
and 1663**
Wax relief; 14 × 15.8 cm
From the Ambras Collection. (3087)

▷

SCENES FROM THE LIFE OF ALEXANDER THE GREAT:
BATTLE OF THE GRANICUS, ALEXANDER ON
HORSEBACK IN THE THICK OF THE BATTLE (SECTION)
**Paris Gobelins (State Tapestry Factory) 1687/8,
Jan Jans the Younger, with initials**
Wool and silk tapestry, some gold and silver
thread; 485 × 845 cm
From a series of eleven, after paintings by
Charles Le Brun (1619–90).
From the Estate of the Emperor Franz I of
Lorraine. (v/2)

THE JUDGMENT OF PARIS
**Ignaz Elhafen (b. Innsbruck 1658,
d. Düsseldorf 1715), Vienna, c 1695/1700,
with initials**
Ivory; 10.4 × 16.7 cm
From the Treasury. (4178)

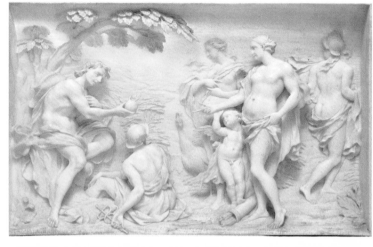

THE BATTLE OF THE AMAZONS
**Ignaz Elhafen (b. Innsbruck 1658,
d. Düsseldorf 1715). Vienna(?), c 1680/5**
Light cedar wood; 12.8 × 19.7 cm
From the Ambras Collection. (3932)

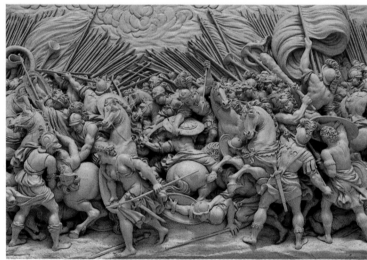

PHAETON SCORCHING THE EARTH
**Johann Ignaz Bendl (worked in Bohemia and
Vienna, c 1730), Vienna, 1684**
Ivory; 14 × 23.8 cm
From the Treasury. (3782)

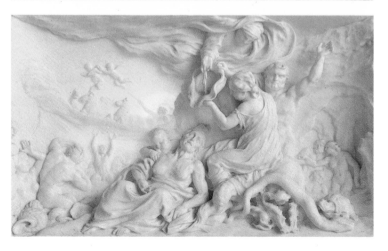

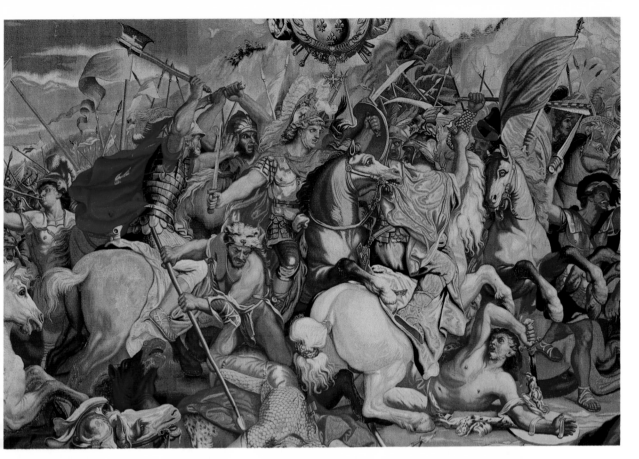

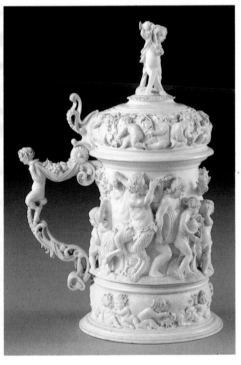

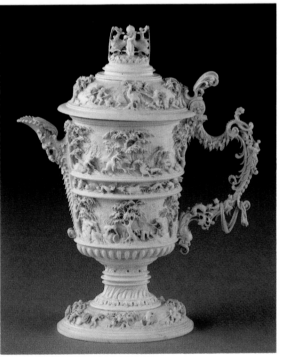

TANKARD WITH BACCHANALIAN SCENES
(German or Netherlandish artist, working in
Vienna(?) from before 1662 until after 1680),
Vienna(?), 1662, with initials BG and dated
Ivory; H 27.6 cm
Listed in the 1750 inventory of the Treasury.
(4499)

JUG WITH LID DEPICTING HUNTING AND FISHING
SCENES
Initials BG (German or Netherlandish artist,
working in Vienna(?) before 1662 until after
1680), Vienna(?), late 17th century
Ivory; H 29.8 cm
Listed in the 1750 inventory of the Treasury.
(4472)

PORTRAIT BUST OF THE EMPEROR LEOPOLD I
**Paul Strudel (b. Cles(?), the Tirol, 1648,
d. Vienna 1708), Vienna, 1695**
Marble from Laas; *H* 86 cm
Purchased 1832 at auction. (5458)

▷

APOLLO AND DAPHNE
**Jakob Auer(?), (b. Haiming, the Tirol, 1646,
d. Grins/Landeck 1706), Vienna, late 17th
century**
Ivory: *H* 43.9 cm
From the Treasury. (4537)

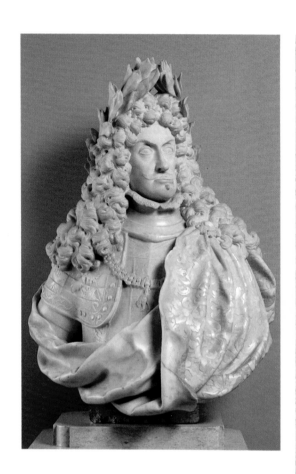

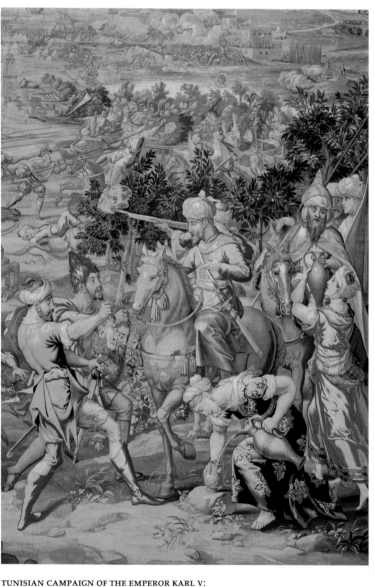

TUNISIAN CAMPAIGN OF THE EMPEROR KARL V:
BATTLE IN THE RUINS OF CARTHAGE (SECTION)
**Studio Jodocus de Vos, Brussels, between
1712 and 1721, signed; cartoons by Jan
Cornelisz Vermeyen (1490/5–1559), painted
from 1546 onwards**
Wool and silk tapestry, gold and silver thread;
520 × 860 cm
From a series of ten.
Woven for the Emperor Karl VI (reigned
1711–40). (x/9)

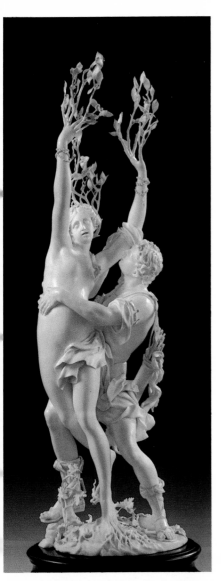

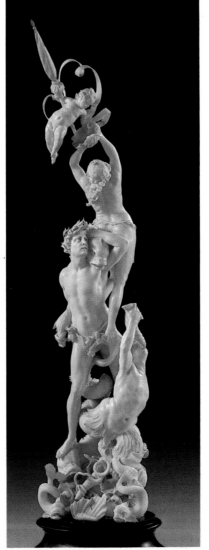

◁

ALLEGORY OF THE ELEMENTS WATER AND AIR
Matthias Steinl(?) (b. *c* 1644, d. Vienna 1727), Vienna *c* 1700
Walrus tusk; *H* 43.9 cm
From the Treasury. (4533)

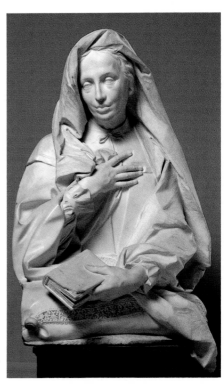

△

PORTRAIT BUST OF GIULIA ALBANI DEGLI ABATI OLIVIERI (1630–1718)
Camillo Rusconi (b. Milan 1658, d. Rome 1728), Rome, 1719
Marble; *H* 96 cm
Originally part of a tombstone in San Domenico in Pesaro.
Taken over from the Austrian Museum of Applied Arts in 1940. (9914)

◁

THE EMPEROR JOSEPH I ON HORSEBACK
Matthias Steinl (b. *c* 1644, d. Vienna 1727), Vienna, 1693, signed and dated
Ivory; *H* including base 70.8 cm
From the Treasury. (4663)

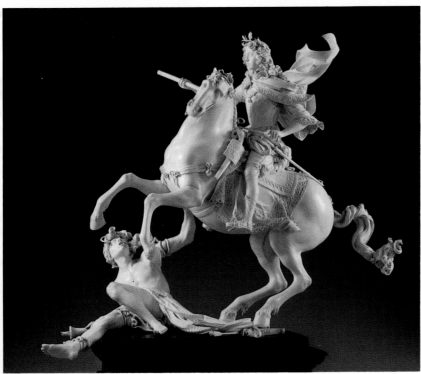

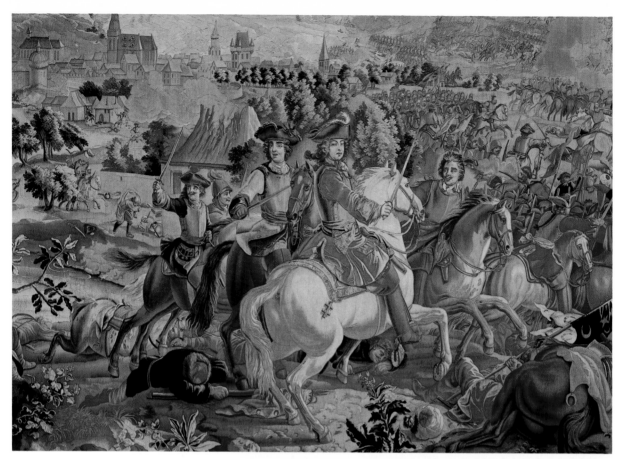

△

THE VICTORIES OF DUKE KARL V OF LORRAINE
(1643–90): THE BATTLE OF BRATISLAVA 1683
(SECTION)
**Ducal Tapestry Factory, Nancy; weaver
Charles Mite, between 1709 and 1718; after
cartoons or oil paintings by Jean Louis Guyon
(1672–1736), Jean Baptiste Martin (1659–
1735) and Claude Jacquard (1685–1736)**
Wool and silk tapestry; 470 × 630 cm
From a series originally comprising nineteen
pieces. From the Estate of the Emperor Franz I
of Lorraine (d. 1765). (IX/1)

▷

TABLE DECORATION BELONGING TO PRINCE KARL
OF LORRAINE (BROTHER OF THE EMPEROR FRANZ I)
**Petrus Josephus Fonson (worked in Brussels
in the second half of 18th century), Brussels,
1755, signed and dated**
Gold, silver, and gilt brass, porcelain;
L 63.2 cm W 46 cm
Presented to the Treasury in 1765. (1268–1280)

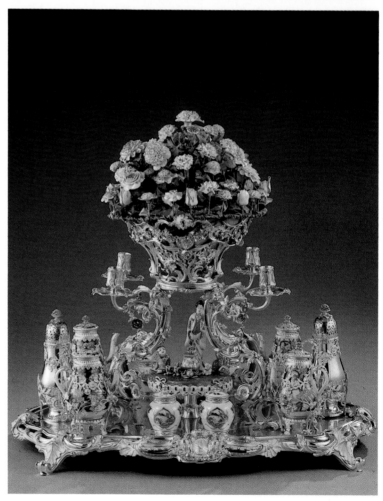

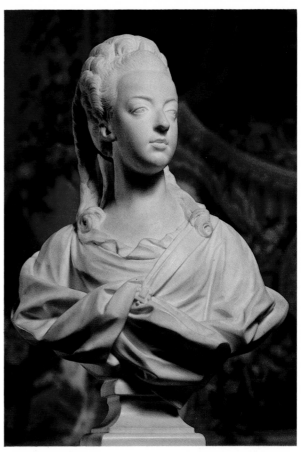

PORTRAIT BUST OF THE ARCHDUCHESS MARIE
ANTOINETTE
**Jean Baptiste Lemoyne (b. and d. Paris
1704–78), Paris, 1771, signed and dated**
Marble, H 76.5 cm
Marie Antoinette was the daughter of the
Empress Maria Theresa, born 1755, married
1770 to the Dauphin, who was later to become
King Louis XVI of France. She was guillotined
in 1793.
Present from King Louis XV of France to the
Empress Maria Theresa in 1772. (5478)

PIECES FROM THE BREAKFAST SERVICE OF THE
EMPRESS MARIA THERESA
**Anton Matthias Domanek (b. and d. Vienna
1713–79), Vienna, mid-18th century**
Gold, ebony, porcelain
Behind, left to right: coffee pot, H 14 cm, (1207);
warming-dish with water jug, *Diam* 35.4 cm,
H of jug 20.3 cm (1199 and 1249); milk jug, H
23.4 cm (1260)
In front: Chocolate mug and stand, sugar basin
on a stand, spatula, tea bowl and saucer,
spoon.
Presented to the Treasury in 1781.

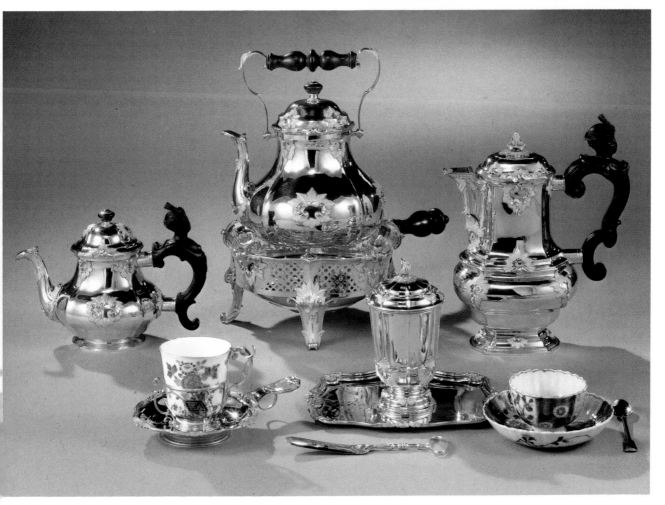

SCENES FROM THE NOVEL *DON QUIXOTE*: LADIES
WAITING ON DON QUIXOTE
**Paris Gobelins (State Tapestry Factory);
weaver Jacques Neilson (1749–88), 1781,
signed and dated; after designs by Charles
Antoine Coypel (1694–1756) of 1714–15**
Wool and silk tapestry; 369 × 513 cm
Present from King Louis XVI to Archduke
Ferdinand, Governor of Lombardy, on the
occasion of the latter's visit to Paris in 1786.
Taken over from the Este Collection. (CXV/1)

The Paintings Collection

The History of the Paintings Collection

The paintings collection of the Kunsthistorische Museum owes its emergence and its idiosyncracies to a number of outstanding Hapsburg collectors. In spite of the drastic political changes which have taken place in the course of its development, and in spite of quite a few acquisitions made in the nineteenth and twentieth centuries, it still retains today the character of a distinguished private collection belonging to a princely house – with all the advantages and disadvantages that implies. Its origins lie in the sixteenth and seventeenth centuries: those features which distinguish it today both in content and in layout were already clearly defined by about 1800. Despite its rich variety, it appears unsystematic when compared with later national galleries such as those of London and Berlin, not to mention the American collections. Those galleries were built up from an encyclopaedic and art-historical point of view, while the Vienna gallery can certainly not be seen as a text-book of the history of art, presenting a balance of all periods, countries and styles, nor does it aim consciously at historical completeness. Instead it has strengths unrivalled by any other central European collection of paintings, but also very significant gaps and, consciously or unconsciously, these have been largely respected by generations of its curators.

The incomparable wealth of sixteenth and seventeenth-century Venetian and Flemish paintings, the completeness of the Italian baroque range (hardly to be found anywhere else), the Bruegel section with twelve authenticated paintings out of the total of about forty extant works, the magnificent collection of early Netherlandish painters and German primitives – all this contrasts with the almost total lack of French and English painters. There is also a surprising absence of Italian primitives, and of Italian early Renaissance works, apart from a few examples. For a gallery of such high standing, the number of Dutch paintings is startlingly small, as is that of Italian paintings of the eighteenth century, although the representatives of those schools and periods which it does possess are outstanding examples.

If one were to take the actual history of the Kunsthistorische Museum's paintings collection as beginning with Emperor Maximilian I (1459–1519), one would merely be putting a theoretical starting-point to the Hapsburgs' picture-collecting activity, for the only work in the Imperial stocks that could possibly be proved to have been commissioned by him, Dürer's portrait of the Emperor, can only be authenticated as being in the collection at a later date. There is no doubt that Maximilian did own pictures; for him, as for his immediate successors, the portrait was a means of forging and recording political family connections and of serving genealogical interests, obligations which Maximilian, like most of his princely contemporaries, had very much at heart. These did not find their finest artistic expression in painting, however, but in the bronze sculptures on his tomb in Innsbruck. This interest in the recording of well-known political and military personalities in portraits – great characters, or figures distinguished simply by physical beauty – is also foremost in the sphere of painting in another of the most interesting Hapsburg collectors, namely Archduke Ferdinand II (1529–95), son of Emperor Ferdinand I, who began as regent of Bohemia, was later governor of Tyrol and possessed more than a thousand portraits as well as the famous *Kunstkammer* (art gallery) in the Castle of Ambras near Innsbruck. The interest in the subject still far outweighed artistic achievement, although some portraits which came into the Kunsthistorische from his collection – those of the Saxon electors by Cranach the Younger, the two small Holbein portraits or the full-length likeness of Charles IX of France by Clouet – show that Archduke Ferdinand was not insensitive to artistic considerations. His desire to evoke and absorb the essence of great figures finds almost magical expression in his famous collection of armour, his 'noble company' as he called it; always recalling the illustrious bearers of the armour, it was the Renaissance projection of an ideal Utopian society.

The emphasis on the portrait, which to a certain extent characterizes every princely collection, is particularly marked from the outset in the Hapsburgs with their intense family pride. The portrait appears again and again in the Vienna paintings gallery, so that all the way through one might speak of a certain 'top-heaviness' in the collection. This continues into the present day, with a kind of 'National Portrait Gallery' of the Hapsburgs and their associated dynasties being installed in the Castle of Ambras in 1976.

With Emperor Rudolf II (1552–1612), we come to the most comprehensive Hapsburg collector. Brought up in Spain at the court of his uncle Philip II and influenced artistically by the Spanish Hapsburg collections, Rudolf was a highly cultivated yet introverted man with a tendency to depression, even to hallucinations. Resident in Prague, he set up there a *Kunstkammer* of encyclopaedic range, legendary even in his own lifetime. With him, art collecting steps out of the sphere of the documentation of family politics, however universal, and out of the sphere of the curious and rare, moving on to take its place beside the pursuit of the natural sciences as part of a well-thought-out, interrelated world order. In addition, Rudolf carried out his purchases with a subtle feeling for quality, giving priority to intrinsic artistic merit.

Rudolf was a passionate collector, following his objectives with the utmost perseverance. 'Everything the Emperor gets to know about, he insists on having,' declared Archduchess Maria of Inner Austria, who, as the daughter, sister and aunt of the great Bavarian collectors Albrecht V, Wilhelm V and Maximilian I, knew what she was talking about. It was also with Rudolf that the idea of gathering together all the artistic possessions of the Hapsburgs under the control of one person, namely the Emperor, became a possibility – although not yet

consistently pursued. Thus, after the death of his uncle, Ferdinand of the Tyrol, he acquired the Ambras *Kunstkammer* from the latter's heirs, along with the greater part of the estate of his brother Ernst, who had been governor in the Netherlands and who had effected the purchase of the Bruegel collection, later to be incorporated in the Vienna gallery.

Although most of Rudolf's collection was scattered to the four winds, especially as a result of the Swedish plundering of Prague in 1648, important parts of it had found their way to Vienna after the Emperor's death in 1612 and thus remained in the possession of the Hapsburgs. What Rudolf valued, as far as any kind of trend in his artistic taste can be deduced, may to some extent reflect the contradictory characteristics in his personality. On the one hand there is the strong intellectual appeal – particularly evident in those works in which the form reveals, sometimes all too obviously, the painstaking creative act. Rudolf was an avid collector of works by Dürer. He purchased the *Adoration of the Trinity* after much wrangling with the City of Nürnberg, the *Martyrdom of the Ten Thousand*, the *Madonna with the Pear* and the ambiguous, sophisticated *Portrait of Johann Kleeberger*, a late work. The art of Rudolf's court painters in Prague, who, on a different intellectual and artistic level, experimented in much the same sophisticated way – the art of Spranger, of Hans von Aachen, of Heintz – points in the same direction and forms one of the most distinctive sets in the Vienna collection. On the other hand, the trouble he took to obtain his brother Ernst's collection, which contained the works of Bruegel, the greatest delineator of the world as it is and ought not to be, may perhaps be an indication of the vain attempt of the recluse high up in the Hradschin to get a grip on reality.

Rudolf's predilection for erotic subjects was apparently well known and presents to the Emperor cunningly took this into account. The list of those pictures which went to his fifth brother Archduke Albrecht in Brussels as part of his estate reads like a recommendation on how to build up an erotic library, and Rudolf's court painters pandered to these Imperial needs particularly cleverly. However, the lengthy negotiations in Spain over the purchase of Correggio's *Amours of Jupiter* – commissioned originally by Federigo Gonzaga – prove that Rudolf demanded artistic excellence even in this field; only *Io* and *Ganymede* escaped the Swedish looting of Prague and can still be found in the Vienna Gallery.

Even if only fragments of Rudolf's collection of paintings have survived, it must be considered as a heritage which imposed an obligation, and as a theoretical starting point for all subsequent Hapsburg patronage of the arts. The real founder of the paintings collection as we know it today was Archduke Leopold Wilhelm (1614–62), the brother of Emperor Ferdinand III. Leopold Wilhelm had taken holy orders and had already had a more or less successful clerical and military career when

he began to collect on a large scale. His purchases of pictures, made almost exclusively during his governorship on behalf of the Spanish King in the Netherlands and facilitated by the political events at the end of the Thirty Years War and the collapse of the British monarchy in 1648, had two objectives. One was to acquire a personal collection, which he transferred to Vienna in 1656 when his diplomatic career in Brussels had come to an end. He had this collection catalogued in 1659, in an extremely detailed inventory which even today can claim to be a model, and finally left it to his nephew, Emperor Leopold I, in his will. These paintings, about fourteen hundred in number, of which the Italian stocks had already been published in illustrated inventories in the Archduke's lifetime (and also recorded in the so-called 'Painted Galleries' by his court painter Teniers the Younger), form the nucleus of the Vienna collection. They were at that time hung in the Stallburg, a part of the Imperial Palace in Vienna. Leopold Wilhelm's second objective was to acquire pictures in Brussels to replenish the stocks of his Imperial brother in the Prague Castle. It was not until the eighteenth century that some of these paintings came to Vienna, when the Imperial collection underwent a rearrangement under Emperor Karl VI.

Leopold Wilhelm's interest was mainly focused on Flemish and Italian painting – particularly Venetian and North Italian work of the fifteenth and sixteenth centuries. It was lucky for him that after the execution of King Charles I, a passionate lover of paintings, and after the confiscation of his courtiers' collections, large stocks of Venetian paintings in particular were offered for sale in Antwerp. Leopold Wilhelm hastened to buy them. Most of the Venetian paintings had come originally from the Bartolomeo della Nave collection in Venice. The purchases ranged from Giorgione, to whom no less than thirteen pictures were attributed in the 1659 inventory, via Palma Vecchio and Titian (out of whose twenty-six putative canvases fifteen are still in the Vienna gallery), to Veronese, Tintoretto, and the Bassani; from Antonello via Bellini to the great masters of Bergamo and Brescia. In the case of the Flemish primitives, the range stretches from Van Eyck – here the historical interest can already be detected: Van Eyck is mentioned in the inventory as the inventor of oil-painting – via Goes, Geertgen, Gossaert, the Massys, Patinier and Aertsen up to Jan Brueghel. In addition Leopold Wilhelm collected the works of his Flemish contemporaries. Teniers was his court painter, Van der Baren his court canon. Rubens had died only shortly before Leopold Wilhelm became governor. He probably acquired Jordaens' *Bean Feast* from the artist himself. The whole Rubens school is represented with rare completeness. What is clearly evident is Leopold Wilhelm's predilection for pictorially meticulous pieces with small figures; for balanced classical painting, for the connoisseur's picture, the still life in its widest sense. Hence his love of Early Netherlandish masters with their painstaking attention to

**Hans von Aachen (b. Cologne 1552, d. Prague
1615),** *c* **1600/03**
Canvas; 60×48 cm
(6438)

detail, of Giorgione and Lotto; and hence his acquisition of
Rubens' 'Small *Lamentation*', and the *Stormy Landscape*, but none
of the great allegories, hunting or mythological pieces. It also
explains why, among the seventeenth-century Italians, he liked
Fetti, Strozzi, Forabosco and Cagnacci, whom he brought to
Vienna, but not so much Pietro da Cortona, Domenichino or
Guido Reni. What he purchased for his Imperial brother, for the
spacious suites of the Prague Castle, was more in keeping with
the 'baroque' taste. Here space-dominating, generous composi-
tions mattered most, as in Titian's *Ecce Homo*, Veronese's series
of Old Testament scenes, Rubens' *Feast of Venus* and the *Four
Continents*.

Although Emperor Leopold's interest was directed towards
music rather than painting – and in these turbulent times, much
against his will, towards the French and Turkish wars –
nevertheless two groups of pictures were acquired during his
reign. The first of these was Velazquez's Infanta portraits, sent
to Vienna from Madrid for personal and dynastic reasons. The
other acquisition was the collection of art treasures, made by
the Tyrolean line of the Hapsburgs and housed in Innsbruck,
which came to the Emperor when that branch of the family died
out. As a result of marriages to Medici princesses through two
generations, there were close ties with Florence and this is why
the Vienna gallery today not only owns outstanding stocks of

Florentine baroque paintings, but also came to possess one of
its greatest masterpieces, Raphael's *Madonna in the Meadow*.

In accordance with the spirit of the age, the collections which
were scattered over various residences called for systematic
organization after the baroque fashion. It was only after Austria
had warded off the double military threat from East and West,
and after the War of the Spanish Succession, at the peak of the
Austrian 'heroic age', that Emperor Karl VI (1685–1740),
possibly stimulated by the collecting zeal of his foremost field-
marshal, Prince Eugene of Savoy, brought together the majority
of the Hapsburg picture collections and established them in the
specially-converted Stallburg halls. Entirely in keeping with the
absolutist idea of the subordination of the individual to the
whole, of the pre-ordained place of the individual within the
social framework, a decorative system was designed, based on
axial symmetry, analagous dimensions, and pyramidical ar-
rangement. Into a system of openings in the carved and gilded
wall panelling, the pictures were, quite literally, fitted in, for
they had no qualms about changing the format of the pictures,
adding to them, cutting them down, and covering up what they
considered superfluous or inappropriate behind the panelling.
We can get a clear idea of what the Imperial Gallery must have
been like in the reign of Karl VI from a painted inventory he
had commissioned in three volumes in 1720, 1730 and 1733,
from F. Astorffer. Magnificent though this sight must have
been, and however unified and well-ordered the wall display
may have appeared, this system must have been so inflexible as
to preclude any possibility of expansion or alteration. Francesco
Solimena's dedicatory picture depicting Graf Gundaker
Althann handing over to the Emperor the inventory of his
collection gives a clear indication of how much this reorganiza-
tion in 1728 meant to Karl VI: the figure of Fama proclaims the
Emperor's understanding of art to all the world.

A number of masterpieces in the present collection appear for
the first time in Astorffer's inventory. These include most of the
Van Dyck portraits, Rubens' *The Fur*, Rembrandt's *Large Self-
portrait*, Rembrandt's son *Titus Reading*, Hals's *Young Man*, the
portrait of *Lady Jane Seymour* by Holbein the Younger and many
more. It is almost impossible for us to get an idea of Karl VI's
taste in pictures, apart from his love of monumental representa-
tion. His grandiose architectural schemes, however, are quite a
different matter.

Perhaps the self-imposed inflexibility of the paintings gallery,
and its concentration on decorative effect, also influenced the
decision not to purchase Prince Eugene's splendid paintings
collection. However its site – Prince Eugene's summer palace,
the Belvedere, acquired by Maria Theresa in 1752 – was to
become significant for the Imperial collections. First of all,
though, one must remember the acquisitions made by Maria
Theresa (1717–80) and by her son, Emperor Josef II (1741–90),
which led directly to the transfer of the Imperial collections to

Francesco Solimena (b. Nocera/Naples 1657, d. Barra/Naples 1747), signed and dated 1728
Canvas; 309×284 cm
Painted for Emperor Karl VI.
Count Althann handing over to the Emperor the Inventory of the Imperial Picture Collection in the Stallburg. The heads of the Emperor and Althann were painted by Johann Gottfried Auerbach. (1601)

PAINTED INVENTORY OF EMPEROR KARL VI'S COLLECTION IN THE STALLBURG, VIENNA
Ferdinand Astorffer, 1720/33
(Min. 75)

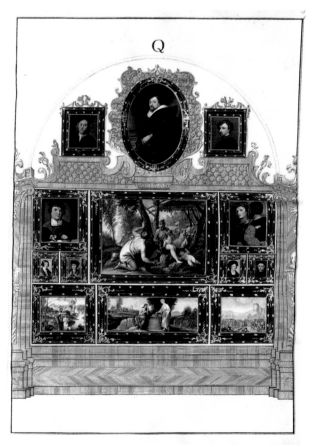

the Belvedere Palace. To describe Maria Theresa as a connoisseur of paintings or even as a lover of pictures may seem inappropriate in view of the astonishing sales of parts of the stocks and the reckless presents of pictures from the old Hapsburg family possessions (the court did, however, commission Bellotto to paint a series of Viennese *veduta* and views of Hapsburg palaces). Nevertheless, steps were being taken from the early 70s onwards to reclassify and relist the Imperial picture collection, to make a new inventory (albeit very badly) and to gather together paintings from various Hungarian and Austrian palaces belonging to the Hapsburgs. In this period of general revival of the art scene, we can perhaps distinguish the 'practical consequences for the arts in an "enlightened" state.' Collections were made accessible to the townspeople in order to enhance their knowledge and appreciation, and this demanded above all a different arrangement, one made according to didactic and historical principles and a scholarly study of the picture stocks. This phase of reorganization, between 1775 and 1781, brought about a general change in the functions of the collection, and with it came the most important additions from the Flemish churches. These included the Rubens altar-pieces (some of which were enormous), and their accompanying sketches, the large Van Dyck and de Crayer altars from the dissolved Jesuit colleges and churches in the Austrian Netherlands in 1775/76, the purchase in 1776 of Rubens' Ildefonso altar-piece and in 1781 the acquisition of Caravaggio's *Madonna of the Rosary* from the Dominican church in Antwerp. There was simply no room in the Stallburg for these very large paintings, and in 1776 Maria Theresa ordered the entire Imperial collection to be transferred to the Upper Belvedere.

At first local talent was used for the new layout, but in 1778, much to the indignation of Curator Rosa, Joseph II called in the Basle engraver and art dealer, Christian von Mechel, whose aim was to use the palace space in such a way that 'the arrangement as a whole and in all its parts would be instructive, and present a visual history of art.' The reorganization was accomplished in 1781, and 1783 saw the publication of the printed catalogue *Verzeichnis der Gemälde* in French and German, compiled by von Mechel himself. It was later described as 'the first catalogue to be drawn up according to modern principles, geared to layman and expert alike, of all the collections subsequently brought together in the Kunsthistorische Museum.' (Lhotsky). The pictures were arranged historically according to school, uniformly mounted in Josephinian frames still used today in the *Sekundärgalerie* (secondary gallery), and in all the rooms captions were appended in two languages. The gallery was open to the public three times a week, but could be entered only after 'shoes had been scraped'; children were excluded, as was the general public on rainy days. Winckelmann's influence is discernible in the general policy, while the pedantry of enlightened despotism is revealed in the detail.

Apart from the altar paintings from the Austrian Netherlands, other large altar-pieces were acquired from churches in Italy and Vienna and these still feature prominently today in the baroque section. The *Archangel Michael* by Giordano came from the church of the Minorites in Vienna, Cerano's *Christ between Peter and Paul* from Milan. In the acquisition of neither of these can one detect much individual taste or preference, but rather a concern that valuable evidence of artistic creativity should not be lost as a result of the disruptive church reforms, and an urge to provide an ideal setting, in a museum designed to enlighten the public, for works distinguished by their now secularized nature. In the case of the Ildefonso altar, the memory of those who had commissioned the altar may also have had some influence.

It is probably a little unfair to take an entirely negative view of the frequently deplored exchange which took place between 1792 and 1821, in the reign of Emperor Franz II (1768–1835), between the Imperial collection in Vienna and the Grandducal (then also Hapsburg-Lorraine) galleries in Florence. The actual plan of filling gaps in the historical sequence was appropriate for the time, but with hindsight we recognize the errors of judgement and the lack of knowledge on the part of the Vienna curators that resulted in the regrettable loss (from the Viennese point of view) of works such as Dürer's *Adoration of the Magi*, Titian's *Flora*, Giovanni Bellini's *Religious Allegory*. On the other hand it must be stressed that works of the Florentine school of the sixteenth century, such as Bronzino's *Holy Family* and Fra Bartolomeo's *Presentation in the Temple*, or seventeenth-century works such as Salvator Rosa's *Return of Astraea* and Pietro da Cortona's *Hagar*, the latter previously housed in the Uffizi Tribuna, make excellent and fitting additions to the Vienna collection.

In 1809, when Vienna was taken by Napoleon, his art director Vivant Denon had four hundred of the pictures, which it had been impossible to evacuate, shipped to France. About forty of these were never returned, and throughout the rest of the century very few old masters were bought. While London, Paris and, particularly in the second half of the century, the great German museums (Berlin in particular), were able to expand their stocks systematically, Vienna's total purchases of old masters could be counted on the fingers of two hands. Although the acquisition of Jacob van Ruisdael's marvellous *Great Forest* may at first have given the impression that the museum wanted to enlarge the nucleus of Dutch paintings of the great century – which had grown up particularly in the second half of the eighteenth century around Rembrandt, Terborch, and Steen – the Imperial family began to exercise restraint with regard to further purchases, in spite of the large number of rich private collections in Vienna. The result was that many of these pictures found their way out of Vienna, for the most part to Germany. The most distressing loss for Austria

in later years was no doubt Rembrandt's *Blinding of Samson*, which was originally part of the Viennese Schönborn collection. Was the picture too brutally baroque? Was it considered unsuitable for the Vienna collection? Possibly. The purchases that were made in the course of the nineteenth century, however, enhanced the strong points of the stocks: Lotto's *Young Man against a White Curtain*, Tura's altar lunette with the *Dead Christ*, the small *Nativity* by Schongauer, Tintoretto's *Susanna and the Elders*, and a few others.

Thus the Vienna gallery, which had been the private property of the Imperial House right up to 1918, remained virtually unchanged throughout the nineteenth century. In fact in 1875 when a general policy was drawn up, the express requirements were 'wise restraint in view of the incomparable quality of many parts of the collection . . .', and an attempt was made 'to achieve excellence within narrow limits rather than to strive after nebulous goals and to collect indiscriminately.' For that reason and also in view of the private character of the collection, no large sums of money were ever to be available. The greed for possession noticeable in other museums never gained the upper hand in Vienna. As the historian Alfons Lhotsky puts it very aptly in this century 'the principles and passions of philately have never seeped through into the Imperial collections.' Every republican government had adhered to this guiding principle, even if this may have been *faute de mieux*.

Attention was turned instead to an internal and external reorganization of all the Hapsburg artistic possessions and their assembly under one roof, namely in the Kunsthistorische Museum built by Semper and Hasenauer in Franz Josef's stately boulevard, the Ring, between 1871 and 1891. Simultaneously with the establishment of the monumental *Jahrbuch der Kunsthistorschen Sammlungen des Allerhöchsten Kaiserhauses* ('Yearbook of the art-historical collections of the Supreme Imperial House'), the year 1883 saw the beginning of the actual historical and art-historical work on the gallery and the three-volume catalogue of the picture collection compiled by the painter and director of the gallery, Eduard von Engerth, an indispensable work even today. The basis for this was research done in the archives on the history of the collection itself. Characteristically, Leopold Wilhelm's inventory of 1659 was only made public for the first time in the first volume of the '*Allerhöchstes Jahrbuch*' ('most supreme yearbook'), as this publication, which still exists, is sometimes ironically known. The actual art historical work, however, was done with some help from international scholars such as Crowe, Cavalcaselle and Abraham Bredius.

The almost-pretentious magnificence and splendour of the newly-built Kunsthistorische Museum, and the close hanging of the pictures in the gallery opened in 1891 – which, although carried out on a historical basis was nevertheless entirely decorative – may seem to be to some degree reminiscent of the

reorganization in the reign of Karl VI. At the beginning of our century, however, this was followed by a counter-reaction in the direction of more progressive, one might even say purist, ideas. From the beginning of this century there was a fundamental move away from decorative hanging, with several rows of pictures one above the other in nearly all the big galleries. Everything that was not considered absolutely necessary and valuable to the public at large was relegated to storerooms accessible only to specialist researchers. Starting out from the strict premise that a work of art could be shown to its full advantage only when seen in some degree of isolation, all sorts of compromises were henceforth attempted between decorative and symmetrical hangings on the one hand and strictly chronological ones on the other, while preserving historical homogeneity and sticking to a single row of pictures. Every generation will find different solutions to this problem – one on which feeling has always run high, touching as it does, quite literally, on a philosophy of life. Following their peculiar sense of historical continuity and directed by their highly trained memories, the Vienna curators of the 1960s installed the so-called *Sekundärgalerie*, a kind of storeroom-gallery accessible to the general public, where, symmetrically arranged, the paintings are hung neatly along the walls in several rows, one above the other. Here, at least, the curators have allowed themselves the pleasure of indulging their nostalgia for a baroque picture gallery.

The directorship of the great scholar, Gustav Glück (1911–31) marked the beginning of an outstandingly successful acquisition policy, formulated by Glück himself: 'Our endeavours should be aimed at making the new additions fit in with the priceless character of the existing stocks so that they merge in complete harmony, so that the new takes its place with a discreet radiance beside the old, whose brilliance it will, at all events, never be able to eclipse. No doubt a streak of conservatism is appropriate here but it must never be allowed to make the collection appear dull.' As a result the eighteenth-century Italian collection has been considerably expanded in this century in spite of slender means and often only as the result of exchanges. Here mention may be made, as examples, of the two large Tiepolos from the Ca' Dolfin in Venice, and of Ricci and Giaquinto. The Dutch section was enlarged and enhanced by masterpieces such as Hals's *Tieleman Roosterman*, a gift from Clarisse de Rothschild, and Vermeer's famous *Allegory of the Art of Painting*, formerly the showpiece of the Czernin collection in Vienna. Among the acquisitions of German painting, the main works worthy of mention are those of the Danube school and, the finest addition, Dürer's portrait of the *Venetian Lady*. For the first time a series of very good English pictures was purchased. Among Flemish works, mention should be made of the purchase and brilliant attribution and identification of the *Head of a Young Man* as part of Rubens' 'Trinity Altar' from Mantua.

In recent years, pictures originally in Archduke Leopold Wilhelm's collection came back to the Vienna gallery as gifts, amongst them Fetti's *Prodigal Son* from the Seilern collection and two *Heads of Apostles* from the so-called Böhler series by Van Dyck which were incorporated into the Flemish section. It is clear that subsequent generations of curators have followed Gustav Glück's cautious policy more or less voluntarily: no attempt has ever been made to change the established character of the gallery. It would seem that lack of funds can have its advantages.

In more recent times another sphere has been added to the Kunsthistorische Museum. The 'New Gallery in the Stallburg' arrived at its appointed place only in 1967, after complicated peregrinations since 1903. It houses a small group of non-Austrian painting and sculpture of the nineteenth and early twentieth centuries, mainly French and German art of very high quality.

It is no easy task to sum up the overall character of the paintings collection of the Kunsthistorische Museum, but certainly it is easier than in the case of other museums, both because the gallery has such specific characteristics and because it is so closely linked with the countries ruled by the Hapsburg dynasty for approximately five hundred years. Both from the point of view of quality and quantity, the most important pictures in the gallery come from Germany and the southern Catholic Low Countries, and from Northern Italy. France, Holland, England and the Italian city states of the later Middle Ages are hardly represented. The few Spanish pictures have a special status. As 'grands seigneurs', the Hapsburgs loved 'the perfect and the complete', nothing that was still in a state of development. There are few works showing 'early' phases of style, works still striving for inner perfection; no thirteenth and fourteenth-century works, no republican Quattrocento, no tormented introverts, few sketches. What they loved was mature style, even 'over-mature'; the Venetian and Flemish sixteenth and seventeenth centuries; the elaborate, perfect, even decorative piece; not the eccentric, but the judiciously contrived; the naturally elegant, but not the pretentious. The gallery itself is conceived as a decorative whole. The Hapsburg taste is 'pious' without ever actually falling into bigotry; the erotic is noticeable, although perhaps not quite so strongly as in their Spanish cousins – prudery did not cause them trouble until much later. All the great Hapsburg collectors loved the Flemish primitives, Bruegel, Titian, Dürer and, later, Rubens and Van Dyck. Their 'family taste', one-sided though it may have been, still marks the Vienna gallery today.

Italian Painting

The paintings of the Mediterranean countries, particularly of Italy, take up almost the entire west wing of the first floor of the Kunsthistorische Museum. Both the merits of the Italian picture stocks and the gaps in them can be accounted for by the history of the collection and by the similar tastes of the Hapsburgs throughout the centuries. Painting from Venice and the Terra Ferma in the sixteenth century is represented in its entirety, the collection covering all its aspects, and there is a fine selection of the mannerist art of central Italy. All aspects of Caravaggesque naturalism can be studied, as well as the schools of Italian baroque painting which are represented by outstanding works in which North Italian and, to a slightly lesser extent, South Italian painting predominate in both quantity and quality. The Italian primitives, however, are conspicuous by their almost total absence.

The main late-fifteenth-century work in the collection is the monumental fragment of the so-called *Pala di San Cassiano* by the Sicilian-born Antonello da Messina. Commissioned in 1475/76 by the Venetian patrician Pietro Bon for San Cassiano in Venice, the 'Sacra Conversazione', in which eight saints originally surrounded the enthroned Madonna, was removed from the church in about 1620 and cut into six parts, coming into the collection of the Archduke Leopold Wilhelm already in this state. It was not until the 1920s that Johannes Wilde succeeded in identifying and piecing together three of the scattered and almost forgotten fragments. Even in its fragmented state, it is easy to recognize its importance; it had a most significant influence on Venetian painting in the sixteenth century, especially on the development of the most common of Venetian altar forms, the Sacra Conversazione. We admire Antonello's interest, derived from his contact with early Netherlandish painting, in the surface texture, combined with his feeling for solidity of form. Compared with the pictorial brilliance of this picture, Gentile Bellini's contemporary Tabernacle Door for the Reliquary of the Particles of the Cross, which Cardinal Bessarion presented to the Venetian Scuola della Carità, appears somewhat wooden. It is, however, of great historical significance as a testimony to the links between Venice and Byzantium, embodied in the truest sense in the Greek Cardinal. Gentile Bellini's style developed mainly under the influence of his brother-in-law Andrea Mantegna. The latter's *Saint Sebastian*, which may be dated about 1460 and is signed in Greek characters, evokes an ancient world in stone, constructed in accordance with strict rules, in which the Christian hero is seen as a marble sculpture and testifies to the specifically archaeological humanism of the painter's native town, Padua.

The large series of sixteenth-century Venetian masterpieces begins with Giorgione and ends in the works of the Bassano family and their school with its wide ramifications, but Giorgione, Titian, Tintoretto, Veronese and Lotto remain the focal points. The idea of classical harmony in the unity of man and landscape – and here the merging goes to the point of obscuring the actual subject – is the essence of Giorgione's still puzzling *Three Philosophers*, which dates from about 1508, and Titian's *Shepherd and Nymph*, although they differ in expression and are separated by a time-span of sixty years. The *Three Philosophers* has already been interpreted in many ways and although an identification of them with the three wise men from the East has much to be said for it, it is nevertheless not surprising that a description dating back to the early sixteenth century, to which the title now in common use goes back, greatly stresses the beauty with which the natural phenomena are depicted. In Titian's later *poesia*, whose content is hardly definable, we are confronted with the vision of a mysteriously threatened idyll; a smoky, dusky atmosphere which blurs all body contours and in whose shimmering light landscape and figure seem to become one. All the facets of Titian's œuvre are fully represented, from its Giorgione-like beginnings in the so-called *Gipsy Madonna*, via the *Ecce Homo*, the main work of his middle baroque period, to the fascinating late portrait of the art dealer and agent, Jacopo Strada, with its masterly evocation, in both colour and composition, of the ambivalent character of the subject.

In the Tintoretto section, the portrait is the prevailing genre, the two outstanding examples being the relatively early likeness of the Venetian councillor *Lorenzo Soranzo*, with its melancholy pose, and the later one of *Sebastiano Venier*, who is depicted as the victorious admiral in the Battle of Lepanto, seen in the background. The focal point, however, is *Susanna and the Elders*, a bold, powerful composition, full of contrasts of light and shade, old and young bodies both clothed and naked, dense vegetation and sparkling water. In the Vienna collection the special merits of Veronese (the youngest of the Venetian trio completed by Titian and Tintoretto), are shown to best advantage – his skill in structuring even large surfaces subtly and harmoniously without violating his natural talent, that magical colour sense. It is his pre-eminence as a decorative artist in the highest sense, which the seventeenth and especially the eighteenth century held in particular esteem, that made this painter one of the great inspirers of Italian painting. In his late work, as for example in *Hercules, Nessus and Deianira*, his palette darkens and the subject of his pictures is less subordinated to the overall decorative effect.

Poetry overshadowed by melancholy, the mood of so many North Italian-Venetian pictures is rendered with particular beauty in Lotto's *Sacra Conversazione* and Moretto's *St Justina*. In the portraits, as in Lotto's *Young Man against a White Curtain*, the penetrating gaze of the subject deepens the mood into something mysteriously disturbing.

The Ferrara school was always at the point of intersection of Venetian and central Italian spheres of influence. Just as Cosimo Tura, at the end of the fifteenth century, had heightened Mantegna's harsh, static forms into expressive and

ecstatic ones, so the essentially gentle, idealized figures of Dosso Dossi, modelled on Raphael, acquire a somewhat strangely disturbed, unclassical quality with their rich, glowing, Venetian colours.

In the Vienna gallery, in the old conflict between 'Disegno' and 'Colore', between Florence/Rome and Venice, between the adherents of a clearly defined form of art, born of the intellect, and the lovers of colour which blurs outlines, the scales come down, as if in the nature of things, on the side of colour. The Kunsthistorische Museum does possess, nevertheless, in Raphael's *Madonna in the Meadow*, and in the works of Fra Bartolomeo, Andrea del Sarto and Bronzino, very typical examples of the opposing faction. In Raphael's *Madonna in the Meadow* dating from about 1505, we recognize the classical embodiment of the Italian high Renaissance, expressing itself in ideal naturalness of forms, in a geometrically ordered pictorial world which is nevertheless animated from within. In Fra Bartolomeo's *Presentation of Christ in the Temple*, about ten years later, the accent is more on strict drawing and simplicity, something which may have been dictated by the subject matter. With Andrea del Sarto there comes a new, more intense expression of emotion, a stronger, more penetrating religious feeling. This is achieved not only by compositional means, which bring the figures closer to the beholder, but also by Leonardo's painting techniques, particularly the soft *sfumato* which envelops the precisely drawn figures. Around the middle of the century Bronzino embarked on a different path. In his paintings he moved towards sculpture, the bodies being so clearly defined that they seem to be carved in stone. Bronzino's marble-like coolness and sophisticated artificiality are the essence of the refined artistic culture in the Florence of the Grand Duke Cosimo I.

The pictures by Correggio and Parmigianino – the outstanding masters of the mannerist school of Emilia – are among the oldest and most venerable stocks of the Vienna gallery. In the case of the *Amours of Jupiter*, which constitute the peak of Correggio's most sensuous painting, and Parmigianino's self-portrait in a convex mirror – so ideally suited both in conception and execution as a presentation piece from the precocious artist to Pope Clement VII – the provenance can be clearly traced back step by step to the painters themselves.

Italian baroque painting has its real starting-point with Annibale Carracci, a native of Bologna, and the Lombard Michelangelo Merisi da Caravaggio. It was in Rome or in southern Italy, however, that both created their main works from around 1600 onwards. One of the principal works of Caravaggio's late period, his *Madonna of the Rosary*, painted in Naples around 1606, is the focal point of the collection of Caravaggesque paintings which covers all local and stylistic aspects of his followers. In deliberate contrast to what had gone before, Caravaggio achieves a direct impact on the beholder by

means of the striking immediacy of all the characters involved: the artistic means to this end is the sharp contrast of light and shade which makes the figures appear as if you could touch them, and great verisimilitude in the reproduction of the scene. Caravaggio had a particularly decisive influence on the development of painting in Naples (Caracciolo, Ribera), in the Netherlands (Honthorst, Janssens), in France (Valentin de Boullogne) and in central Italy, where the Tuscan Orazio Gentileschi did much to spread his pictorial ideas. For Annibale Carracci also, and for his Bolognese and Roman pupils Guido Reni, Giovanni Lanfranco and Guercino, Nature (although idealized and purified) is the starting-point of their art. Carracci is represented here by his serenely classical late work *Christ and the Woman of Samaria at Jacob's Well*. Along with Annibale Carracci, it is Guido Reni among the Bolognese painters of the seventeenth-century who comes nearest in harmonious composition to classic-idealistic art and theory. In his *Baptism of Christ*, dating from about 1620, pathos is relieved by the differentiated tonal values and the delicacy of the drawing. In his roughly contemporary early work *The Return of the Prodigal Son*, Guercino spiritedly demonstrates how a biblical story can be presented dramatically by using jarring chiaroscuro, which fragments the bodies, and strong colour contrasts between coloured half-shadows. Although Giovanni Battista Crespi was not a native of Emilia nor ever worked there – he was in fact born in Cerano and worked mainly in the Milan of Cardinal Federigo Borromeo – his large, late work *Christ appearing to the Apostles Peter and Paul* represents the altar painting of the Counter-Reformation: it is a vision in which the dematerialized, 'transfigured' body of Christ is juxtaposed with the heavy, earth-bound figures of Peter and Paul.

Thanks to two patrons, Vienna is particularly well stocked with later Emilian painting. In 1657 Emperor Leopold I summoned Guido Cagnacci to his court in Vienna, where the painter also carried out work for the Emperor's uncle, Archduke Leopold Wilhelm. In the *Death of Cleopatra* Cagnacci brings out the contrast between closely observed realism, in the distressed gestures of the weeping servant-girls, and classicism in the serene, relaxed posture of the seated heroine. The subtle colour composition and the soft light merging all tone values give the painting a strongly sensuous character. Forty years later Prince Eugene of Savoy employed a whole team of Bolognese painters for the decoration of his winter palace in the Himmelpfortgasse in Vienna. The most interesting among them was Giuseppe Maria Crespi, whose chiaroscuro in the supraporte (picture above the door) *Chiron teaching Achilles to draw the bow* is used to divide the canvas into light and dark areas, rather than to bring out the plasticity of the figures. It seems as if accessibility of 'meaning' is already subordinated to a decorative scheme formed by light planes – a sign of the beginning new century.

Almost nowhere outside Florence itself is it possible to find such a wide ranging collection of Florentine baroque paintings. Special mention should be made of Empoli's *Susanna* of 1600. In it are united all the virtues of this school: clarity of drawing, refined and sensuous colour combinations, soft shading in spite of the overall lightness of colour, a pronounced, almost three-dimensional plasticity – a legacy of a glorious past – and a curious urban arrogance in the slightly mannered elegance of the postures. And Pietro da Cortona, although considered the main exponent of Roman high baroque, was a Tuscan not only by birth and training. He has left us, in the Palazzo Pitti in Florence, a cycle of frescoes which is of the utmost importance. Painted in the 1640s these are therefore contemporary with his *Return of Hagar* in Vienna.

Seventeenth and eighteenth-century Neapolitan paintings have been acquired here since Archduke Leopold Wilhelm began his collection. Examples range from Giovanni Battista Caracciolo's strictly Caravaggesque *Agony of Christ* via Andrea de Leone's *Voyage of Jacob* and Salvator Rosa's *The Return of Astrea*, acquired in the Florentine exchange of 1792 and evoking the return of the Golden Age after the end of the Thirty Years War, to works by Luca Giordano and Francesco Solimena. Vienna has about seventeen pictures by Giordano: the early altar-piece shown here came into the collection from the Vienna church of the Minorites. It is very much in the style of Ribera and depicts St Michael flinging the rebellious angels into the abyss. Solimena as the leader of the Neapolitan school in the first half of the eighteenth century (Naples was then part of the *monarchia austriaca*) worked for both Prince Eugene of Savoy, who commissioned him to execute large ceiling and altar paintings for the Belvedere Palace, and for the Emperor himself. *The Handing Over of the Inventory of the Imperial Art Collection to Karl VI*, dated 1728, has an obvious bearing on the gallery's history. In this painting the heads of Oberbaudirector (Director of Buildings) Count Gundaker Althann and the Emperor were inserted by the Viennese painter Johann Gott-fried Auerbach.

So, as might be expected, the Vienna collection is especially rich in Venetian baroque paintings. There are thirteen paintings by Domenico Fetti and five by Bernardo Strozzi deriving for the most part from the collection of Archduke Leopold Wilhelm. Fetti's style, based directly on the great examples of sixteenth-century Venetian painting, can best be discerned in the *Return of the Prodigal Son* – which was only recently 'brought home'. His feeling for the expressive possibilities of light and shade, which verges on the sinister, can be admired in the altar-piece with the *Betrothal of St Catherine*. Strozzi is probably the most talented decorative master of the North Italian seventeenth century. His radiant colours, in which every single touch of paint is effective, had a far-reaching influence, especially in the eighteenth century. Girolamo Forabosco's *Portrait of a Venetian Lady*, which in its colour effect is probably one of the most sophisticated pictures of the Venetian/Paduan seventeenth-century school, was apparently greatly admired by Archduke Leopold Wilhelm.

The eighteenth-century Venetian or Italian paintings in general were mostly either commissioned directly from the artists, as was the case with Batoni, Guglielmi or Bellotto, or found their way into the gallery at a much later date – mostly not until the twentieth century. Giovanni Battista Tiepolo's ten-part decoration for the great hall of the Ca'Dolfin in Venice was still in private hands in Vienna in its entirety as late as 1870. Today Vienna shares this once no doubt very impressive set with the Metropolitan Museum in New York and the Hermit-age in Leningrad. The paintings record the heroic deeds in Roman history and represent the peak of Tiepolo's early style (1728/30) with its vigorous contrasts of light and shade. Bernar-do Bellotto, the eminent Venetian painter of *veduta* worked in Vienna from 1758–61. Commissioned by the Emperor, he painted thirteen views of the capital and the Imperial palaces. With impeccable precision he transforms the view of the city from the Belvedere Palace into a picture of strict, unified composition. The ceiling frescoes in the Great and Small Galleries in Schönbrunn Palace near Vienna, dating from 1759/62, are by Gregorio Guglielmi, and the Kunsthistorische Museum has the preliminary sketch for *In praise of the ever wise and liberal rule of the House of Hapsburg* in the Small Gallery.

Apart from court portraits, the Vienna gallery has few narrative pictures of Italian neo-classicism. One of the exceptions is Pompeo Batoni's *Return of the Prodigal Son*, purchased in 1773 in Rome from the artist himself. It is a work of measured pathos, formal, a model of precise draughtsmanship and outstanding painterly technique. Not surprisingly it is one of the most frequently copied paintings in the gallery.

**Andrea Mantegna (b. Isola di Cartura 1431,
d. Mantua 1506), *c* 1460**
Wood; 68×30 cm
Signed in Greek letters. In Archduke Leopold
Wilhelm's collection in 1659. (301)

CARDINAL BESSARION AND TWO BROTHERS OF THE
SCUOLA DELLA CARITA IN FRONT OF RELIQUARY
CONTAINING A FRAGMENT OF THE HOLY CROSS
Gentile Bellini (b. and d. Venice *c* 1431–1507)
Wood; 102.5×37 cm
Door of the tabernacle the Cardinal had made
in 1472 to house the reliquary. In Venice,
Scuola della Carità, until the 18th century.
Presented by Erich Lederer 1950. (9109)

ANGELS BEARING THE BODY OF CHRIST
**Cosimo Tura (b. and d. Ferrara *c* 1430–1495),
signed, *c* 1475**
Wood; 44.5×86 cm
Purchased 1857. (1867)

△

THE MADONNA WITH SS NICHOLAS OF BARI,
ANASTASIA (?), URSULA, DOMINIC AND [partly
cut off] HELEN
**Antonello da Messina (b. and d. Messina
c 1430–1479), 1475/76**
Wood; 115/56×133.6 cm
Assembled from three fragments of the altar of
San Cassiano, Venice, there until *c* 1620; the
sawn-up fragments in Archduke Leopold
Wilhelm's collection in 1659. (2574)

▷

THE THREE PHILOSOPHERS
**Giorgione (b. Castelfranco *c* 1477, d. Venice
1510), *c* 1508**
Canvas; 123.8×144.5 cm
1525 in Taddeo Contarini's house in Venice; in
Archduke Leopold Wilhelm's collection in
1659. (111)

YOUNG WOMAN WITH A MIRROR
Giovanni Bellini (b. and d. Venice _c_ 1432/33–1516) signed and dated 1515
Wood; 62×79 cm
In Archduke Leopold Wilhelm's collection in
1659. (97)

▽
VIOLANTE
Tiziano Vecellio called Titian (b. Pieve di Cadore _c_ 1488, d. Venice 1576), _c_ 1515/18
Wood; 64.5×50.8 cm
In Archduke Leopold Wilhelm's collection in
1659.
Titian's painting, which acquired early fame, was occasionally ascribed to Palma Vecchio. Aptly named 'La bella Gatta' (the beautiful cat) in old inventories, the courtesan depicted here was given the name Violante in the 19th century because of the violet she wears in her bosom. (65)

▷▽
PORTRAIT OF A YOUNG WOMAN (LAURA)
Giorgione (b. Castelfranco _c_ 1477, d. Venice 1510), attributed to Giorgione on the back and dated there **1506**
Canvas on wood; 41×33.6 cm
In Archduke Leopold Wilhelm's collection in
1659.
The painting was probably given this name (in the 17th century) because of the laurel branch (lauro) depicted in it, and refers to Petrarch's beloved Laura; the laurel may also be a symbol of loyalty and chastity, virtues with which 'Messer Giacomo', who commissioned the painting and whose name is given on the back, wished the subject to be visibly endowed. (31)

THE GIPSY MADONNA
Tiziano Vecellio called Titian (b. Pieve di Cadore *c* 1488, d. Venice 1576), *c* 1510
Wood; 65.8×83.5 cm
In Archduke Leopold Wilhelm's collection in 1659. (95)

▷

THE VISITATION
Giovanni Busi called Cariani (b. Venice or Bergamo *c* 1485, d. Venice later than 1547), *c* 1523
Canvas; 185.5×189 cm
Gallery reserve. (1828)

◁

PORTRAIT OF A YOUNG MAN AGAINST A WHITE CURTAIN
Lorenzo Lotto (b. Venice 1480, d. Loreto 1556), *c* 1508
Wood; 42.3×35.3 cm
In the Imperial Gallery since 1816. (214)

▷

NYMPHS BATHING
Jacopo Negretti called Palma Vecchio (b. Serina *c* 1480, d. Venice 1528), *c* 1525
Canvas on wood; 77.5×124 cm
In Archduke Leopold Wilhelm's collection in 1659. (6803)

MADONNA AND CHILD WITH ST CATHERINE AND
ST JAMES THE GREATER
Lorenzo Lotto (b. Venice 1480, d. Loreto 1556),
c **1533**
Canvas; 113.5×152 cm
Mentioned as being in the possession of the
Emperor in 1660. (101)

PORTRAIT OF A MAN WITH A BOOK
**Vincenzo di Biagio called Catena (b. probably
Venice *c* 1480, d. Venice 1531), signed *c* 1520**
Wood; 79×59.5 cm
In Archduke Leopold Wilhelm's collection in
1659. (87)

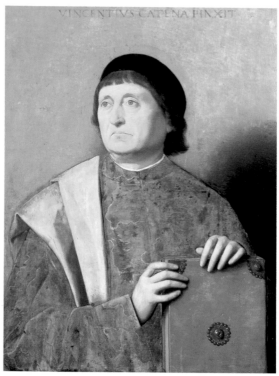

GIRL IN A FUR

Tiziano Vecellio called Titian (b. Pieve di Cadore *c* 1488, d. Venice 1576), *c* 1535

Canvas; 95×63 cm

The painting came via Spain into the possession of King Charles I of England; Hapsburg possession since 1651.

Typical portrait of a courtesan, who had also been Titian's model for other paintings; Rubens copied the painting. (89)

Tiziano Vecellio called Titian (b. Pieve di Cadore *c* 1488, d. Venice 1576), *c* 1515/20

Canvas; 88×75 cm

In Archduke Leopold Wilhelm's collection in 1659.

The subject was probably Titian's doctor. (94)

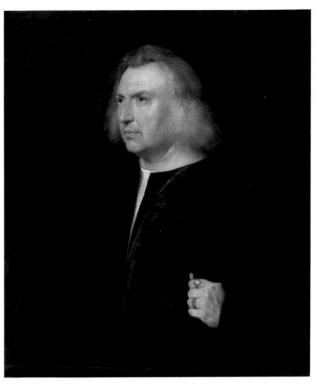

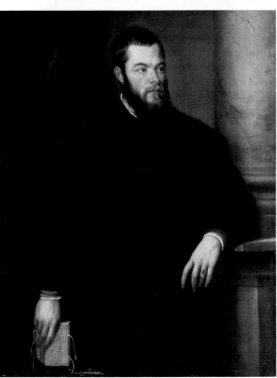

BENEDETTO VARCHI

Tiziano Vecellio called Titian (b. Pieve di Cadore *c* 1488, d. Venice 1576), signed, *c* 1540/43

Canvas; 117×91 cm

In Archduke Leopold Wilhelm's collection in 1659.

The subject (b. Florence 1503, d. Montevarchi 1567), a poet and historian, left Florence as a political fugitive in 1527 and lived in Venice from 1536–43. Recalled to Florence by the Grand Duke Cosimo I, he wrote a history of his native town. (91)

ECCE HOMO

Tiziano Vecellio called Titian (b. Pieve di Cadore _c_ 1488, d. Venice 1576), signed and dated 1543
Canvas; 242×361 cm

Painted for the Flemish merchant Giovanni d'Anna (van Haanen), who had settled in Venice. 1621–48 in the collection of the Duke of Buckingham, auctioned in Antwerp 1648 and purchased by Archduke Leopold Wilhelm for his brother Emperor Ferdinand III in Prague; came to Vienna in 1723 through Emperor Karl VI. (73)

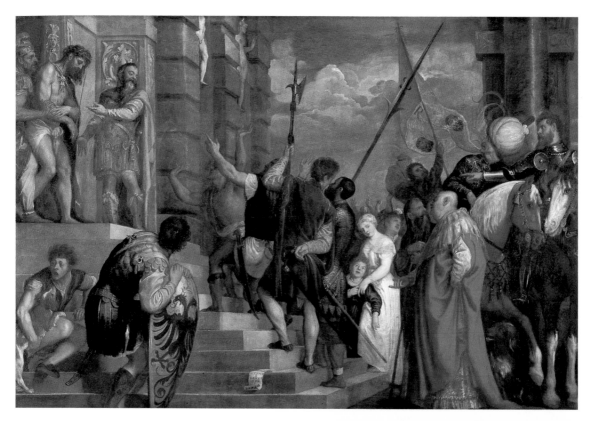

▷

JACOPO DE STRADA

Tiziano Vecellio called Titian (b. Pieve di Cadore _c_ 1488, d. Venice 1576), signed 1567/68
Canvas; 125×95 cm
In Archduke Leopold Wilhelm's collection in 1659.
The subject (b. Mantua 1515?, d. Vienna 1588) was one of the most versatile personalities of the 16th century. Around 1550 he was in the service of Duke Albrecht v of Bavaria as the latter's art expert; later on he was at the Papal Court, and from 1557 onwards in the service of the Hapsburgs at first in Vienna under Ferdinand I, Maximilian II, from 1577 to 1579 at Emperor Rudolf II's Court in Prague. He was a painter, architect, goldsmith, archaeologist, linguist, art-collector and dealer. He was indispensable to his employers as an art expert and buyer of objets d'art. (81)

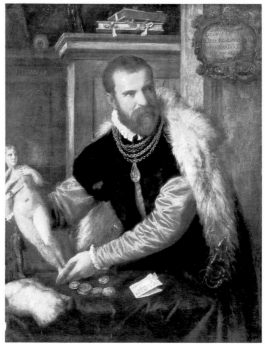

△

SHEPHERD AND NYMPH
Tiziano Vecellio called Titian (b. Pieve di Cadore *c* 1488, d. Venice 1576), after 1570
Canvas; 149.6×187 cm
In Archduke Leopold Wilhelm's collection in 1659. (1825)

◁

ALLEGORY
Paris Bordone (b. Treviso 1500, d. Venice 1571), *c* 1550
Canvas; 111.5×174.5 cm
In the Imperial Gallery in 1781.
Spirit crowning a pair of lovers in the shape of Mars and Venus with myrtle wreaths; myrtle was considered an attribute of Venus. (120)

THE FLAGELLATION OF CHRIST
Jacopo Robusti called Tintoretto (b. and d. Venice 1518–1594), *c* **1585/90**
Canvas; 118.3×106 cm
Purchased 1923. (6451)

LORENZO SORANZO
Jacopo Robusti called Tintoretto (b. and d. Venice 1518–1594), 1553
Canvas; 116×100 cm
In the Imperial Gallery in 1824.
Tintoretto painted the portrait of the Venetian
Councillor in the latter's 35th year. (308)

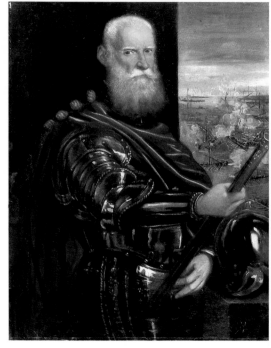

THE FLAGELLATION OF CHRIST
Jacopo Robusti called Tintoretto (b. and d. Venice 1518–1594), *c* **1585/90**

LORENZO SORANZO
Jacopo Robusti called Tintoretto (b. and d. Venice 1518–1594), 1553

SUSANNA AND THE ELDERS
Jacopo Robusti called Tintoretto (b. and d. Venice 1518–1594), *c* **1555/56**
Canvas; 146.6×193.6 cm
In the collection of the painter Nicolas Regnier, Venice, 1648. Probably in Imperial possession before 1712. On record in the gallery in 1824. (1530)

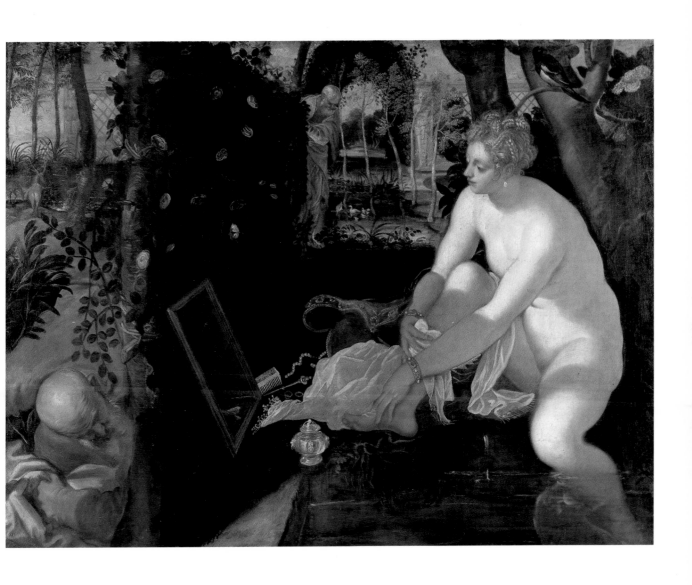

◁
SEBASTIANO VENIER
Jacopo Robusti called Tintoretto (b. and d. Venice 1518–1594), shortly after 1571
Canvas; 104.5×83.5 cm
In Archduke Leopold Wilhelm's collection in 1659.
In the battle of Lepanto in the Gulf of Corinth in 1571, the Venetian forces were under the command of Admiral Venier (d. 1578): with this victory the Holy Alliance (Spain, Venice, the Holy See) destroyed Turkish mastery of the sea in the Mediterranean. (32)

THE ANOINTING OF DAVID
Paolo Caliari called Veronese (b. Verona 1528, d. Venice 1588), *c* 1555/60
Canvas; 173×364 cm
Until 1648 in the collection of the Duke of Buckingham, purchased by Archduke Leopold Wilhelm for his brother Emperor Ferdinand III in Prague; in Vienna since 1733. (40)

THE RAISING OF THE YOUNG MAN OF NAIN
Paolo Caliari called Veronese (b. Verona 1528, d. Venice 1588), *c* 1565/70
Canvas; 102×136 cm
In Archduke Leopold Wilhelm's collection in 1659. (52)

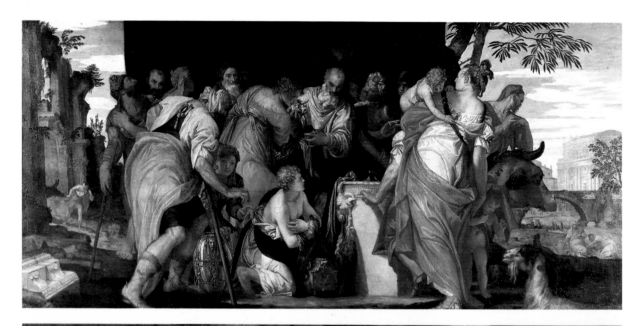

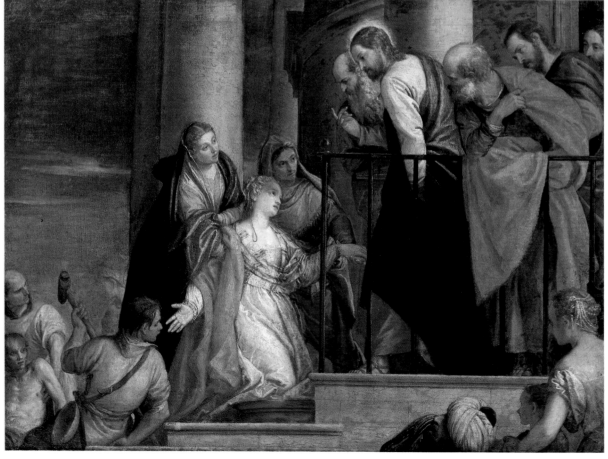

HERCULES, DEIANIRA AND NESSUS
**Paolo Caliari called Veronese (b. Verona 1528,
d. Venice 1588), late work**
Canvas; 68×53 cm
In Archduke Leopold Wilhelm's collection in
1659. (1525)

JUDITH WITH THE HEAD OF HOLOFERNES
**Paolo Caliari called Veronese (b. Verona 1528,
d. Venice 1588), painted in the 70s**
Canvas; 111×100.5 cm
In Archduke Leopold Wilhelm's collection in
1659. (34)

THE HOLY FAMILY WITH ST CATHERINE AND THE
YOUNG ST JOHN
**Andrea Meldolla called Schiavone (b. Zara
1510/15, d. Venice 1563), painted in the early
50s**
Canvas; 95×118 cm
In Archduke Leopold Wilhelm's collection in
1659. (325)

THE ADORATION OF THE MAGI
Jacopo da Ponte called Jacopo Bassano (b. and d. Bassano _c_ 1515–1592), _c_ 1560/65
Canvas; 92.3×117.5 cm
In Archduke Leopold Wilhelm's collection in 1659. (361)

▷

FIRE
Giuseppe Arcimboldo (b. and d. Milan 1527–1593) signed and dated 1566
Wood; 66.5×51 cm
Painted for Emperor Maximilian II; later incorporated into Emperor Rudolf II's _Kunstkammer_.
The element of fire is represented by a half-length portrait made up of burning wood, candles, a lamp, steel, flints and fire-arms. The chain of the Order of the Golden Fleece is probably a reference to the Emperor himself. Arcimboldo's composite heads are the very embodiment of witty Mannerist frivolity. They were already famous in his lifetime. (1585)

▷

JACOPO DA PONTE CALLED JACOPO BASSANO
Leandro da Ponte called Leandro Bassano (b. Bassano 1557, d. Venice 1622), early 90s
Canvas; 80×72 cm
1621 in the Imperial Collection in Prague.
The painter of the portrait is the third son of the subject, who was the head of the famous Bassani studio. (58)

▷▷

PORTRAIT OF A SCULPTOR
Jacopo Negretti called Palma il Giovane (b. and d. Venice _c_ 1548–1628), _c_ 1600
Canvas; 62×48.5 cm
In Archduke Leopold Wilhelm's collection in 1659. (1935)

▷▷▷

ALESSANDRO VITTORIA
Giovanni Battista Moroni (b. Albino/Bergamo 1520/24, d. Bergamo 1578), _c_ 1560/65
Canvas; 87.5×70 cm
In Archduke Leopold Wilhelm's collection in 1659. (78)
Both these portraits probably depict Alessandro Vittoria (b. 1524/25, d. 1608). He was the most important Venetian sculptor of the late 16th century. Both portraits came presumably from his estate.

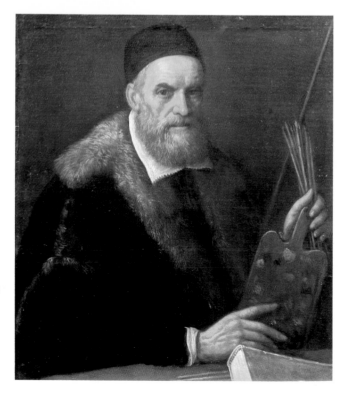

152

THE LAMENTATION OF CHRIST
Giovan Girolamo Savoldo (b. Brescia *c* 1480/ 85, d. Venice later than 1548), 1510/1520
Wood; 72.5×118.5 cm
In Archduke Leopold Wilhelm's collection in 1659. (1619)

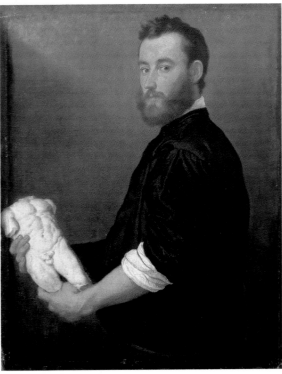

ST JUSTINA AND PATRON
Alessandro Bonvicino called Moretto (b. and d. Brescia *c* 1498–1554), *c* 1530
Wood; 200×139 cm
In the Hapsburg collections in Innsbruck and Ambras 1663. (61)

△

JUPITER, MERCURY AND 'VIRTUE' OR 'VIRGO'
Giovanni de 'Luteri called Dosso Dossi (b. and d. Ferrara 1489–1542), probably painted 1529
Canvas; 112×150 cm
Presented by Anton Count Lanckoroński in 1951.

The picture is based on a fable by the Hellenic poet Lucian. Virtus, pursued by Fortuna, appeals to Jupiter for protection, but Mercury bids her be quiet as Jupiter is busy painting butterflies (souls). Bearing in mind both the practice, common from ancient times, of equating the creator with the creative artist, and also the possibility of making general astrological connections through the constellation Jupiter, Mercury and Virgo (possibly even drawing a parallel with Dosso himself), the picture has been given complex and ambiguous interpretations. The wealth of meaning adds to the charm of this picture, which must rank as one of the most poetic works in the history of painting. (9110)

THE BAPTISM OF CHRIST
Pietro Vanucci called Perugino (b. Citta della Pieve/ Perugia *c* 1445/48, d. Fontignano 1523), *c* 1498/1500
Wood; 30×23.3 cm
1723 in the Hapsburg collections in Ambras Castle near Innsbruck. (139)

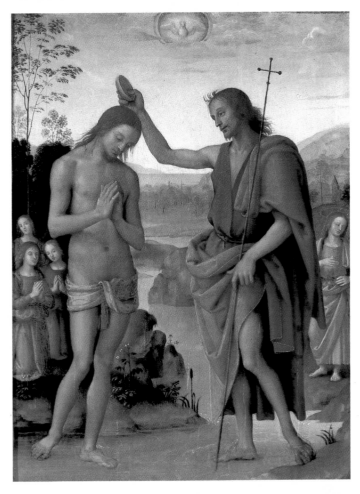

▷
MADONNA IN THE MEADOW
Raffaello Santi called Raphael (b. Urbino 1483, d. Rome 1520), dated 1505 or 1506
Wood; 113×88.5 cm
Painted for Taddeo Taddei in Florence; in the Taddei family palace until 1662; purchased by Archduke Ferdinand Karl for Innsbruck Castle; in Castle of Ambras in 1663; in Vienna since 1773. (175)

◁
THE PRESENTATION OF CHRIST IN THE TEMPLE
Baccio della Porta called Fra Bartolomeo (b. and d. Florence 1475–1517), dated 1516
Wood; 155×159 cm
Painted for the chapel of the novitiate of San Marco in Florence; purchased in 1781 for the Uffizi by Grand Duke Pietro Leopoldo (Emperor Leopold II after 1790); came to Vienna in 1792 as the result of an exchange. (207)

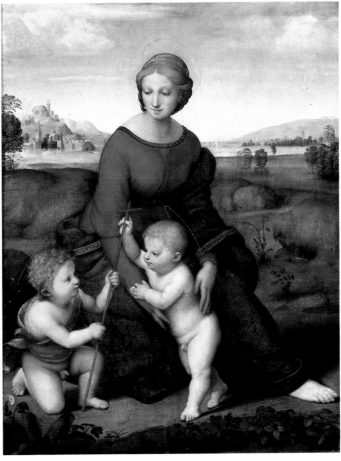

THE LAMENTATION OF CHRIST
Andrea d'Agnolo called Andrea del Sarto
(b. and d. Florence 1486–1530), signed,
c 1519/20
Wood; 99×120 cm
In the collection of the Duke of Buckingham
1635; purchased 1648 by Archduke Leopold
Wilhelm for Emperor Ferdinand III and sent
to Prague; in Vienna since 1723. (201)

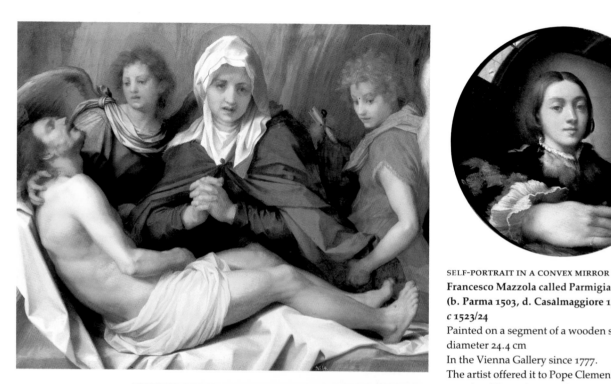

SELF-PORTRAIT IN A CONVEX MIRROR
Francesco Mazzola called Parmigianino
(b. Parma 1503, d. Casalmaggiore 1540),
c 1523/24
Painted on a segment of a wooden sphere;
diameter 24.4 cm
In the Vienna Gallery since 1777.
The artist offered it to Pope Clement VII, who
gave it to Pietro Aretino. From Aretino it
passed into the hands of the Belli family, who
were crystal cutters. Elio Belli commissioned
Andrea Palladio to sell the picture in 1560 to
the sculptor Alessandro Vittoria. The latter left
it in his will to Emperor Rudolf II. In Imperial
possession from 1608. (286)

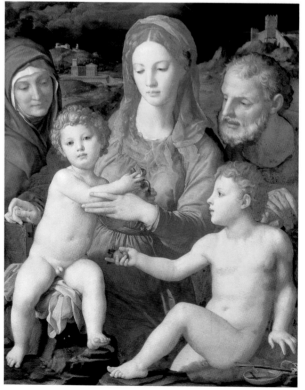

THE HOLY FAMILY WITH ST ANNE AND THE YOUNG
ST JOHN
Agnolo di Cosimo called Bronzino
(b. Monticelli near Florence 1503, d. Florence
1572) signed, c 1545/46
Wood; 124.5×99.5 cm
Acquired 1792 by means of an exchange with
Florence. (183)

From *The Amours of Jupiter*
**Antonio Allegri called Correggio (b. and
d. Correggio 1489/94–1534),** *c* 1530
JUPITER AND IO
Canvas; 163.5×74 cm
In Emperor Rudolf II's *Kunstkammer* in 1601.
(274)
THE ABDUCTION OF GANYMEDE
Canvas; 163.5×70.5 cm
In Emperor Rudolf II's *Kunstkammer* in
1603/04. (276)

Parts of a four-part series depicting the loves of
Jupiter, which Federico Gonzaga probably
presented to Emperor Karl v in Mantua in
1532; taken by the latter to Spain. In 1584 *Io*
was in the possession of the sculptor Leone
Leoni from whose son Pompeo Rudolf II
purchased the painting in 1601. *The Abduction
of Ganymede* ended up in the collection of
Antonio Perez, Philip II's secretary of State.
Rudolf II succeeded in buying the picture only
after the death of Philip II, into whose
possession it had come after Perez's downfall.
These two pictures, having been brought to
Vienna, escaped the Swedish ransacking of
Prague: the other two were carried off by the
Swedes.

157

PORTRAIT OF A MAN WITH A PARROT
**Nicolo dell'Abate (b. Modena 1509/12,
d. Fontainebleau ? 1571?), later than 1552**
Canvas; 125×109 cm
Gallery reserve. (6114)

PORTRAIT OF A MAN (THE CONDOTTIERE
MALATESTA BAGLIONE?)
**Francesco Mazzola called Parmigianino
(b. Parma 1503, d. Casalmaggiore 1540),
between 1520 and 1530**
Wood; 117×98 cm
In the Imperial Gallery in 1772. (277)

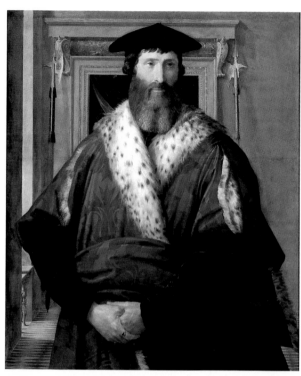

CHRIST AND THE WOMAN OF SAMARIA AT JACOB'S
WELL
**Annibale Carracci (b. Bologna 1560, d. Rome
1609), c 1602/03**
Canvas; 60.5×145 cm
In Archduke Leopold Wilhelm's collection in
1659. (267)

REST DURING THE FLIGHT INTO EGYPT
**Orazio Lomi called Gentileschi (b. Pisa 1563,
d. London 1639), signed, 1625/28**
Canvas; 138.5×216 cm
Probably in the collection of the Duke of
Buckingham until 1648, then bought by
Archduke Leopold Wilhelm for Emperor
Ferdinand III's collections in Prague; in
Vienna since 1772. (180)

◁◁
CHRIST APPEARING TO THE APOSTLES PETER AND
PAUL
**Giovanni Battista Crespi called Cerano
(b. Cerano 1575, d. Milan 1633), c 1626/28**
Canvas; 274×184 cm
Painted for the church of S Pietro dei Pellegrini
in Milan; probably purchased for the Imperial
Gallery in 1779. (273)

◁
THE DEATH OF ST PETER MARTYR
**Giorgio Vasari (b. Arezzo 1511, d. Florence
1574), c 1570**
Wood; 235×161 cm
Painted for the Cappella di S Pietro Martire in
the Vatican; in the Imperial Gallery from 1804.
(219)

MADONNA OF THE ROSARY
Michelangelo Merisi called Caravaggio
(b. Caravaggio 1571, d. Port'Ercole 1610),
1606/07
Canvas; 364×249 cm
In the Dominican church in Antwerp from
c 1620; purchased there in 1781 for the Imperial
Gallery. (147)

▷

DAVID WITH THE HEAD OF GOLIATH
Michelangelo Merisi called Caravaggio
(b. Caravaggio 1571, d. Port'Ercole 1610),
***c* 1606**
Wood; 90.5×116 cm
Probably Charles I of England, Jabach
Collection Cologne, 1667 collection Imstenrae
Cologne and Vienna; bought by Emperor
Leopold I 1667/70. (125)

▷

MADONNA APPEARING TO THE HERMITS ST PAUL
AND ST ANTHONY
Giovanni Lanfranco (b. Parma 1582, d. Rome
1647), *c* 1623
Canvas; 220×127.5 cm
Painted for S Marta in the Vatican. Purchased
1809. (223)

▷▷

THE AGONY OF CHRIST
Giovanni Battista Caracciolo called Battistel
(b. and d. Naples 1578–1635), signed, *c* 1615
Canvas; 147×121 cm
In Archduke Leopold Wilhelm's collection in
1659. (F17)

RETURN OF THE PRODIGAL SON
**Giovanni Francesco Barbieri called Guercino
(b. Cento 1591, d. Bologna 1666), *c* 1619**
Canvas; 106.5×143.5 cm
Painted for Cardinal Jacopo Serra in Ferrara.
Transferred to Vienna from Prague later than
1718. (253)

▷

THE MYSTICAL BETROTHAL OF ST CATHERINE,
WITH THE DOMINICAN SAINTS ST DOMINIC AND
ST PETER MARTYR
**Domenico Fetti (b. Rome 1588/90, d. Venice
1623), 2nd decade of the 17th century**
In Archduke Leopold Wilhelm's collection in
1659. (167)

THE BAPTISM OF CHRIST
Guido Reni (b. and d. Bologna 1575–1642),
c 1620
Canvas; 223.4×186.5 cm
In the collection of the Duke of Buckingham;
purchased 1648 by Archduke Leopold Wilhelm
for Emperor Ferdinand III in Prague;
transferred to Vienna between 1718 and 1733.
(222)

THE RETURN OF THE PRODIGAL SON
**Domenico Fetti (b. Rome 1588/90, d. Venice
1623), *c* 1621/22**
Wood; 60×44.5 cm
From the collection of Charles I of England. In
Archduke Leopold Wilhelm's collection in
1659. Definitely in the Imperial Collections
until 1772. In the collection of Count Seilern,
Vienna and London. Count Seilern Bequest
1981. (9799)

◁

THE DEATH OF CLEOPATRA
**Guido Cagnacci (b. S Arcangelo di Romagna
1601, d. Vienna 1663), signed, after 1657/58**
Canvas 140×159.5 cm
Probably painted in Vienna. In Archduke
Leopold Wilhelm's collection 1659. (1665)

THE RETURN OF HAGAR
Pietro Berettini called da Cortona (b. Cortona 1596, d. Rome 1669), painted in Florence, c 1637/42
Canvas; 123.5×99 cm
Acquired in 1792 for the Imperial Gallery in an exchange from the Grand-Ducal Gallery in Florence where it hung in the famous Uffizi Tribuna. (153)

SUSANNA BATHING
Jacopo Chimenti called da Empoli (b. and d. Florence 1551–1640), signed and dated 1600
Canvas; 229×172 cm
Came to Vienna from Ambras Castle before 1781. (1518)

THE INFANT CHRIST SUMMONING THE CHRISTIAN SOUL TO CROWN IT ACCORDING TO THE SONG OF SOLOMON
Carlo Dolci (b. and d. Florence 1616–1686), signed and dated 1674
Canvas; 96.5×76.5 cm
Commissioned by Empress Claudia Felicitas. (F8)

THE RETURN OF ASTRAEA
Salvator Rosa (b. Naples 1615, d. Rome 1673), signed, early 1640s
Canvas; 138×209 cm
Acquired in an exchange from the Grand Ducal Collections in Florence in 1792. Astraea, the Goddess of Justice (with lion, scales and sword), returns to Earth to proclaim to the peasants the coming of a peaceful golden age. With allusions to Virgil, the painting is the pictorial expression of Man's desire for peace and justice after the 30 Years' War. (1613)

▽ ▽

THE VOYAGE OF JACOB
Andrea de Leone (b. and d. Naples 1610–1685), signed, shortly after 1633
Canvas; 113×144.5 cm
Presented by the Counts Seilern, 1929. (6786)

PORTRAIT OF A VENETIAN LADY
Girolamo Forabosco (b. and d. Padua 1604/05–1679), *c* **1640/50.**
Canvas; 78×64 cm
In Archduke Leopold Wilhelm's collection in 1659. (3518)

THE LUTE PLAYER
Bernardo Strozzi (b. Genoa 1581, d. Venice 1644), *c* **1631/35**
Canvas; 92×76 cm
In Archduke Leopold Wilhelm's collection in 1659. (1612)

THE ARCHANGEL MICHAEL FLINGING THE REBEL
ANGELS INTO THE ABYSS
**Luca Giordano (b. and d. Naples 1634–1705)
signed,** *c* **1655**
Canvas; 419×283 cm
Came to the Imperial Collections from the
Church of the Minorites in Vienna, the Italian
national church, before 1796. (350)

THE DEATH OF CONSUL L. J. BRUTUS IN THE DUEL
WITH ARUNS
**Giovanni Battista Tiepolo (b. Venice 1696,
d. Madrid 1770),** *c* **1728/30**
Canvas; 383×182 cm
Painted for the Ca' Dolfin in Venice; purchased
1930. (6798)

◁

THE PROPHET ELIJAH AND THE WIDOW OF
SAREPTA
**Bernardo Strozzi (b. Genoa 1581, d. Venice
1644),** *c* **1640/44**
Canvas; 106×138 cm
In the Imperial Collections in 1733. (258)

167

Giuseppe Maria Crespi (b. and d. Bologna 1665–1747), *c* **1700**
Canvas; 129×127 cm
Painted for Prince Eugene of Savoy who used it as supraporte in his town palace in Vienna; purchased for the Imperial Collections in 1736. (306)

DEPOSITION
Francesco Solimena (b. Nocera/Naples 1657, d. Barra/Naples 1747), *c* **1731**
Canvas; 427×222 cm
Commissioned by Prince Eugene of Savoy for the chapel in Belvedere Palace, Vienna. Purchased for the Imperial Collections in 1752. (3507)
▷

CHRIST ON THE MOUNT OF OLIVES
Sebastiano Ricci (b. Belluno 1659, d. Venice 1734), *c* **1730**
Canvas; 59×76 cm
In the Gallery of the Princes of Liechtenstein. Purchased 1959. (9134)

△

IN PRAISE OF THE EVER WISE AND LIBERAL RULE OF
THE HOUSE OF HAPSBURG IN AUSTRIA
**Gregorio Guglielmi (b. Rome 1714, d. St
Petersburg 1773)**
Canvas; 76×96 cm
Produced 1759 as a sketch for the fresco in the
small gallery in Schönbrunn Palace, Vienna.
Purchased for the Austrian Gallery in 1935.
(9684)

◁

THE RETURN OF THE PRODIGAL SON
**Pompeo Batoni (b. Lucca 1708, d. Rome 1787),
signed and dated 1773**
Canvas; 138×100.5 cm
Bought for the Imperial Collections from the
artist in 1773. (148)

THE FREYUNG IN VIENNA SEEN FROM THE SOUTH
EAST
**Bernardo Bellotto called Canaletto (b. Venice
1721, d. Warsaw 1780),** *c* **1760**
Canvas; 116×152 cm
In Imperial possession since it was painted.
(1654)

VIEW OF VIENNA FROM BELVEDERE PALACE
**Bernardo Bellotto called Canaletto (b. Venice
1721, d. Warsaw 1780),** *c* **1760**
Canvas; 136×214 cm
In Imperial possession since it was painted.
(1669)

**Bernardo Bellotto called Canaletto (b. Venice
1721, d. Warsaw 1780),** *c* **1760**

Early Netherlandish and Flemish Painting

In the collection of Northern painting, the art of the Southern Netherlands from the fifteenth to the seventeenth centuries is quite clearly preponderant and as all its aspects are represented, it is possible to trace the development with unusual completeness. The four most important groups are the Early Netherlandish masters, Pieter Bruegel the Elder, Rubens and Van Dyck. The way was paved for the blossoming of panel painting in the Netherlands in the fifteenth century in Brussels, Ghent, Louvain, Bruges, Antwerp and Haarlem by an urban culture which had been developing since the late fourteenth century and which was based on the wealth of these Flemish and Brabantian cities – acquired through extensive trading and, more particularly, textile manufacturing. Then there was the ruling house, descended from a branch of the Valois of whose possessions these territories formed part, and the court. The latter administered Europe's most modern state, one which bore the stamp of the highly cultured dukes and which loved art and ceremonial magnificence probably more than any other on the continent, and hence was also their foremost patron.

Archduke Leopold Wilhelm believed himself to be in possession of several pictures by one of the founders of Early Netherlandish panel painting, Jan van Eyck, who worked in Ghent and who, according to the 1659 inventory, 'discovered oil-colours'. Even if modern art history has since ascribed these works to various other masters, they can nevertheless all be numbered among the main works in the gallery. Van Eyck's portrait of 'the Cardinal of Santa Croce', as Leopold Wilhelm's inventory calls it, is today generally recognized as that of Nicolo Albergati, the Cardinal Legate who was on a diplomatic mission to the Netherlands between 1431 and 1435. Jan van Eyck had done a silver-point drawing of the subject (today housed in Dresden) which perhaps gives a slightly more 'lifelike', more natural account of the old cardinal but does not equal the monumentality, severity and dignity of the painted portrait, small though this is. In spite of the detailed portrayal of all the visible marks which life has stamped on the old man's face, the overall conception is monumental, severe and simple; the new sense of realism is not lost in the detail.

Rogier van der Weyden is not so much a coolly objective observer of the world as a portrayer of the drama of the holy event. He is the 'municipal painter' of Brussels, whose Vienna crucifixion triptych must have appeared around 1440/45. In his intense expression of feeling, and in the sometimes ornamental agitation of the draperies and figures, Rogier is closer to the late Gothic tradition than is Van Eyck. His art, nevertheless, is steeped in realism and, thanks to his technique of applying the pigments imbedded in oil resin in layers of thin glaze, his colours are of extraordinary luminosity, which made his pictorial innovations particularly influential not only in the Low Countries but also in central Europe.

It is interesting to observe the gradual change in the relationship of the Early Netherlandish masters to Italy, the centre of the new humanistic, idealistic art. The fact that Rogier van der Weyden went on a pilgrimage to Italy in 1450 has left no mark either on his own painting or in Italy, apart from a few marginal features. Hugo van der Goes, on the other hand, the melancholy master working in Ghent, never in fact went to Italy himself but had a profound influence on Italian painters with the huge altar-piece *The Adoration of the Shepherds* (now in the Uffizi in Florence), which he executed for Tommaso Portinari, head of the Medici trading settlement in Bruges. Not only were his Flemish colours brilliant and luminous but he had above all the ability to bring out the individual psychological experience of the characters portrayed, especially that of suffering, pity, pain and ecstatic fervour, and, in so doing, to inspire sympathetic contemplation in the pious beholder. The impressive feature can also be observed in one of his early masterpieces, the little two-part house altar with the *Fall of Man*, on which is drawn a representation of the redemption through the *Sacrificial Death of Christ*. In contrast to this expressive art, Rogier's pupil Hans Memling comes closer to the Italian sense of form, particularly in his late triptych in Vienna, with the carefully balanced symmetry of its structure and the serene landscape covering all three wings. Then there are the direct borrowings from North Italian early Renaissance painting, with the garland-clasping putti. A generation later, with Jan Gossaert, Bernaert van Orley, Joos van Cleve, and even more with Jan van Scorel, Flemish painting is already completely steeped in the Italian early and high Renaissance but it never abandons the native Flemish ideals of intense striving after realistic representation, of depicting a wealth of minute shapes, with brilliant colouring skills and precision in the grasp of detail. All these painters were in Italy repeatedly and for considerable periods of time, and they were impressed both by its ancient buildings, and, for their purely ornamental aspect, particularly by the frescoes of Filippino Lippi in Rome and Florence. The art of Raphael and his school, the art of Leonardo da Vinci, had already made a deep impression and it was these painters who were largely responsible for making them known in the North.

Obviously, though, some painters, mostly from the northern Low Countries, were hardly influenced by Italian art at all: masters such as Geertgen tot Sint Jans, the so-called Master of the Virgo inter Virgines, the maverick Hieronymus Bosch, or the true creator of Dutch landscape painting, Joachim Patinier, whom Dürer greatly admired and who is represented in Vienna by his main work, the *Baptism of Christ*. The landscape and the open space surrounding the figures already plays an artistically dominant role here, as it was to do pre-eminently in Dutch painting of the seventeenth century. A masterpiece by Geertgen van Haarlem, the account of the fate of the earthly remains of St John the Baptist, also points forward to the Dutch painting of the seventeenth century, albeit in a different genre. This

painting came from the high altar of the church of the Knights of St John in Haarlem. It is painted on the outer right-hand wing (the inside right wing, depicting the *Lamentation of Christ*, is also in the Kunsthistorische Museum). The occasion of the commission was the handing over of the relics of the saint by the Turks in 1484. The painting spans the whole sequence of events from the burial of St John by the wife of Herod (in the background), through the burning of his bones by order of the Emperor Julian Apostata in 362 (in the foreground), to the re-discovery and recovery of the few unburned remains by the Knights of St John in thirteenth-century Acco. These Knights, however, have the faces of the Haarlem Knights Hospitaller of the late fifteenth century. In the complicated structure of this painting, it is the group portraits of the middle ground that play a particularly interesting role: the lining up in the middle ground of a group of like-minded and uniformly dressed people, depicted performing an activity but with their attention peculiarly divided, directed neither towards one another nor to the action which brings them together, points forward to the Dutch group portraits of the late sixteenth and especially the seventeenth centuries.

Roughly a quarter of the works of Pieter Bruegel the Elder which have come down to us are to be found in the Kunsthistorische Museum. It was the Archduke Ernst and his brother the Emperor Rudolf II who amassed the stocks (originally almost twice as numerous), and thus made this the most important Bruegel collection in the world and clearly one of the major points of attraction in the gallery today. The twelve years of the artist's actual painting activity can be followed step by step, the spectrum ranging from the early *Battle Between Carnival and Lent* with its numerous small figures seen from above, through the great series of *The Seasons*, in which Bruegel depicts his ideas about the orderliness of the universe and Man's place therein, to his late compositions with large figures such as the *Peasant Wedding* and *Peasant Dance*. Bruegel is rightly regarded as the culmination of Flemish painting and its highest exponent. The descriptive realism which had characterized Flemish painting, with shifting emphasis, since Jan van Eyck leads in Bruegel, with his even sharper grasp of reality, to a deeper understanding of the universe, to a cosmic interpretation which embraces nature and man equally without taking up any potentially 'dating' stance with regard to specific political or moral issues. His documented painting activity in Antwerp and Brussels starts in 1557 after his return from a prolonged Italian tour, and after working in the publishing house of Hierony-mous Cock, for whom he furnished drawings.

In the ironic realism of his description of the 'human menagery', the customs and sights of the two consecutive yet antagonistic seasons of Carnival and Lent unfold as in a tournament against an urban landscape, between the symbolic settings of inn and church. In the *Tower of Babel*, although he has abandoned the technique of scattering the figures all over a flat surface, he retains a similar concept in the elevated position of the beholder, who is looking across a wide expanse of landscape, in the middle ground of which there looms the enormous bulk of the tower. The allegory satirizes the human hubris which calls forth divine retribution: incompatible archi-tectural concepts such as the external spiral ramps and the multi-storey structure of the interior, plus soaring verticals resting apparently at right angles on the mounting ramps, inevitably making the tower askew, visibly demonstrate the faulty planning of the enterprise from the very outset. Yet the technical apparatus which such a gigantic structure seems to demand has been observed with such tremendous accuracy that the futility of the whole venture is stressed all the more clearly.

In 1565/66 Bruegel created what is probably his most com-prehensive work, the cycle of *The Seasons*. Of the original six parts, three are still in the Kunsthistorische Museum; *Gloomy Day* (early spring), the *Return of the Herd* (autumn) and *Hunters in the Snow* (winter). In these pictures, originally designed as a frieze and all interrelated, Bruegel realizes his concept of an earthly cosmos with natural events succeeding each other in a yearly cycle, into which Man is incorporated in his seasonal activities. Although Bruegel still preserves the old tradition of the representation of the months, and is indeed the culmination of it, he nevertheless abandons in his pictures its quasi-illustrative character. The landscape, although topographically not authentic but a composite one made up of the usual natural elements of mountains, valleys, sea, rivers and cities, shows a high degree of realism in the rendering of space and time. The last years of his short-lived activity as a painter – the main works from this last period are the two peasant paintings in Vienna – see a change in Bruegel's style towards the monumen-tal, with large figures. By reason of the power of their imagery, their pithy grasp of reality, pictures like the *Peasant Wedding* presumably took the place of the real world for the lonely Emperor Rudolf, but still for us today they are the very epitome of scenes painted from life, before this art degenerated into mere genre painting.

Along with those of the Prado, the Louvre and the Alte Pinakothek, the Rubens collection in the Kunsthistorische Museum ranks among the most important in the world. As in Madrid, it was the Hapsburgs who advanced Rubens and collected his pictures. As the Southern Netherlands remained a possession of the Spanish and Austrian Hapsburgs right into the late eighteenth century, the connection with their greatest painter was never severed. Even if all the phases of develop-ment of the master are not equally well represented in the Kunsthistorische Museum – the paintings housed here can be neatly divided between the second decade of the seventeenth century and Rubens' late period – nevertheless there are few

other places where all aspects of his art can be studied through particularly characteristic examples: the great Counter-Reformation altar-piece (along with the preliminary sketches), the devotional picture intended for private meditation, the portrait, landscape, mythology and allegory, and also political allegory, a means of expression so characteristic of Rubens the diplomat (as in the *Meeting near Nördlingen*).

Rubens' only 'Italian' work in the gallery is a fragment, acquired as late as 1908, from the originally enormous altar painting for the Jesuit church in Mantua – *The Holy Trinity Worshipped by Vincenzo Gonzaga and his Family*. Painted in 1604/5 for the apse of the church, it was probably the most important commission that Rubens received as court painter to the Gonzaga in Mantua. It depicts Vincenzo II, the youngest son of the Duke and Duchess, who had originally been placed to the left behind his father and his two elder brothers. In spite of the painterly style, strongly influenced by Veronese, one of Rubens' essential features – his ability to comprehend the human figure organically and to give it shape and substance – can be recognized here in the life-like presence of the eleven-year-old boy who almost steps out of the picture to meet the beholder.

After his return from Italy in 1609 Rubens found full scope in his 'native' town of Antwerp for his extensive activity as court painter of the governors, the Archduke Albrecht, brother of Emperor Rudolf II, and his wife and cousin, the Infanta Isabella Clara Eugenia, daughter of Philip II of Spain. The favourite painter of the Antwerp bourgeoisie, steadily acquiring wealth, he was now painting for the great orders, especially in the service of the Jesuits, but also for foreign princes such as the Count Palatine, Wolfgang Wilhelm von Pfalz-Neuburg (from whose collection the Rubens stocks in the Alte Pinakothek in Munich largely derive). As ability, skill, charm and loyalty made Rubens particularly well qualified for diplomatic missions at the behest of the Infanta and of the Spanish king, his fame soon spread all over the art world. In order to be able to satisfy the growing demand for pictures, Rubens gathered around him a group of collaborators (among them Van Dyck, Jordaens and Jan Brueghel the Elder), who shared the work in a well organized studio.

Of Rubens' most ambitious enterprise in the second decade of the seventeenth century, namely the decoration of the Jesuit church in Antwerp with thirty-nine soffits and three enormous altar paintings, only the three altar paintings with the Assumption of the Virgin and the two depicting the Miracles of St Ignatius and St Francis Xavier survived the fire of 1718 and are now preserved in Vienna. Sketches, such as that for the high altar panel shown here depicting the *Miracles of St Ignatius Loyola*, served two purposes. On the one hand they could be submitted to the patron for approval, allowing him to suggest any necessary changes, and on the other they served as a means for the artist to make a final check of the overall pictorial composition, in terms of both content and technique, when the work was seen in situ. When the picture was transferred to its large format, the changes involved mainly the clarification and enlargement of the composition, the more detailed working through of the individual figures and the spacing out of clusters of figures. Thus the meaning of the altar paintings designed to be seen at a distance became more clearly 'readable' for the devout. No doubt the sketches appeal more to modern feeling as they are the immediate creation of the artist – we appreciate the bold brush-strokes, the spontaneity of pictorial invention; we savour the vigour of the artist in the execution of these provisional sketches more than the sometimes calculated end-product, which can be overloaded with detail and of which large portions may have been painted by collaborators. In the large altar-pieces and also in allegories such as the *Four Continents*, we are impressed by the dynamic figures, charged with emotion, of a gigantic race of men in whom, in Rubens' own words, the redeemed world (and also the re-awakened world of antiquity) is presented as an ideal yet earthly creation. These are juxtaposed with modern Man, who has been brought down by 'centuries of senile enfeeblement as a result of misfortune and new vices which have emerged.' In the small pictures for private worship, such as the so-called 'Small *Lamentation*', Rubens stresses realistically and with exquisite pictorial precision the individual, significant devotional motif. Rubens' conceptual plan is admirable: he combines the exhortatory task of the religious painting of the Counter-Reformation with an artistic concept in which the ideal and the illusion of absolute reality become one. What is ideal is the classical form, while the figures, suffused with warm life, are the natural element; in the grip of passion, they seem palpably real to us.

Rubens' landscape painting is particularly well represented in the *Stormy Landscape*. It is not simply a landscape but one given heightened meaning by the later addition of the Philemon and Baucis scene. Even though he seeks to justify the landscape mythologically by extending it into the elemental dimension of the Flood, it is Nature 'in its most powerful activity, in its most strongly human aspect, namely that of destruction, that remains the true protagonist of the drama.' (Demus).

Rubens' later period, biographically speaking, began with his resignation from official diplomatic duties and his second marriage to Hélène Fourment, his junior by thirty-seven years, and it reaches its first climax in the *Ildefonso Altar*. This work, a miracle of painting, was executed between 1630 and 1632 and commissioned by his patroness the Infanta Isabella Clara Eugenia in memory of her husband who had died in 1621. Both patrons are depicted on the wings of the altar together with their patron saints. Rubens uses the form of the triptych, familiar to us from Early Netherlandish painting. The outer side

of the wings can also be seen, re-assembled as *The Holy Family under the Apple Tree*, in the Kunsthistorische Museum. With maximum pictorial licence, sometimes using bold impasto brush-strokes, sometimes putting on the paint in transparent layers, he realizes a vision of gold, red and a few cool tones. Through this he achieves a unique combination of the outstanding qualities of his strongly contrasting models: the hazy colour technique, so full of atmosphere, of the sixteenth-century Venetians, and the exquisite, closely observed, enamel-like corporeality of Early Netherlandish painting. Among the maidens accompanying the Virgin we can see, as in almost all Rubens' late work, the figure of Hélène Fourment. Rubens must have been infatuated with the charms of his young wife; her recurrence in his paintings was even remarked on, half in admiration, half in irritation, by the new Spanish governor of the Low Countries, the Cardinal-Infante Ferdinand – for whose triumphal entry into Antwerp Rubens painted, among other works, the *Meeting near Nördlingen*.

In *The Fur* (the title used by Rubens himself) Vienna possesses what is probably the most subtle blending of portrait and mythological travesty. What remains uncertain is whether in this painting the classical *Venus Pudica* has merely taken on the features of Hélène Fourment or whether Rubens actually intended to portray his wife, but wanted to elevate the intimacy of the subjective into the sphere of the universal by translating it into mythology. The picture has come down to us from Rubens' estate; he had left it to his wife with the express stipulation that its material value was not to be considered in any assessment of her share in his fortune.

Rubens' late self-portrait, painted when he was about sixty-two, is the only one which conforms to the official three-quarter-length tradition. Also 'official' are the attributes, clothes and pose of the courtier, the representative form in which the master painter chooses to depict himself, in spite of his self-confessed desire to distance himself from court life. However, behind the official pose his features show a certain sceptical weariness, coupled with an alert, appraising look: 'reflective and at the same time conscious of his own value – a total fusion of idea and reality – he wanted to face the world as a man of absolute veracity.' (Klauner).

None of the Flemish painters of the seventeenth century could escape the overwhelming influence of Rubens. Abraham Janssens, Jacob Jordaens and of course Sir Anthony van Dyck were probably the ones who continued to develop most individually. Almost the same age as Rubens, and a fully fledged artist when the latter returned from Italy in 1609, Janssens developed a classical style influenced by the Bolognese school and Caravaggio, a style that brings out figures and draperies plastically and monumentally in bright colours: *Venus and Adonis* comes from his later period – a characteristic composition, very much according to the rules, whose exten-sive background was painted by Jan Wildens, an artist who had also worked for Rubens as a landscape specialist.

Jordaens' inimitable way of reproducing directly an often farcical and lusty reality should not mislead us into thinking that he did not compose his paintings strictly, although they are so full of life and movement that they almost burst out of the frame. Thus the beholder's eye finds its way immediately among the apparent (but only apparent) muddle of the *Feast of the Bean King* dating from Jordaens' late period. In content also the picture goes beyond mere genre representation: surmounting and overriding the whole is the Latin tag under the satyr's mask, pointing to the fact that humanity, represented by the drunken courtiers of the Bean King, is raving away aimlessly; no one resembles the madman more than the drunkard.

Van Dyck, probably the most important of Rubens' pupils and collaborators, did not take the path indicated by Jordaens, which may have led him to paint in a coarser vein rather gross, folksy subjects. Instead he developed a style in contrast to Rubens, perceiving and sensitively portraying the drama enacted in the human soul. Both in his religious and mythological scenes and in his portraits, Van Dyck's figures always reveal their restless striving, their longings, their fervent devotion, their passions – sometimes almost shamelessly and ecstatically. Thus particularly in his early period, when Van Dyck was still collaborating closely with Rubens (1616–20), but also later on, after his return from the sobering Italian trip (1622–27), we have confused, 'ruffled' brushstrokes of unevenly applied paint; nervous, careless, often coarse, striving to depict not the smooth curves of the body but the immediate facial expression (see the *Apostle Philip*). Hence also in his late English period (1632–41), as the successful court painter, he developed the definitive portrait of the aristocrat in his presumptuous nonchalance, adopting swift, flowing, elegant, virtuoso brushstrokes to capture the charm of colour in silks, brocades, armour and skin (see the portrait of *Nicholas Lanier*). Here also the brushstroke serves expression, portraying the subject as a person of rank in all his desired elegance and dignity, but behind this we can sense an emotional tension between the elegant representation and the actual character. Sometimes this is just barely perceptible in a gesture, from the vaguest signs of nervous irritation to the expression of downright arrogance found in some of the portraits of aristocrats in his late English period. Van Dyck's figures are never self-contained as are those of Rubens, they always point beyond themselves: they are there to be looked at by a beholder. In compositions involving more than one figure – which, characteristically, he also prefers even in his portrait commissions – 'the figures are held together by their consciousness of one another and their movements. There is something almost neurotically sensitive in the hands that reach out and in the light that brushes past their heads.' (Gerson).

Van Dyck's own hypersensitivity, his inner restlessness – which showed itself in his extreme precociousness, and later on in the way he rushed to and fro from one country to another doing the round of the European courts, always driven by ambition – coupled with his ability to sense emotional relationships between people may, in his paintings, verge on the sentimental or, at the other end of the scale, on the ecstatic. In his religious paintings these qualities allow him to strike a note of gentle tenderness and charm hitherto unknown in baroque painting. This is particularly true of the *Vision of the Blessed Hermann Joseph*. In pictures such as *Samson and Delilah* they release, as the drama is enacted, an almost compulsive importunity in the eye-contact of the protagonists. In a portrait such as that of *Jacomo de Cachiopin*, a friend of Van Dyck's, we experience the painter's sensitivity as an expression of introspection and melancholy, features which are found again in the portrait of the so-called 'General in gilded armour' (*Portrait of a Young General*). Despite his heroic gesture, there is a touch of sobering melancholy about this young man – as indeed is also discernible in the sixteenth-century Venetian portraits which served as models here.

DIPTYCH WITH THE FALL OF MAN AND THE
LAMENTATION OF CHRIST
**Hugo van der Goes (b. Ghent 1430/40,
d. Brussels 1482), before 1475**
Wood; 32.3×21.9 cm (Fall of Man),
34.4×22.8 cm (Lamentation)
Possibly purchased from the artist by
Archduke Maximilian (later Emperor
Maximilian I). In Archduke Leopold
Wilhelm's collection in 1659 as Van Eyck.
(5822, 945)

DIPTYCH WITH THE FALL OF MAN AND THE
LAMENTATION OF CHRIST

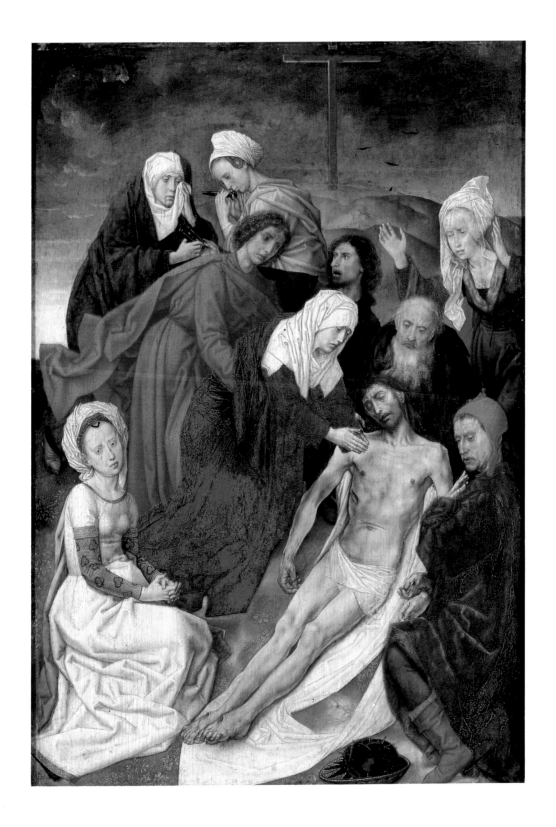

**Hans Memling (b. Seligenstadt/Main *c* 1435,
d. Bruges 1494), late work**
Wood; 69×47 cm (centre panel), 63.5×18.5 cm
(each wing)
In Archduke Leopold Wilhelm's collection in
1659 as Van Eyck. (939, 943 a, b)

CRUCIFIXION TRIPTYCH WITH ST MARY MAGADALEN
AND ST VERONICA AND UNKNOWN PATRONS
**Rogier van der Weyden (b. Tournai 1399/1400,
d. Brussels 1464),** *c* **1440/45**
Wood; 96×69 cm (centre painting), 101×35 cm
(wings)
In Archduke Leopold Wilhelm's collection in
1659. (901)

THE FATE OF THE EARTHLY REMAINS OF
ST JOHN THE BAPTIST
**Geertgen tot sint Jans (b. Leyden (?) 1460/65,
d. Haarlem later than 1490), datable later than
1484**
Wood; 172×139 cm
Outer right-hand wing of the high-altar of the
chapel of the Knights of St John in Haarlem;
brought to Utrecht after the destruction of the
altar. Presented in 1635 to King Charles I of
England by the States General; the latter
presented it to the Marquess of Hamilton. In
Archduke Leopold Wilhelm's collection in
1659. (993)

CHRIST CARRYING THE CROSS
**Juan de Flandes (mentioned since 1496,
d. Palencia (?) before 1519), between 1496–
1504**
Wood; 21.5×15.5 cm
Presented in 1913.
Part of an altar consisting of 47 small panels
with scenes from the Life of Our Lord painted
by Juan de Flandes and Michiel Sittow for
Queen Isabella of Castile. Of the 28 surviving
panels – now scattered throughout the world –
the *Nailing to the Cross* is also in the
Kunsthistorische Museum. (6269).

CHRIST CARRYING THE CROSS
**Hieronymus Bosch (b. and d. Hertogenbosch
c 1450–1516), *c* 1480**
Wood; 57×32 cm
Purchased 1923. Left wing of a small
crucifixion altar; on the back in *grisaille,* a child
with windmill and push-cart. (6429)

THE BAPTISM OF CHRIST
Joachim Patinier (b. Bouvignes (?) c 1485,
d. Antwerp 1524), signed, c 1515
Wood; 59.7×76.3 cm
In Archduke Leopold Wilhelm's collection in
1659. (981)

▷

ST THOMAS AND ST MATTHEW ALTAR-PIECE
Bernaert van Orley (b. and d. Brussels 1488–
1541), signed c 1512/15
Wood; 140×180 cm
Presented by the Masons' and Carpenters'
Guild to Notre Dame du Sablon in Brussels.
Purchased 1809.
Centre panel of a triptych; wings in Musées
Royaux des Beaux-Arts, Brussels. (992)

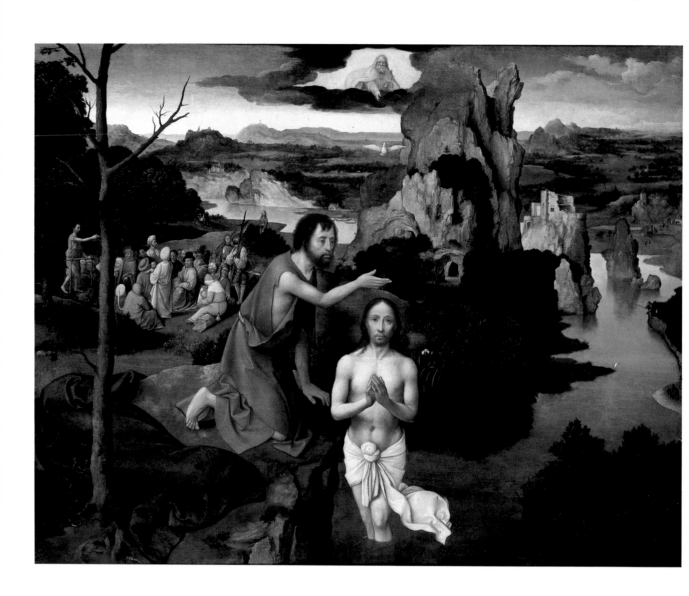

▷

TRIPTYCH WITH THE HOLY FAMILY, ST GEORGE, ST
CATHERINE AND UNKNOWN PATRONS
Joos van Cleve (b. Cleve (?) c 1485/90,
d. Antwerp 1540), c 1530
Wood; 94.5×70 cm (centre panel), 94.5×30 cm
(each wing)
In Imperial possession in 1619 as Hans
Holbein. (938)

184

THE BIRTH OF CHRIST
Master of the Virgo inter Virgines (worked in Delft *c* **1470–1500),** *c* **1500**
Wood; 90.5×68 cm
Purchased 1921. (6375)

▷

ST LUKE PAINTING THE VIRGIN
Jan Gossaert called Mabuse (b. Maubeuge *c* **1478, d. Antwerp (?) 1532),** *c* **1520**
Wood; 109.5×82 cm
In Archduke Leopold Wilhelm's collection in 1659. (894)

THE PRESENTATION OF CHRIST IN THE TEMPLE
**Jan van Scorel (b. Schoorl 1495, d. Utrecht
1562), *c* 1528/30**
Wood; 114×85 cm
Purchased 1910. (6161)

THE LAST JUDGMENT
**Frans de Vriendt called Floris (b. and
d. Antwerp 1519/20–1570), signed, dated 1565**
Canvas on wood; 162×220 cm
In Archduke Leopold Wilhelm's collection in
1659. (3581)

THE BATTLE BETWEEN CARNIVAL AND LENT
**Pieter Bruegel the Elder (b. Breda (?) 1525/30,
d. Brussels 1569), signed, dated 1559**
Wood; 118×164.5 cm
Presumably in the collection of Emperor
Rudolf II. (1016)

▷
THE TOWER OF BABEL
**Pieter Bruegel the Elder (b. Breda (?) 1525/30,
d. Brussels 1569), signed, dated 1563**
Wood; 114×155 cm
1566 in the hands of Nicolaas Jongelinck,
Antwerp, then in the possession of the city of
Antwerp; in the collection of Emperor Rudolf
II, in Archduke Leopold Wilhelm's collection
in 1659. (1026)

◁
PEASANT DANCE
**Pieter Bruegel the Elder (b. Breda (?) 1525/30,
d. Brussels 1569), signed, c 1568**
Wood; 114×164 cm
Emperor Rudolf II's collection. (1059)

▷
PEASANT WEDDING
**Pieter Bruegel the Elder (b. Breda (?) 1525/30,
d. Brussels 1569), c 1568**
Wood; 114×164 cm
Purchased by Archduke Ernst in Brussels in
1594; probably in the collection of Emperor
Rudolf II. In Archduke Leopold Wilhelm's
collection in 1659. (1027)

THE CONVERSION OF ST PAUL
Pieter Bruegel the Elder (b. Breda (?) 1525/30, d. Brussels 1569), signed, dated 1567
Wood; 108×156 cm
Purchased by Archduke Ernst in Brussels in 1594. In Emperor Rudolf II's collection. (3690)

△

HUNTERS IN THE SNOW (WINTER)
Pieter Bruegel the Elder (b. Breda (?) 1525/30, d. Brussels 1569), signed, dated 1565
Wood; 117×162 cm (1838)

The Seasons: In 1566 in the hands of Nicolaas Jongelinck in Antwerp; he used them to guarantee someone else's debt to the city of Antwerp; after the forfeit of this guarantee the city of Antwerp presented the (Spanish) Regent, Archduke Ernst, brother of Emperor Rudolf II, with the six-part series. The Emperor later gained possession of Ernst's paintings. In Archduke Leopold Wilhelm's collection in 1659.

▷

THE RETURN OF THE HERD (AUTUMN)
Pieter Bruegel the Elder (b. Breda (?) 1525/30, d. Brussels 1569), signed, dated 1565
Wood; 117×159 cm (1018)

FLOWERS IN A BLUE VASE
**Jan Brueghel the Elder (b. Brussels 1568,
d. Antwerp 1625), c 1608**
Wood; 66×50.5 cm
Came to the Imperial Gallery from the Secular
Treasury. (558)

THE ADORATION OF THE MAGI
**Jan Brueghel the Elder (b. Brussels 1568,
d. Antwerp 1625), signed, dated 1598**
Copper; 33×48 cm
Purchased 1806. (617)

◁
ORPHEUS IN THE UNDERWORLD
**Roelandt Savery (b. Courtrai 1576, d. Utrecht
1639), signed, c 1610/20**
Copper; 28×36 cm
In Imperial possession in Prague 1621. (3534)

▷
THE LAMENTATION OF CHRIST
**Peter Paul Rubens (b. Siegen 1577,
d. Antwerp 1640) signed, dated 1614**
Wood; 40.5×52.5 cm
In the collection of the Marquess of Hamilton
in 1638. In Archduke Leopold Wilhelm's
collection in 1659. (515)

VINCENZO (II) GONZAGA
Peter Paul Rubens (b. Siegen 1577,
d. Antwerp 1640), *c* 1604/05
Canvas; 67×51.5 cm
Purchased 1908. Fragment of the altar painting
(cut into pieces in 1801) in the Jesuit Church in
Mantua. It depicts the Holy Trinity
worshipped by the Gonzaga family. (6084)

THE MIRACLES OF ST IGNATIUS LOYOLA
Peter Paul Rubens (b. Siegen 1577,
d. Antwerp 1640), *c* 1615
Wood; 105.5×74 cm
Purchased 1776.
Sketch for the former high-altar-piece in the
Jesuit Church in Antwerp. The latter was
probably finished in 1618 and is also in the
Kunsthistorische Museum. (530)

THE FOUR CONTINENTS
**Peter Paul Rubens (b. Siegen 1577,
d. Antwerp 1640),** *c* **1615**
Canvas; 209×284 cm
In 1685 in the Imperial Collections in Prague,
in Vienna in 1733. (526)

▷
STORMY LANDSCAPE WITH PHILEMON AND
BAUCIS
**Peter Paul Rubens (b. Siegen 1577,
d. Antwerp 1640),** *c* **1620/25**
Wood; 146×208.5 cm
Mentioned 1640 in the inventory of Rubens'
estate. In Archduke Leopold Wilhelm's
collection 1659. (690)

▷
THE FEAST OF VENUS
**Peter Paul Rubens (b. Siegen 1577,
d. Antwerp 1640),** *c* **1635/37**
Canvas; 217×350 cm
In the Imperial Collections in Prague 1685; in
Vienna 1721.
The Feast of Venus derives from Titian's *Worship
of Venus*, now in Madrid. Rubens copied the
picture which relates back to antique
descriptions by Philostratus of actual
paintings. Here, Rubens paraphrases Titian,
giving the latter's interpretation concrete
expression but turning it, both in content and
artistically, into a highly complex and entirely
new pictorial poem. (684)

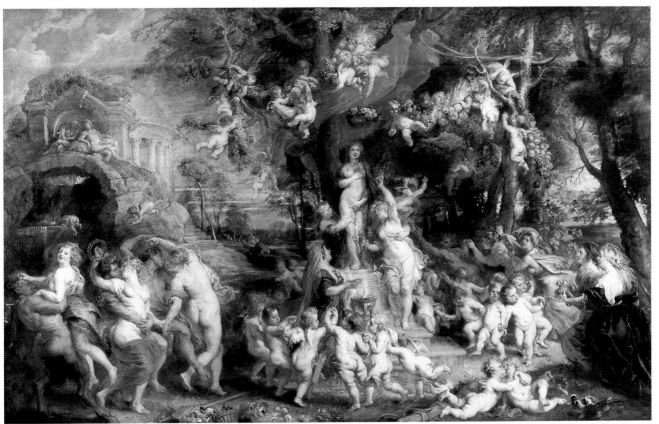

ILDEFONSO ALTAR-PIECE
Peter Paul Rubens (b. Siegen 1577,
d. Antwerp 1640), 1630/32
Wood; 352×236 cm (centre panel), 352×109 cm
(each wing)
Purchased 1777. (678)

▷
THE FUR
Peter Paul Rubens (b. Siegen 1577,
d. Antwerp 1640), *c* 1635/40
Wood; 176×83 cm
Listed in the inventory of Rubens' estate; in
the Imperial Collections in Vienna in 1730.
(688)

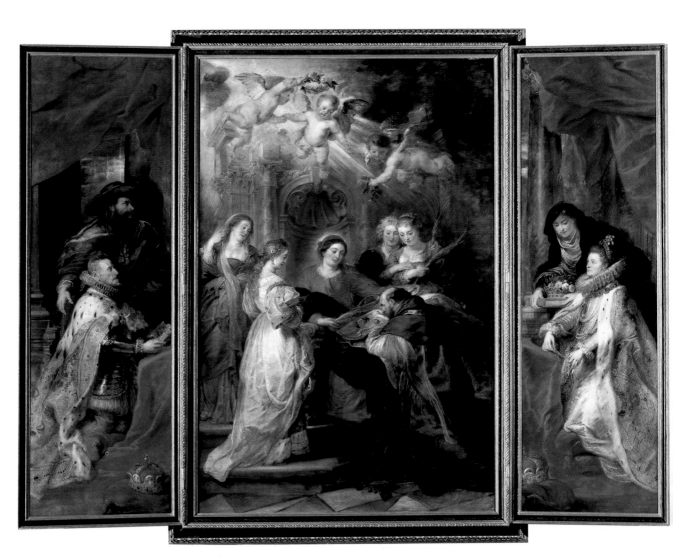

▷
MEETING BETWEEN KING FERDINAND OF HUNGARY
AND THE CARDINAL-INFANTE FERDINAND BEFORE
THE BATTLE OF NÖRDLINGEN
Peter Paul Rubens (b. Siegen 1577,
d. Antwerp 1640), 1634/35
Canvas; 328×388 cm
In the Imperial Gallery in Vienna 1730.
Part of a festive decoration which Rubens
produced to celebrate the solemn entry into
Antwerp of the Spanish Regent Cardinal-
Infante Ferdinand in 1635. In the battle of
Nördlingen on 6 September 1634 the combined
Spanish and Imperial armies inflicted a heavy
defeat upon the Swedish army. (525)

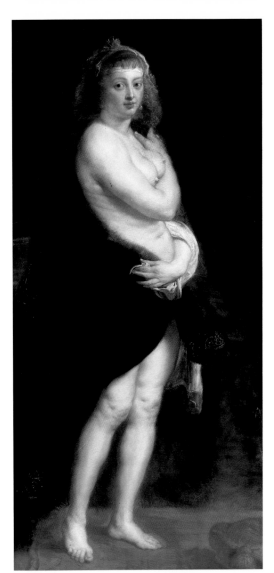

SELF-PORTRAIT
Peter Paul Rubens (b. Siegen 1577,
d. Antwerp 1640), *c* **1638/40**
Canvas; 109.5×85 cm
In the Imperial Collections in Vienna in 1720.
(527)

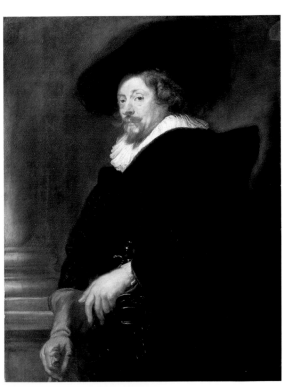

MERCURY SETS EYES ON HERSE

Jan Boeckhorst (b. Münster 1605, d. Antwerp 1668), c 1650

Canvas; 118×178.5 cm

In Archduke Leopold Wilhelm's collection in 1659. (379)

THE FEAST OF THE BEAN KING

Jacob Jordaens (b. and d. Antwerp 1593–1678), before 1656

Canvas; 242×300 cm

In Archduke Leopold Wilhelm's collection in 1659. (786)

VENUS AND ADONIS
**Abraham Janssens (b. and d. Antwerp 1576–
1632), c 1620**
Canvas; 200×240 cm
In the Imperial Gallery in Vienna 1781.
Landscape painted by Jan Wildens (b. and
d. Antwerp 1586–1653). (728)

**CHALICE AND HOST ENCIRCLED BY GARLANDS OF
FRUIT**
**Jan Davidsz de Heem (b. Utrecht 1606,
d. Antwerp 1683/84), signed, dated 1648**
Canvas; 138×125.5 cm
In Archduke Leopold Wilhelm's collection in
1659. (571)

◁

**STILL LIFE COMPOSED OF THE GIFTS OF THE MAGI
(ALLEGORY OF EPIPHANY)**
**Jan Anton van der Baren (b. Brussels (?) 1615/
16, d. Vienna 1686), 1650s**
Canvas; 71×74 cm
In Archduke Leopold Wilhelm's collection in
1659.
The paintings of De Heem and Van der Baren –
the latter Leopold Wilhelm's Court Chaplain,
and expert author of the 1659 inventory – are
typical examples of the brilliantly painted
religious still life so highly prized by Leopold
Wilhelm. (8608)

THE VISION OF THE BLESSED HERMANN JOSEPH
WITH MARY
**Sir Anthony van Dyck (b. Antwerp 1599,
d. London 1641), 1630**
Canvas; 160×128 cm
Painted for the Celibate Brotherhood in
Antwerp. Purchased 1776 from the Jesuit
convent in Antwerp. (488)

PORTRAIT OF A YOUNG GENERAL
**Sir Anthony van Dyck (b. Antwerp 1599,
d. London 1641), c 1624**
Canvas; 115.5×104 cm
In the Imperial Gallery in Vienna in 1720. (490)

◁

THE APOSTLE PHILIP
**Sir Anthony van Dyck (b. Antwerp 1599,
d. London 1641), c 1616**
Wood; 64×51 cm
In the Brignole Sale collection in Genoa 1748;
in the Serra collection in Genoa 1766, then in
the collection of the Princes of Cellamare in
Naples. Julius Böhler, Munich 1913/14;
presented to the Museum in 1976 by Dr Oskar
Strakosch. (9703)

NICHOLAS LANIER ▷
**Sir Anthony van Dyck (b. Antwerp 1599,
d. London 1641), c 1628/29**
Canvas; 111×87.6 cm
In the collection of King Charles I of England;
purchased by Lanier after the King's death; in
the Imperial Gallery in Vienna in 1720.
Lanier (1588–1666) was Charles I's court
Master of Music and adviser on artistic
matters. He played an important part in the
purchase of the ducal collections in Mantua
and their transport to England in 1627/28. (501)

200

SAMSON AND DELILAH
**Sir Anthony van Dyck (b. Antwerp 1599,
d. London 1641),** *c* **1628/30**
Canvas; 146×254 cm
In Archduke Leopold Wilhelm's collection in
1659. (512)

JACOMO DE CACHIOPIN ▽▽
**Sir Anthony van Dyck (b. Antwerp 1599,
d. London 1641),** *c* **1628/30**
Canvas; 111×84.5 cm
In the Imperial Gallery in Vienna in 1720.
The subject (1578–1642), lover of the arts and
collector of paintings, was a friend of Van
Dyck's. (503)

Sir Anthony van Dyck (b. Antwerp 1599,
d. London 1641), *c* 1628/30

Sir Anthony van Dyck (b. Antwerp 1599,
d. London 1641), *c* 1628/30

201

Dutch Painting of the Seventeenth Century

Just as it is wide of the mark to label seventeenth-century Dutch art as simply 'bourgeois' and Flemish as courtly and aristocratic, so it is just as much a cliché to regard Dutch painting, with the exception of Rembrandt, as only interested in depicting the immediate human environment – landscape, cities, the sea or the simplest forms of everyday life – while Flemish art is supposed to have concentrated on the more highly-rated historical painting, on themes from mythology or classical literature. From the theoretical standpoint this is misleading, as Dutch theoreticians also gave historical painting pride of place in the hierarchy, but it is also historically false. Paintings with allegorical and religious themes were needed for public buildings, for the residences of the regents, and to satisfy the desire for prestige on the part of rich citizens, irrespective of denomination. The catholic churches also needed them (albeit clandestinely), and they gradually crept in again even to Calvinist churches. The aggressive intransigence of Calvinism never quite managed to quench the spark of the moderating tradition of Erasmus of Rotterdam, or the humanistic 'craving for culture' (Huizinga) in Holland. The widespread impression that Dutch painting is thematically restricted to landscape and the depiction of everyday life stems from nineteenth and early twentieth-century art-historical prejudice, which gave pride of place to 'historical' painting: not surprisingly, this is conspicuously reflected in many museums.

In view of the constant exchanges and reciprocal influencing up to the early seventeenth century, the rigid division which art historians make between the Flemish and Dutch parts of the Netherlands in their school of painting, is artificial. The Amsterdam-born Pieter Aertsen had worked for twenty years in Antwerp, where the *Still Life with Christ at the Home of Mary and Martha* was painted, before returning to his native city in 1557. His most important successor, pupil and nephew, Joachim Bueckelaer, spent his whole life in Antwerp; Jan van Hemessen came from the surroundings of Antwerp, where he also worked until 1550/51, when he moved to Haarlem. So it was mainly from 1579/81 onwards – that is to say, from the time of the Union of Utrecht and the secession of the seven Northern provinces – that a large number of Southern Netherlanders moved for religious reasons to the Protestant half of the country, effectively splitting the country in two.

Moves towards independent development in Dutch painting were often initiated by artists of the Southern Netherlands. The Antwerp-born Bartholomäus Spranger was developing a highly artificial virtuoso style in Rome around 1570, which was to become an international 'language' as a result of Spranger's stays in Vienna and Prague. In Rome and Vienna, Spranger met Karel van Mander, a painter and theoretician, and when the latter moved to Haarlem in 1583, he took this style back with him to his new country. One of the foremost masters of this Haarlem or Utrecht mannerist style is Abraham Bloemaert,

represented in Vienna by the picture which appeared in Amsterdam in 1593: *Judith Showing the People the Head of Holofernes*.

Esaias van de Velde, born in Holland as the son of Flemish immigrants and trained in the circle of the Flemings Vinckeboons and Coninxloo, developed in his early works (amongst them *St John the Baptist Preaching*) a realistic, colourful style of genre painting, in which the planes are divided according to colour – a style which goes back to Jan Brueghel the Elder. In his later work he was creating pictures with an unprecedented freedom of spatial setting, abandoning the device of breaking up a landscape into several parts and unifying the different planes by subtle shifts in *valeurs*. He shares this change of style, accomplished not only in the space of one generation but even within the life-span of one artist, with painters such as his pupil Jan van Goyen. Around 1630 this trend established itself firmly all over Holland. Artists were no longer concerned with presenting a pleasing arrangement of objects but instead wanted to convey the experience of space; the atmosphere of a wide expanse overhung by clouds is transmitted by increasing use of monochrome colours. Goyen's *View across the River Merwede to Dordrecht*, painted in 1644, is a late example of this 'tonal' phase of Dutch landscape painting. One of the most monumental baroque Dutch landscapes, the *Great Forest* of Jacob van Ruisdael, dating from the late fifties, belongs to a later phase. Now the idea is no longer to present a grey-brown, more or less amorphous expanse of space with a few motifs to hold the attention; on the contrary, the firmly accentuated structure of the severe composition determines the impression. No longer is attention directed to the individual tree but to clumps of trees juxtaposed by means of colour, to the paths and waterways, running into and crossing each other, drawing the beholder right into the depths of the canvas.

Influenced by Italian landscape and genre painting, Philips Wouwerman was a painter whose equestrian scenes, sometimes martial and sometimes small-scale and pure genre style, were among the best loved Dutch paintings in the eighteenth and nineteenth century. In his landscapes around the middle of the century (fewer in number but of very high quality), such as the *Dune Landscape*, he achieved a composition in which the individual motifs are judiciously contrasted. The purest example of the Italianate type of landscape is represented in the work of Nicholas Berchem. His works were very much to the taste of the eighteenth century and enjoyed their most widespread popularity through engravings. In contrast to the pictures of Wouwerman and Berchem, the 'romantic' paintings of the Amsterdam-born Aert van der Neer, which explored light effects at dusk and in moonlight, were not appreciated by his contemporaries – the painter died in poverty after even an attempt to establish himself as an innkeeper had failed. It was not until the early nineteenth century – and not by chance – that

artists such as Turner and Friedrich discovered this forerunner of their art.

Dutch genre painting, which is indeed seldom the mere portrayal of domestic life but frequently carries an emblematic or moral message, is represented in Vienna by works of all its major exponents. Leyden was the centre where this art was practised, and it was here that Gerard Dou, Rembrandt's first pupil from 1627–31, became the founder of the so-called Leyden school of *Feinmalerei*. In making the jug and birdcage 'attributes' of the *Old Woman at the Window*, Dou may be hinting obliquely at bygone pleasures of love and at transience in general. His pupil Frans van Mieris, however, quite openly depicts present erotic delights in his *Cavalier in a Shop*. And even if Gerard ter Borch appears to be presenting a tender, intimate picture of a child gazing with longing eyes at its young mother peeling apples, the true moral aim of the *Woman Peeling Apples* is to point out critically that no one should be given all his heart desires and that above all we should not indulge our own cravings. In his *Topsy-Turvy World*, Jan Steen, tellingly and wittily turning the 'normal' upside down, demonstrates where it will all end if people indulge too freely in riotous living, though the obvious enjoyment they derive from their tom-foolery belies the seriousness of the moral message.

The three greatest Dutch figure-painters Frans Hals, Rembrandt Harmensz van Rijn and Jan Vermeer van Delft succeeded each other at intervals of roughly one generation. Hals, born in Antwerp and mainly active as a portraitist in Haarlem, has become for many the incarnation of the vital, spontaneous, extrovert virtuoso Dutch painter, in contrast – according to the stereotype – to the 'thinker' Rembrandt, whose art plumbed the very depths of human destiny. Like all stereotypes, this is both false and true. What immediately strikes the beholder of Hals's portraits or group-portraits is the painter's extraordinary ability to represent a human being in one sudden, spontaneous, emotion-charged gesture. To convey the impression of a transitory moment, Hals uses a very bold, seemingly irregular brushstroke with crossing zigzags or crosshatching, producing a restless, flickering sketchy surface texture, which takes on coherent shape only when viewed from sufficient distance. In *Tieleman Roosterman*, which appeared in 1634, the bright colours of Hals's early period have developed into a black and white range, handled with virtuosity. The obviously deliberate hint of pose and pretentiousness found here is completely absent in the portrait of an *Unknown Man* some twenty years later. Hals contrasts the firmly moulded fleshy face with the flat outline of the black figure, which in its turn stands out against the light, spaceless background. The pale, astonishingly life-like hand, tossed off with incredible sureness of touch, seems to figure as the storm-centre amid its black surroundings. The portraits of Hals's late period come close to the works of Rembrandt in their unerring psychological

penetration and their total renunciation of pose.

Rembrandt himself is represented in Vienna only by portraits, among them three self-portraits. A year before her death, Rembrandt painted his mother as the aged prophetess Hannah, whose life in the temple was centred solely on the hope of being granted a sight of the Messiah. For those familiar with it, this story is the symbol of hope fulfilled, a symbol authorized by the Bible, and for us it is the definitive image of old age in all its dignity and frailty. The technique is extremely detailed, the brushstroke follows meticulously every fold, every billow of the drapery and even the precious clasp of her gown. In the so-called *Large Self-Portrait* of 1652, the painter faces us confidently, three-quarter face, almost challengingly in his brown smock. In the *Small Self-Portrait*, however, painted after Rembrandt's financial collapse in 1656, all the attention is focused on the swollen face, which, one is tempted to say, has assumed something of the introspective intensity, something of the dejection of the afflicted subject.

Jan Vermeer's discreet, undramatic art has been seen as the expression of the Dutch bourgeoisie, self-sufficient and pleased with what it had achieved after its heroic struggle during the first half of the century. Better than any other, Vermeer was seen as having captured the peaceful domestic atmosphere in which Dutch life was clearly to unfold in the second half of the century. But the simplicity of Vermeer's pictures is deceptive. Their clarity and peacefulness are the result of rational, ingenious devices, including newly developed technical ones such as the camera obscura.

The *Allegory of the Art of Painting*, painted around 1670, was undoubtedly his most ambitious picture as far as content is concerned and, at the same time, represents a colouristic peak in Vermeer's work. It was destined for the halls of the Delft painters' guild, of which Vermeer had been head for some years. There are several overlapping layers of meaning in this picture, in which the glory of Dutch painting is presented to us. By increasing the brightness from the dark foreground towards the light-filled background, space and light perspectives are presented as contradictory to each other. The colour is graduated over Vermeer's favourite combination of blue and yellow and, in contrast to earlier periods, it retains its typical softness and matt quality. Peculiar to Vermeer is a kind of pointillé technique which spreads thick, bright points as highlights over a dark area, giving the illusion of sparkling life to his underlying tonal design. It seems as if, as once was said, the paint consists of crushed pearls melted together. What had begun with Jan van Eyck – the passive, distanced view of the motionless world – has remained a basic theme of Dutch painting and has become, in Vermeer's *Art of Painting*, an allegorical and at the same time an actual apotheosis of vision.

Joachim Bueckelaer (b. and d. Antwerp
c 1530–1574), signed, dated 1567
Wood; 109×140 cm
In the Imperial Gallery in 1824. (964)

THE CALLING OF ST MATTHEW
**Jan Sanders van Hemessen (b. Hemixen near
Antwerp *c* 1500, d. Haarlem later than 1563), a
little earlier than 1550**
Wood; 114×137 cm
In the Imperial Gallery in 1720. (961)

STILL LIFE WITH CHRIST AT THE HOME
OF MARY AND MARTHA
**Pieter Aertsen (b. and d. Amsterdam 1508/09–
1575), signed, dated 1552**
Wood; 60×101.5 cm
In Archduke Leopold Wilhelm's collection in
1659; re-purchased 1930. (6927)

ST JOHN THE BAPTIST PREACHING
**Esaias van de Velde (b. Amsterdam 1590,
d. The Hague 1630), early work**
Wood; 69×96 cm
Gift of Galerie St Lucas, Vienna 1940. (6991)

JUDITH SHOWING THE PEOPLE THE HEAD OF
HOLOFERNES
**Abraham Bloemaert (b. Gorkum 1564,
d. Utrecht 1651), signed, dated 1593**
Wood; 34.5×44.5 cm
Purchased 1926. (6514)

THE GREAT FOREST
**Jacob van Ruisdael (b. Haarlem 1628/29,
d. Amsterdam (?) 1682), signed, *c* 1655/60**
Canvas; 139×180 cm
Purchased 1806. (426)

VIEW ACROSS THE RIVER MERWEDE TO
DORDRECHT
**Jan van Goyen (b. Leyden 1596, d. The Hague
1656), signed, dated 1644**
Canvas; 103.5×133 cm
Purchased 1923 from the collection of Frits
Lugt. (6450)

FISHING BY MOONLIGHT
**Aert van der Neer (b. and d. Amsterdam
1603/04–1677),** *c* **1665/70**
Canvas; 66.5×86.5 cm
Purchased 1924. (6487)

DUNE LANDSCAPE
**Philips Wouwerman (b. and d. Haarlem 1619–
1668), signed,** *c* **1645/50**
Wood; 37×50 cm
In the collection of the Duke of Orléans 1749.
Purchased 1923 from the collection of Frits
Lugt. (6431)

HERD OF CATTLE WITH WOMEN WASHING
**Nicolaes Berchem (b. Haarlem 1620,
d. Amsterdam 1683), signed, late work**
Wood; 40×53 cm
Presumably acquired between 1772 and 1781
from the Vienna Schottenstift. (658)

OLD WOMAN AT THE WINDOW WATERING FLOWERS
Gerard Dou (b. and d. Leyden 1613–1675), signed, *c* **1660/65**
Wood; 28.3×22.8 cm
Purchased 1811. (624)

WOMAN PEELING APPLES
Gerard ter Borch (b. Zwolle 1617, d. Deventer 1681), *c* **1661**
Canvas on wood; 36.3×30.7 cm
In the Imperial Gallery 1781. (588)

▷
CAVALIER IN A SHOP
Frans van Mieris (b. and d. Leyden 1635–1681), signed, dated 1660
Wood; 54.5×42.7 cm
Purchased 1660 by Archduke Leopold Wilhelm. (586)

△

WOMAN WITH CHILD AT HER BREAST AND SERVING
MAID
Pieter de Hooch (b. Rotterdam 1629,
d. Amsterdam later than 1684), *c* **1663/65**
Canvas; 64×76 cm
Gift 1903. (5976)

◁

VERTUMNUS AND POMONA
Adriaen van de Velde (b. and d. Amsterdam
1636–1672), signed, dated 1670
Canvas; 76.5×103 cm
Purchased 1923. (6446)

PEASANTS IN A BARN
Adriaen van Ostade (b. and d. Haarlem 1610–1684/85), signed, dated 1647
Wood; 36.4×47 cm
Purchased 1919. (6338)

NOLI ME TANGERE
Gabriel Metsu (b. Leyden 1629, d. Amsterdam 1667), signed, dated 1667
Wood; 63.7×51 cm
Bequest 1907. (6044)

TIELEMAN ROOSTERMAN

Frans Hals (b. Antwerp 1582/83, d. Haarlem 1666), dated 1634

Canvas; 117×87 cm

Gsell sale, Vienna 1872; collection of Nathanael and Alphonse de Rothschild, Vienna; presented by Clarisse de Rothschild 1947.

Hals painted Roosterman, one of the nouveau-riche Haarlem merchants, in the latter's 36th year. (9009)

PORTRAIT OF A MAN

Frans Hals (b. Antwerp 1582/83, d. Haarlem 1666), c 1650/52

Canvas; 108×79.5 cm

Gsell sale, Vienna 1872; Baron Albert von Rothschild's collection, Vienna; presented by Baron Louis de Rothschild 1947. (9091)

◁

MAN LOOKING THROUGH A WINDOW

Samuel van Hoogstraten (b. and d. Dordrecht 1626–1678), signed, dated 1653

Canvas; 111×86.5 cm

Painted in Vienna, then in the Imperial Treasury Prague; in the Imperial Gallery in Vienna 1781.

The subject is traditionally thought to be Rabbi Jom-Tob Lipmann Heller (1579–1654), who lived in Vienna, Prague and Cracow but was not resident in Vienna in 1653. (378)

◁◁

TOPSY-TURVY WORLD

Jan Steen (b. and d. Leyden 1626–1679), signed, dated 1663 (?)

Canvas; 105×145 cm

In Duke Charles of Lorraine's collection in 1779. Purchased 1780. (791)

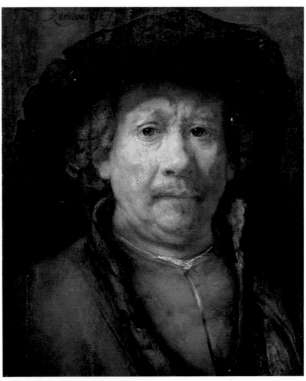

△

THE ARTIST'S SON, TITUS, READING
**Rembrandt Harmensz van Rijn (b. Leyden
1606, d. Amsterdam 1669),** *c* **1656/57**
Canvas; 70.5×64 cm
In the Imperial Gallery 1720. (410)

▷

LARGE SELF-PORTRAIT
**Rembrandt Harmensz van Rijn (b. Leyden
1606, d. Amsterdam 1669), signed, dated 1652**
Canvas; 112×81.5 cm
In the Imperial Gallery in 1720. (411)

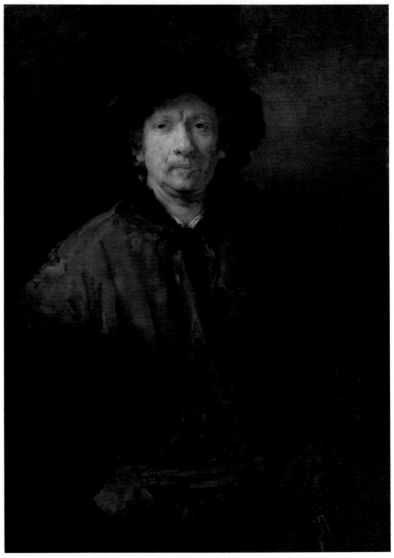

◁

SMALL SELF-PORTRAIT
Rembrandt Harmensz van Rijn (b. Leyden 1606, d. Amsterdam 1669), signed, *c* 1657
Wood; 48.8×40.6 cm
In the Imperial Gallery in 1781. (414)

THE ARTIST'S MOTHER DEPICTED AS THE
PROPHETESS HANNAH
Rembrandt Harmensz van Rijn (b. Leyden 1606, d. Amsterdam 1669), signed, dated 1639
Wood; cut down to oval shape, 79.5×61.7 cm
Brought from Bratislava Castle 1772.
Rembrandt painted his mother in her 71st year. (408)

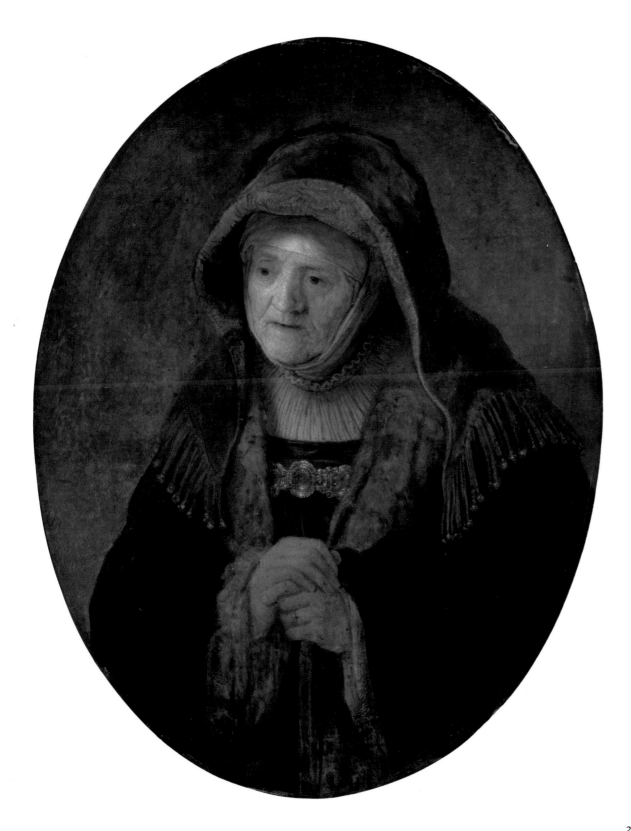

Jan Vermeer van Delft (b. and d. Delft 1632–1675), signed, *c* **1670**

Canvas; 120×100 cm

In the auction of Vermeer's estate 1677; purchased 1813 by Count Czernin from a saddler in Vienna as a De Hooch painting; purchased 1946.

The following interpretative titles of the painting have been put forward: 'The muse of history inspiring painting'; 'The painter's daydream of the erstwhile distinguished position of his art in the Netherlands'; 'The art of painting – the glory of the Netherlands'. However, a more restrained interpretation seems more acceptable: presumably a kind of fanciful self-portrait, brilliantly combining appearance and reality. (9128)

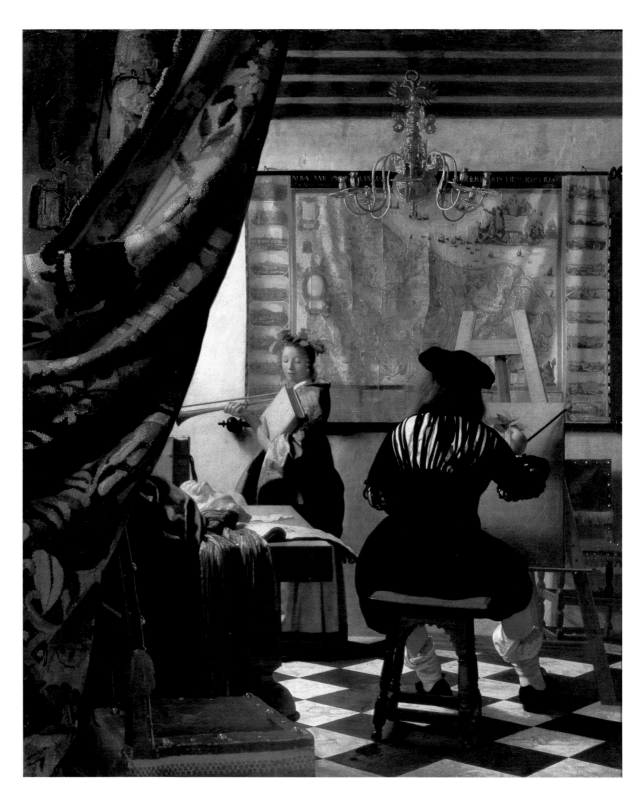

Spanish, French and English Painting

Spanish painting

As Velazquez's Infanta portraits are to be dealt with in the chapter on court portrait painting, we will only mention here four painters from the small stocks of Spanish masters. The main concern of Spanish writers as well as of Spanish painters of the *siglo de oro*, the golden seventeenth century, was to reproduce reality, even in its sometimes repulsive aspects. This tendency was encouraged by an art-historical situation that had arisen in the early seventeenth century when Caravaggio's revolutionary painting in Italy made the observation of reality into an artistic programme. Probably the most significant painter of the realistic trend in Spanish painting was Jusepe de Ribera, who came from the Valencia area, settled in Italy and was later appointed court painter to the Spanish viceroys in Naples. From 1616 onwards his work had a widespread influence. From Ribera's middle period dates *Christ among the Doctors*, a famous, often copied picture from the collection of Archduke Leopold Wilhelm. Recent research, however, has suggested that it might be of Neapolitan origin, and this in itself is evidence of the stylistic affinity which existed between Spanish and Southern Italian art at this time. The pronounced realistic tendencies are particularly apparent in the *Blind Hurdy-gurdy Player*, observed in close-up, by Francisco de Herrera, who was Velazquez's teacher during the latter's early years in Seville. The *Allegory of Vanity* by Antonio de Pereda, is a reminder of the transience of all earthly power. Probably dating from about 1640, this picture contains such obvious allusions to the Casa de Austria (the cameo of Emperor Karl v above the globe, the Augustus medal etc) that one has to assume that it was a royal commission. The rich, powerful right-hand side is juxtaposed to the poor left-hand side which indicates death and transience: the message of the picture seems to be that with every step, even the most powerful man draws nearer to the grave. The art of Juan Bautista del Mazo, the son-in-law of Velazquez and his successor in court offices, is confined to the sphere of the court. His picture of around 1665, in which are portrayed his children from two marriages and his second wife all together in the artist's studio, translates into the private and personal sphere Velazquez's group portrait *Las Meninas*, which depicts the Infanta Margarita Teresa with her ladies-in-waiting and in the presence of the royal parents and of the court painter himself. Mazo's work is a subtle tribute, with all the connotations of the court portrait, to the greatest of Spanish painters.

French painting

The small number of French pictures in the Gallery makes any coherent representation of French painting quite impossible and thus only half a dozen examples are being selected for mention. It has not yet been possible to establish the identity of the so-called Master of Heiligenkreuz, who was probably working in France around 1400. His two-part altar comes from the Cistercian abbey of Heiligenkreuz in Austria. Exaggerated proportions in the figures, the soft, flowing style of the garments and the sumptuous colour mark this work as a typical product of the so-called International Gothic style. It is difficult to pinpoint the exact place of origin in works of art of this period, as works from Paris, Prague, Milan, Vienna or Cologne are frequently so similar. Until recently there was also uncertainty as to the attribution and placing of *The Ferrara Court Jester, Gonella* – even the remark in Archduke Leopold Wilhelm's inventory is typical: 'In the manner of Albrecht Dürer by Johanne Bellino, original.' This attribution was followed by others to Van Eyck, to Pieter Bruegel or to 'fifteenth-century Netherlandish' in general. Only when Jean Fouquet was brought into the picture were the many inconsistencies sorted out. Stylistic comparisons were supported by the findings of infra-red reflectography when colour indications, written in French in the underdrawings, came to light.

Typical of the Hapsburg 'collecting' of French painting in the seventeenth century is the provenance of the pictures of Valentin, Poussin and Philippe de Champaigne. Valentin de Boulogne lived and died in Rome and right up to his death remained a follower of Caravaggio; thus his *Moses with the Tablets of the Law* is ascribed to 'Valentino', using the Italian form of his name. The *Destruction of the Temple in Jerusalem by Emperor Titus* by Nicolas Poussin is the only picture left in Austria by this artist, who was probably the most significant of the Franco-Roman painters of the seventeenth century. In 1638 Poussin received the commission from Francesco Barberini, the nephew of Pope Urban VIII, and the picture was handed over to the Imperial Ambassador by the Pope as a gift for Emperor Ferdinand III. The *Lamentation over the Death of Abel* by Philippe de Champaigne, represented here in a smaller version by the artist himself, was painted for Archduke Leopold Wilhelm. Although for us today Champaigne seems thoroughly French, and in spite of the typical 'Frenchness' of the piety in his pictures, stamped as they are by the Jansenists of Port-Royal, nevertheless the painting of this Brussels-born artist is still firmly rooted in his Flemish origins.

The two likenesses selected here as examples of French portrait art of the last quarter of the eighteenth century show an Austrian musician and an Austrian music-lover. The man who restored the musical drama, Christoph Willibald Ritter von Gluck, was portrayed by Joseph Duplessis in 1775, after the triumphant performances of *Iphigenia in Aulis* and *Orfeo*, when the composer was at the height of his career in Paris. This picture, which has the artist pausing in the very moment of inspiration, can be seen as a model for the portrait of the essential creative man. François Gérard painted *The Family of*

Reichsgraf Moritz Christian Fries in 1803/4 during Fries' stay in Paris. The son of one of the richest bankers and industrialists in Austria, Fries was an important collector and a patron of music. His particular protégés were Haydn and Beethoven, who dedicated his seventh symphony, among other works, to him. Unfortunately the Reichsgraf's extravagant life-style led after 1820 to the bankruptcy of the Fries banking-house, the loss of his fortune and the sale of his large art collections.

English painting

The Vienna gallery affords only a somewhat incomplete idea of the rich variety of mood in the English painting of the late eighteenth century and of the wealth of possibilities of social representation. The two great contrasting figures, Sir Joshua Reynolds and Thomas Gainsborough, are represented by, respectively, a portrait sketch, which is probably unfinished, and a landscape.

Probably undue emphasis has been placed on the differences between the two painters; Reynolds the intellectual *homme des lettres* and President of the Academy, being played off against the graceful Bohemian Gainsborough, who is said to have recognized no teacher other than Nature and to have been fascinated only by the beauties of the passing moment, the play of light and shade in landscape, on faces and in the texture of precious garments. In Reynolds' *Portrait Study of a Young Woman*, in spite of all his feeling for the solidity of the body, which can be sensed even though the picture is unfinished, it is the tender, sensitive approach to the model, the gracefulness of her reflective movement that we find touching. Gainsborough's landscape was painted in the early 1750s in his native Suffolk. It is based on Dutch models and in spite of the stormy movement of the clouds and the path winding away into the distance, the restless contours of the trees, the sketchiness, it is a very consciously constructed landscape. It serves to remind the viewer that Gainsborough used to make model landscapes on table-tops, based on sketches made in the open, and using coal, moss, cork, sand and heads of asparagus for his compositions.

Joseph Wright, generally referred to as Wright of Derby, was stimulated by a circle of people who were familiar with the latest scientific findings and experiments and keenly interested in the reproduction of the optical phenomena of light, darkness, fire, volcanic eruptions etc. This interest in the natural sciences also led him to observe the consequences of the industrial revolution – the first painter to do so. What is memorable in his Vienna *Portrait of the Reverend Basil Bury Beridge* is above all the cool, dispassionate observation of the human subject, which seems to be reciprocated by the sitter, in a harsh light which throws up glaring contrasts.

Sir Thomas Lawrence's European reputation no doubt rests on the fact that he was commissioned by George IV to carry out portraits of the leading statesmen, generals and the men and women of society of the alliance after the final defeat of Napoleon in 1815. Thus between 1815 and 1820 he visited several of the capitals of Europe, including Vienna. Reproduced here is the portrait of *Diana Sturt, Lady Milner*, instead of the frequently reproduced 'Vienna' portraits of 1818/19. It probably dates from between 1800 and 1805, the year of Lady Milner's death.

THE BLIND HURDY-GURDY PLAYER
Francisco de Herrera (b. Seville *c* 1585,
d. Madrid later than 1657), *c* 1640
Canvas; 71×92 cm
Presented by Rudolf Count Czernin in 1963.
(9552)

CHRIST AMONG THE DOCTORS
Jusepe de Ribera (b. Jativa/Valencia 1591,
d. Naples 1652), *c* 1630/40
Canvas; 129×175 cm
In Archduke Leopold Wilhelm's collection in
1659. (326)

THE ARTIST'S FAMILY

**Juan Bautista Martinez del Mazo (b. Beteta/
Cuenca (?) c 1612, d. Madrid 1667), c 1664/65**
Canvas; 148×174.5 cm
Signed with coat of arms with bell-hammer
(= mazo)
Purchased 1800.
On the left, in dark clothes, the four children
from Mazo's first marriage to Velazquez's
daughter Francisca; on the right Mazo's
second wife Francisca de la Vega with her four
children. (320)

ALLEGORY OF VANITY

**Antonio de Pereda (b. Valladolid 1611,
d. Madrid 1678), c 1640**
Canvas; 139.5×174 cm
In the Imperial Gallery in 1733. (771)

**Juan Bautista Martinez del Mazo (b. Beteta/
Cuenca (?) c 1612, d. Madrid 1667), c 1664/65**

THE MYSTICAL BETROTHAL OF ST CATHERINE, WITH
ST DOROTHY AND ST BARBARA
**The Master of Heiligenkreuz (working in
France *c* 1395–*c* 1420), *c* 1410**
Wood; 72×43.5 cm
Purchased from the Cistercian Abbey of
Heiligenkreuz in Lower Austria in 1926. (6523)

THE FERRARA COURT JESTER GONELLA
**Jean Fouquet (b. and d. Tours *c* 1415/20–
c 1477/81), *c* 1445**
Wood; 36×24 cm
In Archduke Leopold Wilhelm's collection in
1659. (1840)

▷

MOSES WITH THE TABLETS OF THE LAW
**Valentin de Boulogne (b. Coulommiers 1591,
d. Rome 1632), *c* 1630**
Canvas; 131×103.5 cm
In the collection of Nicolas Regnier, Venice. In
Archduke Leopold Wilhelm's collection in
1659. (163)

THE DESTRUCTION OF THE TEMPLE IN JERUSALEM
BY EMPEROR TITUS
**Nicolas Poussin (b. Les Andelys 1594,
d. Rome 1665), signed, datable 1638**
Canvas; 148×199 cm
The gift of Cardinal Francesco Barberini to
Emperor Ferdinand III, handed by the
Cardinal to the Imperial Ambassador in Rome,
Prince Eggenberg. In Prague in 1718; re-
purchased 1820 from Prince Kaunitz. (1556)

THE LAMENTATION OVER THE DEATH OF ABEL
**Philippe de Champaigne (b. Brussels 1602,
d. Paris 1674), 1650s**
Canvas; 52×62 cm
Purchased 1970.
Small version of the enormous picture painted
for Archduke Leopold Wilhelm in 1656. (9685)

CHRISTOPH WILLIBALD RITTER VON GLUCK AT THE
SPINET
**Joseph Duplessis (b. Carpentras/Vaucluse
1725, d. Versailles 1802), signed, dated 1775**
Canvas; 99.5×80.5 cm
In the Imperial Gallery 1824. (1795)

THE FAMILY OF REICHSGRAF MORITZ CHRISTIAN
FRIES
**François Gerard (b. Rome 1770, d. Paris 1837),
signed *c* 1803/04**
Canvas; 223×163.5 cm
Purchased 1938. (NG 105)

PORTRAIT STUDY OF A YOUNG WOMAN
**Sir Joshua Reynolds (b. Plymton 1723,
d. London 1792), mid 1770s**
Canvas; 76.5×63 cm
Purchased 1913. (6264)

SUFFOLK LANDSCAPE
**Thomas Gainsborough (b. Sudbury 1727,
d. London 1788), early 1750s**
Canvas; 66×95 cm
Humphrey Roberts auction 1908. Purchased
1913 from Agnew's. (6271)

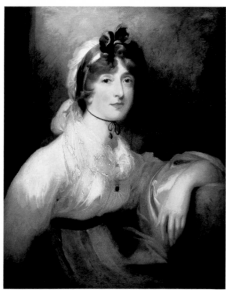

PORTRAIT OF DIANA STURT, LADY MILNER
**Sir Thomas Lawrence (b. Bristol 1769,
d. London 1830), c 1800/05**
Canvas; 78×65 cm
Presented 1948 by Baroness Springer. (9001)

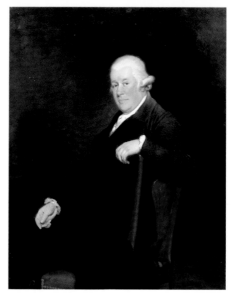

THE REV BASIL BURY BERIDGE
**Joseph Wright called Wright of Derby (b. and
d. Derby 1734–1797), signed, c 1780/90**
Canvas; 127×101 cm
Rev B. Beridge auction at Christie's, London
1911. Presented 1912.
The subject (d. 1808) was the Rector and Lord
of the Manor of Algarkirk, Lincolnshire from
1782. (6237)

German Painting

The section of German painting is particularly rich in pictures by Albrecht Dürer, the two Cranachs and Holbein the Younger. It also has a large number of works of the Danube school and of sixteenth-century Augsburg portrait art. The pictures by Emperor Rudolf's court painters have a quite unique character directly connected with the personality of that eccentric monarch. The collection of German baroque painting is not homogeneous and that indeed is a typical feature of all the German seventeenth-century art. A representative of the international neo-classicism towards the end of the eighteenth century, Anton Raphael Mengs, rounds off the series. There are various reasons for the gaps in the collection from periods in which German painting could be said to be on a par with the painting of other great centres, and for the absence of artists who rank among the most significant of European painters. The complete stocks of South German-Austrian-Bohemian painting of the late Gothic period and of the eighteenth century are today housed in the Austrian gallery in Castle Belvedere. It is perhaps idle to speculate as to why such an important collection possesses no work by Dürer's great opposite number, Mathias Grünewald; and of the work of Adam Elsheimer, the most important German painter of the seventeenth century, Archduke Leopold Wilhelm possessed only a 'copy after Elsheimer'. Lower Rhenish and North German painting of the late Gothic are not represented, no doubt for geographical and political reasons.

Panel paintings by Martin Schongauer are few in number. This master, born in Alsace, was the first to lift German painting and graphic art once and for all out of their somewhat provincial state and it was largely through him that the way was paved for the synthesis of Netherlandish and Italian, which Dürer was then able to achieve. In spite of Schongauer's dependence on the art of Rogier van der Weyden, a totally personal, warm, intimate atmosphere emerges in the *Nativity*, which is quite alien to its model.

Apart from the *Portrait of a Venetian Lady*, all Dürer's pictures in Vienna come from ancient Imperial possessions. Nearly all of them were acquired as a result of Rudolf II's passion for everything connected with the name of Dürer. With one exception, all the works in the collection are dated after Dürer's second visit to Venice, that is, later than 1505. The highlight of the Vienna Dürer collection is, without any doubt, the *Adoration of the Trinity* (1511), in which the earthly community of Christians, with popes, emperor and the founders of the altar, are seen united with the heavenly community led by Mary and John in the adoration of the Trinity. Both Dürer, who portrays himself on the 'New Earth' renewed in the sunrise after the last Judgement, and the pious beholder experience this vision 'in which the miraculous seems near and the ordinary far away' (Wölfflin). Dürer had already put himself in the midst of the cruel events in the *Martyrdom of the Ten Thousand*, along with his humanist friend Konrad Celtes. This detailed depiction of the martyrdom of the ten thousand Christians, some of whose bones were in the famous collection of relics owned by Elector Friedrich the Wise, the commissioner of Dürer's picture, is turned into a model passion conceived in the imitation of Christ. The influence of Venetian painting is to be seen in the not quite completed *Portrait of a Venetian Lady*, particularly in the exploration of the sensuous qualities of the skin texture and the hair of this attractive young girl and in the softer light playing around the head, while in the *Madonna with the Pear* (1512), the bodily heaviness of the child in its complicated gesture – almost reminiscent of Michelangelo – is something to which Dürer had become receptive in Italy. One of the most fascinating pictures of the German Renaissance is the portrait of the enigmatic Johann Kleberger, much of whose ambivalence of character seems to have entered into the painting's formal structure.

Beginning in the first decade of the sixteenth century there had developed, particularly from Dürer's series of wood-carvings of the Apocalypse, a style which is usually called the 'Danube style' after the geographical area that it covers. Its main exponents are Lucas Cranach, born in Franconia, Albrecht Altdorfer from Regensburg and Wolf Huber, a native of Feldkirch in Vorarlberg who spent a large part of his life in Passau. This style of painting grew out of the infinitely varied wealth of forms of late Gothic art but differs from previous styles in its totally novel relationship to nature, particularly landscape. Trees, mountains, rocks, plants, sky and figures are the bearers of an all-embracing, often boisterously exuberant, sometimes idyllic atmosphere. The individual elements depicted tend to merge into each other: robes sometimes look like roots, branches like faces, hair like dangling old man's beard – and vice versa. Moreover, the brush stroke now becomes the direct vehicle of expression and in its spontaneous expressiveness no longer has much to do with the craft traditions of fifteenth-century painting. The decisive paintings in the first phase are those of the early period of Lucas Cranach, who worked in Vienna between 1500 and 1503. Among these is the *Crucifixion* reproduced here. In Altdorfer and his school we see a further development of this expressive style. From the predella of his major work, the Sebastian altar in St Florian in Upper Austria, is taken a small panel in which nature and the glowing red sky reflect the overwhelming miracle of light in the *Resurrection*. The manner in which Altdorfer impressively 'distorts' a classical Italian model is seen in his *Holy Family with Angel*, originally part of Archduke Leopold Wilhelm's collection. This robust, emotion-charged style was also appreciated in the humanistic circle of the Bishop of Passau, Wolfgang I, Count Salm. The large *Allegory of Redemption* by Wolf Huber, the court painter in Passau, and his severe portrait of the geographer and astronomer *Jacob Ziegler*, in which the so-to-

speak 'transparent' scholar's head is set against a landscape dissolving into the endless blue distance, are other examples of this romantic and at the same time scholarly type of painting. After 1504, when he was called to Wittenberg as court painter of Elector Friedrich the Wise of Saxony, Lucas Cranach turned away from the expressive style of his early period and right up to his death there is scarcely any further change in his decorative style. This also determined the work of his son Lucas.

Hans Holbein the Younger, almost a generation younger than Dürer, Cranach and Altdorfer, is represented in Vienna by seven portraits from his late English period. Among all the German painters he can probably be described as coming closest to the classical feeling for form. With an impeccable, dispassionate eye but still retaining the utmost immediacy – always subordinating the detail to keep the simplicity of the whole and concentrating attention on his sitters by enclosing them within a narrow frame – Holbein presents us with the members of the English court or with the merchants of the Stahlhof, the German trade settlement in London. While he lavishes great care and warmth and touching humanity on the depiction of Jane Seymour, Henry VIII's third Queen, whom he painted in 1536, the characterization and form in his last portraits, such as that of the *Young Merchant* of 1541, become almost stern.

Nearly all the pictures from the artistic circle called 'Rudolfine', after the Emperor, come from Rudolf II's *Kunstkammer* in Prague. The numerous works of these painters, namely Bartholomäus Spranger, Joseph Heintz and Hans von Aachen, and among whom, at least in his late works, must be counted also the Milan-born Giuseppe Arcimboldo, reflect in their work the highly sophisticated taste of the Emperor. Today they form an especially characteristic ensemble in the Vienna gallery. A high degree of technical skill, refined formalism and morbidly sensual treatment of the surface, the complicated allegorical and mythological subjects for whose erotic connotations the introverted patron had a special predilection, all these characterize Prague court painting at the turn of the seventeenth century.

Four masters of the seventeenth century should also be indicated, who demonstrate admirably how heterogeneous German painting must have been around this time and that, apart from a few exceptions, the word 'German' as a style concept had lost its meaning in a country whose cultural life was further paralysed as a result of the war-time and political

chaos. Sandrart, represented here by his *Betrothal of St Catherine*, epitomizes the *peintre chevalier*: as courtier, antiquary, landed gentleman, art theoretician and writer he was widely travelled and had observed critically the whole spectrum of European painting. His style as a painter remains curiously vacillating and hybrid, although as a result of his early training in the Netherlands, the Flemish elements are still discernible. Johann Heinrich Schönfeld's most fruitful years lie between 1633 and 1651, when the artist was working in Rome and Naples. His graceful compositions, full of reminiscences of antiquity, with figures in slightly mannered poses, can be admired in their characteristic shimmering, delicate colouring, dominated by blue. The pictures of Christoffer Paudiss, a pupil of Rembrandt's in the forties and active in Dresden, Vienna and Freising, are often bewildering in their blatant representation of gruesome martyrdoms, in the crass misery and human isolation they show. In the *Martyrdom of St Thiemo*, pale bluish paint thinly applied gives a flickering effect to bizarre, frighteningly naturalistic details, such as the martyr's entrails scattered on the ground. Johann Carl Loth was no loner but had a busy atelier in Venice, mainly frequented by 'Northerners', which, by serving as a rallying point, was able to give decisive impetus to the South German-Austrian painting of the eighteenth century. As early as 1659 Archduke Leopold Wilhelm possessed, in the Philemon and Baucis scene, a characteristic early work of the 'Carlotto Bavarese'.

As a result of the above-mentioned 'geographical' spread of the Austrian art collections, the Museum now again possesses important works, particularly portraits, by German painters from the neo-classical period. Here attention should be drawn to a monumental religious work, *St Joseph's Dream* by Anton Raphael Mengs. Like Sandrart at the beginning, Mengs is, at the end of the German 'baroque' period of painting, a scholar, a celebrated prince of painting, writer, theoretician, court painter and Academy professor, whose art it is difficult to label as German. As a Roman, which he actually wanted to be – although he spent a long time working in Spain – he had most at heart the renewal of painting through the spirit of antiquity and of the high Renaissance, especially Raphael. Thus, through his art and what his contemporaries saw as the realization of ideal beauty, he became the founder of neo-classicism in Rome, and took the lead, together with his friend Johann Joachim Winkelmann, in the theoretical formulation of neo-classical doctrines.

NATIVITY
**Martin Schongauer (b. Colmar (?) c 1450,
d. Breisach 1491), 1480s**
Wood; 26×17 cm
Purchased 1865. (843)

PORTRAIT OF A VENETIAN LADY
**Albrecht Dürer (b. and d. Nürnberg 1471–
1528), signed, dated 1505**
Wood; 32.5×24.5 cm
In the Schwartz collection in Danzig at the end
of the 18th century. Lithuanian private
collection. Purchased 1923. (6440)

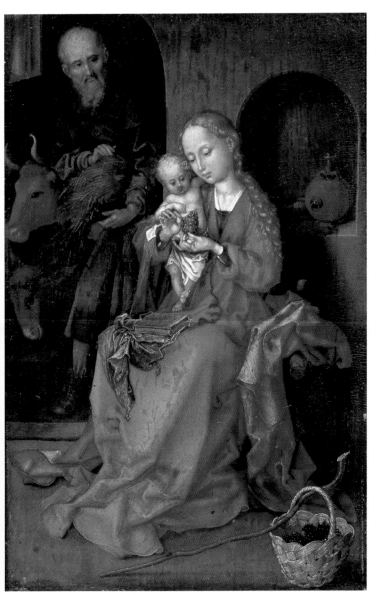

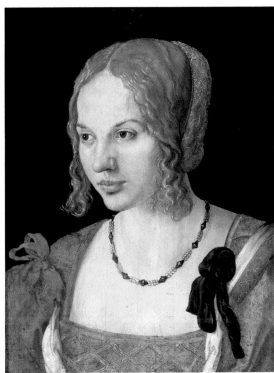

MADONNA WITH THE PEAR
**Albrecht Dürer (b. and d. Nürnberg 1471–
1528), signed, dated 1512**
Wood; 49×37 cm
Probably purchased by Emperor Rudolf II in
1600 from the collection of Count Cantecroy in
Besançon. (848)

ADORATION OF THE TRINITY

Albrecht Dürer (b. and d. Nürnberg 1471–1528), signed, dated 1511

Wood; 135×123.4 cm

Frame a modern copy of the original frame in Nürnberg produced on the basis of Dürer's design (German National Museum).

Bought by Emperor Rudolf II in 1585 from the Zwölfbruderhaus foundation. In the lower row on the left the donor of the altar, Matthäus Landauer, on the right his son-in-law Wilhelm Haller, lower right self-portrait of Dürer. (838)

THE MARTYRDOM OF THE TEN THOUSAND

Albrecht Dürer (b. and d. Nürnberg 1471–1528), signed, dated 1508

Wood transferred to canvas; 99×87 cm
Painted for Elector Friedrich the Wise of Saxony. Granvella collection. Purchased in 1600 from Count Cantecroy in Besançon by Emperor Rudolf II. (835)

JOHANN KLEBERGER

Albrecht Dürer (b. and d. Nürnberg 1471–1528), signed, dated 1526

Wood; 37×36.6 cm
Imhoff collection, Nürnberg, from which Emperor Rudolf II purchased it in 1588. The subject, actually Johann Scheuenpflug (1486–1547), of a lower class family, left Nürnberg for unknown reasons and returned in 1526 under a different name with a large fortune. In the face of violent opposition from her father, he married in 1528 the daughter of Willibald Pirckheimer, a Nürnberg humanist and friend of Dürer's but left Nürnberg, and his wife, unaccountably a few days after the wedding. When his wife died a year and a half later, Pirckheimer accused his son-in-law, without justification, of poisoning her. Kleberger settled in Lyons from 1532 onwards and divided his fortune between the poor of the city, who erected a statue to him after his death, known as the 'Bon Allemand'. (850)

CRUCIFIXION
**Lucas Cranach the Elder (b. Kronach 1472,
d. Weimar 1553)** *c* 1500/01
Wood; 58.5×45 cm
Confirmed to have been in the Schottenstift in
Vienna since 1800. Purchased 1934. (6905)

THE RESURRECTION OF CHRIST
Albrecht Altdorfer (b. Regensburg (?) *c* 1480,
d. Regensburg 1538), dated 1518
Wood; 70×37 cm
Part of the predella of the triptych in St Florian,
Upper Austria. Purchased from St Florian in
1930. (6796)

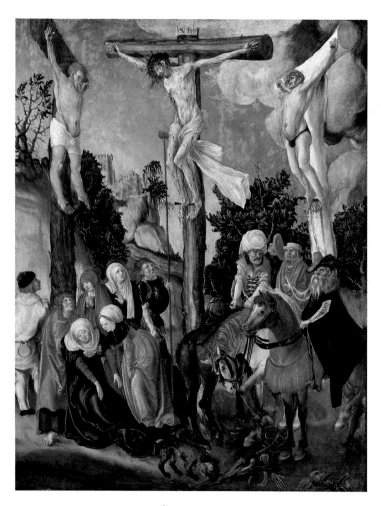

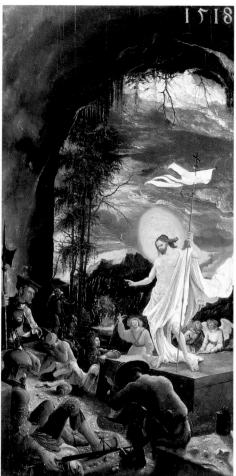

▷
HOLY FAMILY WITH AN ANGEL
Albrecht Altdorfer (b. Regensburg (?) *c* 1480,
d. Regensburg 1538), signed, dated 1515
Wood; 22.5×20.5 cm
In Archduke Leopold Wilhelm's collection in
1659. (5687)

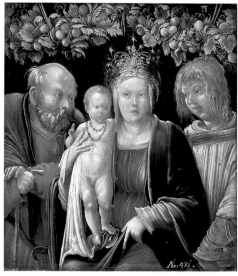

THE BEHEADING OF JOHN THE BAPTIST
Master of the Historia Friderici et Maximiliani (working in Austria 1st third of 16th C), *c* **1508**
Wood; 31×24 cm
Transferred from the Austrian gallery in 1922.
The painter is a Bavarian or Austrian pupil of Altdorfer's, called after the pen drawings in the 'Historia Friderici et Maximiliani', compiled by the humanist J. Grünpeck in 1514/15. (A133)

PORTRAIT OF JACOB ZIEGLER
Wolf Huber (b. Feldkirch *c* **1485, d. Passau 1553), 1544/49**
Wood; 58.5×44.3 cm
From the Gallery reserve.
This versatile scholar (1470/71–1549), whose most interesting achievements lay in the field of geography and astronomy, worked at the court of the Prince Bishop of Passau, Wolfgang I, Count Salm, from 1544 onwards. (1942)

◁
ALLEGORY OF REDEMPTION
Wolf Huber (b. Feldkirch *c* **1485, d. Passau 1553),** *c* **1540**
Wood; 154×131 cm
Transferred from the ecclesiastical Treasury to the Imperial Gallery.
Starting from St Peter's speech in front of the Jewish High Council (Acts 4, 10–12) with the annunciation of the Redemption, the Crucifixion and the setting up of the Brazen Serpent are typologically juxtaposed. In the background, the healing of the lame man and the imprisonment of the apostles, Peter and John. In the foreground, kneeling, is the donor, Wolfgang I, Count Salm, Prince Bishop of Passau from 1540–1555. (971)

THE STAG HUNT OF ELECTOR FRIEDRICH THE WISE
**Lucas Cranach the Elder (b. Kronach 1472,
d. Weimar 1553), signed, dated 1529**
Wood; 80×114 cm

In the Imperial Collections in Prague in 1621.
Among the hunters are Elector Friedrich the
Wise (d. 1525) and Emperor Maximilian I
(d. 1519); on the right Johann der Beständige.
As two of the participants in the hunt were
already dead in 1529, this is clearly a memorial
painting which Johann der Beständige
commissioned to commemorate the hunt.
(3560)

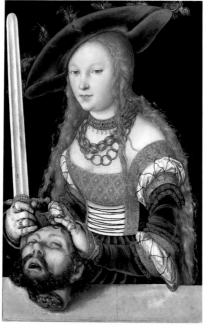

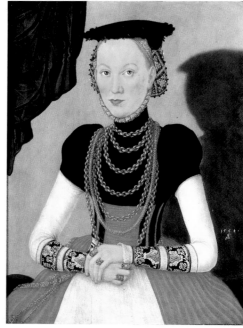

PORTRAITS OF ONE OF HENRY VIII'S COURT
SERVANTS AND HIS WIFE
Hans Holbein the Younger (b. Augsburg
c **1497, d. London 1543), 1534**
Wood; each 12 cm diam.
From the Ambras Collection. (5432 and 6272)

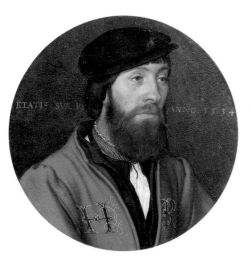

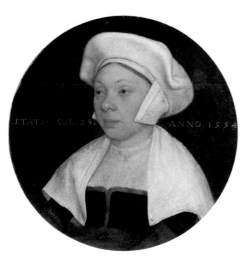

◁◁

JUDITH WITH THE HEAD OF HOLOFERNES
Lucas Cranach the Elder (b. Kronach 1472,
d. Weimar 1553), signed, *c* 1530
Wood; 87×56 cm
In the Imperial Collections in Vienna *c* 1615.
(858)

◁

PORTRAIT OF A WOMAN
Lucas Cranach the Younger (b. Wittenberg
1515, d. Weimar 1586), signed, dated 1564
Wood; 83×64 cm
In Archduke Leopold Wilhelm's collection in
1659. (886)

△

PORTRAIT OF JANE SEYMOUR, QUEEN OF ENGLAND
Hans Holbein the Younger (b. Augsburg
c **1497, d. London 1543), 1536**
Wood; 65.4×40.7 cm
Mentioned in Amsterdam in 1605. Only in
1720 known with certainty to be in the Imperial
Collections.
Jane Seymour (*c* 1509–1537), eldest daughter of
Sir John Seymour of Wolfhall, came to court in
1530 and served the two Queens, Catherine of
Aragon and Anne Boleyn, as lady-in-waiting.
Henry VIII married her in 1536; she died in
childbirth in 1537, the child being the heir to
the throne, later King Edward VI.(881)

PORTRAIT OF A YOUNG MERCHANT
**Hans Holbein the Younger (b. Augsburg
c 1497, d. London 1543), dated 1541**
Wood; 46.4×34.8 cm
In Archduke Leopold Wilhelm's collection in
1659. (905)

▷▷
DR JOHN CHAMBERS
**Hans Holbein the Younger (b. Augsburg
c 1497, d. London 1543) c 1541/43**
Wood; 57.8×39.7 cm
Collection of Thomas Earl of Arundel; in
Archduke Leopold Wilhelm's collection in
1659.
One of Holbein's late, most mature portraits,
depicting Henry VIII's personal physician at
the age of 88. (882)

PORTRAIT OF A KNIGHT OF AN ORDER
**Bartholomäus Bruyn the Elder (b. Wesel/
Niederrhein c 1493, d. Cologne 1555), dated
1531**
Wood; 63×47 cm
In Archduke Leopold Wilhelm's collection in
1659 as a Holbein.
One of the few examples in the Vienna gallery
of western or northern German painting. (868)

ÆTATIS · SVE · 88 ·

THE NÜRNBERG PATRICIAN, CHRISTOPH
BAUMGARTNER
**Christoph Amberger (b. Augsburg *c* 1500,
d. 1561/62), dated 1543**
Wood; 83×62.5 cm
In the Imperial Collections in Vienna in 1733.
(889)

PORTRAIT OF A REFEREE
**Barthel Beham (b. Nürnberg 1502, d. Bologna
1540), dated 1529**
Wood; 84.8×66 cm
In the Imperial Gallery in Vienna in 1781.
The subject is marking the score for archery or
a ball game. (783)

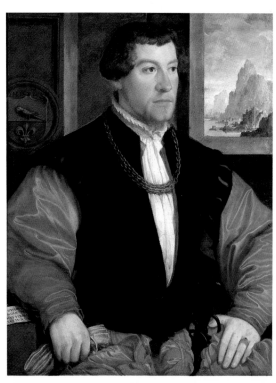

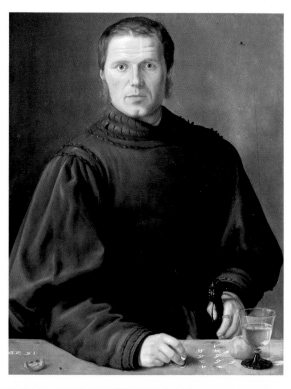

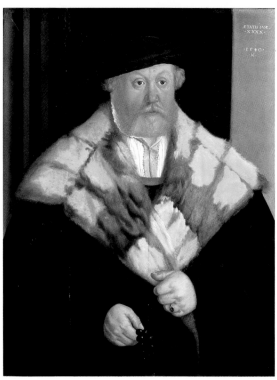

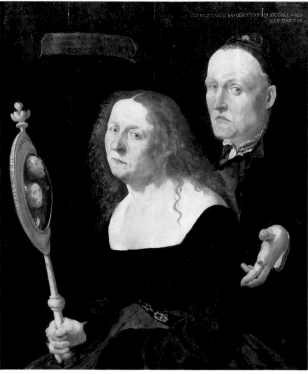

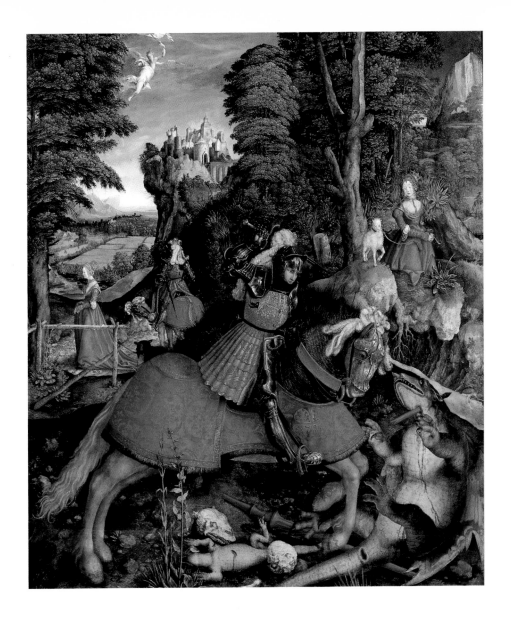

MINERVA VICTORIOUS OVER IGNORANCE
**Bartholomäus Spranger (b. Antwerp 1546,
d. Prague 1611),** *c* 1591
Canvas; 163×117 cm
From Rudolf II's *Kunstkammer*.
Minerva, surrounded by the nine muses,
protects knowledge and art and conquers
Ignorance, shown with ass's ears. (1133)

DIANA AND ACTAEON
**Joseph Heintz the Elder (b. Basle 1564,
d. Prague 1609), signed,** *c* 1595
Copper 40×49 cm
Painted for Rudolf II. (1115)

GIDEON REVIEWS HIS TROOPS
**Johann Heinrich Schönfeld (b. Biberach/Risz
1609, d. Augsburg 1683), signed,** *c* **1640/45**
Canvas; 99×179 cm
In the Prague *Kunstkammer* in 1663. (1143)

◁◁
BACCHUS, CERES AND CUPID
**Hans von Aachen (b. Cologne 1552, d. Prague
1615), signed,** *c* **1610**
Canvas; 163×113 cm
In the Imperial Collections in Prague in 1621.
(1098)

◁
APELLES WITH CAMPASPE
**Jodocus a Winghe (b. Brussels 1544,
d. Frankfurt am Main 1603), signed,**
c **1600/03**
Canvas; 210×175 cm
In Rudolf II's possession in 1604. (1686)

▷
THE MYSTICAL BETROTHAL OF ST CATHERINE,
WITH ST LEOPOLD AND ST WILLIAM
**Joachim von Sandrart (b. Frankfurt am Main
1606, d. Nürnberg 1688), signed, dated 1647**
Wood; 74×57 cm
Painted for Archduke Leopold Willhelm.
(1117)

JUPITER AND MERCURY VISITING PHILEMON AND
BAUCIS
**Johann Carl Loth (b. Munich 1632, d. Venice
1698), early work**
Canvas; 178×252 cm
In Archduke Leopold Wilhelm's collection in
1659. (109)

ST JOSEPH'S DREAM
**Anton Raphael Mengs (b. Aussig 1728,
d. Rome 1779), late work**
Wood; 114×86 cm
In the Imperial Picture Gallery in 1796. (124)

◁

THE MARTYRDOM OF ST THIEMO
**Christoffer Paudiss (b. Lower Saxony c 1625,
d. Freising 1666), signed, dated 1662**
Canvas; 336×191 cm
Acquired in Salzburg 1806/09. (2284)

Court Portrait Painting

As one might expect in a paintings collection which bears the stamp of one of Europe's major dynasties, the court portrait plays a central part. It was mainly genealogical considerations that determined the composition of Archduke Ferdinand of the Tyrol's portrait collection of some thousand miniature likenesses, which he assembled in the Castle of Ambras near Innsbruck from 1576 onwards. In numerous other Hapsburg castles, also, family portraits and likenesses of the personalities associated with the Hapsburgs had gradually been accumulated, having been considered, even as early as the age of Enlightenment, as 'worthy of an appropriate home'. However it was only in 1976, after repeated attempts, that this portrait gallery illustrating Austria's history was set up in what was, historically speaking, an extremely apposite location, namely Castle Ambras. By this time not only had the material been scientifically studied, but the Republic of Austria could be regarded as so well established that no political consequences could ensue as a result of the establishment of what amounted to a 'Hapsburg' portrait gallery with approximately two hundred and eighty pictures.

The fact that artistic quality is not always achieved in court portraiture has to do with the many-faceted nature of the genre. Apart from the fact that even the Hapsburgs did not always have painters of European stature at their disposal for their portrait commissions, the two-fold task imposed on the court portrait artist may in itself have restricted the free development of his artistic abilities. The court portrait began to develop only at the court of Emperor Maximilian I, after preliminaries in the Burgundian-Netherlandish area. Here for the first time a balance was reached between the political demands of the official portrait, with the various titles of rank, and the immediate observation of the Emperor's physiognomy, which remained characteristic even when depicted in abstract form. Similarly, Dürer's famous portrait of Maximilian, *Der Letzte Ritter* (the Last Knight) painted in 1519, the year of the Emperor's death, coined the image which posterity still has of him. However, a look at Holbein the Younger's portrait of the English Queen *Jane Seymour*, which did not appear until 1536, may give an idea of the possibilities of interpretation on the highest artistic level. In the case of Maximilian's court painter Bernhard Strigel, and more particularly of his successors, the accent is rather on the 'supra-individual', the courtly in general, which always involved the risk of a certain emptiness of expression. This can also be detected in the charming group portrait of Maximilian's family dating from 1515, charming from the point of view of colour, composition and conception. Cranach's *Princesses of Saxony* is a North German example of this type of group court portrait.

German painting also played a decisive part, again after preparatory steps in the Netherlands, in finding a vehicle of expression which was capable of conveying greatness and the virtues of rulers largely without any outward signs or insignia. This was of importance for the further development of court portraiture in the emergence of the full-length portrait. *Emperor Karl V with his Ulm Mastiff* by the Austrian Jacob Seisenegger, painted in Bologna in 1532, was the immediate model for Titian's magnificent 'copy' in the Prado in Madrid. Seisenegger's portrait set the pattern and provided a point of departure for many other artists. The fourth significant court painter who deserves mention is Anthonis Mor, who worked mainly for the Spanish Hapsburgs in Brussels and Madrid and who ranks as 'one of the creators of the concept of the *homme politique*' (Heinz). He combines the keen observation, peculiar to the Netherlanders, of material texture or facial expression with a pictorial arrangement which was able to convey to the beholder the austere and inaccessible atmosphere in which the individual representing monarchy wanted to be seen. His portrait of *Queen Anne of Spain*, the fourth spouse of King Philip II, represents a tradition that extended through Sanchez Coëllo (his portrait of *Prince Don Carlos*, the 'unlucky' son of Philip II), and Pantoja de la Cruz, right down to Velazquez and his followers. The typical bearing, gestures and accessories of this kind of portrait have a strange, frozen quality which has a very powerful effect and in fact survives, particularly in the Hapsburg-ruled countries, right into the nineteenth century.

Mor, Seisenegger, Cranach and Titian met at the Reichstagen (Imperial diets) of Augsburg in 1548 and 1550: the concept of the court portrait is stamped with the Hapsburg ideal of the ruler and from their sphere it spread over the whole of Europe. Mor was particularly captivated by the art of the great Venetian. Titian's Vienna portrait of *Elector Johann Friedrich von Sachsen*, taken prisoner by Karl V after the battle of Mühlberg, appeared at this time, no doubt commissioned by the Emperor himself. Titian's portrait art is so individual that it had scarcely any influence on the immediate development of the court portrait, in spite of its 'unsurpassed expression of nobility and moral stature' (Heinz), and bore fruit only in Rubens and Van Dyck, who referred back to Titian's portraits in order to renew the art of painting court portraits by injecting 'life' into its rigid schemes. In Van Dyck's portrait of *Prince Rupert of the Palatine*, painted around 1630, the architecture, dog, drapery and strip of landscape belong to the old stock-in-trade of the court portrait, but they are deployed here most ingeniously as if to reveal action; movement and repose, attitude and action are so closely integrated that what emerges is an unparalleled, quintessential image of effortless, haughty elegance and control.

The Vienna collection is especially famous for Velazquez's 'Infanta' portraits, of the children of King Philip IV of Spain. The earliest of those shown here is *Infanta Margarita Teresa in a Pink Dress*, dating from 1653/54. The other two, dating from 1659, depict the two-year-old *Infante Philip Prosper* who died soon after, and again *Margarita Teresa in a Blue Dress*, now eight

years old. She was later married to her cousin – also her uncle – Emperor Leopold I. As court painter of Philip IV, Velazquez also retains in his child portraits all the traditional gestures of the official portrait, but he transforms all the solid objects into pure pictorial terms. With incredible sureness of touch and economy, he brings together what he sees into an (only apparently) loose synthesis of bold separate brush strokes and patches of colour. Here – more obviously than in Van Dyck, just because it is achieved without nervous energy – a perfect balance has been reached between the demands of the official, commissioned portrait and the purest painterly work of art.

On the Austrian Hapsburg side nothing comparable can be set against this – we merely mention as a curiosity the portrait of *Emperor Leopold I in Theatrical Costume*, which is by Jan Thomas and shows the music-loving monarch, himself a composer, as Acis in *La Galatea*, a *favola* set to music by Antonio Draghi. In this picture Emperor Leopold I is already wearing the large black wig customary at the French court from the sixties onwards. Otherwise the Hapsburg countries were conservative and had remained uninfluenced by a new, late baroque portrait style developed at the court of Louis XIV which probably found its purest form in Hyacinthe Rigaud. Its distinguishing marks were the ostentatious display of symbols of state and power, the powerful presence of the subject himself, magnified to still greater proportions by means of billowing draperies. Rigaud's portrait of *Count Philip Wenzel von Sinzendorf*, the Imperial Ambassador to the French court, is, in the context of the Vienna collection, an early example (1728) of that conception. It becomes abundantly clear that later on in a period of turbulent change, the overbearing prestige of the monarch could no longer be convincingly portrayed, especially as a more 'enlightened' type of portrait had become highly regarded in court circles from the second half of the eighteenth century onwards. The latter combined ethical appeal with a popular, middle-class flavour particularly favoured by the Hapsburgs. Excellent examples of this type of portrait by Batoni, Mengs, Anton von Maron and Johann Zoffany can be found in the Vienna gallery.

▷

THE FAMILY OF EMPEROR MAXIMILIAN I
Bernhard Strigel (b. and d. Memmingen c 1460–1528), c 1515
Wood; 72.8×60.4 cm
Painted for Emperor Maximilian, later in the possession of the humanist Johannes Cuspinian, in the Imperial Collections in Vienna around 1615 for sure. Maximilian and his first wife Mary of Burgundy; between them their son Philip I (the Fair), King of Castile (d. 1506); in the foreground left the latter's sons, one of whom became Emperor Karl V (d. 1558) and the other Emperor Ferdinand I (d. 1564); on the right Maximilian's grandson-in-law, Ludwig II of Hungary. Probably painted in 1515 on the occasion of the double betrothal of Maximilian's grandchildren Ferdinand and Maria to Anna and Ludwig of Hungary. The inscriptions elevating the Imperial family to the Holy Family were probably not added until 1520. (832)

▷▷

EMPEROR MAXIMILIAN I
Albrecht Dürer (b. and d. Nürnberg 1471–1528), signed, dated 1519
Wood; 74×61.5 cm
Known with certainty to have been in the Imperial Gallery only in 1781.
Maximilian (1459–1519), son of Emperor Frederick III, succeeded in securing the Burgundian territories for the House of Hapsburg through his marriage to Mary of Burgundy (1477). Roman king in 1486, his second marriage was to Bianca Maria Sforza in 1494. Proclaimed Roman Emperor in Trent 1508. An ardent patron of the arts and very conscious of their importance for his own standing with posterity. (825)

▷

THE PRINCESSES SIBYLLA, EMILIA AND SIDONIA OF SAXONY
Lucas Cranach the Elder (b. Kronach 1472, d. Weimar 1553), c 1535
Wood; 62×89 cm
In the Imperial Collections in Vienna in 1619.
(877)

EMPEROR KARL V WITH HIS ULM MASTIFF
Jacob Seisenegger (b. Lower Austria 1505,
d. Linz 1567), signed, dated 1532
Canvas; 203.5×123 cm
In the Imperial Collections in Prague in 1685.
Karl (1500–1558), King of Spain 1516, Emperor
1519, crowned Emperor in Bologna in 1530; he
abdicated in 1556. (A 114)

PRINCE RUPERT OF THE PALATINE
Sir Anthony van Dyck (b. Antwerp 1599,
d. London 1641), c 1630/32
Canvas; 175×95.5 cm
In the Imperial Collections in 1730.
Rupert (1619–1682), younger son of Frederick
v, the Winter King, lived in exile in the Hague
before joining his uncle Charles I of England
in London in 1636. Artistically talented, lively
and enterprising, he played an important part
in social and military life in England. (484)

◁◁

ANTON PERRENOT DE GRANVELLA
Anthonis Mor (b. Utrecht c 1516/19,
d. Antwerp 1575), signed, dated 1549
Wood; 107×82 cm
In the Imperial Gallery in 1772.
Granvella (1517–1586), later a Cardinal, was
Minister of State to Karl v and to King Philip
II of Spain. In 1559 he became Minister of the
Regent of the Netherlands, Margaret of Parma,
a daughter of Karl v; became Spanish Viceroy
in Naples in 1571. (1035)

◁

QUEEN ANNE OF SPAIN
Anthonis Mor (b. Utrecht c 1516/19,
d. Antwerp 1575), signed, dated 1570
Canvas; 161×110 cm
Longstanding Imperial property.
Anne (1549–1580), daughter of Emperor
Maximilian II, became the 4th wife of King
Philip II of Spain. (3053)

THE INFANTE DON CARLOS

Alonso Sánchez Coëllo (b. Alquería Blanca 1531/32, d. Madrid 1588), signed, dated 1564

Canvas; 186×82.5 cm

In the Imperial Collections 1564.

Despite subsequent literary and musical attempts to present him as a heroic figure, Don Carlos (1545–1568), son of Philip II of Spain, was both mentally and physically handicapped. (3235)

ELECTOR JOHANN FRIEDRICH OF SAXONY

Tiziano Vecellio called Titian (b. Pieve di Cadore c 1488, d. Venice 1576), 1550/51

Canvas; 103.5×83 cm

Probably purchased by Archduke Leopold Wilhelm.

Johann Friedrich the Magnanimous (1503–1554) was defeated by Karl V at the Battle of Mühlberg and taken prisoner. His portrait was painted by Titian when he was a prisoner in Augsburg. He was released in 1552. (100)

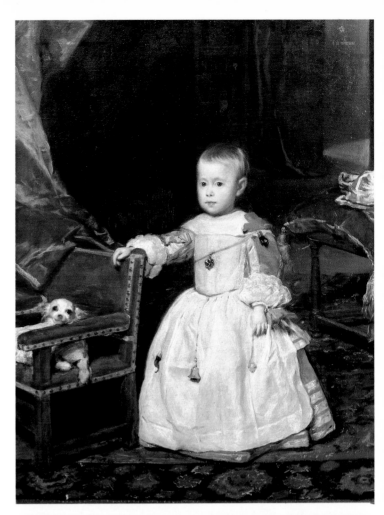

△

THE INFANTE PHILIP PROSPER

Diego Velazquez (b. Seville 1599, d. Madrid 1660), 1659

Canvas; 128.5×99.5 cm

Sent as a present to the Vienna court in 1659.

(319)

▽

EMPEROR LEOPOLD I IN THEATRICAL COSTUME

Jan Thomas (b. Ypres 1617, d. Vienna 1678), c 1667

Copper; 33.3×24.2 cm

Acquired 1960. Exhibited in Castle Ambras from 1976.

With Leopold (1640–1705), second son of Ferdinand III and Emperor from 1658, begins the Austrian 'Heroic Age', during which the *monarchia austriaca* rose to become a great European power, especially after the threat from Turkey had been successfully warded off.

(9135)

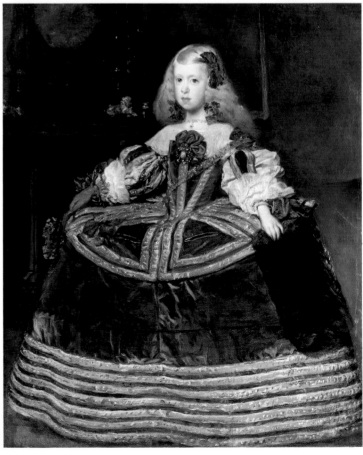

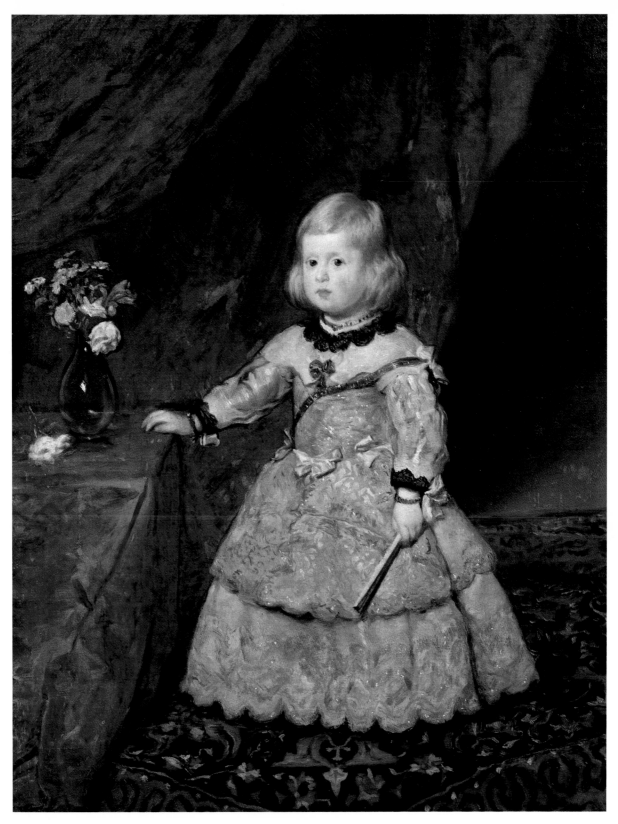

◁

THE INFANTA MARGARITA TERESA IN A BLUE
DRESS
**Diego Velazquez (b. Seville 1599, d. Madrid
1660), 1659**
Canvas; 127×107 cm
Sent as a present to the Vienna court in 1659.
(2130)

△

THE INFANTA MARGARITA TERESA IN A PINK
DRESS
**Diego Velazquez (b. Seville 1599, d. Madrid
1660), 1653/54**
Canvas; 128.5×100 cm
Longstanding Imperial property. (321)

GRAND DUKE PIETRO LEOPOLDO OF TUSCANY
AND HIS FAMILY
**Johann Zoffany (b. Frankfurt am Main 1733,
d. London 1810) 1775/78**
Canvas; 325×398 cm
Begun in Florence for the Imperial Family,
completed in Vienna.

The Grand Duke and his (at that time) eight
children are portrayed in the courtyard of the
Pitti Palace in Florence. Pietro Leopoldo (1747–
1792) became Emperor in 1790 as Leopold II;
his eldest son Franz, in front on the right, in
red, succeeded him as Emperor Franz II.
(3771)

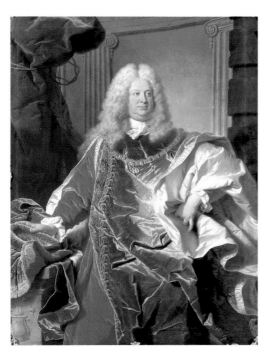

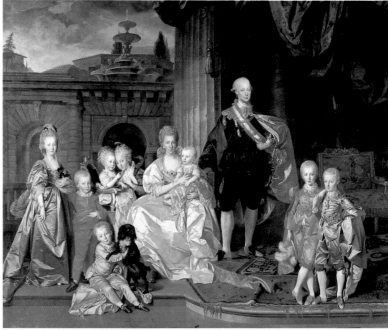

△

PHILIPP LUDWIG WENZEL, COUNT SINZENDORF
**Hyacinthe Rigaud (b. Perpignan 1659, d. Paris
1743), 1728**
Canvas; 166×132 cm
Presented by Clarisse de Rothschild 1948.
Sinzendorf (1671–1742) was a diplomat and
high official under the Emperors Leopold I,
Josef I and Karl VI. He is seen here wearing
the Order of the Golden Fleece. (9010)

▷

THE INFANTA MARIA LUDOVIKA
**Anton Raphael Mengs (b. Aussig 1728,
d. Rome 1779), c 1764/65**
Canvas; 85×65 cm
In the Imperial Gallery in 1796. The Infanta
(1745–1792), daughter of Charles III of Spain
married (1765) Pietro Leopoldo, son of
Emperor Franz I and Maria Theresa, who later
became Grand Duke of Tuscany. On her
bracelet is a miniature portrait of her
betrothed. (1644)

Nineteenth and Twentieth-Century Painting

The 'Neue Galerie', the collection of non-Austrian paintings of the nineteenth and early twentieth centuries, is housed today in a location rich in tradition for the Imperial collections. After long years of homelessness it has been accommodated, along with the successors of the Emperor's household horses, the Lippizaner, in the Stallburg, a mid-sixteenth-century palace built around an arcaded quadrangle in which Archduke Leopold Wilhelm had established his collection in 1656. The 'Moderne Galerie' was founded in 1903 at the instance of the Association of Visual Artists, the Sezession. Its purpose, namely to raise Vienna's cultural standing in the international development of the arts to the same level as that of other European centres, was to be realized through 'the rapid acquisition of major works of those masters whose names are synonymous with the art of contemporary Europe.' As a spectacular send-off, the Sezession immediately presented the Moderne Galerie with Van Gogh's *The Plain of Auvers-sur-Oise*, dating from 1890, and Segantini's *Die Bösen Mütter* of 1894. Having been housed in the Upper Belvedere Palace since 1924 and the Lower since 1929, the gallery came to an abrupt end as a result of political events and the Second World War. When the 'Austrian Gallery' was housed in the Belvedere after the war, in pursuance of the concept of a National Museum, the non-Austrian pictures of the Moderne Galerie were incorporated into the Kunsthistorische Museum, although owing to a lack of space, they were not exhibited. It was not until 1967 that these precious stocks found a permanent home as the Neue Galerie in the Stallburg, in the very place where Vienna's museum activity had begun.

The two central threads in the painting of the nineteenth century, landscape and portrait, can easily be followed in significant examples from the neo-classical to the early modern period, the main accent being on German and French painting.

The German school of romantic painting is represented by perhaps an unusual example. Caspar David Friedrich, probably its most significant representative, settled in Dresden in 1798. We know from reports that Friedrich's studio there '. . . was completely empty. Even his paint-box, which had every right to be there, together with his bottle of oil and painting rag, were relegated to the next room, it being Friedrich's opinion that all extraneous objects disturb the inner world of images.' (Kügelgen, 1812). Further evidence of this 'mystical sobriety' is to be found in his picture *View from Friedrich's Dresden Studio Window* across the Elbe, where the strictness of composition is obvious right down to the smallest and most subtle details.

In France it was mainly among the painters of Barbizon, a group of artists working near the Forest of Fontainebleau, that a new landscape art developed, based on the direct rendering of the artist's experience of nature and partly anticipating Impressionist trends. One of its founder-members was Camille Corot, whose work also bears the impress of three periods

spent in Italy, some of them of several years' duration. Jean François Millet's *Plain of Chailly*, painted in Barbizon in 1862, captures the melancholy atmosphere of winter and links it symbolically to peasant life through the abandoned farm implements. Gustave Courbet, probably France's most important 'realistic' painter – when the jury at the Paris World Exhibition rejected him, he mounted his own counter-exhibition in the Pavillon du Réalisme – is represented in Vienna not by his pictures expressing social criticism nor by the enchanted female nudes in watery landscapes which are so typical of him, but by landscape and portraits, the one reproduced here being a late portrait of a girl, dating from 1872.

Courbet had a profound influence on German painting and this is particularly evident in Wilhelm Leibl. Courbet knew him personally and called him the first and only German colourist. The Prussian Adolph von Menzel can also be counted as one of the realists, with his totally unsentimental and keenly observed view of reality, both historical and present-day. His *Early Mass*, painted in brilliant sparkling colours in 1852 during the first of many travels in South Germany and Austria, probably depicts the interior of the Church of the Holy Spirit in Munich. If, sometimes at least, Courbet's realism was the masking, in terms of paint, of his idyllic core, Wilhelm Busch's idyll to some extent becomes a visionary internalization of the external world (Traeger). Busch, the brilliant author of ironically humorous picture stories for children and adults, virtually hid his paintings from the outside world, describing them as 'my coloured stuff' or 'rubbish'. His furious, impulsive brush-work – his 'daubing' – almost bursts out of the tiny format of his paintings, mostly done on cardboard. For the first time the contrast between the idyllic subject and the realism of the painting is made clear. When asked whether he loved the ideal or the real, Busch gave the pointed, inscrutable answer: 'One lives and hopes.'

Anselm Feuerbach, whose *Orpheus and Eurydice* with its strangely subdued colours evokes an antique relief, and Arnold Böcklin, whose mythological creatures inhabit a totally realistic seascape, may be said to represent the idealistic, reflective aspect of German painting of the nineteenth century.

'In France the phlegmatic outlook of the realists gave rise to the passivity which was part of the Impressionist programme.' (Traeger); but both the programme on the one hand and on the other its scientific explanations of the immediate, spontaneous colour event and its impact on the retina, frequently did not square with the reality of the pictures. *After Bathing* (1876) by August Renoir and *Fishermen on the Seine near Poissy*, painted six years later by Claude Monet, demonstrate characteristic aspects of the art of these two masters who belonged to the nucleus of the Impressionist group. The naked female body (here the model is Anna from Montmartre) is celebrated by Renoir in innumerable variations, in the most delicate colour gradation

and in all nuances of light, while Monet in his landscape painting observed the changing play of light and colour in nature, especially on water, often seeking out an unusual perspective.

Another group of paintings, important on account of its size, should be mentioned here, namely the eleven pictures by Lovis Corinth. It was mainly in the years following his serious illness of 1911–12 that Corinth concerned himself increasingly with landscape, and the region around Lake Walchen in Bavaria was to become his favourite subject in his last years. The changing light of the seasons is captured in the strong impasto brushwork, 'heavy' but firm (perhaps partly due to his stroke), which he used to great effect.

The manifold possibilities of getting beyond the stylistic trends of the nineteenth century can be observed in the Stallburg in pictures which were all painted around the turn of the century. Both the choice of subject and its artistic rendering reflect the general crisis of the times around 1900. New solutions in form were being sought for exceptional psychological situations, for the torments of sensual and sexual misdemeanour and the taboos surrounding these, for the uncanny and sinister elements in landscape, for the inner world of the artist and of visible things. Invariably the painters' attempts to transfer three-dimensional phenomena to two-dimensional canvas involve tremendous inner tension. In Munch the landscape can become an ornamental structure of colours and shapes; in Van Gogh the *Plain near Auvers-sur-Oise* is the ecstatic, convulsive expression of the artist's critical emotional state during the last weeks of his life. Sometimes myths of the human race, highly complex emotions, are reduced to ciphers, as in Segantini's *Die Bösen Mütter* (Wicked Mothers) or Hodler's *Ergriffenheit* (Emotion).

Broadly speaking, Paul Cézanne also belongs to this group, being the most forward-looking artist personality of the day. In 1904, shortly after he had painted the *Still Life* now in Vienna, Cézanne laid down that 'Nature is to be reproduced in terms of spheres, cones and cylinders', and that 'everything is to be put in proper perspective'. Although this was not so in the case of Cézanne, the attempt to reduce an object to its basic structures leads to the autonomy of geometrically conceived shapes, to a picture as a thing in itself, which no longer needs any recognizable 'objects'.

THE PLAIN OF CHAILLY
Jean François Millet (b. Gruchy, Normandy, 1814, d. Barbizon 1875), signed, 1866
Canvas; 60×73 cm
Purchased 1924. (NG 203)

PORTRAIT OF A YOUNG WOMAN (MADAME LEGOIS)
Camille Corot (b. and d. Paris 1796–1875), signed, 1838
Canvas; 53×40 cm
Purchased 1923. (NG 58)

▷
EARLY MASS
Adolph von Menzel (b. Breslau 1815, d. Berlin 1905), signed, 1852
Canvas; 58×68 cm
Purchased 1939. (NG 194)

PORTRAIT OF A GIRL
Gustave Courbet (b. Ornans 1819, d. La Tour-de-Peilz 1877), signed, dated 1872
Canvas; 73×60 cm
Purchased 1908. (NG 62)

△

COUNTESS ROSINE TREUBERG, NÉE VON POSCHINGER
Wilhelm Leibl (b. Cologne 1844, d. Würzburg 1900), signed, dated 1877
Wood; 88×67 cm
Purchased 1913. (NG 160)

◁

FOREST LANDSCAPE WITH COWS AND PEASANTS
Wilhelm Busch (b. Wiedensahl 1832, d. Mechtshausen 1908), c 1890/95
Paper on cardboard; 14×18 cm
Purchased 1941. (NG 36)

251

ORPHEUS AND EURYDICE
**Anselm Feuerbach (b. Speyer 1829,
d. Venice 1880), signed, dated 1869**
Canvas; 195×124 cm
Purchased 1916.
Painted in Rome. (NG 87)

SEA IDYLL
**Arnold Böcklin (b. Basel 1827, d. San
Domenico/Fiesole 1901), signed, dated 1887**
Wood; 167×224 cm
Purchased 1901. (NG 13)

▷

LAKE WALCHEN WITH THE HERZOGSTAND
IN THE SNOW
**Lovis Corinth (b. Tapiau/East Prussia 1858,
d. Zandvoort 1925), signed, dated 1922**
Canvas; 78×98 cm
Purchased from the artist 1923. (NG 49)

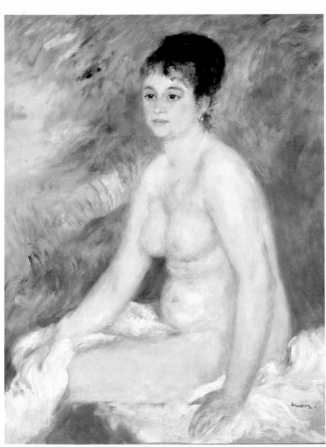

AFTER BATHING
**Auguste Renoir (b. Limoges 1841, d. Cagnes
1919), signed, 1876**
Canvas; 93×73 cm
Purchased 1910. (NG 248)

▽

FISHERMEN ON THE SEINE NEAR POISSY
**Claude Monet (b. Paris 1840, d. Giverny
1926), signed, dated 1882**
Canvas; 60×82 cm
Purchased 1942. (NG 206)

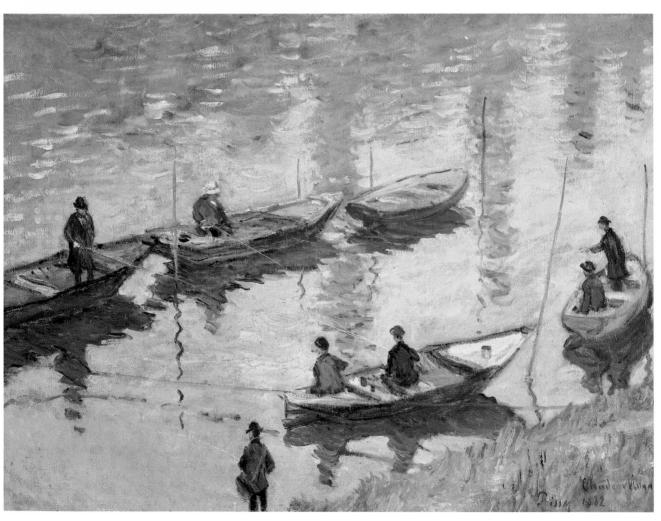

DIE BÖSEN MÜTTER (THE WICKED MOTHERS)
Giovanni Segantini (b. Arco 1858, d. Pontresina 1899), signed, dated 1894
Canvas; 105×200 cm
Presented 1901 by the Vienna Secession.
One of the Nirvana paintings. Development of a Buddhist legend: child murderesses, restlessly hovering over snowy fields, suckling their dead children. (NG 269)

▷

SUMMER NIGHT ON THE SHORE
Edvard Munch (b. Løten 1863, d. near Oslo 1944), signed, c 1902
Canvas; 103×120 cm
Collection Carl Moll, Alma Mahler-Werfel. Purchased 1940.
(NG 213)

▷▷

STILL LIFE WITH BLUE BOTTLE, SUGAR BOWL AND APPLES
Paul Cézanne (b. and d. Aix-en-Provence, 1839–1906), c 1900
Watercolour on paper; 48×63 cm
Art-dealers Vollard, Paris; Collection C. Reininghaus. Purchased 1928.
(NG 42)

ERGRIFFENHEIT (EMOTION)
Ferdinand Hodler (b. Bern 1853, d. Geneva 1918), signed, 1900
Canvas; 115×70 cm
Exhibited 1903/04 in the Vienna Secession.
Purchased from the C. Reininghaus collection
in 1918. (NG 121)

PLAIN NEAR AUVERS-SUR-OISE
Vincent van Gogh (b. Groot-Zundert/Brabant 1853, d. Auvers-sur-Oise 1890), June 1890
Canvas; 50×101 cm
Galerie d'art van Gogh, Amsterdam;
presented 1903 by the Vienna Secession.
(NG 301)

Index

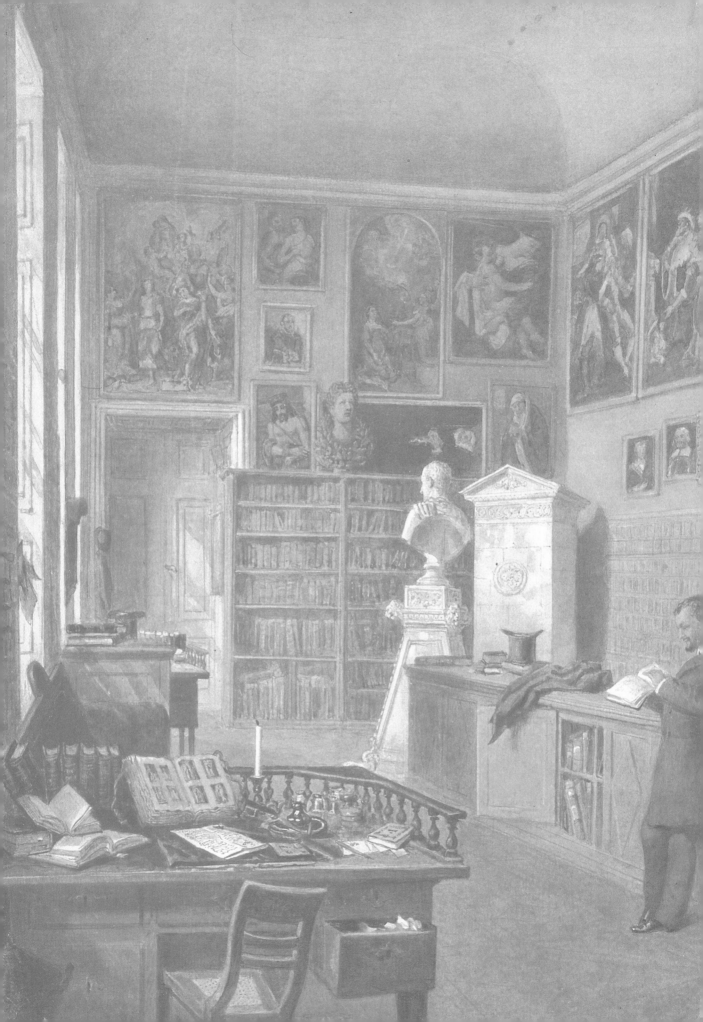